Meet MISS SUBWAYS

New York's Beauty Queens 1941-1976

Photography by FIONA GARDNER Text by AMY ZIMMER
with an essay by KATHY PEISS

SEAPOINT BOOKS
An imprint of Smith/Kerr Associates, LLC
Kittery, ME

Distributed to the trade by National Book Network

Generous quantity discounts are available through Smith/Kerr Associates, LLC, 1 Government St #1, Kittery, ME, 03904, (207) 702-2314, www.smithkerr.com

Cataloging-in-publication date is on file at the Library of Congress

ISBN 13: 978-0-9830622-3-3

ISBN 10: 0-9830622-3-4

Cover and book design by: Jody Churchfield

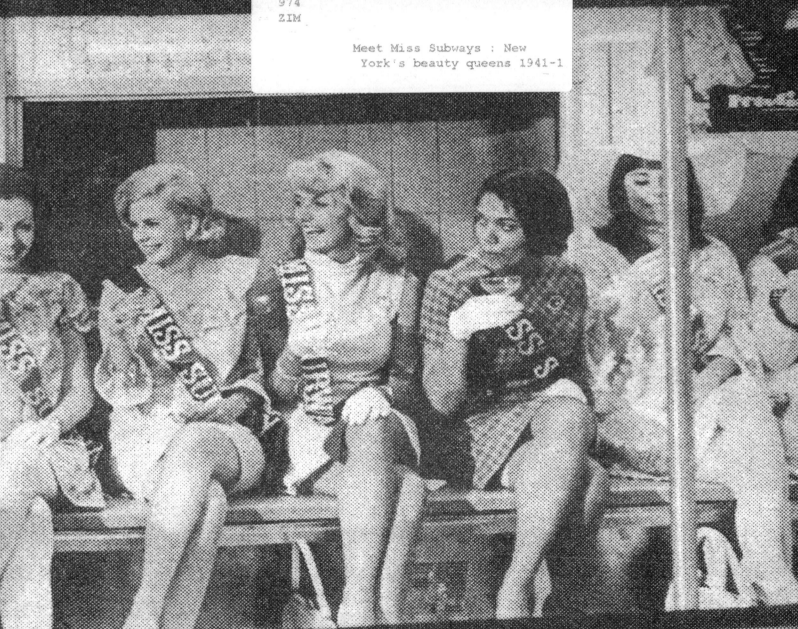

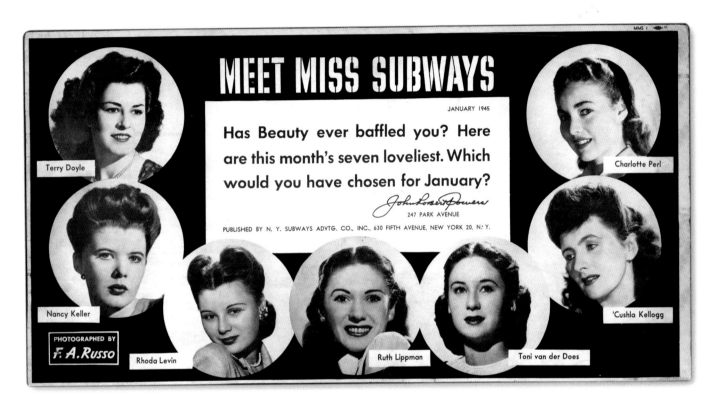

This book is dedicated to all Miss Subways.

To the many women who warmly welcomed us into their lives and shared their stories with us; to those who passed away before the project began and while it was underway; and to those whose names we have yet to uncover.

Contents

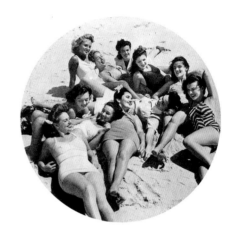

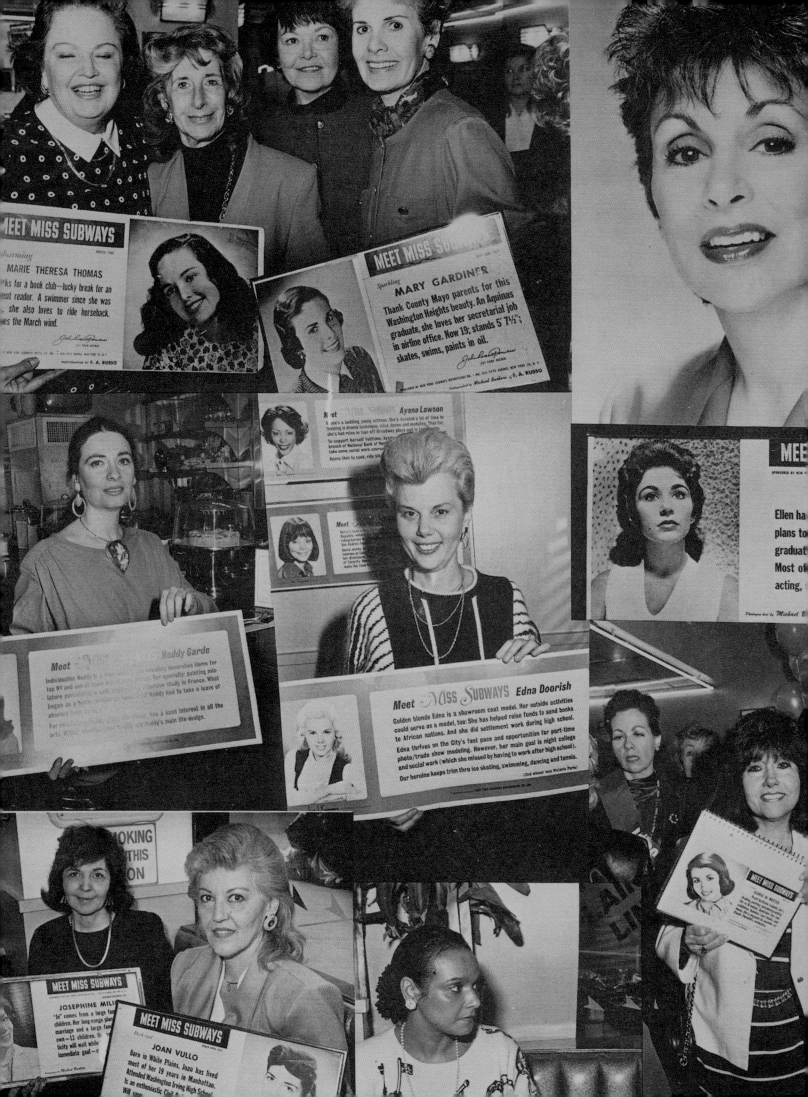

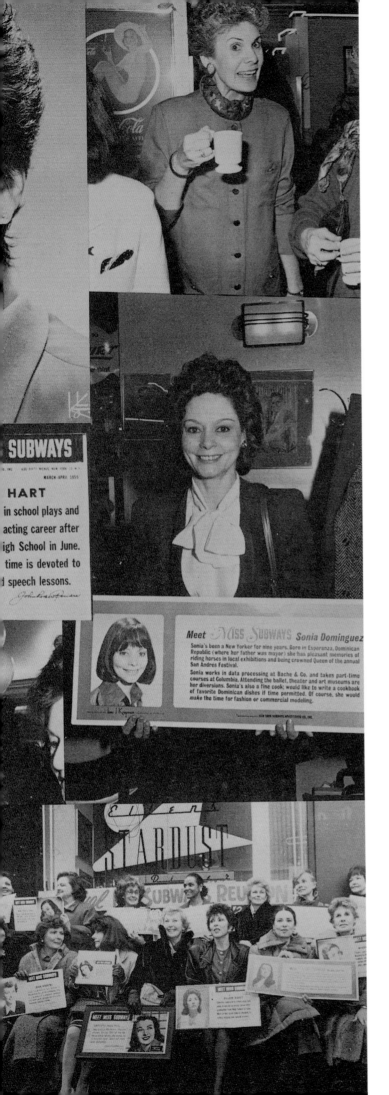

FINDING MISS SUBWAYS

By Amy Zimmer

COMMEMORATING THE CONTEST Ellen Hart Sturm, Miss Subways 1959, has hosted several Miss Subways reunions at her Stardust Diner on Broadway in Midtown Manhattan. For a 1989 event she created collage placemats featuring contest winners with their posters.

MEET MISS SUBWAYS

NEW YORK-BASED ARTIST FIONA GARDNER HAD NEVER HEARD OF MISS SUBWAYS UNTIL THE METROPOLITAN TRANSPORTATION AUTHORITY BROUGHT IT BACK AS "MS. SUBWAYS" FOR ONE YEAR TO COMMEMORATE THE SUBWAY SYSTEM'S CENTENNIAL IN 2004. THOUGH THE CONTEMPORARY CAMPAIGN WAS MORE OF A DOWDY "MISS MANNERS," WITH POSTERS URGING RIDERS TO GIVE UP THEIR SEATS FOR THE ELDERLY OR DISABLED, IT INSPIRED GARDNER TO RESEARCH THE ORIGINAL CONTEST.

Nearly 200 women held the Miss Subways title between 1941 and 1976. They never had to don a swimsuit, play the flute, or tap their way to a crown. They simply posed for a photographer and told an ad-man a little something about their accomplishments, hobbies and aspirations. They were "career girls," but they were also eye candy meant to inspire the daydreams of straphangers during their commutes. Their hopes, on full display, left unanswered questions. What happened to these women? Gardner set out to find and photograph them, embarking on a five-year journey that culminated with this book.

The original portraits were imbued with the glamour of Hollywood starlets, yet the women also seemed somewhat ordinary and approachable, even inviting, sharing tidbits about how they enjoyed skiing or going to the theater. Only the very first Miss Subways, Mona Freeman, became a movie star. Many dreamed of becoming models, actresses and singers, but most quietly returned to their regular lives after their faces were plastered on as many as 14,000 posters seen by nearly 5 million pairs of eyes a day. Along with their fleeting fame, the contest itself faded mostly into oblivion.

Like so much popular culture, Miss Subways posters weren't preserved for posterity. Because there were no records of the contest that spanned 35 years, this project became something greater than the artistic endeavor Gardner originally conceived. It became an effort to recover a lost history of New York and build an archive of stories from winners, who saw great change in the roles women could play in this country since the contest began more

than 70 years ago. Although Miss Subways were singled out for their looks when they were young, this project celebrates them for other accomplishments, big and small, and attempts to bring visibility to older women—a group that often becomes invisible to a certain extent in our obsessive youth culture. "Because you are not seen as the object of desire in the same way, you often don't get heard as an older woman," Gardner says. As she began planning the project, Gardner realized she wanted to do more than capture the images of the women today: She wanted to give them a voice, too, so I became a collaborator, compiling an oral history of the former winners. Having written about the 2004 Ms. Subways contest for a New York City newspaper, I was immediately delighted with the project, and as a native New Yorker I was vaguely familiar with the contest but wanted to know more. We landed a piece in *The New York Times* in 2007 featuring nearly a dozen photos and interview excerpts of the first women we met, and from there the project grew.

There was no master list for the winners, and piecing one together was a painstaking process. Early on, Gardner discovered Ellen's Stardust Diner, a 1950's-retro tourist mecca in Midtown Manhattan run by former Miss Subways Ellen Sturm. Thanks to a series of Miss Subways reunions over three decades, Ellen's boasts the most comprehensive collection of posters there is, plastered over the vinyl booths, along staircase railings and even in the bathrooms. Gardner—a Minnesota-native who landed in New York after attending Columbia for her MFA—was hooked on this slice of city history and often found herself at Ellen's during her

lunch break from her day job as a photo re-toucher for *The New York Times Magazine*. Jotting down names and biographical information such as ages, schools, neighborhoods and professions, she felt as if a door had opened and revealed all these New York women who had strived to make something of themselves. "They were speaking directly to me," Gardner says. As the list grew, we became more and more interested in Miss Subways as a different kind of beauty pageant; unlike others at the time it was progressive and diverse, reflecting the real face of New York.

Using the 70 posters hanging in Ellen's Diner as a starting point, Gardner tracked down nearly twice as many more, digitally restoring them to pristine condition. There are 146 posters reprinted in this book along with personal histories of 41 Miss Subways, as told by the women themselves and, in two cases, by daughters speaking on behalf of mothers unable to speak for health reasons. We also include the Broadway star, Sono Osato, who originated the role of "Miss Turnstiles" in the famed 1944 musical "On the Town," a role based on Miss Subways.

Though Gardner is trained as an artist, she became something of a sleuth in service to this project. She found Miss Subways by combing through local newspapers on microfiche at the New York Public Library since columnists would sometimes voice their approval for the winners. She found model release forms for a four-year chunk of the contest at an archive based at Duke University. She went to voter registration offices in New York to find voter records in the hopes of getting leads for addresses. She wrote to college alumni offices. She went to a local police precinct in hopes of finding a lead for one Miss Subways who made headlines after her reign for allegedly stabbing her boyfriend. Gardner scoured obituary notices to find relatives who might know where the old posters were. She even enlisted the help of a professional private eye, Charles Eric Gordon, a Sherlock Holmes-like character, who helped us locate Marcia Hocker, a 1975 Miss Subways who had lived with her diplomat husband in Colombia and New Zealand before settling in Portland, Oregon.

Making the search more difficult, many of the winners got married and changed their names, and many left New York City after their stints as Miss Subways. The personal histories of Miss Subways echoed larger shifts in migration patterns of New Yorkers as many women left behind their working-class outer-borough neighborhoods for the suburbs—at the same time the subway system and other city services were falling into disrepair. We found many former Miss Subways living in Long Island, West-

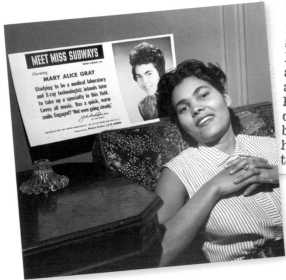

MR. & MRS.

New York's 'Miss Subways' Jailed In Stabbing

Mary Alice Gray, 22-year-old New York model and second Negro named "Miss Subways," stabbed her machinist sweetheart, William Gomez, 27, in his Harlem apartment for "two-timing her" and was arrested on a felonious assault charge. Police said the model visited Gomez, became enraged and stabbed him with a butcher knife following a quarrel with him about an unidentified girl who came to visit him while she was there.

"Miss Subways"

FOLLOWING LEADS After finding old articles that Mary Alice Gray, a 1954 Miss Subways—and the contest's second African American—had a run-in with the law, photographer Fiona Gardner enlisted the local police department, hoping to track her down.

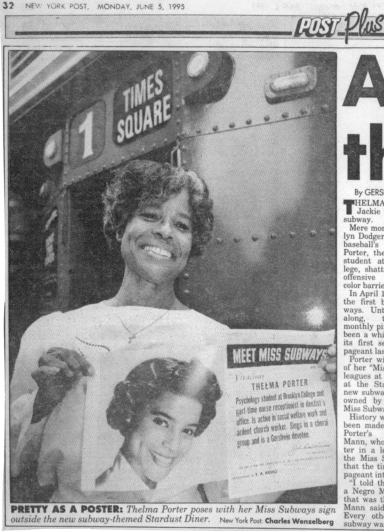

POST Plus

A sign of the times

By GERSH KUNTZMAN

THELMA Porter is the Jackie Robinson of the subway.

Mere months after Brooklyn Dodger Robinson broke baseball's color barrier, Porter, then a 20-year-old student at Brooklyn College, shattered an equally offensive subterranean color barrier.

In April 1948, she became the first black Miss Subways. Until Porter came along, the railroad's monthly pin-up contest had been a whites-only club for its first seven years. The pageant lasted until 1977.

Porter will join about 40 of her "Miss Subways" colleagues at a reunion today at the Stardust Diner, a new subway-themed eatery owned by Ellen Hart (a Miss Subways in 1959).

History would never have been made were it not for Porter's friend Sylvia Mann, who nominated Porter in a letter which told the Miss Subways contest that the time had come for pageant integration.

"I told them they needed a Negro Miss Subways — that was the term I used," Mann said. "They had to. Every other face on the subway was black."

First black Miss Subways recalls breaking the color barrier

But still, the agency that handled the Miss Subways contest dawdled for three years after receiving Mann's letter.

"Naming the first African-American Miss Subways was a big thing for that era," said Transit Museum curator Tom Harrington. "The Board of Transportation did not have a good reputation in race relations."

But in the 1940s, the decade of the Harlem bus boycott, the board realized it not only should hire blacks, but celebrate them.

So Porter got the nod. "I was flabbergasted," Porter said. "I didn't know Sylvia had written to them. And it wasn't as if I was trying to be Miss Subways."

Her "Miss Subways" poster now sounds as dated as the very notion of a color barrier: "Vivacious Thelma Porter. Psychology student at Brooklyn College and part-time nurse reception-

ist in dentist's office. Is active in social welfare work and ardent church worker. Sings in a choral group and is a Gershwin devotee."

But it was more than Porter's good looks or work ethic that got her noticed. Like Robinson, Porter was ultimately chosen because the powers that be felt she could handle the pressure of being the first.

"I had won the Personality Plus, Cover Girl and Miss Victory contests at Eastern District, and Sylvia mentioned them to the committee," Porter said, downplaying her history-making role.

While Robinson faced the taunts of know-nothing fans, Porter met no such hatred.

"There was none," Porter said. "I didn't hear that anyone complained about a black Miss Subways."

The Miss Subways award did earn Porter some modeling work, but she gave it up quickly to become a typist. Life in the glamour set just wasn't her style.

"I felt then, as I do now, that a young woman should get married," said Porter, who wed her high-school sweetheart shortly after her Miss Subways reign.

PRETTY AS A POSTER: *Thelma Porter poses with her Miss Subways sign outside the new subway-themed Stardust Diner.* New York Post: **Charles Wenzelberg**

SEEKING MISS SUBWAYS As the first African American winner, Thelma Porter made history as Miss Subways, reigning at a time when most beauty contests were segregated. Unfortunately, she passed away before we were able to interview her.

chester and New Jersey. Thanks to an artist-in-residency program, we traveled to Florida, where a number of the women have retired. We found others in California, Vermont and Massachusetts. They've settled in Las Vegas and beyond. As might be expected considering the vintage of the contest, many Miss Subways have also passed away, including a few who passed after they posed for Gardner's portraits and some who we weren't able to meet in time. Thelma Porter, the first black Miss Subways from 1948, passed away in Colorado just a few weeks before we were planning to photograph her.

In addition to tracking down women from Ellen's posters, Gardner strove to expand her archive by finding additional posters as well. Since the posters were printed double-sided in the early years—to save printing costs— once Gardner found one woman willing to share her poster, she had a second winner on the other side. One Miss Subways placard turned up on eBay. When Gardner was outbid by a nostalgia buff in Pennsylvania, he kindly let her borrow the poster and scan it when he came on a trip to New York. Some children and grandchildren of former winners provided posters after seeing the project's Face-

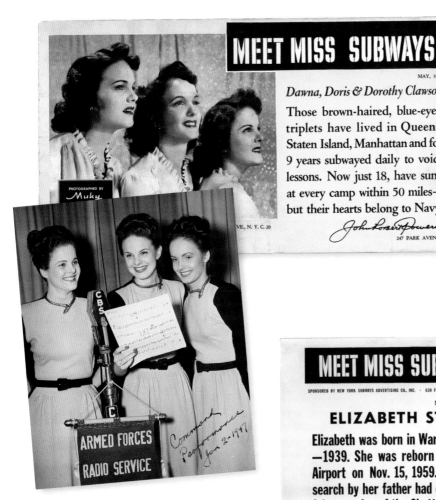

MEET MISS SUBWAYS

MAY, 1944

Dawna, Doris & Dorothy Clawson

Those brown-haired, blue-eyed triplets have lived in Queens, Staten Island, Manhattan and for 9 years subwayed daily to voice lessons. Now just 18, have sung at every camp within 50 miles—but their hearts belong to Navy.

John Robert Powers

247 PARK AVENUE

POSTER SECRETS

A Facebook post from a relative revealed that the Clawsons were not triplets as their poster declared, but instead twins and an older sister. By contrast, Elizabeth Stern's son may never have known about her Jewish heritage if not for the text on her poster.

MEET MISS SUBWAYS

SPONSORED BY NEW YORK SUBWAYS ADVERTISING CO., INC. · 630 FIFTH AVENUE, NEW YORK 20, N.Y.

SEPTEMBER-OCTOBER 1960

ELIZABETH STERN

Elizabeth was born in Warsaw, Poland —1939. She was reborn at Idlewild Airport on Nov. 15, 1959. A 20 year search by her father had ended. Painful memories of the Ghetto, a war and a long separation would fade. For now, Elizabeth has a father.

Photographed by Michael Barbero

book page and provided additional background. Through Facebook, for instance, Gardner learned that Dawna, Doris and Dorothy Clawson, winners in May 1944, were not triplets as their poster said, but twins and an older sister. A granddaughter of one of the sisters—all three of whom have passed away—said they called themselves triplets as a showbiz gimmick.

In other cases, the later generations learned new information about mothers or grandmothers through the posters. Gardner connected with the son of a former Miss Subways from September and October 1960, whose poster

named her as Elizabeth Stern and said she was born in Poland in 1939, "reborn" in New York in 1959, and reunited with her father after 20 years. "Painful memories of the Ghetto, a war," the poster said, implying how the Holocaust tore apart her family. Elizabeth was taken in by a Catholic Polish family and raised her son Catholic, too. He never knew about his mother's childhood or that she was Jewish until reading the poster.

While we have done our best to construct a complete archive of all the Miss Subways in the appendix of this book, the portraits and stories are by no means complete.

We were not able to visit and photograph all of the women we tracked down. Others who claimed to have been Miss Subways were not included here if they did not have a poster. The Miss Subways featured in this book were the ones who opened their arms and agreed to participate. Like those who go to their high school or college reunions, it may be a bit of a self-selecting group of those willing to put their lives on display. They graciously invited us into their homes and opened up old photo albums—which sometimes

as the landscape for working women evolved. Several saw early marriages dissolve, sometimes because careers became more consuming. For those who were encouraged to get married instead of going to college, several ended up going back to school later in life. And now as they've entered middle age and beyond, many have suffered deep personal losses of husbands or children. Some have had cancer or heart attacks. They are caring for ill husbands or elderly mothers, or being cared for themselves.

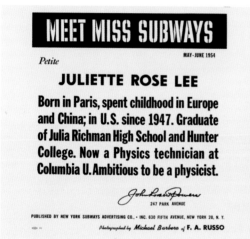

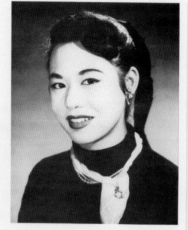

MEET MISS SUBWAYS

Petite

MAY-JUNE 1954

JULIETTE ROSE LEE

Born in Paris, spent childhood in Europe and China; in U.S. since 1947. Graduate of Julia Richman High School and Hunter College. Now a Physics technician at Columbia U. Ambitious to be a physicist.

John Law Powers
247 PARK AVENUE

PUBLISHED BY NEW YORK SUBWAYS ADVERTISING CO., • INC. 630 FIFTH AVENUE, NEW YORK 20, N. Y.

Photographed by Michael Barbero of F. A. RUSSO

PAGING DR. LEE After reading a blurb by the gossip columnist Walter Winchell, Fiona Gardner sent a letter to a Juliette Rose Lee to a New York address she tracked down. Nearly two years later, the physicist emailed from where she now lives in Italy. She was the second known Chinese winner.

Gardner sent out hundreds of letters to find these women—she had up to 10 possible addresses for certain names—and more than half were returned. But letter writing did unearth some Miss Subways included here. After reading a May 1954 blurb by the famous gossip columnist Walter Winchell, Gardner learned that a woman named Juliette Rose Lee had won that month and sent a letter to a possible New York address. Two years later a Juliette Rose Lee Francini emailed from Italy, where she works as a physicist. She was the second known Asian Miss Subways, after Helen Lee,

hadn't been touched in years. They kindly shared these pieces of their past with us and allowed us to publish many gorgeous images from their glory days of modeling or from photo ops while they were Miss Subways or winners of other contests. They were often touched that two women, both born the year the Miss Subways contest ended, would be interested in their lives and a contest that had long lost its currency. "In some ways I feel like I got a lot of grand-mothers out of this process," Gardner says of the women who have posed for her for hours at a time and have remained in her life over the years since the project began.

As we got to know these women, we found common threads whether they were Miss Subways in the 1940s or in the 1970s. Many faced difficult choices between family life and careers, often opting out of work to raise children and then struggling to find careers as their children got older or

and may have been a fairly enlightened selection for a beauty contest run by an advertising agency in that era. But Winchell did not write about it from that perspective. "The current Miss Subways is Juliette Rose Lee, a china doll, most tempting Chinese dish this side of chop suey." Winchell's commentary doesn't come as a surprise, but Gardner found it interesting that a famous newspaperman reduced the aspiring physicist, with a job at Columbia to boot, as an exotic object. "All of his praise is really about her physical appearance," Gardner says. "I think it just gives you a sense of what women were up against in a lot of ways."

In our portraits—both the photos and the inter-views—we wanted to show a different side than the original contest, which was conceived by ad men and focused on the promise of youth. It can't be denied that there is a voyeuristic experience of seeing the new por-

traits alongside the old posters and other photos from the women's private collections. Viewers can't help but be drawn into comparing the faces on the original posters, which so perfectly captured that buoyant moment of youthful possibility, with those in Gardner's contemplative works. In contrast to the original portraits, we wanted to celebrate the women in their own surroundings, in their living rooms, bedrooms and workplaces. Yes, there are even a few poolside shots, echoing the long gone days of bathing beauties, but they display the full ordinariness of current life rather than mimic the sparkling cover-girl days some of the women had. Rather than the pithy, clever posters conceived by copy writers, we share their stories in their own words, reflecting on what the contest meant to them and where they've since landed. Gardner's images lay bare the aging process; my interviews celebrate life having been lived, paths taken—or not. And just as we learned that sometimes the winners provided truthful accounts for their posters, and sometimes fictitious ones, in these stories here too, we recognize that memory is flexible and that the women each chose what to share and how to portray themselves.

Gardner has found in the art world, just like in other realms of commerce, more credence is given to the celebration of youth than to the exposure of the aging process. "Many fine art photographers are caught up in youth and this age of innocence and possibility and a certain kind of abandonment and female bodies as a space of desire and all those kinds of things," Gardner says. "The truth of the matter is that beauty is something that sells or that perception of beauty is what sells." Her work has often focused on women, aging and performance. She has photographed Southern belles, female entertainers at roadside attractions and former mermaids, some in their 80s, still performing occasionally at Florida's Weeki Wachee Springs, an entertainment venue that has been operating since the late 1940s. "I think from a visual or physical standpoint there is

IN OUR PORTRAITS— BOTH THE PHOTOS AND THE INTERVIEWS— WE WANTED TO SHOW A DIFFERENT SIDE THAN THE ORIGINAL CONTEST, WHICH WAS CONCEIVED BY AD MEN AND FOCUSED ON THE PROMISE OF YOUTH.

something beautiful about seeing somebody who has gone through some things," she says. "It's about the story told rather than the beginning of a journey."

To create her richly detailed, methodically constructed portraits, Gardner still shoots on film with her Hasselblad camera—a care for craft and technique that is a holdover from her days as a painter. She borrows the language and lighting of a film set and wraps each woman in a "Miss Subways" sash, referencing the common beauty pageant prop. The font and colors on the sashes are based on the typography of the women's original posters—a visual link between past and present. Many of the women hold flowers, another reference to the world of beauty pageants and a symbol of youth. These props become Gardner's stage. "The portrait is the performance," she says. "My work is on the edge between documentary and constructed traditions in photography. I see my process as a documentation of a specific moment, collaboration with my subjects, as well as a heightened reality."

The artifice that runs through the portraits has confounded some viewers unfamiliar with the contest. When 10 works from the series were on display in April 2008 at Rush Arts, a gallery in Manhattan's Chelsea district, many of the space's regular audience thought the project was an elaborate fabrication. Perhaps they thought it was a conceptual commentary on women and aging because the actual topic is so often kept under wraps. Indeed, the point of Gardner's work is not to create a conceptual piece, but to strive for work that provides points of entry for a wide audience—a more democratic space in the art world, much like the subway itself. This show also traveled to the City Reliquary, a nonprofit community museum in the trendy neighborhood of Williamsburg, Brooklyn where, in November 2009, the organization held its own quirky version of the contest. It sponsored a Miss G Train pageant, celebrating the much-maligned New York City subway line that runs through Brooklyn and Queens

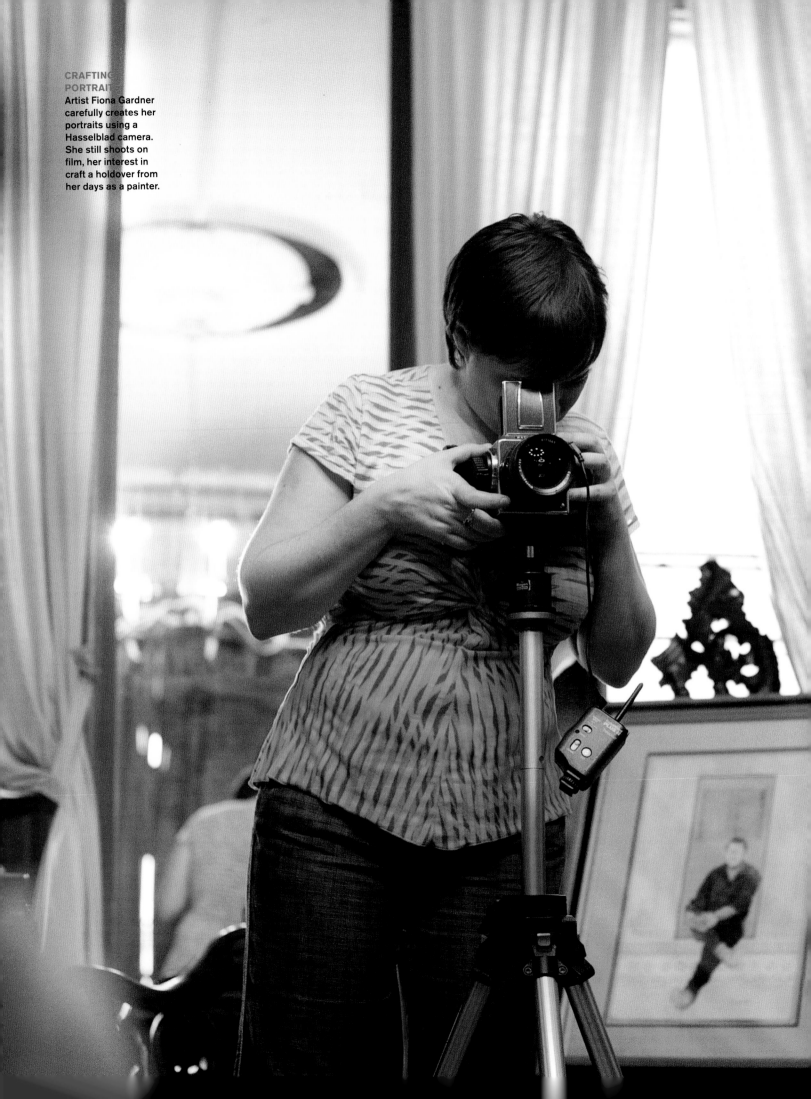

CRAFTING A
PORTRAIT
Artist Fiona Gardner
carefully creates her
portraits using a
Hasselblad camera.
She still shoots on
film, her interest in
craft a holdover from
her days as a painter.

but does not go into Manhattan. Unlike the real Miss Subways, the City Reliquary's G Train contest, where Fiona was one of the judges, was tongue-in-cheek, with an essay contest and talent competition that included a hula hoop performer, a drag queen playing classical violin and a contestant demonstrating how to make a perfect gimlet.

The publication of this book in November 2012 coincides with a major exhibition of our Miss Subways project at the New York Transit Museum in Brooklyn Heights, which is the largest museum in the United States dedicated to urban public transportation history. The book and the

MISS G TRAIN In conjunction with an exhibition of Miss Subways portraits at their non-profit gallery, the City Reliquary in Williamsburg, Brooklyn, hosted a cheeky beauty pageant of their own, celebrating the much-maligned train that runs between Brooklyn and Queens.

show commemorate this contest, which just celebrated the 70th anniversary of its launch, and the women whose ordinary lives were touched, at times in profound ways or sometimes just ever so slightly, by an invisible beauty queen crown ruling over the world's largest transit system. There are, of course, many New Yorkers who still remember seeing Miss Subways on trains and buses across the Big Apple. But with a younger generation unfamiliar with this piece of New York history, tracking down its winners and their stories gives the contest a new platform. The former Miss Subways are riding another moment of celebrity. In some ways, however, the project is not complete. There are still Miss Subways winners, whose names and once smiling fresh faces—at least for the moment—remain lost in the dustbin of transit history.

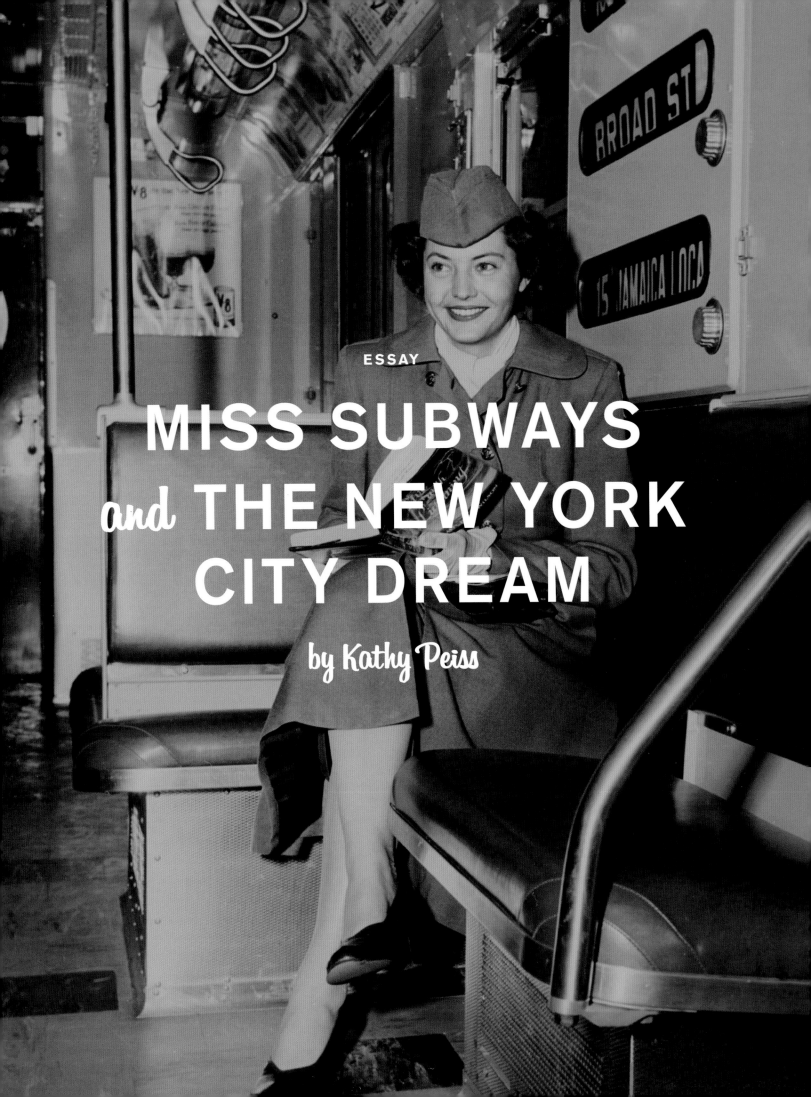

ESSAY

MISS SUBWAYS and THE NEW YORK CITY DREAM

by Kathy Peiss

"LOOK AROUND THIS CAR! NEXT MONTH'S SELECTION MAY BE RIDING WITH YOU." IN SPRING 1941, NEW YORKERS ON THEIR DAILY COMMUTE BEGAN TO SEE A NEW PASSENGER AMONGST THEM. "MEET MISS SUBWAYS," THE PLACARDS INVITED STRAPHANGERS ON THE IRT AND OTHER LINES. FOR THIRTY-FIVE YEARS, NEW YORKERS, HURTLING UNDERGROUND TO WORK OR PLAY, COULD RAISE THEIR EYES ABOVE THE CROWDS AND GAZE UPON AN ATTRACTIVE YOUNG WOMAN, SMILING WITH EQUANIMITY, ACCOMPANIED BY A BRIEF DESCRIPTION OF HER WORK AND PASTIMES.

Although millions of New Yorkers saw her face and read her story day after day, this beauty contest has nevertheless faded into obscurity. New Yorkers of a certain age may nod knowingly, a memory distantly recalled. Classic movie fans might summon up Miss Turnstiles, the object of Gene Kelly's desire in the 1949 musical film "On the Town." Still, in a city whose history is dominated by outsized figures and masses of striving migrants, Miss Subways is easily forgotten. In history books, documentaries, and even the definitive *Encyclopedia of New York City,* she receives nary a footnote. Why should we care about this beauty contest now? Miss Subways opens to view hidden histories of everyday life in New York that touch upon the changing ideals and aspirations of women, the struggle for civil rights, and the rise of a modern culture of beauty, consumption, fashion, and image-making. These are, in fact, significant themes in the annals of New York and America's history.

Although it sprang up in the months before the U.S. entered World War II, the Miss Subways contest could trace its lineage deep into the American past. Beauty contests originated in the traditions of rural festivals, market fairs, and holy day rituals, in such customs as the crowning of May Queens or the Queen of Carnival during Mardi Gras. In the early 1800s, classical ideals of feminine beauty came to symbolize American freedom and civic virtue, and pretty young women might be featured at national celebrations and local fairs. The modern beauty contest, however, typically had a commercial imperative. Indeed, it was the consummate pitchman of the nineteenth century, P. T. Barnum, who is credited with the first attempt to hold a formal beauty contest in the United States, in 1854, in order to attract more customers to his dime museum. However, proper ladies of that era refused to line up and display themselves before an audience of judges, and the only applicants seemed to be disreputable women. Barnum compromised by hanging photographs of good-looking women for the competition. This approach became quite common by the early 1900s, with organizations calling for

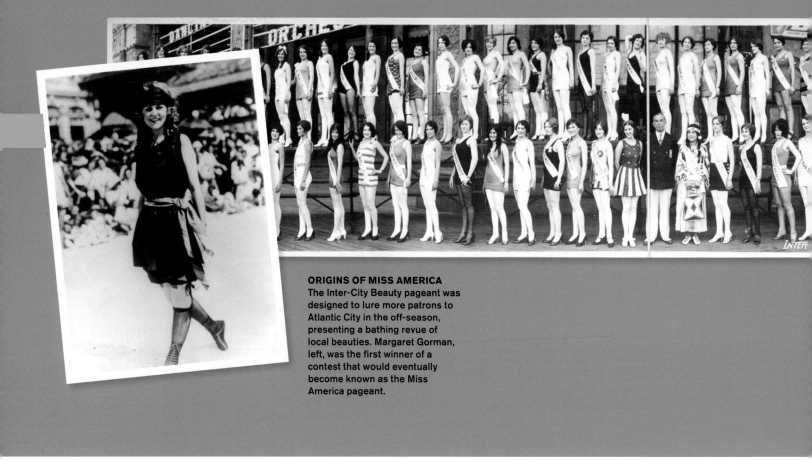

ORIGINS OF MISS AMERICA
The Inter-City Beauty pageant was designed to lure more patrons to Atlantic City in the off-season, presenting a bathing revue of local beauties. Margaret Gorman, left, was the first winner of a contest that would eventually become known as the Miss America pageant.

the submission of photographs and sometimes urging the public to vote for the most attractive. Evaluating a visual image at one remove from the living body made beauty contests more respectable.

By the early twentieth century, such Victorian strictures on female propriety and public display had loosened. Billboards, theatrical posters, and advertising cards featured smiling women in flirtatious poses, poised to entice consumers. Motion pictures projected close-up views of glamorous faces and shapely bodies, as women's magazines, advice columnists, and a nascent cosmetics industry sold the idea that all women had the right to be beautiful, and could achieve beauty, if only they bought the right products. Women began to shed their corsets, hemlines began to rise, and fashions revealed the body's curves and limbs. At such seaside resorts as Atlantic City and Coney Island, long bathing costumes gave way to more revealing swimwear.

Social attitudes had changed sufficiently that in 1921 Atlantic City promoters, looking for new ways to attract

visitors and extend the season into the fall, ran the "Inter-City Beauty Contest." Women representing various localities paraded on the boardwalk and appeared in a bathing beauty revue. Sixteen-year-old Margaret Gorman, with curly bobbed hair and swimsuit, won. With a few interruptions, this contest became the annual Miss America pageant. Despite changing social mores about the display of women's bodies, beauty contests often found themselves on the defensive, fighting accusations of tawdriness and sexual shenanigans. As the Miss America pageant grew in the 1930s, the organizers strictly policed the entrants' marital status and social life, insisting on their virtue, while displaying their bodies to the public. In 1945, they initiated an educational scholarship program to attract reputable and talented contestants. The idea that ambitious women would use their looks to further opportunities—not only in modeling, singing, and acting but in pursuit of less traditional careers—was a formula that would continue to the present day.

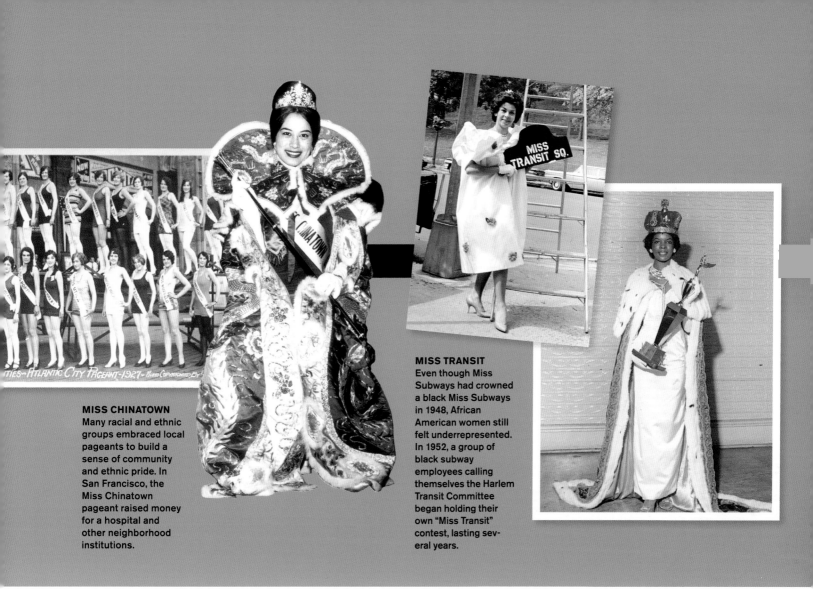

MISS CHINATOWN
Many racial and ethnic groups embraced local pageants to build a sense of community and ethnic pride. In San Francisco, the Miss Chinatown pageant raised money for a hospital and other neighborhood institutions.

MISS TRANSIT
Even though Miss Subways had crowned a black Miss Subways in 1948, African American women still felt underrepresented. In 1952, a group of black subway employees calling themselves the Harlem Transit Committee began holding their own "Miss Transit" contest, lasting several years.

The success of Miss America gave rise to a host of other large-scale beauty contests, especially after World War II, including Miss U.S.A. and America's Junior Miss, along with international pageants such as Miss World and Miss Universe. These became enormous undertakings, run with military precision. An elaborate structure of "feeder" pageants, held at the town, county, and state levels, supplied the prominent national and international pageants and involved hundreds of organizers and contestants each year. Commercial sponsorship, which began with local chambers of commerce and swimsuit manufacturers, exploded when television began broadcasting the big pageants in the 1950s. By mid-century, beauty pageants had become a big business and media presence.

The spectacle of these large-scale pageants overshadowed what were, in fact, the most common types of beauty contest, which were intensely local. In the 1920s, crowning beauty queens increasingly became a culminating event at county fairs and commercial expositions. They also became an occasion for different racial and ethnic groups to express a sense of community and identity. Such newspapers as the *Baltimore Afro-American, Pittsburgh Courier,* and *Chicago Defender* sponsored beauty contests by inviting readers to send in photographs of women, and publishing the most vivacious, accomplished, and best-looking among them. African American business associations, intercollegiate groups, and fraternal societies regularly ran beauty contests in such well-known venues as the Savoy Ballroom in Harlem, but also in church basements, YMCAs, and high school gyms. Local "Miss Sepias" and "Miss Bronzevilles" were a matter of racial pride. Chinese Americans also embraced these competitions; in San Francisco, a Miss Chinatown pageant, originating in the 1920s, raised money for a hospital and other community institutions.

Miss Subways followed the pattern of the local contests, yet became a uniquely New York phenomenon. It began as an initiative of the New York Subways Advertising

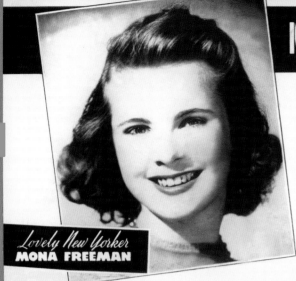

MEET MISS SUBWAYS

of MAY, 1941
selected by JOHN ROBERT POWERS
Famous Beauty Authority

Attending high school, vivacious Mona Freeman writes for her school paper, lives in Pelham. Her ambition is to be a top notch magazine illustrator. She's interested in school dramatics. Broadway and Hollywood please note!

Each month Mr. Powers selects Miss Subways from among those who use the greatest transportation system in the world. Look around this car. Next month's selection may be riding with you.

Lovely New Yorker **MONA FREEMAN**

JOHN ROBERT POWERS
This modeling agency pioneer was tasked with the talent search for the Miss Subways contest. While he had scouts in the city and invited photo submissions, Powers picked many of the girls himself—including Mona Freeman, the very first Miss Subways.

Company, which came into existence in 1940, gaining exclusive rights to sell ad space in the subways and elevated trains. The firm intended "Meet Miss Subways" to draw attention to other subway advertising posters and ultimately increase ad revenue. "There's plenty of time to read them," one wartime squib noted, "because the average ride is 23½ minutes." Transit and outdoor advertising was already a well-established business, and from the early twentieth century, subways featured public service announcements, publicity for the subway system, and ads for department stores and consumer goods.

The company enlisted John Robert Powers, a pioneer of the commercial modeling agency beginning in the 1920s, to run the Miss Subways contest. Powers himself chose the early Miss Subways, sometimes with the serendipity of a Hollywood film. The story was that he would walk up to women on the street, tell them they were beautiful and that they must become Miss Subways. One was a manicurist at the Waldorf when Powers came in to get his nails done;

before she knew it, her image graced 9,000 subway cards. Another worked as a sales clerk in Alexander's when a Powers employee approached her about the contest. New Yorkers flooded Powers' office with photographs of potential Miss Subways as well. By the early 1960s, Powers was out, and the public took more of a hand in making the selections by voting for their favorite finalists. Family and friends were mobilized in support as can be seen in Marcia Kilpatrick's effort to become Miss Subways in 1974. Kilpatrick, who worked for Off-Track Betting, not only distributed postcard ballots to her union local, but enlisted her entire family to hand them out where they worked or knew people, including the garment district, Wall Street, her policeman-father's old beat, and a law office.

"Meet Miss Subways" quickly caught the attention and imagination of the millions of New Yorkers who rode underground each day. Like all Americans, they were bombarded with glamorous beauty images in advertising, magazines, and movies. At home, in the workplace, and

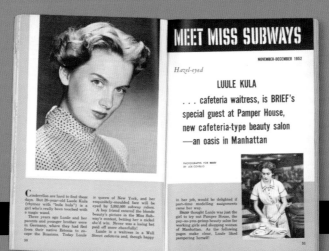

WHAT IS MOST STRIKING ABOUT MISS SUBWAYS, IN THIS CONTEXT, IS HOW MUCH SHE CLOSED THE GAP BETWEEN IDEALIZED BEAUTY AND REAL WOMEN.

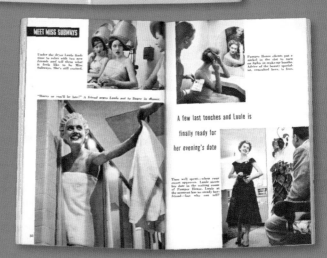

at school, the message went out that a well-groomed and lovely appearance was essential for women's success in marriage and employment. The term "body image," coined by psychologist Paul Schilder in 1934, came to be understood as an internalized mirror, enabling self-scrutiny and self-assessment.

What is most striking about Miss Subways, in this context, is how much she closed the gap between idealized beauty and real women. Unlike commercial models posing anonymously in advertisements, Miss Subways offered a personal story. To the straphangers, she seemed a representative of the city: she, too, rode the subways, worked for a living or went to school, and had dreams of making something of herself. Powers made it clear he wanted "no glamour gal types or hand-painted masterpieces." The seeming ordinariness of Miss Subways made her accessible, an image possessed by every New Yorker.

That very familiarity made Miss Subways a target of African American civil rights activists. In a city of such great diversity, why was Miss Subways white? Beauty contests are trivial in many ways, but they convey a serious underlying message about social inclusion and exclusion. Beauty queens express group norms and represent communal identities. In the early decades of the twentieth century, when racial segregation was rampant, immigrants excluded from the country, and eugenic ideas of "racial betterment" were widespread, beauty contests frequently tied female beauty to the affirmation of white identity. The Miss America pageant, notoriously, had a written rule that "contestants must be of good health and of the white race." The power of prejudice went beyond formal rules: only a narrow range of facial features and body types qualified a woman to compete. Biography mattered too, so that women who were manifestly "ethnic" made little progress in the competition. The 1940s saw a glimmer of change—Asian and Hispanic contestants from Hawaii and Puerto Rico respectively, a Native-American Miss Oklahoma, and, most notably, Bess Myerson, the only Jewish Miss America,

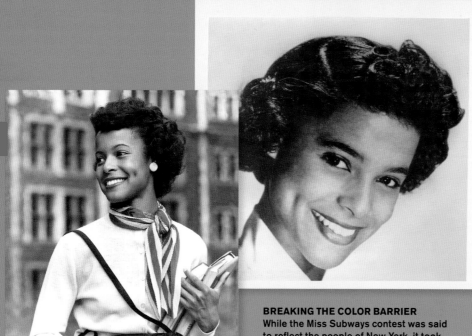

MEET MISS SUBWAYS

APRIL 1948

Vivacious
THELMA PORTER

Psychology student at Brooklyn College and part-time nurse receptionist in dentist's office. Is active in social welfare work and ardent church worker. Sings in a choral group and is a Gershwin devotee.

John Robert Powers
247 PARK AVENUE

PUBLISHED BY NEW YORK SUBWAYS ADVTG. CO., INC. • 630 FIFTH AVENUE, NEW YORK 20, N. Y.

PHOTOGRAPHED BY **F. A. RUSSO**

BREAKING THE COLOR BARRIER
While the Miss Subways contest was said to reflect the people of New York, it took a behind the scenes campaign to crown the first black winner, Thelma Porter, in 1948. (Opposite page) When she was named Miss Subways, Thelma appeared on the cover of the NAACP's journal, *The Crisis.*

crowned in 1945. Until recent decades, however, Miss America barely deviated from a racially and ethnically specific vision of loveliness. Despite years of pressure from civil rights organizations, it was not until 1970 that the first African American state winner appeared in the televised pageant and 1984 when Vanessa Williams was crowned Miss America.

As the Great Depression gave way to wartime mobilization, African Americans increasingly demanded job opportunities, full citizenship, and recognition of their human dignity. They called it the Double V campaign, for victory against fascism abroad and segregation at home. One part of this effort was to call attention to demeaning racist images and African Americans' exclusion from the social and cultural rituals that made up what was called the "American way of life." The black press continually condemned the treatment of African Americans in movies, in concert halls, and on the playing field, and they attacked the 1939 World's Fair organizers for excluding

African American scientific and artistic achievements from the "World of Tomorrow." Civil rights leaders and ordinary African Americans alike recognized how a burgeoning visual culture, from commercial advertising to photo-journalism, celebrated the experiences of white Americans and, in doing so, upheld racial segregation.

African Americans instantly paid attention to Powers's choice of Miss Subways—all of them white. "Harlem's younger female set is mad as hell about the implied insult to them in the subway cars," wrote *New York Amsterdam News* columnist Dan Burley in 1942. Black newspapers, including the *Amsterdam News* and the *People's Voice,* campaigned to get Powers to choose an African American Miss Subways. Columnist Bill Chase called on readers to flood the Powers modeling agency with recommendations of beautiful young women, urging that their complexions be dark enough "so that there'll be no question in the minds of subwayites as to their true racial identity." The *Chicago Defender* reported that Powers' scouts had actually

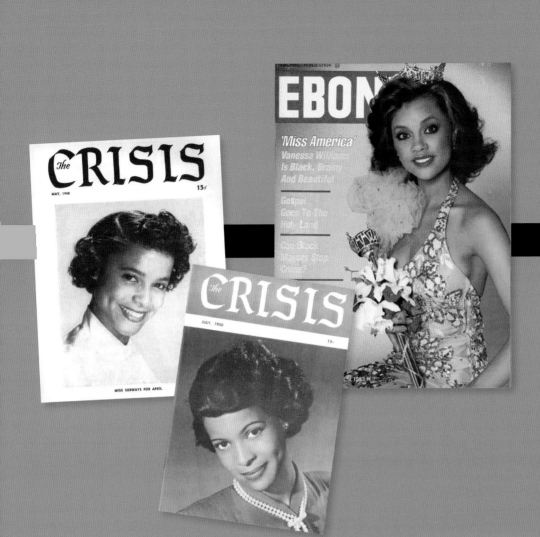

AFRICAN AMERICANS INSTANTLY PAID ATTENTION TO POWERS'S CHOICE OF MISS SUBWAYS—ALL OF THEM WHITE.

selected a young African American woman on the subway and told her to appear at his office, but she failed to show up: "Little did they know she was colored, working downtown, and passing." Groups from the Abyssianian College Club to the Harlem Youth Center, sponsored by the left-wing American Youth for Democracy, held events to select African American candidates for Miss Subways and submitted them to the Powers agency. In 1944 Powers even seemed to make a commitment to choose one of the "sepia lassies" as the first "Miss Negro Subways" but then backed away.

Earl Conrad, writing for the *Defender,* sought an interview with Powers, telling him he promoted "a certain stereotyped, chisel-featured, pink beauty" that "caused many a negro girl (and many a white girl) to feel that she was just out of the running where current projected national standards of beauty are concerned." Although the modeling agent believed that World War II would generate more expansive beauty ideals, as American servicemen met women from around the world, he gave no evidence of understanding that his choice of models was not simply aesthetic, but had political implications. Conrad concluded, however, that Powers "unwittingly does more to project the notions of white supremacy in this country than most Southern Congressmen do consciously."

The campaign for an African American Miss Subways, occurring below the radar of most white New Yorkers, came to fruition in April 1948, decades before the first black woman was crowned Miss America. A month earlier, the Hillbillies—an exclusive (and ironically named) club of black professional women and society leaders—confronted Powers, New York City Mayor William O'Dwyer, and the Board of Transportation, who quickly gave in. Thelma Porter was in many ways a typical Miss Subways—a nineteen-year-old psychology major at Brooklyn College, part-time nurse receptionist in a dentist's office, "active in social welfare work and ardent church worker." Good looks, a big smile, sparkling eyes, and neatly waved hair, she looked the part—except that she was the president of the

MISS SUBWAYS REFLECTED THE RANGE OF WARTIME ROLES FOR WOMEN, AS WELL AS THE ESPRIT AND ENERGY SO MANY WOMEN FELT AS THEY CONTRIBUTED TO THE DRIVE FOR VICTORY.

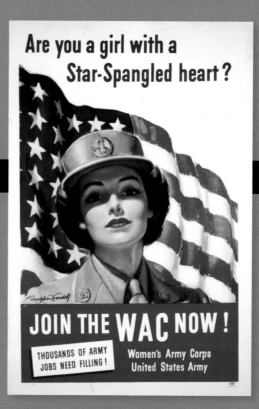

Are you a girl with a Star-Spangled heart?

JOIN THE WAC NOW !

THOUSANDS OF ARMY JOBS NEED FILLING !

Women's Army Corps United States Army

WAC
In contrast to the popular "pin up girls" of the 1940s, wartime also offered images of women serving their country in new roles and many of the early Miss Subways highlighted their World War II-related jobs.

Brooklyn Youth Council, involved with the NAACP, and, when she was named Miss Subways, appeared on the cover of the organization's journal *The Crisis.* The Hillbillies presented Porter at a reception in her honor, where she was photographed with civil rights leaders Thurgood Marshall and William H. Hastie. She was no accidental vehicle of social change.

First appearing in the months before Pearl Harbor, Miss Subways was affected by the mobilization of women for war. Whether older Rosie the Riveters or beauties with bright red lipstick, women held wrenches and welding torches, found ways to conserve food, textiles and other wartime material, and served in local civil defense activities. Propaganda films, posters, magazine covers and advertising were filled with such images. "Pin up" photographs, in which wholesome "girl next door" types appeared in cheesecake poses, also became a popular phenomenon. But there were also events like "Miss Victory," a city-wide contest of defense plant workers

sponsored by a New York newspaper; this was not a beauty contest, but rather honored the "growing army of women who are giving this war effort their best."

Miss Subways struck a similar chord. They were often working women, laboring not only as "business girls" but also in industrial jobs. Stella Mikrut, a Miss Subways in 1942, worked at Sperry Gyroscope and also posed for a war bond drive. Peggy Healy was "chosen Pin-up Girl of the defense plant where she works." Another Sperry worker, Rosemary Gregory, had "studied ballet, but feels her war work the most important thing now." Miss Subways reflected the range of wartime roles for women, as well as the esprit and energy so many women felt as they contributed to the drive for victory.

The combination of good looks, personality, and the P.R. agent's wit that created each woman's short biography—whether factual or fictive—made Miss Subways an appealing representative of a self-aware metropolis. It is no wonder that Betty Comden and Adolph Green,

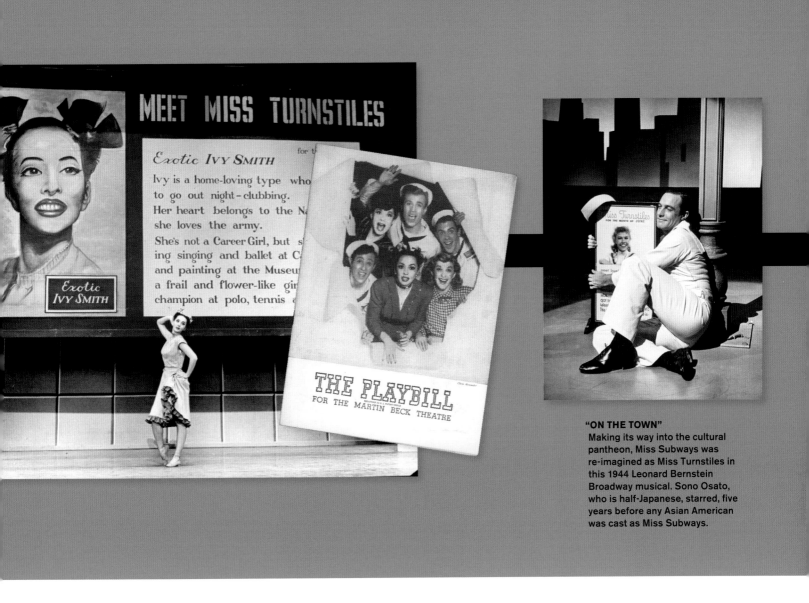

"ON THE TOWN"
Making its way into the cultural pantheon, Miss Subways was re-imagined as Miss Turnstiles in this 1944 Leonard Bernstein Broadway musical. Sono Osato, who is half-Japanese, starred, five years before any Asian American was cast as Miss Subways.

when writing "On the Town" in 1944, poked fun at the contest when they made Miss Turnstiles a hoochie coochie dancer on Coney Island. "A home-loving type who loves to go out night-clubbing," her subway card read, "her heart belongs to the Navy, but she loves the army." On stage Miss Turnstiles was played by Sono Osato, acclaimed for her performance and looks; *The New York Times* theater critic had no trouble imagining her off Broadway, saying "any day now, her picture will be in the trains as Miss Subways." In a sense, she broke the racial and ethnic barrier as Miss Turnstiles, five years before the first Asian American Miss Subways was chosen. Here again New Yorkers were deemed readier for a more expansive definition of beauty than the rest of the United States: the film version of the musical starred white dancer and actress Vera-Ellen.

Although the novelty of the contest wore off, Miss Subways continued on through the 1950s and 1960s. She appeared in fashion shows, received marriage proposals, and was, for a brief time, a local celebrity. Among the many Miss Subways were those who dreamed of modeling and Hollywood, and others who had "hopes for the right man and a family." Yet over the months and years, straphangers would see college students, women in the armed forces, nurses, educators, and a number who were undaunted by the challenge of the law or other professions dominated by men. To a surprising degree for mid-century America, Miss Subways revealed young women who faced the future with a complex mix of ambitions and hopes.

The contest tried to keep up with the times, including a heavy-handed dose of hip language in Miss Subways' biography—a "'Now Yorker," said one, "an altogether person." But the times irrevocably changed. The feminist movement of the late 1960s and 1970s attacked the culture of beauty, fashion, and femininity that dominated women's consciousness and limited their horizons. Women's liberationists picketed the Miss America pageant in Atlantic City in 1968 and 1969; indeed, the derogatory label "bra-burner" originated in these protests, in which

MEET MISS SUBWAYS

BRA BURNER
In 1968 and 1969, women's liberationists picketed the Miss America pageant, filling trashcans with bras and giving us the term "bra burner."

TOKEN WOMEN
With the rise of feminism, Miss Subways hit the skids in 1976 as beauty pageants became ridiculed for treating women as objects.

trashcans were filled with the accoutrements of feminine appearance—although not set on fire. The new feminist consciousness rendered Miss Subways an anachronism, not a symbol of ordinary women's aspirations. "Token Women," *New York* magazine called Miss Subways in 1976. Moreover, a subway system riddled with crime, filth, and graffiti came to epitomize New York's financial crisis of the late 1970s and the decline of civic life. Insults and obscenities defaced Miss Subways' photographs. While the winners once received marriage proposals, now they were targets of sexual harassers and stalkers.

After their posters were taken down, what happened to Miss Subways? According to the Subways Advertising Company in the 1950s, "99 per cent of them resume[d] their hum-drum lives." As this book demonstrates, however, the subway placards represent a moment in time, a snapshot of lives lived, sometimes according to the trajectory imagined by the winners, but often taking very different and fascinating directions.

Looking back, we can see that Miss Subways staked a humble claim for women's aspirations and public presence, and for the idea that beauty could be found in the appearance and individuality of women in all walks of life, in the diversity of the city. If beauty contests offer symbols that represent the ideals of a community, Miss Subways was the true New Yorker. She reigned over a mode of transportation that is itself a kind of everyday democracy, a place of jostling interaction, but also a place of dreams, in which sundry travelers move about the boroughs, anticipating work, play, and the myriad activities of this urban beehive. For weary straphangers, Miss Subways' sunny look invited a moment's reflection: Here was the "everywoman," a girl who rode the subways too and promised to make something of herself. If Lady Liberty's impassive face beckons all to New York, for over three decades Miss Subways, each with her own hopes and desires, watched over this domain, and helped make real the city of inclusion and aspiration. Meet Miss Subways: She is worth getting to know.

21

TICKET TO FAME
(Right) New York's "prettiest strap-hangers relax on the white sand at Jones Beach," according to a *Collier's* Magazine spread from September 1943 that featured some of the early Miss Subways winners in bathing beauty mode. (Below) Anne Peregrim became the center of attention as Miss Subways 1950.

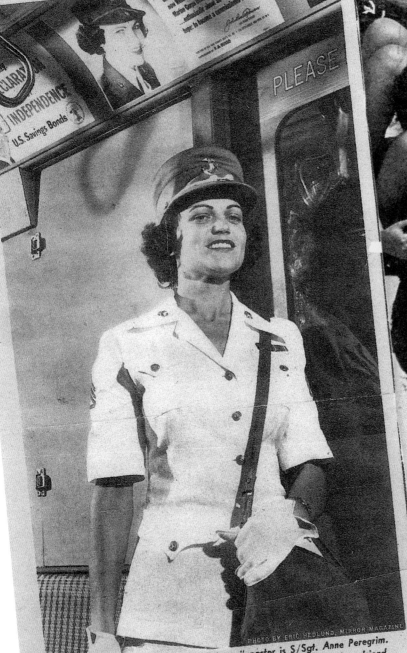

She Wanted to See the World But the World Saw Her Instead

PLEASE

INDEPENDENCE
U.S. Savings Bonds

PHOTO BY ERIC HEDLUND, MIRROR MAGAZINE

Smiling at herself from a "Miss Subways" poster is S/Sgt. Anne Peregrim. Anne was chosen subway beauty-of-the-month from photo sent in by a friend.

BACK IN 1945, when Anne Peregrim left Blakeley, Pennsylvania, to enlist in the United States Marine Corps, she did so for two reasons: (1) patriotism (2) to see the world. So far, Anne—now better known as ... hasn't seen

Marine sergeant being selected as the subway beauty-of-the-month.

"I was never so surprised in my life as when I received a letter telling me I'd been selected 'Miss Subways,'" Anne recalls.

However, it was no surprise to her ... Marines at 346 Broadway, who ... 5'2" fig-

MEET MISS SU

LOVELY Jean Grogar

Jean fancies fudge su
perfumes and the Merc
You can see her in a fame
as a hostess. She atten
school, too. *John*

PUBLISHED BY N. Y. SUBWAYS ADVTG. CO., INC., 630 FI

THE CONTEST BEGINS:

The Girl Next Door Smiles at Straphangers and Shares Her Dreams

The Miss Subways contest was created in part around the idea that the image of a comely "career girl," pasted in ad space owned by New York Subways Advertising, would direct eye-traffic toward adjacent commercials for products like hay-fever relief, cigarettes and chewing gum.

The legendary advertising agency J. Walter Thompson, working with big time model agent John Robert Powers, created the campaign to prove that the subways could be a successful marketing medium during the dark days of the war. The contest also brought the possibility of fame for the alluring and pert young women who were selected. Powers plucked Mona Freeman from the suburbs of Westchester to be the first Miss Subways in May 1941. The 14-year-old, who had never actually been on the subway, scored a screen test with Paramount Pictures and went to Hollywood where she appeared in nearly 20 films. Others achieved some degree of fame as well, though perhaps on a smaller scale. Marie Theresa Thomas became a top model. Patti Freeman appeared on television series like "Batman" and "Get Smart."

When the contest launched, New York's subway system was in a period of transition. Private ownership of the ailing Interborough Rapid Transit (IRT) and Brooklyn-Manhattan Transit (BMT) companies had just come to an end, and the lines were merged with the public Independent Rapid Transit Railroad (IND) to create the New York City Board of Transportation, putting the municipal government in control of the entire subway system. Price controls kept the cost of a ride to a nickel, but the system was bankrupt. In 1948, subway ridership hit its all-time peak, surpassing two billion annual passengers, despite a fare hike to 10 cents. Yet public attitudes toward the subways were low—the cars were dirty and over-crowded, the service poor. A photograph of a pretty girl perched above the coarse wooden seats could give beleaguered straphangers a lift and provide a space for daydreaming during jam-packed commutes. Men could indulge in fantasies of dating Miss Subways and women could long to be her. And why not? The winners reflected the diverse faces of New York, in terms of race, religion and ethnicity. They were largely working-class women, riding the trains to their college classes or secretarial job, striving for a better life.

While the women were accessible, there was also something aspirational about winning the contest. Miss Subways were mentioned in gossip columns and featured in *Life* magazine spreads. A department store in the 1940s reported a spate of calls from women seeking a particular blouse worn on a poster by one Miss Subways, and 1,500 soldiers once petitioned for an audience with another. It even inspired the role of Miss Turnstiles in the 1944 Broadway musical "On the Town."

The contest was a boon to the John Robert Powers agency, giving it a platform to test out models. Some of the contest's winners were with the agency before becoming Miss Subways, while others were found through scouts keeping an eye out across the city; several of these girls became models for the agency after their posters ran. Powers also welcomed public input, and friends, sorority sisters, relatives, boyfriends or husbands submitted photos in droves. Sometimes Miss Subways hopefuls

sent in pictures themselves. In addition to the flood of nomination letters, Powers received petitions from New York University and Hunter College and one from the Washington Heights neighborhood, signed by 1,000 people. Powers made all the final selections, whittling down a monthly pool of around 250 submissions to one winner based on test shots and interviews with a small number of finalists. For many winners, being photographed was something of a prize in and of itself. They were photographed by Hollywood professionals like Menyhert Munkacsi— known as Muky— who did publicity stills for scores of films. The Miss Subways contest provided a space for women to shine in front of more than 5 million pairs of eyes a day, and many winners agree that the jolt of confidence felt from winning the contest stayed with them for years.

As the contest got underway in 1941, the war effort was already transforming roles for women. Many were entering the workforce, filling in at factories and other jobs as their husbands and brothers were sent to fight in Europe or the Pacific. Of course, once the war was over in 1945, men returned to jobs that women had taken up in their absence and the birth rate spiked as the nation's focus turned toward the family. Indeed, many of the posters reminded riders that the winning women were looking forward to marriage. Ruth Ericsson's poster said she "hopes for the right man and family." Patti Freeman's "ambition," her poster said, was "success in both theatre and marriage." Enid Berkowitz was "plugging for a B.A, but would settle for an M.R.S.". Some Miss Subways were, in fact, already

In 1948, subway ridership hit its all-time peak, surpassing two billion annual passengers, despite a fare hike to 10 cents. Yet public attitudes toward the subways were low— the cars were dirty and over-crowded, the service poor. A photograph of a pretty girl perched above the coarse wooden seats could give beleaguered straphangers a lift and provide a space for daydreaming during jam-packed commutes.

married. Ruth Lippman, whose husband was in the army when her poster ran, recalled how his buddies jokingly called him "Mr. Subways."

While the war created opportunities for work, the subsequent baby boom reinforced a widespread expectation that women would serve as mothers. Many left their modeling or office jobs behind to rear their children. Some struggled with difficult choices between balancing work and family— something that today's mothers might consider a modern and unique challenge, but was a prevalent struggle for Miss Subways as early as the 1940s. Perhaps more surprisingly, many of these first winners later went back to school and looked for ways to reenter the workforce for second or even third careers.

Talking to these women some seven decades later, we are reminded that their posters—like any advertisement—presented just one piece of the total picture, an image carefully crafted, in part, by male copy writers. While women were invited to the contest in this era based on their looks—how photogenic they were— their ultimate selection as Miss Subways also depended on their interests and ambitions. Enid Berkowitz, whose poster proclaimed she was seeking to marry, now has no recollection of citing marriage as one of her goals. Here, in their own words, we get a more complex view into this era when women's roles were bound to traditions but on the cusp of change. In telling their stories, these women took the opportunity for another "15 minutes"—choosing for themselves what to include and what to leave out of their lives.

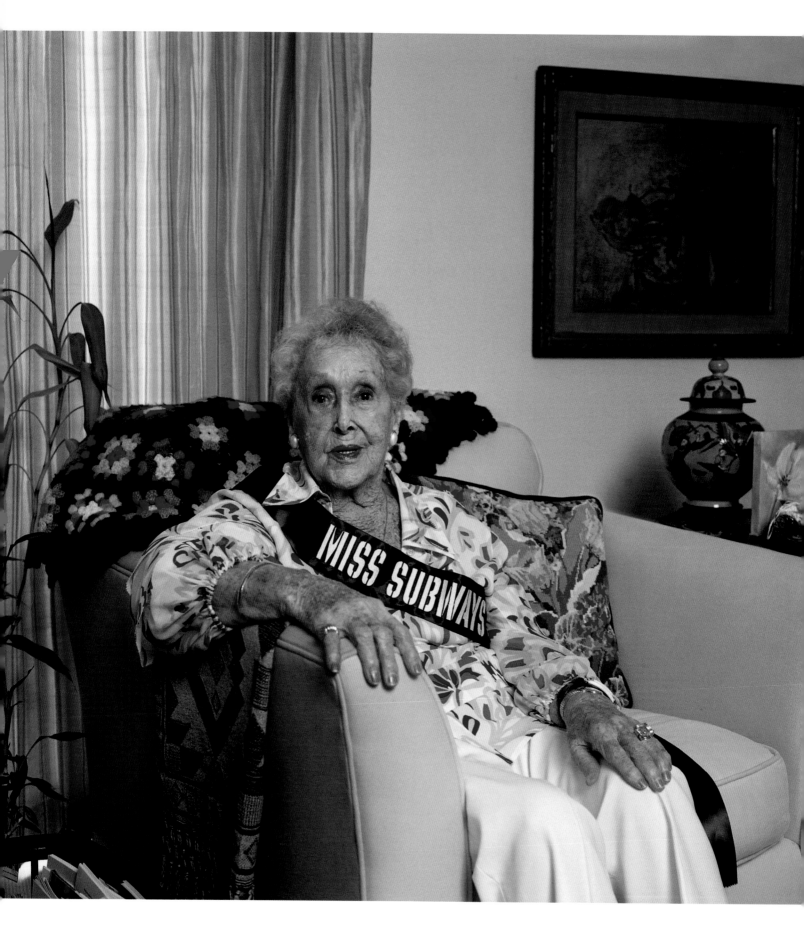

RUTH ERICSSON in her apartment in Palm Beach, Florida 2010.

Meet Ruth Ericsson

MISS SUBWAYS DECEMBER 1941

I was born the 30th of March 1914, on a cold brisk day in Sweden. We lived on a farm, and there was no midwife or doctor in the neighborhood, so my mother took care of it herself. My first playmate was a rabbit. I dressed him up in doll's clothes, then I put a little hat on him and tied it so tight in the neck, he died. I was not a pretty baby. I was cross-eyed and I had a pimple on my nose. When I was about 4 years old, I fell and slid all the way down a hill, which got rid of the pimple on my nose and my eyes straightened out. That was my first facelift.

My mother didn't really want to go to America. We were all settled in a nice house, but pop insisted. He said, "I'll go ahead and make a living." He was in bookbinding. About a year later, he sent for my oldest brother. They got a house in Pelham, New York and then sent for us.

I did my first model picture at the age of 17. Years later, this fellow came along one day when I was on the subway. He said, "You're so beautiful. You have to be one of my Miss Subways." I said, "Thank you. I'll send you a check next week." But he was serious and off I went to the John Robert Powers model agency and I became a model there. One of the Miss Subways before me was Mona Freeman, who went out to Hollywood. The agency said I should go to Hollywood for a screen test, too, but I didn't go because my mother was very ill and I loved my mother more than anything in the world. Soon enough, the perks of being Miss Subways appeared. One day a car delivered a pie three feet across. The whole block had a piece of that meringue pie. I received an orchid every week for a whole year. I got 278 proposals. A lot of them were kids in the army that thought it was fun to write to somebody. I did write letters back.

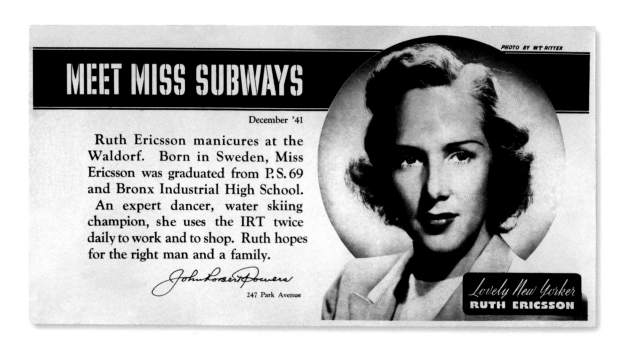

MEET MISS SUBWAYS

December '41

Ruth Ericsson manicures at the Waldorf. Born in Sweden, Miss Ericsson was graduated from P.S. 69 and Bronx Industrial High School. An expert dancer, water skiing champion, she uses the IRT twice daily to work and to shop. Ruth hopes for the right man and a family.

John Robert Powers
247 Park Avenue

Lovely New Yorker
RUTH ERICSSON

PHOTO BY WT RITTER

I worked at the Waldorf-Astoria Hotel doing manicures in the barbershop. There was a married guy who gave me $200 tips. I had nothing to do with him beyond his nails, but he did have a girlfriend on the side and when his wife accused him of having an affair, the girlfriend blamed everything on me. I was good friends with Perry Como in those days—he was a barber when I was a manicurist. Then he started singing and I quit manicuring to sing with a band, too. I dated a lot, and I danced very well. I was one of the best in the dance halls they had on Broadway. I won a pivot contest at Madison Square Garden. I used to get all the cups and prizes at Roseland and the Palladium. A bunch of musicians—Charles Barnett, Gene Krupa—lived across the street from the dance hall I went to all the time. They lived in a $30 a month apartment, and in the middle of the floor they had a bathtub they put a board on top of. We girls would put a cloth on that and then we had dinner there. In those days we didn't have anything. If we made $20 a week, that was a lot. My apartment was $36 a month. Can you imagine?

I wanted to be an actress, but when I got married I was happy and didn't need to struggle. My husband, Bob Brinsmade, was born in Puebla, Mexico, of American parents. We met at a nightclub in New York. He asked me to dance to a Tennessee waltz even though he had two left feet and a wooden leg. Three weeks later we were engaged and two months later, on April 6, 1953, we were married. We moved to Venezuela where we had 20 Arabian stallions at our hacienda. Bob was an international lawyer. He had the only tile factory in the country of Venezuela and he owned the only newspaper, called La Calle. I wrote the society column in English: So-and-so came in with a green dress and diamonds all over the place. Bob was a widower. He had two girls and a boy, and they became everything to me.

Our fairytale life came to an end in Venezuela with the revolution in 1958, and the American-backed overthrow of the dictator. There was a directive to kill those who were

pro-dictator and had names beginning with A, then B. We were Brinsmade, so we had to get out of there. My kids were sitting on the floor of a plane and off we went. My husband was left behind. He had a servant, Manuel, who was also his pilot of our helicopter, so he said to Manuel, "I have to leave to New York. First I have to go to my office. I have money in a bank I have to take along." He got the money in a bag, and then my husband got in the plane and Manuel took off, but he landed in Florida on a beach. He pointed a gun at my husband and told him to get out. Manuel made my husband take his clothes off, took the money and shot him in the foot.

My husband survived. We still had a beautiful home up in Bedford Hills with 25 rooms and an apartment in the city. I worked at Tiffany's for a few years. Greta Garbo used to come in and we'd speak in Swedish. At that time, Mrs. Kennedy used to come in with her son and buy crosses for him. He would pull them off his neck. I enjoyed working there, but you had to stand up the whole time, so my legs got bad those days and I had to quit. If I didn't have these legs, I'd be out doing the jitterbug right now.

TOAST OF THE TOWN
(Center) Ruth Ericsson received an orchid a week for a whole year from an admirer who saw her Miss Subways poster. (Below left) Ruth with comedian Bob Hope, on her left, and her husband, Bob Brinsmade. (Below right.) Ruth sits in the front row, far right, listening to musicians at the Royal Palace in Sweden.

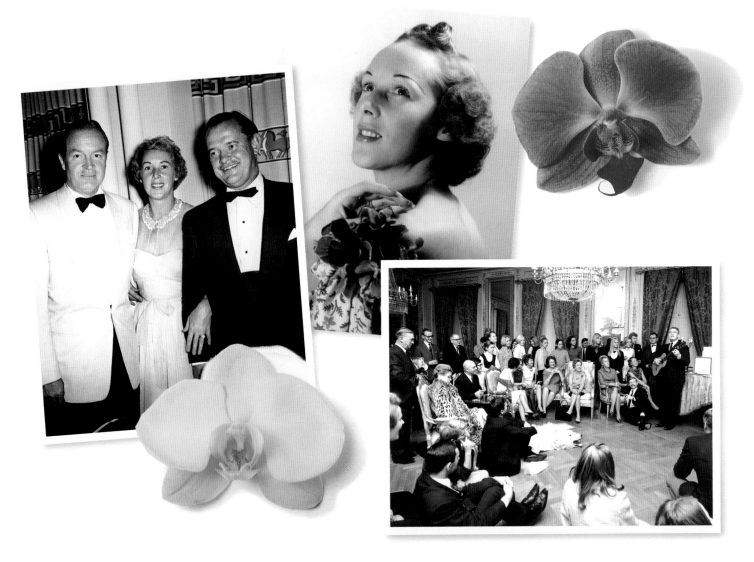

Meet Elaine Kusins Pollack

MISS SUBWAYS MARCH 1942

Kusins wasn't my real name. In high school I went by Kusnitz, but when I got into modeling I went by Kusins. I lived near the Utica Avenue station in Crown Heights. I went to Tilden High School on the bus and we would pass potato farms. Donald Trump's father was just starting to build little houses out there.

We were just coming out of the Depression and there was terrible unemployment. My father only really got work when the war started. He was a housepainter and later became a builder and did construction in Brooklyn and Long Island. I had a brother who was younger and we had enough money for one person to go to college. Guess who went? He did. So, I went to work doing modeling. I also worked at the St. George Hotel in Brooklyn Heights in the food-purchasing department. Nobody knew they were poor because everybody was poor.

ELAINE KUSINS POLLACK at her apartment complex in Miami Beach, Florida 2010.

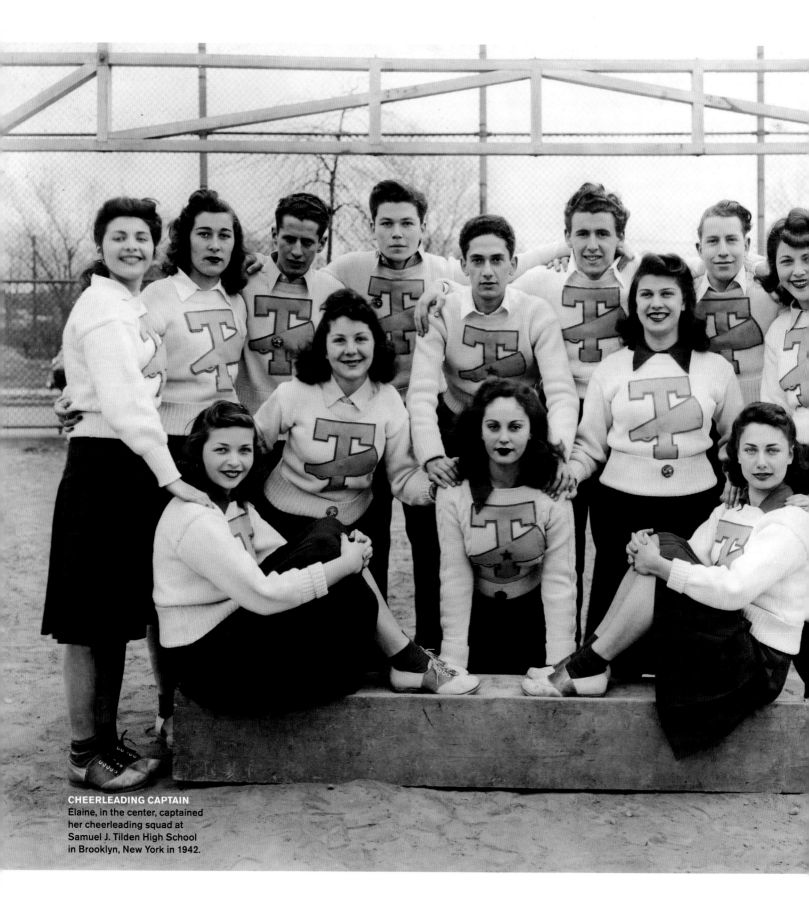

CHEERLEADING CAPTAIN
Elaine, in the center, captained
her cheerleading squad at
Samuel J. Tilden High School
in Brooklyn, New York in 1942.

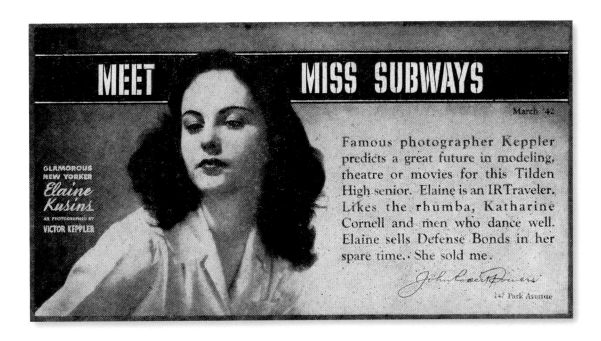

MEET MISS SUBWAYS

March '42

GLAMOROUS
NEW YORKER
Elaine
Kusins
AS PHOTOGRAPHED BY
VICTOR KEPPLER

Famous photographer Keppler predicts a great future in modeling, theatre or movies for this Tilden High senior. Elaine is an IRT raveler. Likes the rhumba, Katharine Cornell and men who dance well. Elaine sells Defense Bonds in her spare time. She sold me.

147 Park Avenue

I got married when I was very young, so that put the end to modeling. I was 19; he was 24. We met when I was 12 years old in Monticello, New York. My family would go up there for the summer to a really broken down bungalow colony. People did as much as they could to get their children out of the city because there was no air conditioning in those days. His parents had a big grocery store. I remember my mother sent me into town to buy some cheese one day and told me not to go there because it was too expensive. But there were three brothers at the store and they were all very cute, so I didn't listen to my mother. That's how I met him.

We must have been crazy because we got married during the Battle of the Bulge. It was dangerous times, but when you're young and stupid you just don't know what you're doing. We were just very lucky he didn't get sent overseas. I went to live with him in Virginia. The colonel in charge, Colonel Watson from Chattanooga, Tennessee, was a very smart man. He saw my husband was a lawyer who graduated from Cornell Law School and Harvard Business School and wanted to work with him. So, we stayed there until the end of the war. I had a wonderful time. I hate to say it, but I did. First of all, there was food. We didn't have to have ration cards. I was an officer's wife. I went to the officers' country club.

Then we came back to New York. My husband hated it. I remember the first day he took the subway to work, he said, "These people are crazy. They push, they shove." But then he learned, you don't push, you don't get a seat. He wanted out, and he didn't like law. His family was in Miami so we joined them in 1951 and stayed there except for 22 years when we lived in Israel. When we first moved to Miami it was gorgeous. Nothing was here. We saw the beautiful ocean, virgin beach. It was a small community. I remember when there was a big party when Miami Beach registered their 50,000th resident. They were glory years. My husband and his brother built some hotels on the beach.

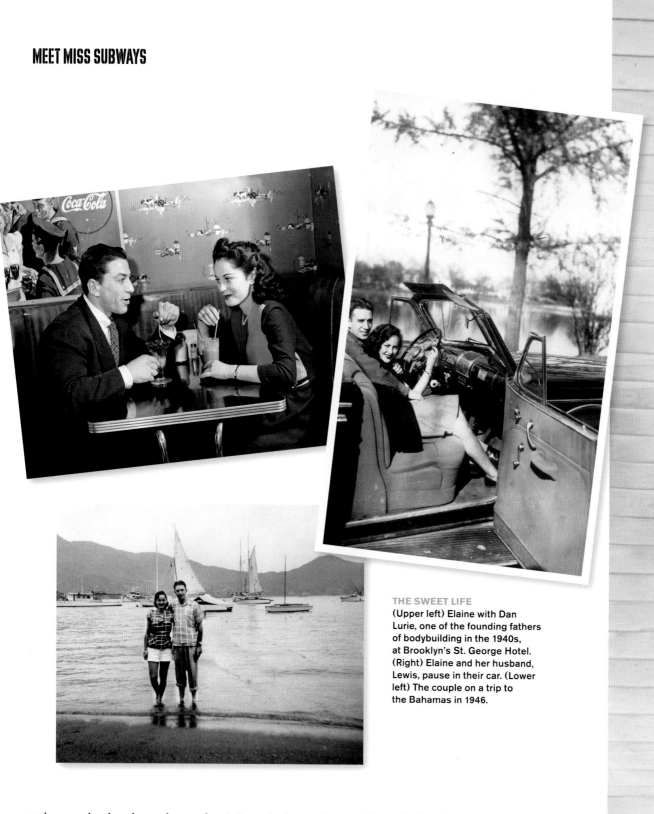

THE SWEET LIFE
(Upper left) Elaine with Dan Lurie, one of the founding fathers of bodybuilding in the 1940s, at Brooklyn's St. George Hotel. (Right) Elaine and her husband, Lewis, pause in their car. (Lower left) The couple on a trip to the Bahamas in 1946.

When my husband saw the condominiums he knew they would put the hotels out of business. "People wouldn't have to stay in hotels anymore."

My husband and I were married for 62 years. I didn't really appreciate him until recently. A lot of us here in Florida unfortunately are widows and when I hear about their lives I realize how lucky I was. I remember saying to him, "Why do you want to marry me? I never went to college. I'll never be able to keep up with you." And he said, "College is like a trip around the world. It depends upon how many ports you enter and how long you stay there. I will teach you." And he did. I still do the best I can, keeping my mind active and busy. I'm in the pool every day at 7:30 a.m. You have to do something.

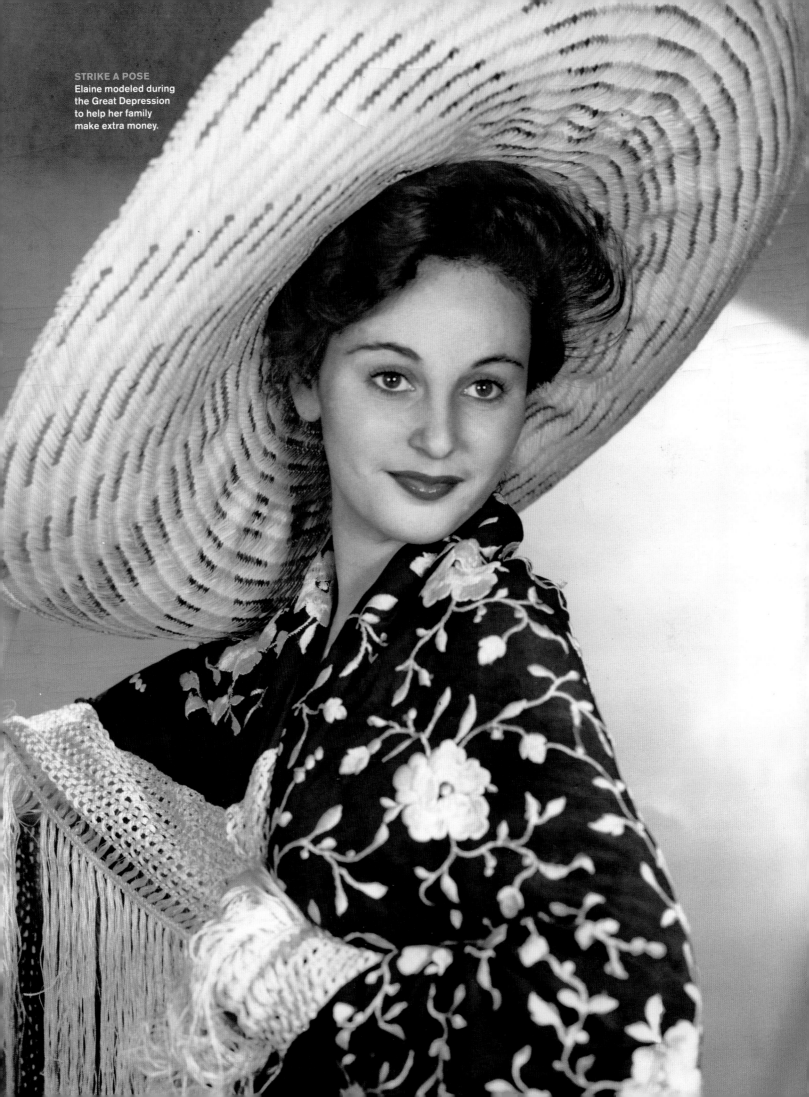

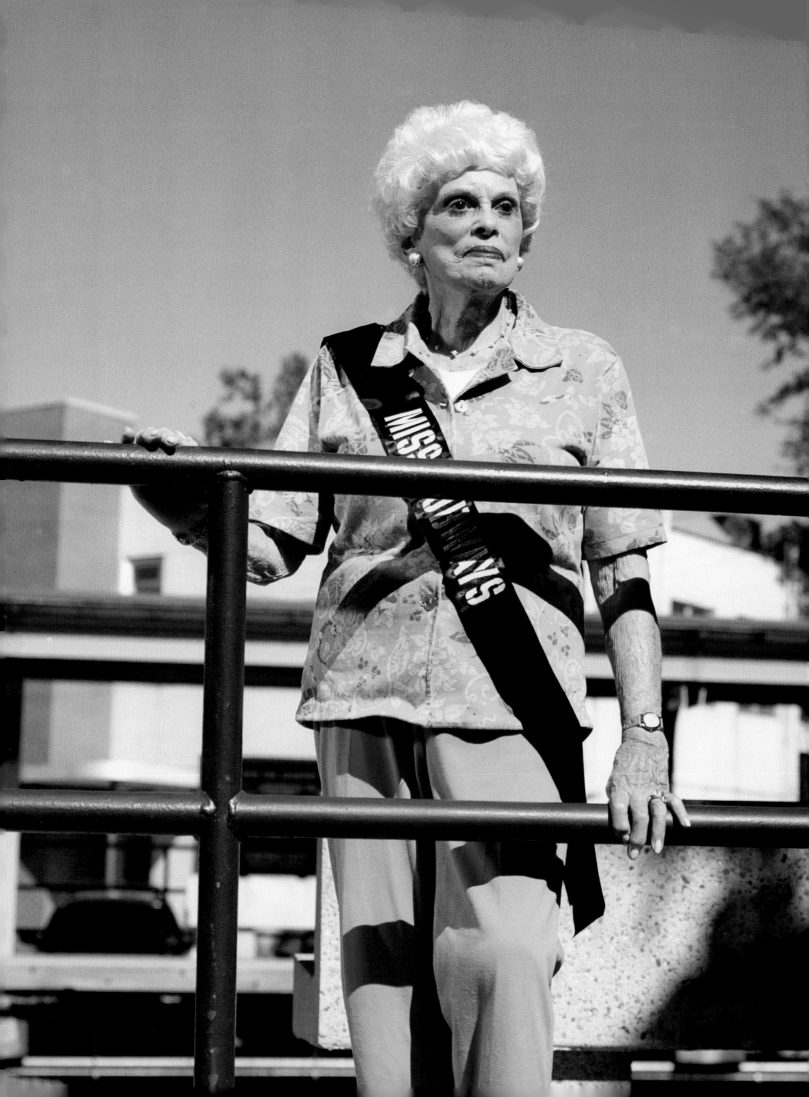

Meet Dorothea Mate Hart

MISS SUBWAYS JUNE 1942

I was a married Miss Subways. It even said so on my poster. I was 22 years old, 5'10" and living in the Inwood section of New York. I didn't even know what the Miss Subways contest was when it started. My brother was in the advertising business and he learned about it. They needed people, and I was pretty, so he sent my picture in. I had to go up and see John Robert Powers, who had the leading agency for models. But I don't think it was just about a pretty face. It was during war times when he picked me. I was a volunteer with the Office of Emergency Management. I think I was a role model.

After my poster ran, I did a layout for *Life* magazine at Jones Beach with some of the other Miss Subways. I was married, so I didn't get any proposals, but a tea company sent me 300 tea bags. Plus, I got other modeling jobs. I weighed 143 pounds back then, which was pleasantly plump. Someone I knew said Richard Hudnot, who had a cosmetic store on Fifth Avenue, liked pretty, fat ladies.

DORTHEA MATE HART at the train station in Hartsdale, New York 2007.

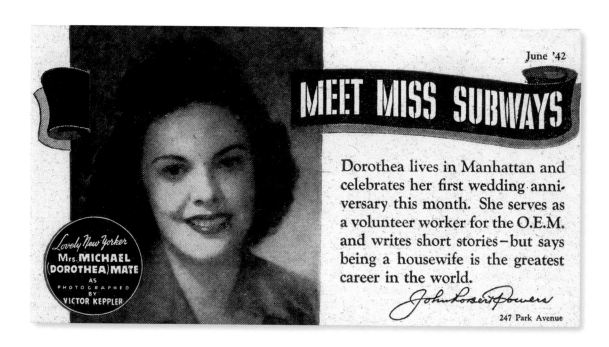

June '42

MEET MISS SUBWAYS

Dorothea lives in Manhattan and celebrates her first wedding anniversary this month. She serves as a volunteer worker for the O.E.M. and writes short stories—but says being a housewife is the greatest career in the world.

John Robert Powers

247 Park Avenue

Lovely New Yorker
Mrs. MICHAEL (DOROTHEA) MATE
AS PHOTOGRAPHED BY VICTOR KEPPLER

They slimmed 'em down and then used them in their advertisements. So, again, my brother wrote a letter and they used me for Richard Hudnot's weight reduction school. They took me on and I lost 25 pounds in six weeks. My picture ran in an advertisement in *The New York Times* with before and after photos. Then I became a Conover model with Harry Conover, who was very famous. I did some catalog modeling and showroom modeling. I was on television for a bit, on the DuMont Television Network.

My husband was pleased with the modeling. I had a wonderful guy. He had an auto parts store with his brother in the Bronx. If it made me happy, he was okay with it. Then I decided to be a mother, and I had my first baby when I turned 25 years old. We moved to Westchester and had a home in New Rochelle for 50 years. When my son, who now lives in Los Angeles, was in college, I decided I wanted to go back to work, so I became a travel agent. I did that until I was about 60 and then I figured there's more to life than just work. So my husband and I traveled.

My daughter is a stunning young woman. When she was 19 I sent her picture in to be a Miss Subways, and she was accepted as a semifinalist. However, she was getting married and wanted no part of it. She would have won. My daughter lives in New York, so I ride the subways. I wish they would start something again. It's nice to see a pretty girl. But they would have to approach the contest differently now. It would have to be more than a pretty face. There are very smart ladies who are pretty—It could be a role model for young women. It wasn't the same for my generation. A pretty face was qualification for vice president or this and that.

Being Miss Subways was very important in my life. Even though I'm older now— and I'm still attractive—I look at myself and say, "You were Miss Subways." I walk into a room, my relatives say, "Ah, here comes Miss Subways." It may be superficial because it's only looks, but it has helped me over the years.

MY CUP OF TEA
A tea company sent Dorothea 300 tea bags when she was Miss Subways.

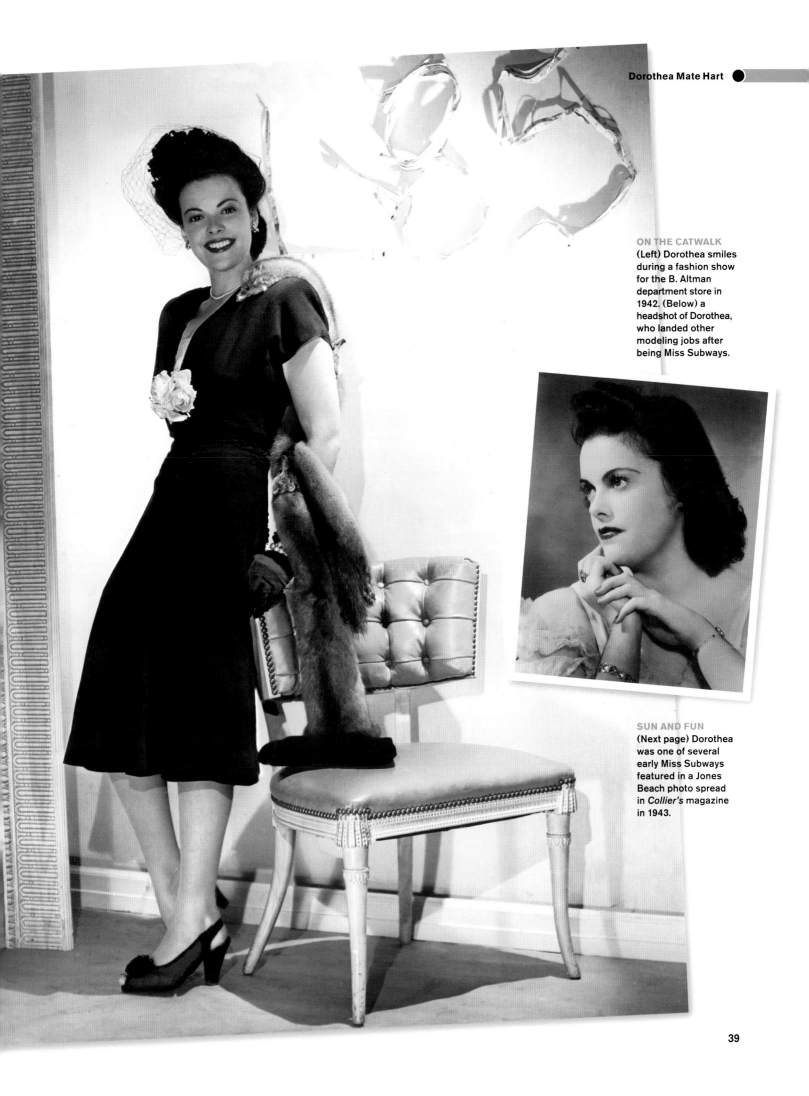

ON THE CATWALK
(Left) Dorothea smiles during a fashion show for the B. Altman department store in 1942. (Below) a headshot of Dorothea, who landed other modeling jobs after being Miss Subways.

SUN AND FUN
(Next page) Dorothea was one of several early Miss Subways featured in a Jones Beach photo spread in *Collier's* magazine in 1943.

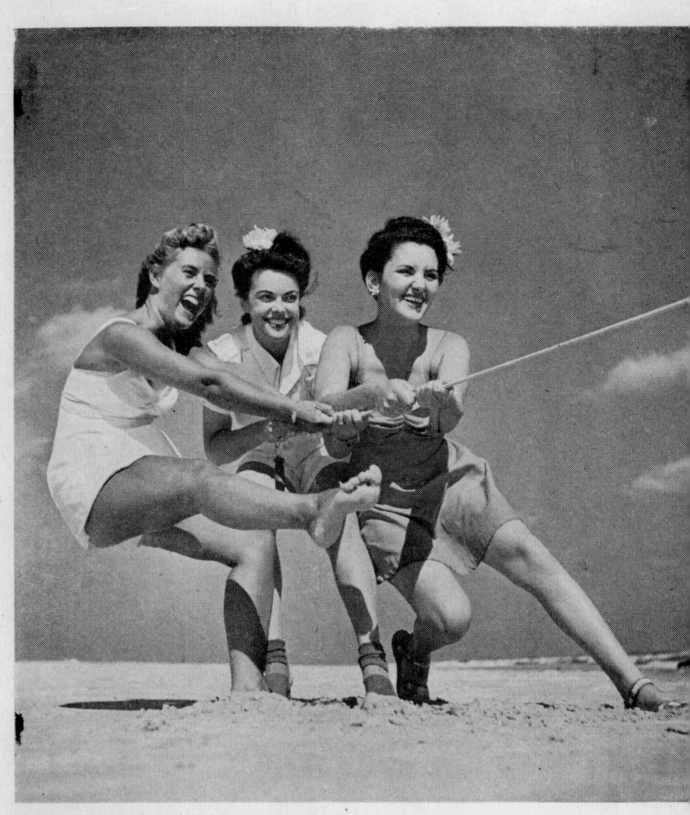

Fan mail of Attorney Helen Borgia, who is shown at the right, led to new clients.
Rosemary Gregory, left, and Dorothea Mate, center, now do modeling occasionally

TO MILLIONS of New Yorkers, the subway is just
one way of getting around, but to more and more
of the city's prettiest strap-hangers, it has become

months after her pictur
despite 258 marriage offe
one young man she met

Dorothea Mate, center, one of two Miss Subways who are married. Her husband's business (dealer in automobile parts), boomed after she won the Miss Subways contest

eared. She is still single, she carries the picture of h the contest. He is now

Miss Subways: "Today about six people recognized me on the subway. . . . Everyone in the office is excited about the celebrity they're housing. . . . The phone won't stop ring-

Meet Winifred McAleer Noyes

MISS SUBWAYS JUNE 1944

This is from an interview with her daughter, Nancy Foss, since Winifred was not well enough to be interviewed.

Mom wanted to be an actress. I found her high school yearbook not too long ago, and there were a couple of certificates she got for excellence for fashion and makeup. That was perfect—she was impeccably groomed and always looked stylish and pretty. She was in drama club in high school, but she never got far in New York.

She used to tell me that her father didn't think it was necessary for her to go to college. Her brother went to Yale, but her father told her, "You need to get a job with the phone company because they have a good pension plan." This was when she was 19 years old. She wasn't thinking about pensions. I'm sure her parents assumed, too, that she would get married and a man would take care of her.

Mom got a job at a place called Press Wireless. It was like a news agency. Someone at work sent her picture to the

WINIFRED McALEER NOYES in Marblehead, Massachusetts 2010.

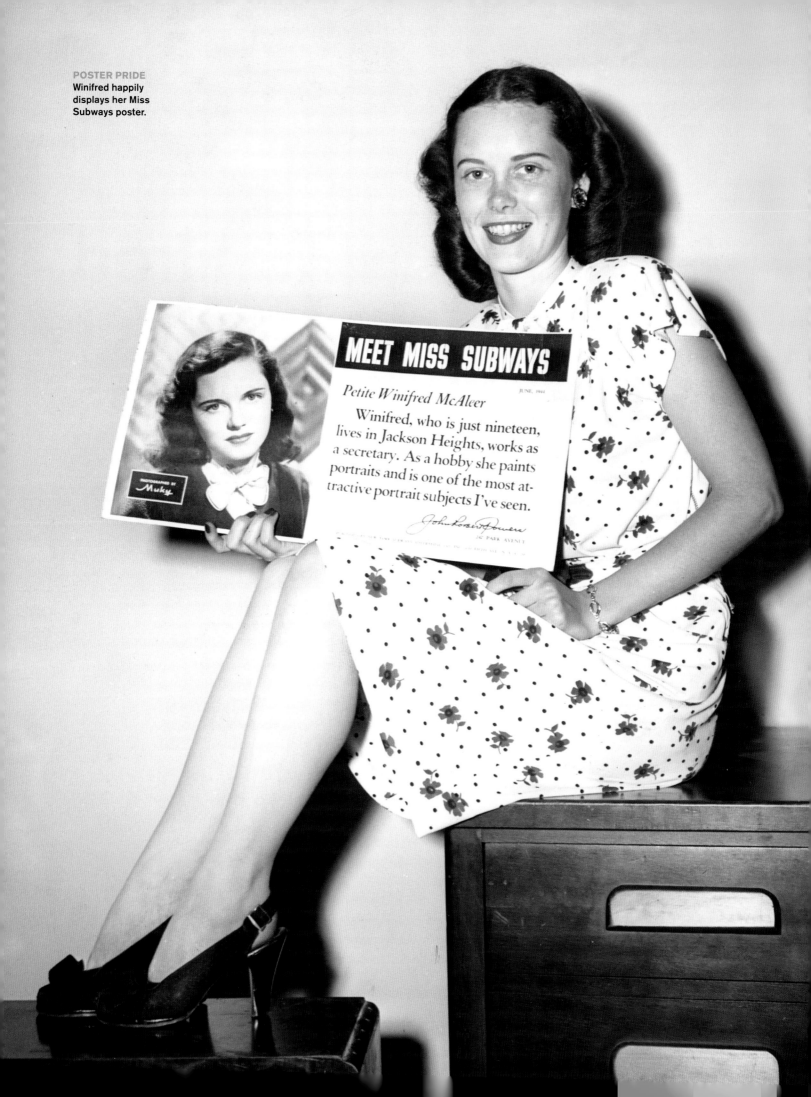

MEET MISS SUBWAYS

JUNE, 1944

Petite Winifred McAleer
Winifred, who is just nineteen, lives in Jackson Heights, works as a secretary. As a hobby she paints portraits and is one of the most attractive portrait subjects I've seen.

John Robert Powers
PARK AVENUE

PHOTOGRAPHED BY
Muky

MEET MISS SUBWAYS

JUNE. 1944

Petite Winifred McAleer

Winifred, who is just nineteen lives in Jackson Heights, works as a secretary. As a hobby she paints portraits and is one of the most attractive portrait subjects I've seen

John Robert Powers

247 PARK AVENUE

PUBLISHED BY NEW YORK SUBWAYS ADVERTISING CO., INC., 630 FIFTH AVE., N. Y

John Robert Powers agency and said she should be Miss Subways, and the agency liked her picture. She thought being Miss Subways was kind of amusing. Her poster was in *Life* magazine, the issue that reported the death of Franklin Delano Roosevelt. When the magazine came out, she got letters from service men all over the world. People would call the house and want to talk to her, and her father was just horrified: "Strange men calling my daughter." But it provided a lot of amusement at the dinner table: "Well, who'd you get a letter from today, Winnie?"

She was out of high school at that time and always with her best friend, Jean, who lived in Manhattan. Jean was dating my father, and then Jean and Daddy had a parting of the ways. Daddy called my mom and said, "How would you like to go out?" They were married in 1946, after the war.

Mom and Dad lived in New York when they were first married. My father worked for Procter and Gamble on Staten Island, but they moved him to Cincinnati, to their headquarters, in 1948. My older brother was a few months old, and my mom was 23 and had never left New York. She told me that every time her parents came out to visit—they used to take the train because they were both afraid to fly—her father would go out on the porch and say, "Winnie, where are the people?"

They ended up living in Cincinnati until 1976. My mom was very active in local community theater type stuff. My two brothers and I each have one of her little trophies she won for best actress with the Wyoming Players, the troupe in the town where we lived. She was quite an actress, but always on an amateur level. My parents had a lot of fun, weirdo theater friends. They had New Year's Eve parties every year where they would try to outdo each other by bringing strange food. The next morning I'd come downstairs and there would be a plate with little octopus things and chocolate covered ants and stuff.

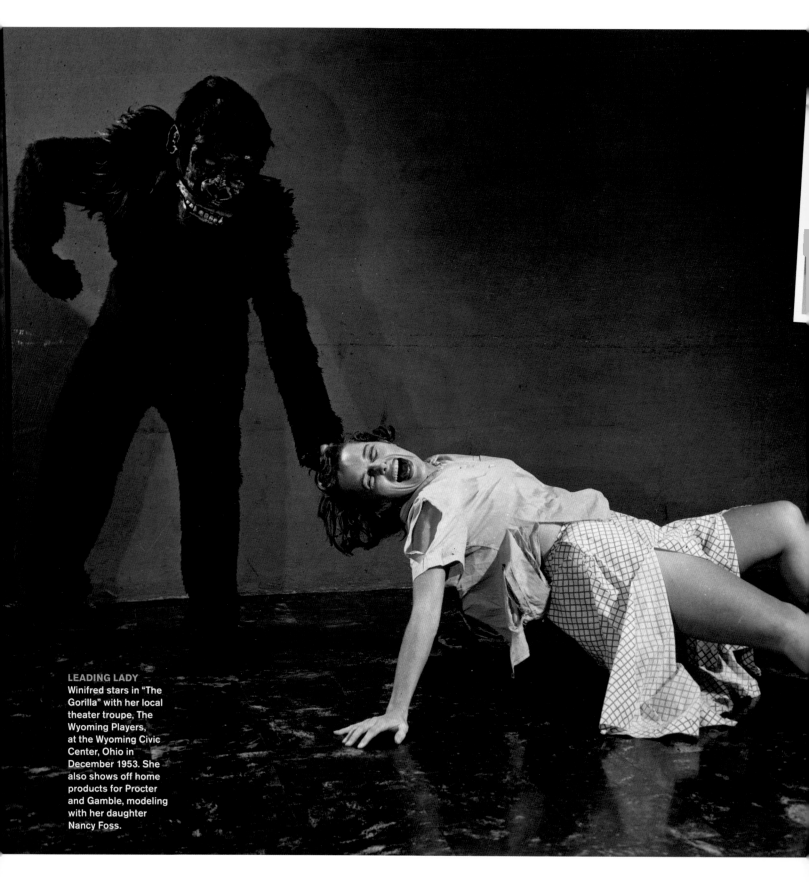

LEADING LADY
Winifred stars in "The Gorilla" with her local theater troupe, The Wyoming Players, at the Wyoming Civic Center, Ohio in December 1953. She also shows off home products for Procter and Gamble, modeling with her daughter Nancy Foss.

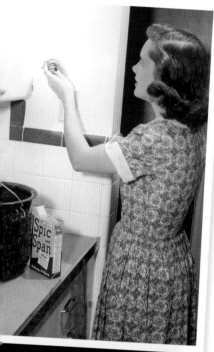

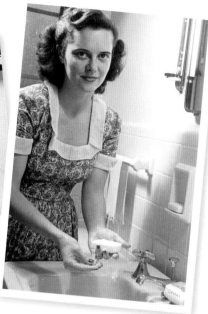

Who knows what would have happened if she and my dad weren't crazy about each other and hadn't gotten married? She might have stayed in New York and tried to pursue acting. But she was in the generation of women who wouldn't have dreamed of having a career instead of being a mom. She didn't go to work full time until I was a junior in high school and my brother was a senior, in 1965 or 1966, when my parents realized they needed money to pay for our college. She worked for about 10 years as the manager of a community club where the women's club and the Kiwanis and Girl Scout troops met. It was where the Wyoming Players put on their shows. She was in the middle of everything, so she really liked that. Her work was literally around the corner from our house, so she still felt like she was an at-home mom. She would say, "You all have to stop at my office on your way home from school." When we did, she would say things like, "OK, make sure Jamie doesn't fall out a window." Our younger brother was 9 or 10 at the time.

She and daddy were very forward thinking as far as education. It was extremely important to both of them. Dad was in the class of '40 at Yale. I was in the class of '71. That was Yale's first graduating class of women. My older brother took a year off and ended up graduating with me. Our grandfather was the director of admissions. He was in the class of '13. It's like everyone in our family has gone there.

My mom always encouraged me to do anything. She always said, "You can do absolutely anything in the world." She never wanted me to settle down with a boyfriend. She was happy I was pretty footloose for most of my college years. I think she was disappointed that I ended up being a secretary, that I got married and never really did anything special with my education. But at least I was able to support myself after my divorce.

My parents had a really good marriage. They were very much in love all the way through it. My older brother is on his third wife. My younger brother is on his second wife and I've been divorced for 30 years. Mom always said, "What did we do wrong?" And the three of us would say, "You didn't do anything wrong. It's just us. We can't seem to stay married." They gave us a really good example and maybe we all expected too much. They were very happily married.

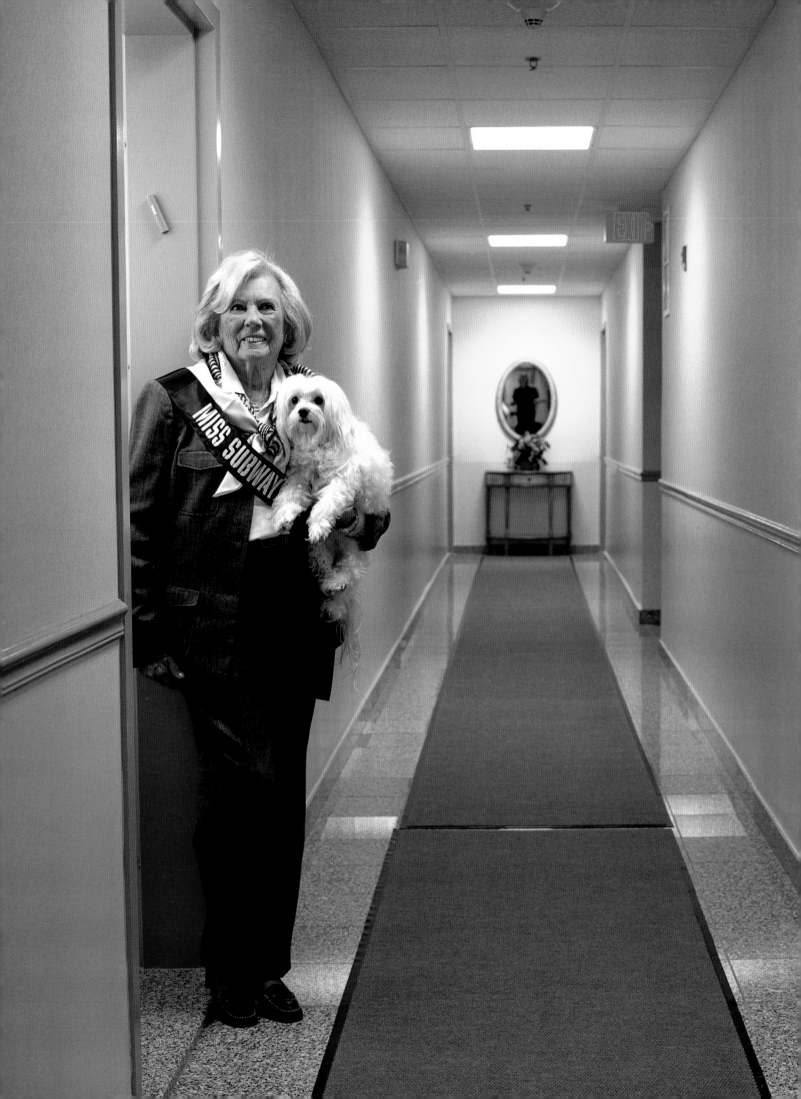

Meet Ruth Lippman

MISS SUBWAYS JANUARY 1945

I grew up in Kensington, a very fancy name for a very plain area in Brooklyn. I lived on Louisa Street in a modest, but nice, two-family brick home with a porch. My family had a successful automobile repair business, but my father had a serious heart attack when I was about 16 years old, and that's when I started modeling. My mother tried to keep the business going while he was sick for six months, but they were robbing her blind. So I went to work after school since I was the oldest and we didn't have a lot of money then. I went to Brooklyn College at night for about a year.

My mother was furious that I was modeling, though my father thought it was the greatest thing. I don't know what takes place in the modeling field now, but then you had to wear a black slip with nothing underneath. I was dating a young doctor at the time, and my mother hated him. She would shake her finger at me and say, "He'll ruin

RUTH LIPPMAN at her apartment in Great Neck, New York 2008.

49

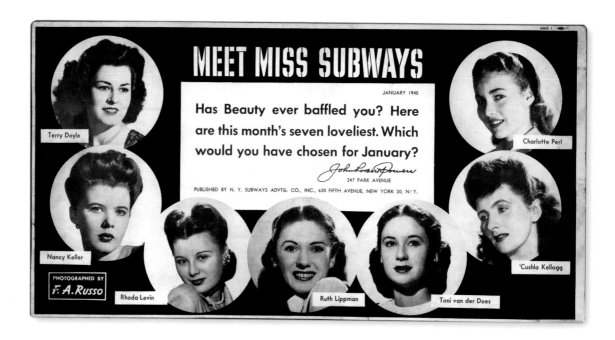

you." I was just getting out of high school, and he was 27. She would communicate with him as little as possible, but she would try and get him to go down to the garment center and pick me up and bring me right home, so I wasn't exposed to too many men there. Imagine a Jewish mother who did not like a doctor. I ended up marrying an artist.

Bert was a fancy roller skater. We met at Atlantic Beach. He belonged to a group of roller skaters and they danced the way you see ice skaters dance. I went there on an outing with work. I remember what I wore: a silk shantung man-tailored suit. I always wore man-tailored suits when I was young. In those days you picked up guys. Somebody would see somebody they liked and walk over and say hello. I gave Bert my telephone number and he called me on a Friday night just as Stan the jeweler cancelled on me.

After we were married, Bert joined the army and he was stationed at Camp Upton in Patchogue, Long Island. I would take the bus out at five a.m. with the telephone operators. Then he was transferred to Camp Ellis, Illinois. I traveled out there to be with him and lived in a town called Ipava, Illinois: population 500. I lived with a lovely family, who were hell bent on converting me to go to church. Every Sunday morning there would be a knock on my door: "Ruth, darling, we are going to church, would you like to come with us?" And I would say, "Thank you, but I am not of your faith. I'm Jewish." And then the next Sunday, the same knock on the door. My mother, back in Brooklyn, would say, "Come home, my princess," but in the next breath would say, "No, you have to stay with your husband."

I did stay with him until he was transferred to Camp Shanks in upstate NY, then I moved home to my mother's house in Brooklyn and did some runway and garment center modeling, ordinary jobs. A friend of mine sent my photograph in to John Robert Powers. I didn't even know about it. I got a letter from the office to come for an interview. So I was not a "Miss" Subways really, I was a "Mrs.", which we were not supposed to say. Bert was

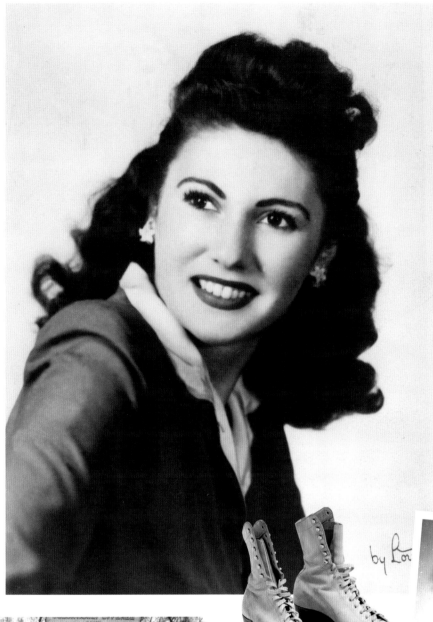

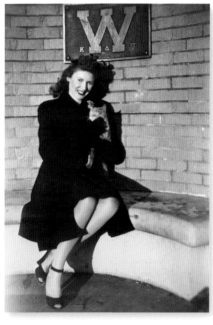

WAR DAYS
(Above) Ruth sits with a cat at Western State Teachers College in Macomb, Illinois, where she lived during World War II.

CALLING MR. POWERS
(Left) The headshot Ruth's friend submitted in 1944 to John Robert Powers for the Miss Subways contest.

ARMY COUPLE
(Left) Ruth enjoys a day off with her husband, who was stationed at Camp Ellis, Illinois, during wartime. They met when she saw him roller skating at Atlantic Beach.

PICTURE PERFECT
(Right) Ruth in front of a portrait her friend painted of her, which still hangs in her living room.

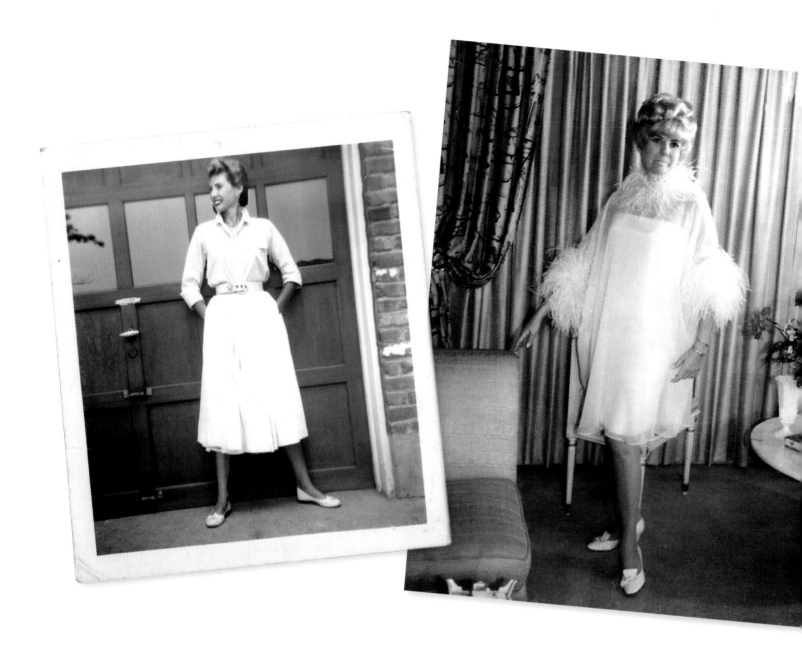

SUBURBAN STYLE
(Left) Ruth looking smart on a Sunday afternoon in front of her Hewlett, Long Island, home. (Right) She dons her favorite pink chiffon and ostrich feather dress for a wedding.

excited when I was chosen. He was in the Special Services with a couple of professional people in his unit: Joe Lewis, the prizefighter, and a man named Jules Munshin, a very popular comedian at that time. Jules Munshin nicknamed Bert "Mr. Subways."

I was one of seven women on that poster, and at the end of the month Powers picked some of the girls and offered them modeling contracts. He had a lot of famous models in his repertoire at that time. He had Jinx Falkenburg, a model named Bettina, the Prell Girls. I was not in that class. I was not offered a contract. But I remember I was going to work one day—I rode the subway, naturally—and I didn't realize it, but I sat down right under the poster. People were nudging each other, like, "Hey, look who's there." Trains then were not like the subways now—there weren't that many seats and there were straphangers crushed together. They were all looking at me and whispering

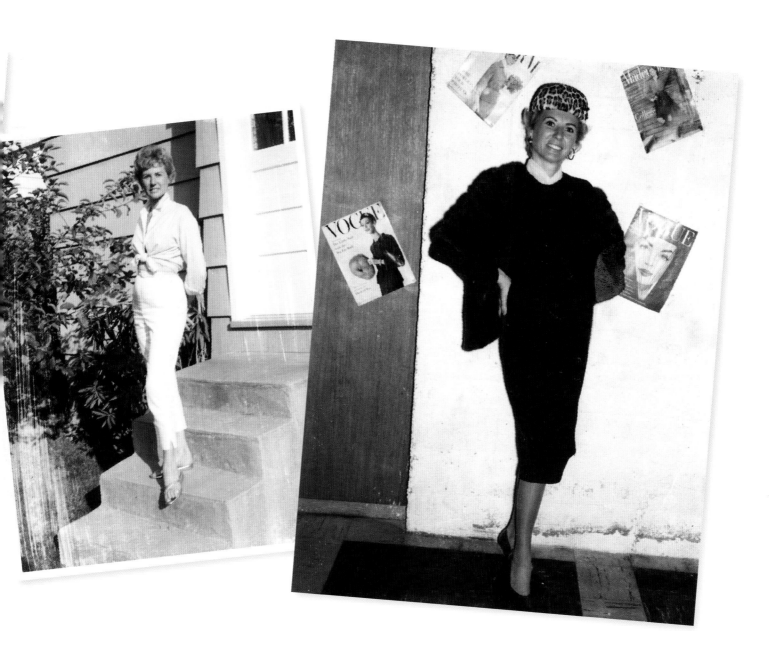

among themselves. It was my one big moment of fame. I thought the copy was great: 'Has beauty ever baffled you?'

When my husband returned from the army, we moved back to New York. The head model I used to work with wanted me to continue modeling, but my husband said no. We moved to suburbia, and then I became a housewife for many years. I raised two fantastic children and I have my marvelous grandchildren. My husband and I were active in the temple. He was a set designer, and I was the star of all the temple shows. Once my kids were grown I went into the sportswear business. I had four boutiques, all over Long Island, and that kept me very busy for 35 years. Everything anybody wore came from my store, wholesale or for nothing. I got my kids their wedding gowns, all my sisters-in-law their wedding gowns. I got all my friends their wedding dresses. It was great.

STEPPING OUT
(Left) Ruth, on the terrace at her home in Hewlett, looks model-ready for a day at Atlantic Beach. (Right) Ruth waits for her turn at a fashion show at the Woodmere Country Club near her home in Long Island.

53

Meet Marie Theresa Thomas Ferrari

MISS SUBWAYS MARCH 1946

As a teenager, I would enter "Misses" contests because I had an elderly mother who was ill and I was trying to get a gold watch for her. Usually if you became a Miss of this and that, you'd get something. For the Miss Tulip Queen, they provided us with a trainload of tulips. In another contest, I got a bed. Finally, I got a gold watch for my mother.

One of my friends sent my picture in to John Robert Powers when I was 16. The night before I went in to the agency, I was awake all night because my mother was quite ill. Penicillin had just come out and every four hours I had to boil water and sterilize needles to give her an injection. I went in to John Robert Powers with three hours of sleep.

MARIE THERESA THOMAS FERRARI **at her apartment building in Garden City, New York 2011.**

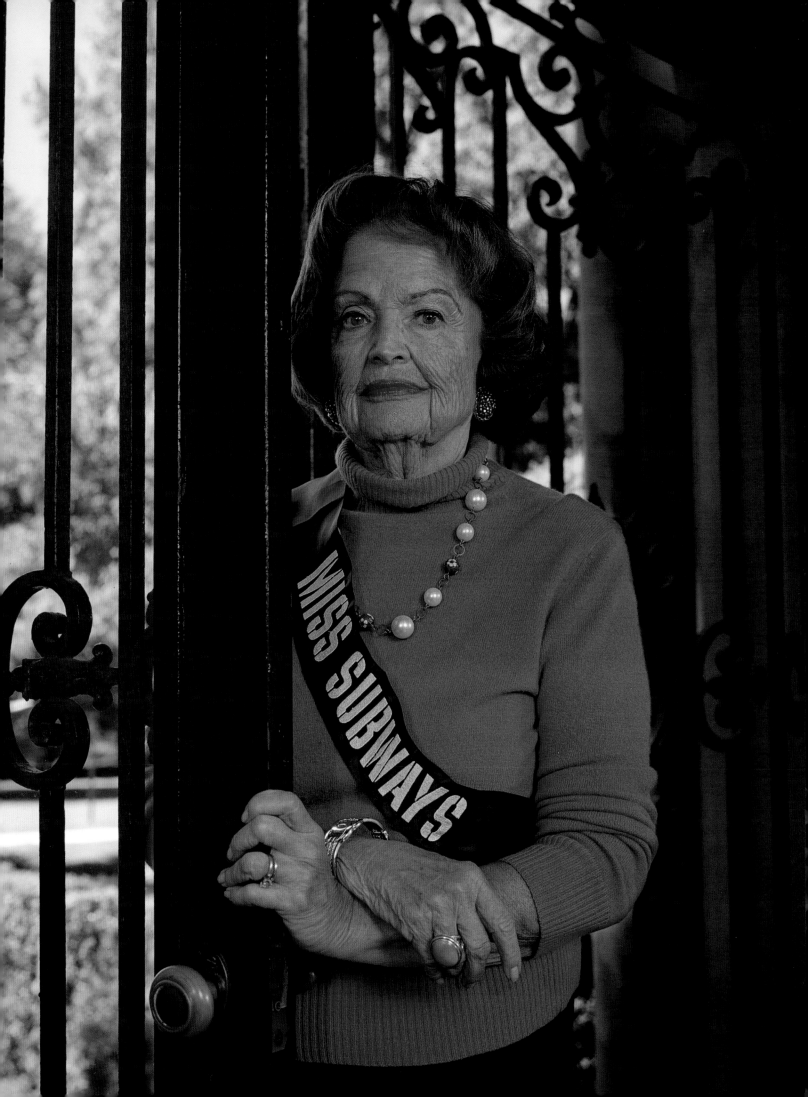

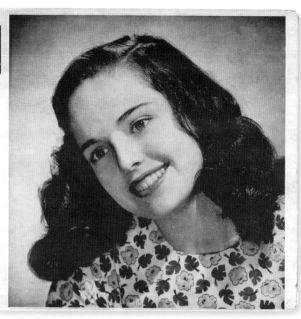

MEET MISS SUBWAYS

MARCH 1946

Charming

MARIE THERESA THOMAS

works for a book club—lucky break for an ardent reader. A swimmer since she was two, she also loves to ride horseback. Adores the March wind.

John Robert Powers
247 PARK AVENUE

PUBLISHED BY NEW YORK SUBWAYS ADVTG. CO., INC. • 630 FIFTH AVENUE, NEW YORK 20, N. Y.

PHOTOGRAPHED BY **F. A. RUSSO**

ALL-AMERICAN GIRL
(Above) Marie was a favorite with commercial artists for her "Coca Cola" look.

TELEGENIC SMILE
(Opposite page) For Motorola's 20th anniversary, "Terry," as she was known, was crowned the most beautiful girl on TV, winning a modeling contract, a CBS audition and a television set to take home with her.

I never thought I'd get it, but I did, and afterwards I became a John Robert Powers model. The girls were very nice. There were 67 of us and we were always together. Mr. Powers took very good care of us. We all did different shows. I went to Washington with Grace Kelly. We did a newsreel. She was absolutely gorgeous—the pictures didn't do her justice. She went out to the West Coast then, but I had made this vow that I wouldn't do that.

My parents were very strict. I had to ask the family priest if it was okay to model. He said it was okay since I never did anything wrong, but I promised not to go to California even though I had a couple of offers. Mervyn LeRoy, the director who discovered Judy Garland, asked. And I said no. I did my own thing here. I was in a Coca-Cola ad painted by Norman Rockwell when he was just starting. I'm the girl with the gold bow.

When I started, I didn't even know what a model was. I was such an All-American Coca-Cola girl. I had balls and jacks. But with my name, Marie Theresa, they would think you're a Vogue model, all sophisticated, and they'd be very disappointed if you showed up an All-American Coca-Cola girl, so John Robert Powers changed it to Terry Thomas. Then, the famous English actor Terry Thomas from years ago said, "Find Terry Thomas." Because I was a member of the Screen Actors Guild, he apparently wasn't allowed to make movies here. So he found me at a party and I signed papers giving him permission.

I did the first television commercial live on television, for the U.S. Rubber Company. I had to go to Philadelphia to the DuMont studios. We had to wear black lipstick on television in those days. The lights were so strong the steam would come up from all the hairspray and they'd have to shut off the cameras. Then I was on all these television shows—"Strike it Rich," "The Jackie Gleason Show." I was the girl who sold Maxwell House coffee on "What's My Line." It was fun. Television was the easiest, most lucrative job. It was easier than photography. You didn't have to stand around. I was in an article in *Look* magazine that called me "the most beautiful girl in television."

...mas glows with excitement as Motorola president Paul Galvin congratulates her on winning the company's twentieth anniversary contest.

The most beautiful girl on
TELEVISION

She is blue-eyed Terry Thomas, 21, a model from Bellerose, L. I.

IT was a dazzling array: 22 New York beauties and 22 beautiful new television receivers standing side-by-side. The occasion: Motorola's 20th anniversary and the selection of the most telegenic girl in New York City.

The press which crowded the Waldorf-Astoria's Wedgwood Room was treated to one of the most original shows in some time. They watched while each girl mod... had her image projected on a televisio... screen. Then judges, picked for their expe... rience in television and in judging fema... beauty, selected the most telegenic girl.

The winner, 21-year-old Terry Thoma... a 1947 LOOK cover girl, received a modelin... contract, a CBS audition and a television set to take home with her.

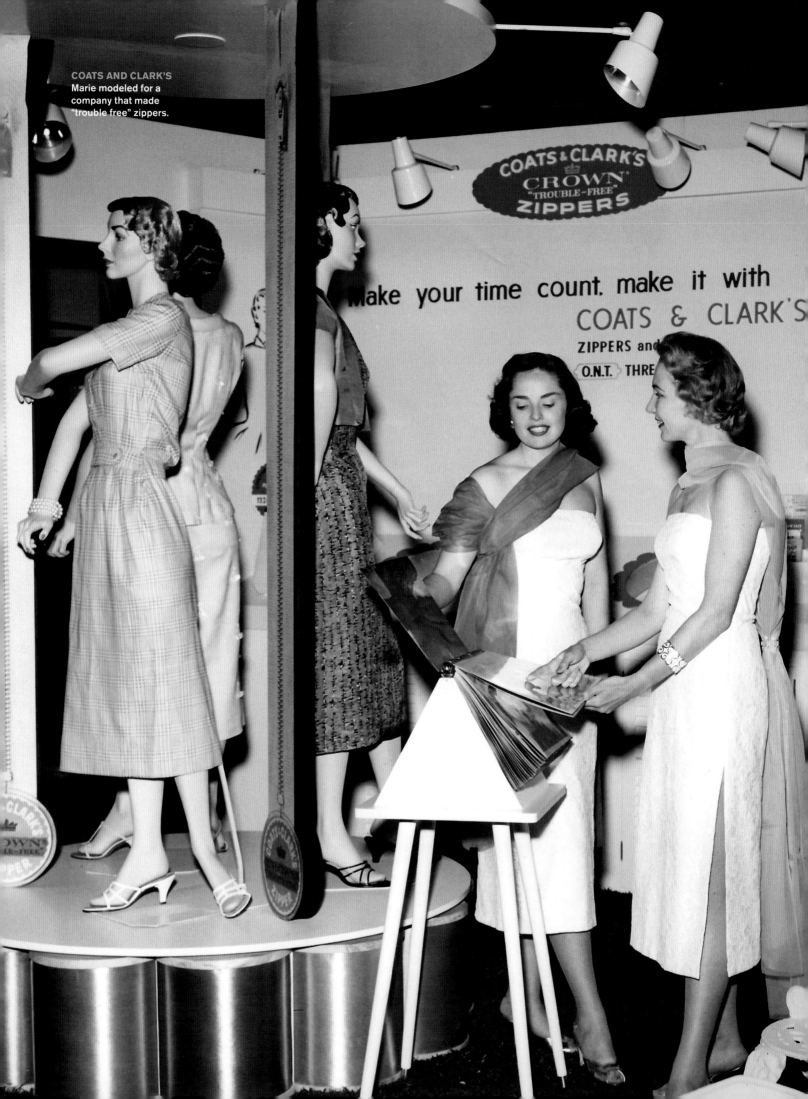

COATS AND CLARK'S
Marie modeled for a company that made "trouble free" zippers.

COATS & CLARK'S
CROWN
"TROUBLE-FREE"
ZIPPERS

make your time count. make it with
COATS & CLARK'S
ZIPPERS and
O.N.T. THRE

I married a nice man from New Jersey. He had been a football star and was supposed to have a full scholarship where he played at Notre Dame, but he was wounded in World War II and was disabled. He became the largest pizza manufacturer in New York, introducing frozen pizza to supermarkets. It was called Nino's Pizza. He also introduced orange juice into the frozen food section. When people didn't have fresh orange juice, they could always get it in cans. He was a bright man.

I modeled for 10 years and then my husband wanted a wife and I was ready then. I was getting older. When I got married at the age of 27, I wanted to settle down. But I never had so much fun in my life as when I was working. I loved it.

'IT' GIRL
(Above) Marie's model shots include a 1948 *Family Circle* magazine cover; the face of a *True Romance* magazine, featuring the story "Don't be scared into marriage" by Jean Nash; and her "ball-and-jacks" looks for a Coca-Cola ad.

Meet Enid Berkowitz Schwarzbaum

MISS SUBWAYS JULY 1946

I was tall for my age in that era and skinny like a noodle. I always thought my friend who was the complete opposite—short and curvy—was so sexy. So, I sent her photograph in for Miss Subways, and they said, "Thank you, but no thank you." Sometime later, I decided to send mine in. I did it as a test: I had not noticed any Jewish names up there and there was going to be no mistake that I was Jewish. I thought they'd send it back, "Thank you, no thank you." Well, they called me for a preliminary shot with John Powers, the hot photographer of the advertising world at the time.

I don't regard being selected as an accomplishment. I think someone who's really done something, who's really given something or made something of himself, that's really an accomplishment. So I did the shot and that was it. I was 20 years old, a senior in college. I was just interested in getting out of school with a qualification to earn a living.

ENID BERKOWITZ SCHWARZBAUM at home amid her art work in Valley Stream, New York 2008.

MEET MISS SUBWAYS

JULY 1946

Creative

ENID BERKOWITZ

Art student at Hunter College—interested in advertising and costume design—makes own clothes—plugging for B.A. but would settle for M.R.S.

John Robert Powers
247 PARK AVENUE

PUBLISHED BY NEW YORK SUBWAYS ADVTG. CO., INC. • 630 FIFTH AVENUE, NEW YORK 20, N. Y.

PHOTOGRAPHED BY **F. A. RUSSO**

ARTISTIC EYE
(Above) Enid's sculpture of the female figure, "Young Girl," made of rose aurora marble in 1972.

"RAGA AEGIS"
(Opposite page) Her abstract sculpture made from pink alabaster in 1967.

I didn't come from the kind of background where I was going to be supported. The only reason I was able to go to Hunter College was that it was tuition free. Nobody in my family had gone to college. My family was all foreign-born. My father was in the garment industry. My mother didn't work. My brother went into the army in World War II, right after high school.

I did a little bit of substitute teaching in the New York City school system. But it really wasn't what I wanted to be doing. I really wanted to be in the business world, and I wanted to be in the art part of the business world. I ended up getting several jobs with advertising agencies where I would do layouts and spot drawings and very basic beginnings of an ad. I worked even after I got married to Leon, until we had our first child. Then I got out because I was a full-time 1950s mom, and I loved every minute of that. But after we had our second child and moved to Long Island, I was getting restless. I needed to get back into art. I needed to take classes. Paul, my third child, was in diapers when I went to school at Adelphi at night. There was no way I could go to class until after everybody had dinner. I took a course in sculpting. That's when I was introduced to stone carving. It spoke to me. There was something about the resistance—maybe I was getting rid of anger.

When Paul was old enough to go to school for a whole day, in first grade, I went to the city to the New School to take classes. I was there for a year when the teacher suggested to the students in the class that we get ourselves a working space. We formed a cooperative sculpture studio at 41 Union Square. What did we know about signing a lease? What did we know about the business end of it? Everyone had to put the money in upfront. There were older women, young women with little children, women with children in college. It was terrific. I lasted there for about 11 years. It was such a support group of women, not only in our work, but also in our private lives.

After that I decided to get back into the business world, for which I wasn't qualified. So I went to the local college to learn how to type, and I became a lousy typist. And there I was—going out on job interviews in my 50s. Eventually I got a job with an investment bank as a schlepper, delivering things from one department to another. Then the personnel person had another job for me with a man who was considered rather difficult to work for. I told her, "I'm married so long, what could be so difficult?" It turned out to be one of the partners in the upper echelon in the company. When he interviewed me, I faked my work experience. I said, "I ran this art studio. I was the managing director." And he said, "Well I think I'd like to take a chance with you." I was with him over 10 years. At first, I was sure I'd be fired. I didn't even know what stocks and bonds were. Meanwhile all of this great material was on my desk every morning. I said to my boss, "Is there some course I could take?" I was relying on other people, the other women nearby or whoever. So, I took a finance course, then another, and another. Well, I started to invest after that. You learn on the job. You just have to get your foot in the door.

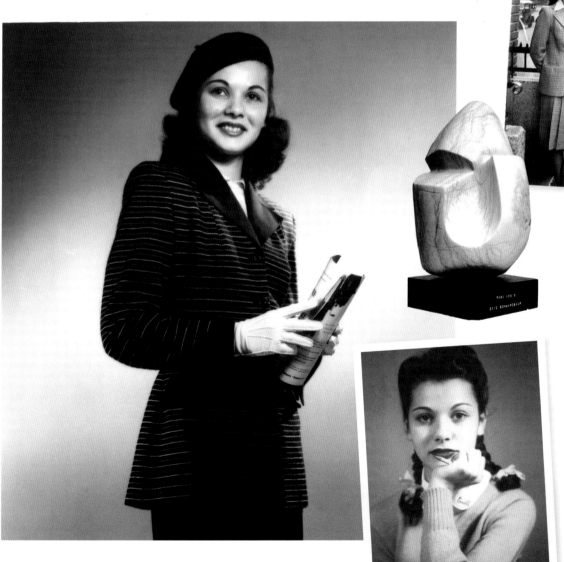

TRADEMARK BERET
(Left) Enid often wore a beret, as she does in this 1946 photo, with a tailored striped knit jacket and gloves. (Center) A braided Enid embroidered her name on her Peter Pan collar.

BEST FRIENDS
(Above) Enid always thought her best friend Lola, pictured with her in the Bronx in 1943, was more beautiful than she was.

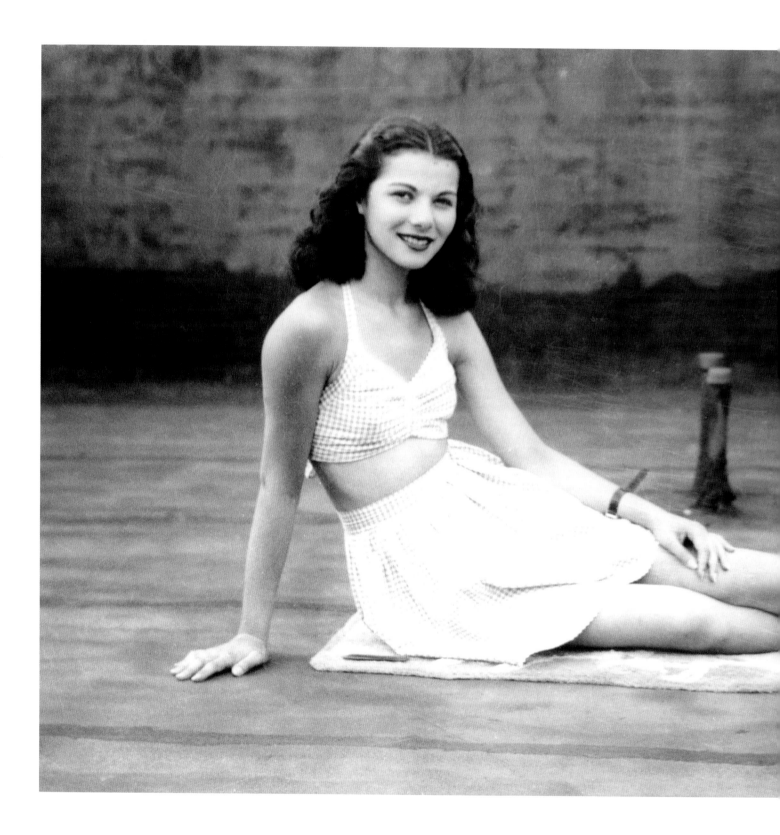

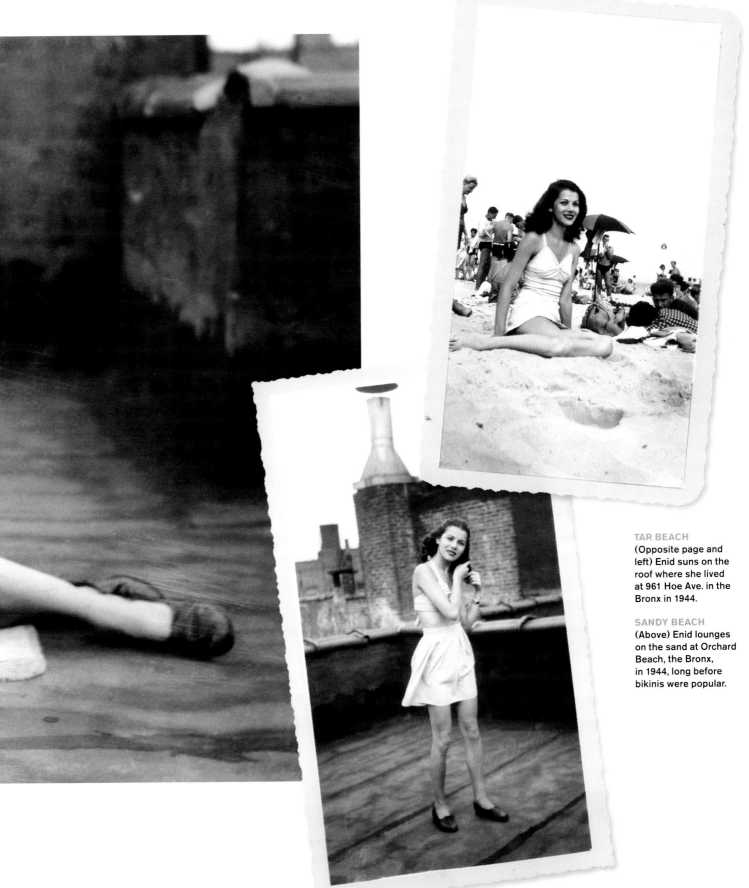

TAR BEACH
(Opposite page and left) Enid suns on the roof where she lived at 961 Hoe Ave. in the Bronx in 1944.

SANDY BEACH
(Above) Enid lounges on the sand at Orchard Beach, the Bronx, in 1944, long before bikinis were popular.

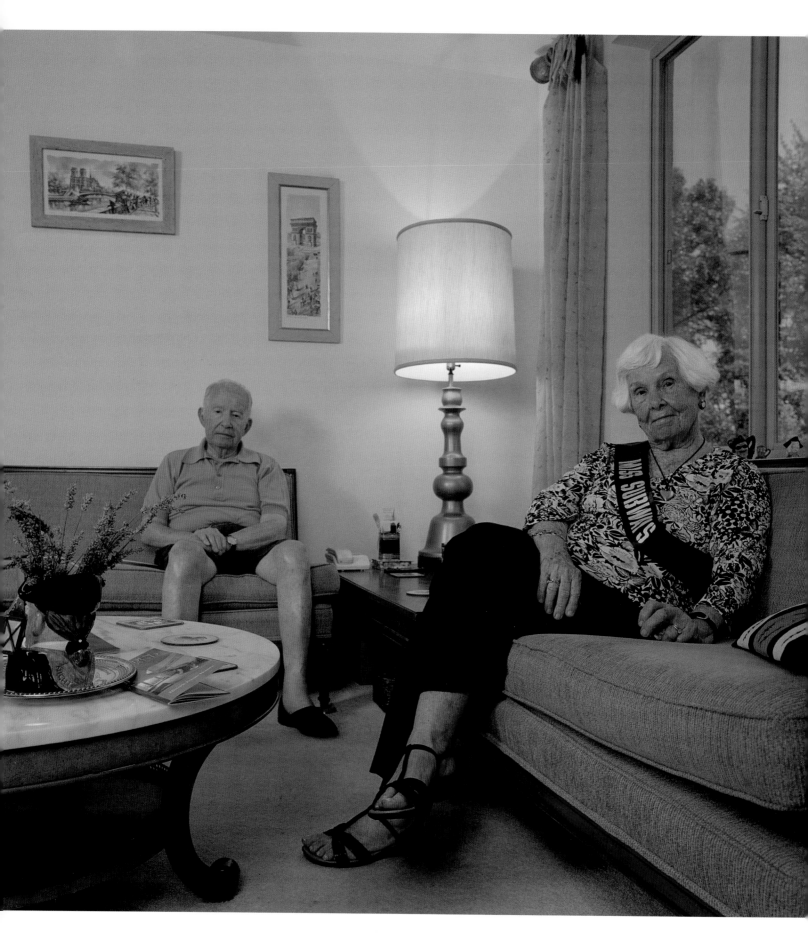

FRANCES SMITH CAULO with her husband in their apartment in Hingham, Massachusetts 2010.

Meet **Frances Smith Caulo**

I remember being on a date and my date and I would sit under my Miss Subways poster and he would observe if anyone recognized me. It was weird seeing my picture, I must say. I had a brother-in-law who was an amateur photographer, always taking pictures. He worked for the city of New York as an engineer, and I believe he submitted the picture to John Powers, and that's how it happened. I also had a cousin who worked for the subways—my father was dead, but he had been a motorman on the subway lines—so this cousin must have gotten, oh, 30 or 40 posters when the time was up so I could give them out to everybody. Three of my children have it mounted and hanging on their living room walls. I had it hanging in the house too, down in the family room, and it was always a topic of conversation. But it was fleeting. It was like 15 minutes of fame.

I never wanted to be a model. Nursing was something I decided very early on that I wanted to do. I grew up in Highbridge, in the southwest part of the Bronx, just north of Yankee Stadium overlooking the Harlem River and the Polo Grounds over in Upper Manhattan. I attended the local parochial schools and Mother Cabrini High School and Hunter College, which was only for females then. They had a campus at 68th Street, which is still there, and then they had a Bronx campus. It was and still is an excellent

MEET MISS SUBWAYS

MARCH 1947

Irish Colleen
FRANCES SMITH

Has R.N. and B.S. degrees from Columbia University—Army Nurse 14 months. Now working in large New York Hospital. Hobbies: Irish folklore and collecting shillelaghs.

247 PARK AVENUE
PUBLISHED BY NEW YORK SUBWAYS ADVTG. CO., INC. • 630 FIFTH AVENUE, NEW YORK 20, N. Y.

PHOTOGRAPHED BY **F. A. RUSSO**

school. After two years at Hunter I enrolled at Presbyterian Hospital for a three-year program and then graduated from Columbia University in 1944 as a graduate nurse.

Those were the war years. I enlisted in the Army Nurse Corps in 1945 with three of my classmates. We went down to Whitehall Street and we insisted that we would enlist if we could stay together, so we did. I guess they must have been desperate. We all enlisted as volunteers and had basic training in Texas, and most of us were employed at Fort Sam Houston, Brooke General Hospital for over a year. We had prisoners of war and returning soldiers because the war was imminently at the end. It was hard work but exhilarating.

When I came back to New York I was employed again at Postgraduate Hospital in the East 20s until I was married in 1949. My husband and I met at postgraduate. It was a blind date and it's lasted more than 60 years. We moved to New Jersey and we had five children. I was not really excited to leave New York. It was a whole new life, but with the coming of children I was so busy, with not enough time in the day. When they started to school I obtained a position as a school nurse teacher in Franklin Lakes where I worked for about 13 years. Not many women worked. Most were stay-at-home mothers. But I had a profession and I could earn money for my children's tuitions and it was local and I enjoyed it. It was very rewarding. I was around new ideas, young children and young teachers. I was meeting people, helping. I felt I should pay them instead of their paying me.

We moved up to Cape Cod in 1982 to the town of Centerville, Massachusetts. We lived there for over 20 years and then retired up to Hingham here in Massachusetts. Most of our children were living in the New England area and we had vacationed here, so it just seemed feasible. The two of us are enjoying retirement and our five children and our grandchildren and leading an easy quiet life.

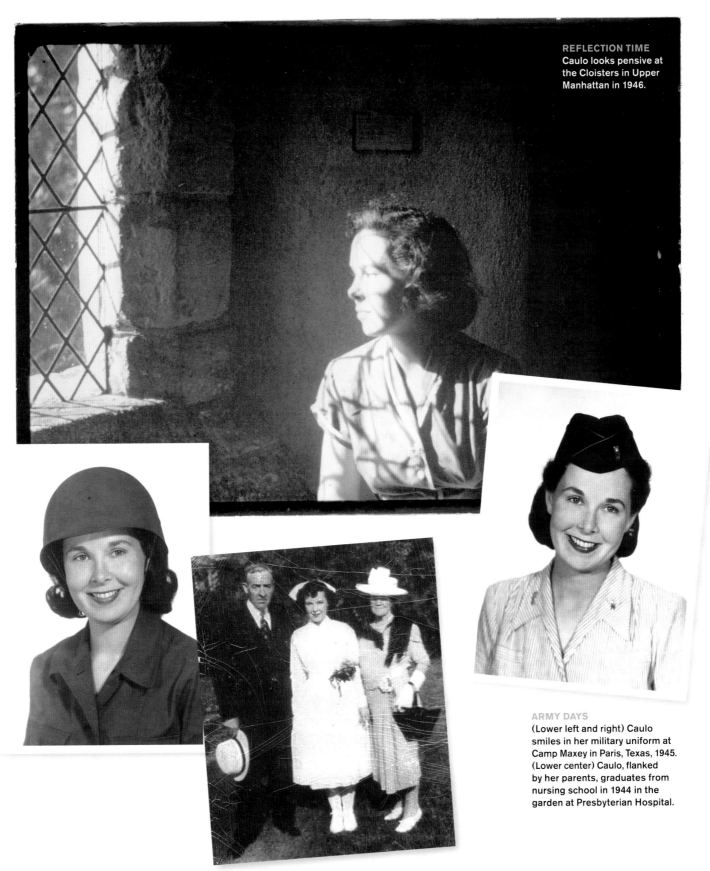

REFLECTION TIME
Caulo looks pensive at the Cloisters in Upper Manhattan in 1946.

ARMY DAYS
(Lower left and right) Caulo smiles in her military uniform at Camp Maxey in Paris, Texas, 1945. (Lower center) Caulo, flanked by her parents, graduates from nursing school in 1944 in the garden at Presbyterian Hospital.

Meet Saralee Singer Pincus

MISS SUBWAYS FEBRUARY 1950

Being Miss Subways was embarrassing. I hadn't wanted that publicity. I didn't think the picture was flattering. I was an intellectual person, and in that sense, I didn't think of myself as pretty. My granddaughter has my poster now. It says I like skiing and sailing, but I made that up. What else was I going to say, likes to read? My husband sent my picture in to the contest. I was 20 years old, and we had just gotten married in 1949.

Just a few months after the poster was up, my husband got a job in Seaford, Delaware, a little town with 3,000 people and 10,000 chickens. He worked for the DuPont Company and I taught school. Going from Flatbush, Brooklyn, to Seaford, Delaware, was a big shock. I didn't even know how to drive a car. My husband later went to work for the New Holland Machine Company in Pennsylvania. We lived there

SARALEE SINGER PINCUS in her apartment in Manhattan, New York 2007.

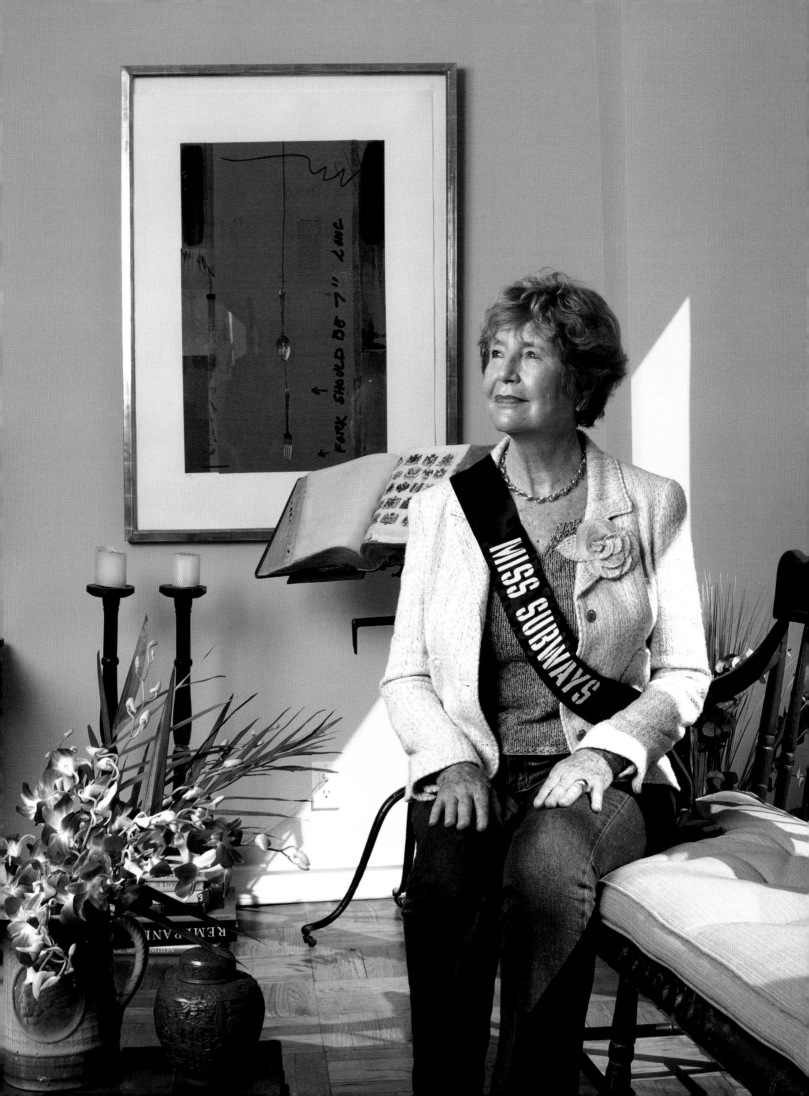

BC Cutie Justifies 10-Cent Fare

New York's Miss Subways Mrs. Nothing But Her Husband

By JACK LEAVITT

On a recent IRT ride, two puzzled girls sat facing Saralee Singer. They stared at her, stared at the photograph of Miss Subways which was posted directly above her head, and mumbled to one another, "That picture up there—nah—it couldn't be her."

Few people, it seems, detect more than a fleeting resemblance between the portrait of the sleepy-eyed turnstile queen for February and the flesh-and-blood appearance of the girl whose features had been embraced by the camera. Saralee, however, is very definitely the transportation system's choice—the third Brooklyn College girl to have reached such depths.

A graduating senior who plans to teach elementary school, Saralee found herself competing for the role of subterranean charmer without any personal i̶t̶

in turn, asked Saralee to pose for them. And the pert miss, not "beautiful" by movie-screen standards, handily won the run-off on the basis of her charm and photogenic attributes.

Tugging at her wedding ring, she assured us that whether or not Mike's efforts enabled her to keep company with beer and deodorant advertisements, "We would have gotten married anyway."

"Going to school and being ⬚⬚d works very nicely," Sara-⬚⬚amed. "In a few years, we ⬚ raise a large family, if—" ⬚⬚llied with the thought— ⬚sband is willing."

⬚ activities does she enjoy

ontinued on Page 6)

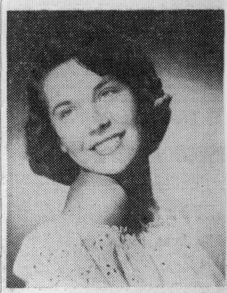

SARALEE SINGER

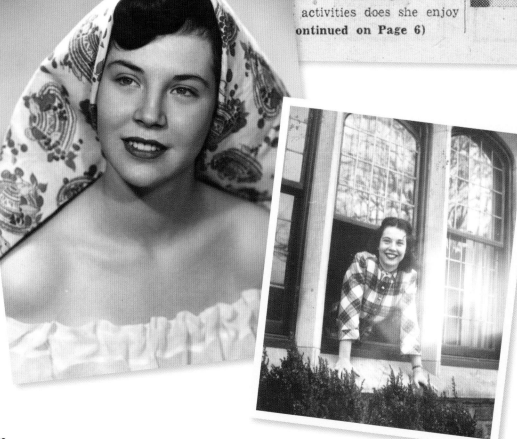

BROOKLYN SWEETHEART
(Top) Saralee makes waves at Brooklyn College as Miss Subways in her senior year.

GOODBYE NEW YORK
(Left) Saralee's husband sent her photo in to the contest. (Right) Shortly after her win they packed up and relocated several times for his work, though Saralee said New York was always home.

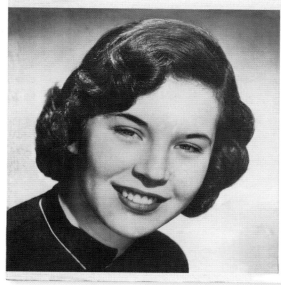

MEET MISS SUBWAYS

FEBRUARY 1950

Charming
SARALEE SINGER

Senior at Brooklyn College . . . preparing to teach elementary school. Recently married her childhood sweetheart. Both love sports: skiing in winter and sailing in summer.

John Robert Powers

247 PARK AVENUE

PUBLISHED BY NEW YORK SUBWAYS ADVTG. CO., INC. • 630 FIFTH AVENUE, NEW YORK 20, N. Y.
PHOTOGRAPHED BY **F. A. RUSSO**

and our children went to school there until we moved back to New York in 1968. Even though we had this big wonderful house and I had done a lot of things—I ran a nursery school for the Jewish community center, I did substitute teaching and I worked for the county with foster children—Lancaster was confining. Our home was really New York and our families were here.

I didn't know what to do when I returned, but I had fruitcake that I made and would give to friends at Christmas. They all said, "You should sell this." And lo and behold, I went into business. We had friends who owned companies and they gave my cake out as Christmas or Thanksgiving gifts. Then the people who got them wanted to know where they came from, so it snowballed. I took it to the head of the food department at Altman's and he liked the cake, but I had to label it, name it, put the ingredients on it and package it. This was in the early 1970s, before there were packaged homemade foods. I worked out of my apartment on East End Avenue. That was a joke. But I only worked during the holiday season, from September until December.

Then I went to Bendel's, and they liked it so much, they said, "What are you going to have for Easter?" So, I thought of another product that my aunt used to make. We called it rugelach, but no one in New York knew rugelach in that day except bakeries that catered to Jewish customers, selling challah and cakes. I called it Betsy's Sweet Fancies and we put them in little baskets. Then we did brownies, and I put those in a bucket. Then it just got too much for my little apartment, and I opened up a shop upstairs on Lexington Avenue and 72nd Street around 1976. Evelyn Lauder would come up and she would send tins to her son William, who's now head of Estée Lauder, when he was studying at the University of Pennsylvania. Jacqueline Kennedy's secretary would come. I had a lot of free publicity because to package homemade things was a brand-new idea. I was written up in *Town & Country* and *Esquire*. *New York* magazine voted me

the best brownie in the city, and Mimi Sheraton had a big write-up about ordering the cake through the mail. I called it Betsy's because that's my daughter's name. I couldn't use Saralee because that company was already famous. Saralee Cummings once came up to the bakery and said, "I've heard of you, and I know your name is Saralee, too. I always wanted to do what you're doing, but my father took my name for his company." She went into the catering business.

When I had the store, it became much more commercial. I hadn't really understood how to go into business, but I learned through an organization called the American Women's Economic Development Corporation. I started to sell not only to department stores like Saks Fifth Ave and Bonwit Teller, but to new stores that were opening up around the city, like Word Of Mouth and Silver Palate, where you could buy home-cooked food. I'd get a yen for a certain cookie and I'd look for recipes and then I'd combine some of them. It was very exciting. It was like a fourth child. I was in complete control and no one answered back. But it was tension provoking and I can't say my husband enjoyed it, so we divorced. The year my youngest son went to college, I was very fortunate because I met someone else. We were together for about two years and then married for about 18 years. He got a big kick out of the business, but I left and brought

HONEY NO. 7

REFRESHING IS THE WORD which aptly describes Saralee Entin, our choice for the Honey No. 7 spot. This 18-year-old former New Yorker, who boasts a magnetic smile and sparkling green eyes, works in the library when not attending classes. A Noble Mason orchid will be presented to Saralee and each Hurricane Honey to appear.

my son in. He made the business even bigger with a wonderful bakery in the Bronx. He supplies stores like Zabars and Fairway, and you can also buy Betsy's Place online.

Eventually I went back to school at NYU where the Folk Art Museum was giving a graduate degree. That's how I started collecting 20th century folk art. I went to New Orleans to buy art from artists like David Butler and Howard Finster and the wonderful woman Clementine Hunter. I had a very happy life with my second husband, who unfortunately died a long time ago. But all the children and grandchildren—both my own and my husband's—love coming to New York. I told the children that I wanted to be cremated and my ashes sprinkled on Madison Avenue, in front of Armani, Sonia Rykiel, Chanel. My stepchildren thought it was hysterical.

ANGELA VORSTEG NORRIS at her apartment complex in Greenacres, Florida 2009.

Meet Angela Vorsteg Norris

I was born in Pottsville, Pennsylvania. I was 18 when I left—I thought I was going to be a movie star. I used to go down to my basement and sing and do all kinds of things like that. I knew I had to have a career and wanted to end up in New York.

I was the oldest of 11. My father was a salesman. He was having all kinds of medical problems and was out of work for a while. There were too many of us, too many mouths to feed, so the three older girls—all of us one year apart—rented a furnished room together in West Redding, splitting the rent. Another girl we knew was going to Key West and I decided to take the bus with her even though I wanted to go to New York: just to get out of Pennsylvania. I told one of my sisters I was leaving, but I didn't have the nerve to tell my mother. At some point on the ride a state trooper stopped our bus and my friend said to me, "Your father probably has a search out for you. We have to change your name. How about Darlene Sanders?" So when I first started modeling I was still using that name. I changed it back later.

My husband was a Manhattan man. I met him in a diner the second week in Key West. He was getting a divorce, and Florida was the place to go for that at the time. It was easier than up North. Some guy had taken me out to dinner earlier that night, to one of those fancy restaurants. I was young and I didn't know which knife to use. I had to watch everything my date did and I didn't enjoy it, so when he dropped me off at my

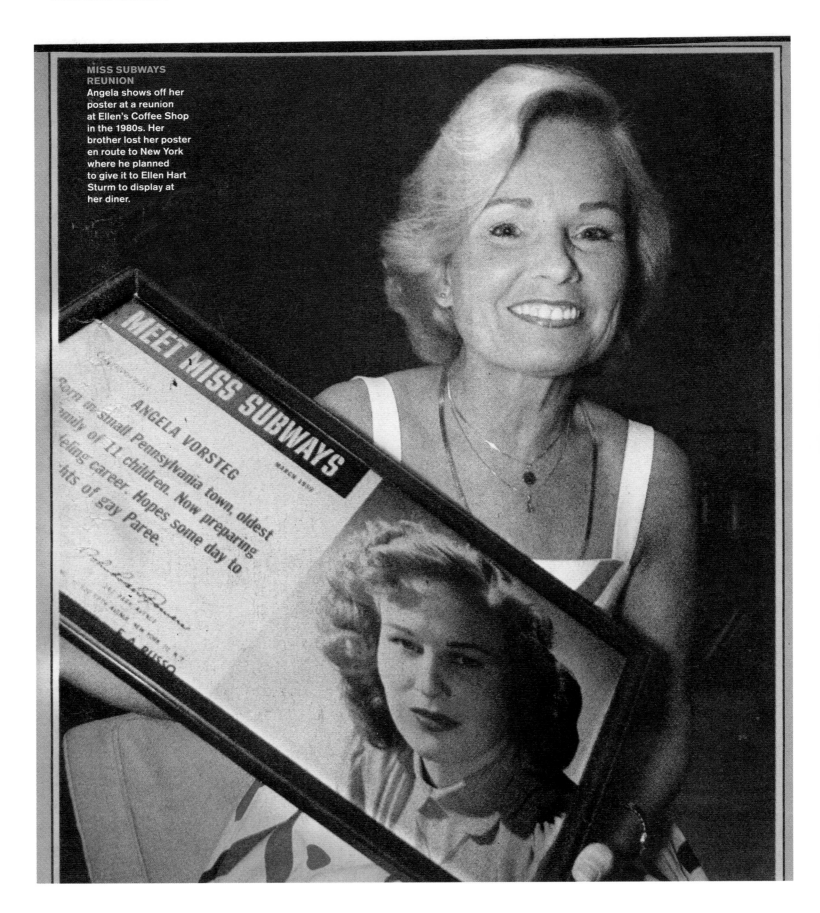

MISS SUBWAYS REUNION
Angela shows off her poster at a reunion at Ellen's Coffee Shop in the 1980s. Her brother lost her poster en route to New York where he planned to give it to Ellen Hart Sturm to display at her diner.

MEET MISS SUBWAYS

MARCH 1950

ANGELA VORSTEG

Born in small Pennsylvania town, oldest of family of 11 children. Now preparing for modeling career. Hopes some day to see sights of gay Paree.

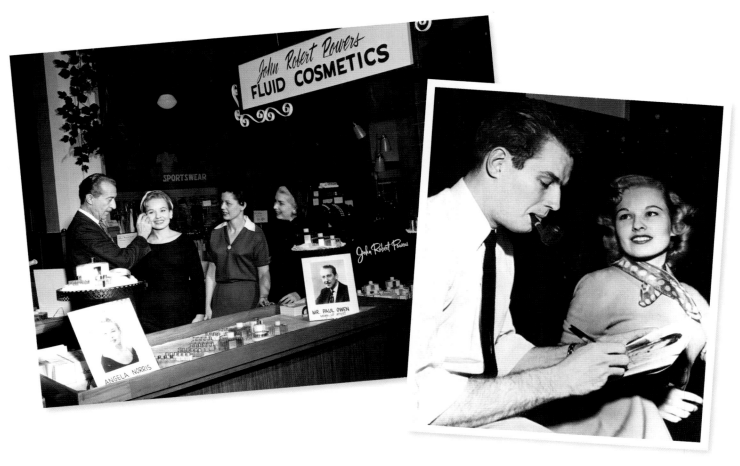

hotel I was still hungry. I went into the coffee shop, and that's when I met my husband. We went together to New York.

We first lived all the way at the end of the line in Manhattan in Spuyten Duyvil overlooking the Hudson River. I'd look out my window and there was the Columbia crew team rowing down the river. Then we moved downtown, and that was fine with me since I was modeling and could take the bus or walk to the go-sees. I'm only 5'4'' and I would put matchboxes in my heels when I went on a go-see because I was considered short. People told me, "You're too short for high fashion, but you have a great head."

It was my husband who brought my picture over to the John Robert Powers model agency. They asked me to come in for a photograph, and that's how I became Miss Subways and a John Robert Powers model. My husband encouraged me to model, but I did have one opportunity where he held me back— a photo shoot on a cruise to Europe that would have taken me away for a couple of months or more. I did travel a lot when I was working for John Robert Powers cosmetics, when I had a 3-month old son, but it was only a week at a time. Every week it was a different place: Bangor, Maine; Lincoln, Nebraska; Lafayette, Indiana. I'd go to department stores and use a machine called a cosmeticscope. It showed you the shade of your skin to match with the makeup. It wasn't that successful.

I had a great career in my seven years of modeling. I remember meeting Charlton Heston for a photo shoot. I was supposed to be a teenage fan of his looking at him

MAKEUP ARTIST
(Above left) As a John Robert Powers model, Angela promotes cosmetics, demonstrating the look of a new foundation.

TEENAGE FAN
(Above) Angela plays the role of a star struck girl for a photo shoot with actor Charlton Heston.

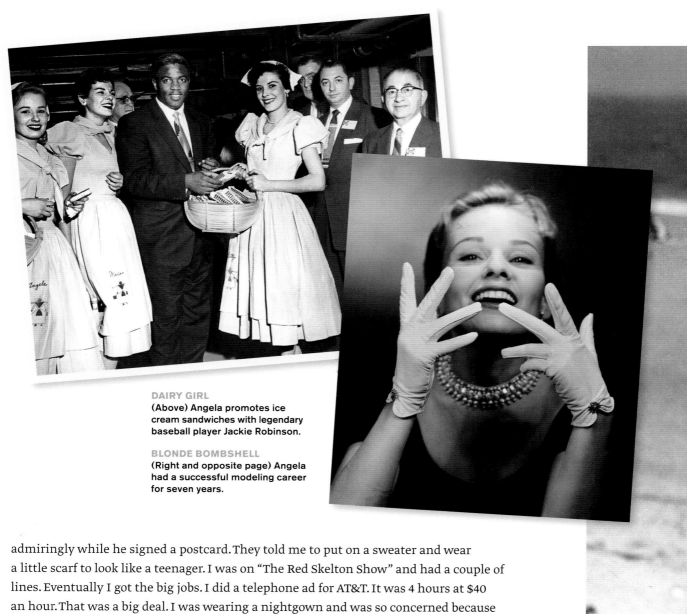

DAIRY GIRL
(Above) Angela promotes ice cream sandwiches with legendary baseball player Jackie Robinson.

BLONDE BOMBSHELL
(Right and opposite page) Angela had a successful modeling career for seven years.

admiringly while he signed a postcard. They told me to put on a sweater and wear a little scarf to look like a teenager. I was on "The Red Skelton Show" and had a couple of lines. Eventually I got the big jobs. I did a telephone ad for AT&T. It was 4 hours at $40 an hour. That was a big deal. I was wearing a nightgown and was so concerned because they wouldn't let me wear anything underneath. They said don't worry if anything shows, we'll airbrush it. The pictures were on the sides of all the telephone trucks at the time. There was a photo of me with a white phone and a red phone—before that, phones were all black. These had a light-up dial, too, which is why the pictures are in the dark. I also did a commercial for Kodak or some film company—the shoot was a day at the beach. I'm in a bathing suit with my Marilyn Monroe smile. That's what they were looking for at the time.

I always loved New York. I used to meet my girlfriends at the Plaza Hotel for cocktails. They always had a violinist come over to us and play. After my modeling career I did makeovers at Saks Fifth Avenue and Bonwit Teller. When my husband and I left Manhattan for New Jersey, we moved just across the George Washington Bridge, so we weren't too far. That meant a lot to me.

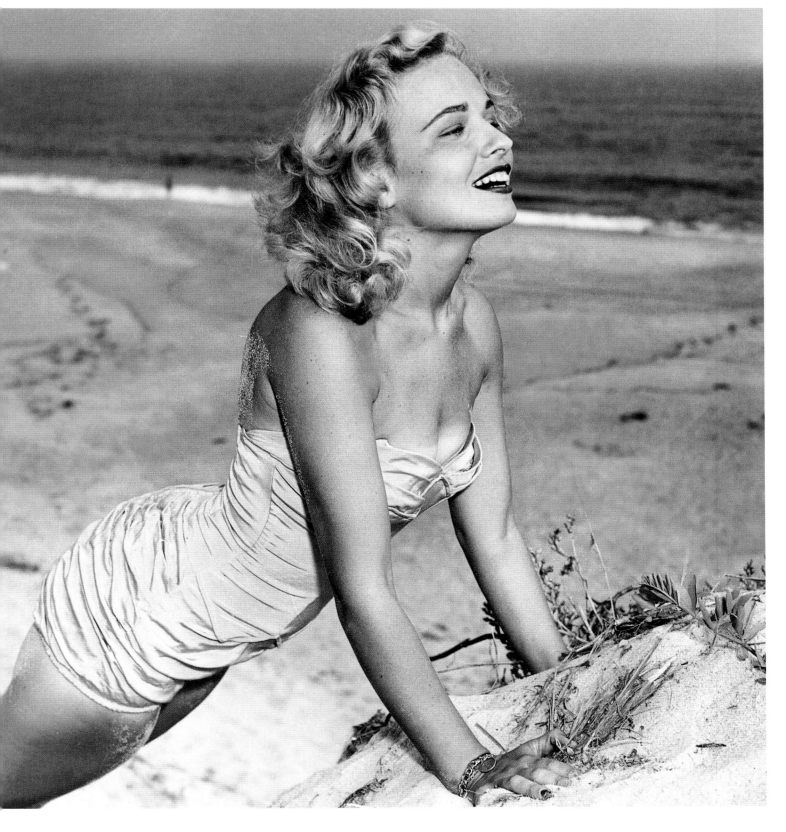

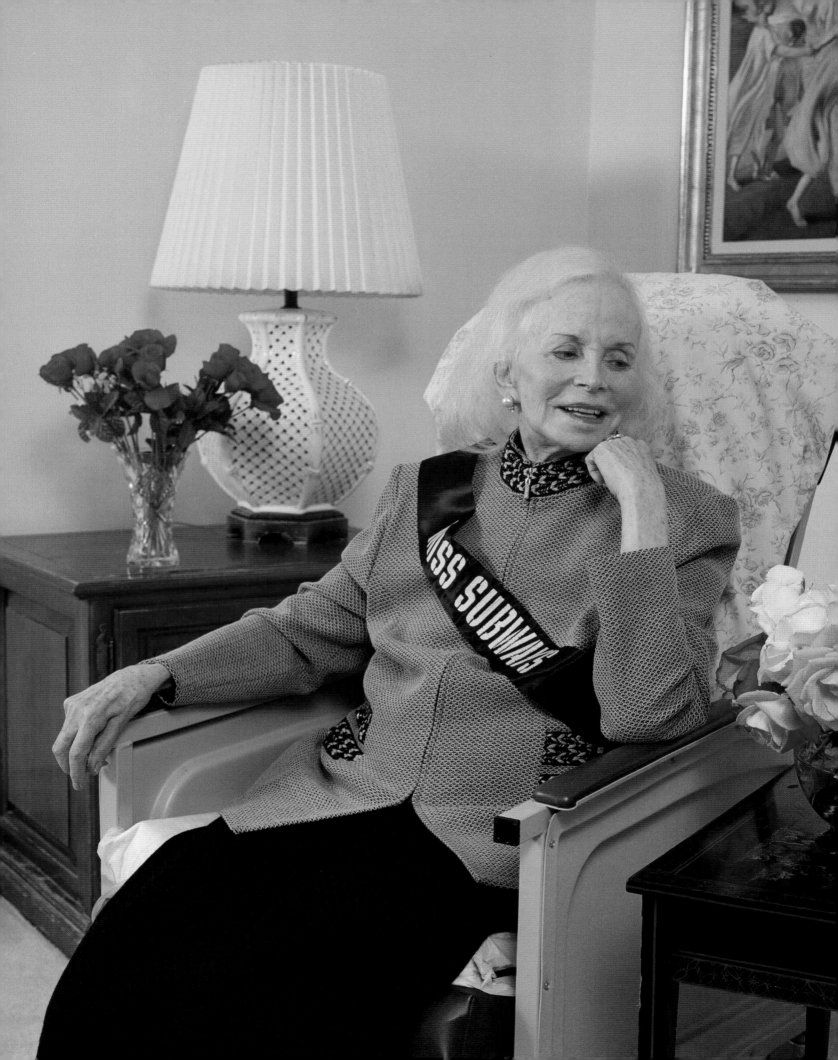

Meet Patti Freeman Gilbert

MISS SUBWAYS MAY 1950

This is from interviews with Patti's daughters, Gina Moffitt and Laurel Phillips. Patti passed away after being photographed.

Laurel: My mother knew she wanted to lead a talented, glamorous life. She didn't come from a family that revered that at all. My grandmother cared about being smart and going to school and being thrifty and very efficient at what you do. My mother was the complete opposite. She couldn't wait to run off and have amazing adventures. She went to High School of Music & Art, which was in Harlem at the time, and had fun classmates who later became big deals.

My mother was a model from the age of maybe 16 or 15 with John Robert Powers, and I believe the agency would submit ladies for the Miss Subways contest. I think the modeling agency submitted her last name as Freeman, which

PATTI FREEMAN GILBERT at her home in Los Angeles, California 2010.

83

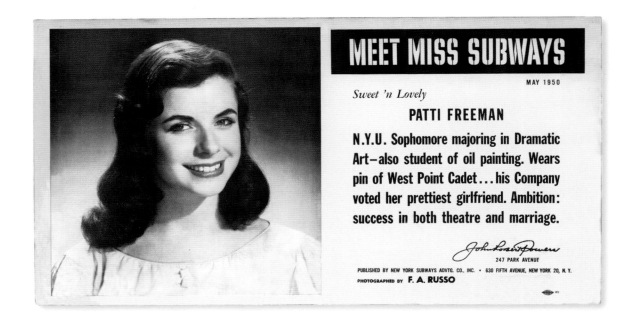

MEET MISS SUBWAYS

MAY 1950

Sweet 'n Lovely

PATTI FREEMAN

N.Y.U. Sophomore majoring in Dramatic Art—also student of oil painting. Wears pin of West Point Cadet...his Company voted her prettiest girlfriend. Ambition: success in both theatre and marriage.

247 PARK AVENUE
PUBLISHED BY NEW YORK SUBWAYS ADVTG. CO., INC. • 630 FIFTH AVENUE, NEW YORK 20, N. Y.
PHOTOGRAPHED BY **F. A. RUSSO**

was never legally her name. It was always Friedman. But they thought maybe that would be too ethnic so they changed it. She didn't care and never kept that name going forward.

At that time my mother was dating my father, Henry Gilbert, who was a West Point cadet. It was a big deal if you were dating a cadet. You could go to these impressive parties and weekends. She was a freshman at NYU in the drama school. Then she was married and went to Germany with my dad, who had foreign service after graduating. I was born in Germany. Later, my father resigned his commission because my mother didn't like the army life. He went to work for his own father in Chicago, and my sister was born in the suburbs of Chicago in 1954.

Gina: My mother was kind of a prominent stage actress in Chicago. She was the leading lady in a group of players that did all these plays in repertory. I remember I used to memorize her plays. She did that for many years until we came to California when I was in eighth grade. It was her dream to come to California and pursue acting.

Laurel: It took a long time for her to get there. My parents got divorced in 1960 or '61 and my dad would not let us leave the state of Illinois. It wasn't until 1967 that she was able to make the court believe she could earn a better living if she was able to move to California.

She met Hank Saperstein, who owned United Productions of America, a movie studio and film library for television near Burbank studios, in '65 or '66 and married him in 1967. That's how we got ensconced in Beverly Hills. I think that little bit of celebrity as Miss Subways really gave her the taste of what she would go after and eventually achieve, to move to Hollywood and live in Beverly Hills and marry a Hollywood producer.

Gina: She was never really famous, but she did smaller stuff on television and with voiceovers, and she worked hard. On "Batman," she was King Tut's girlfriend, Shirley. She told me that the costume they gave her was one Elizabeth Taylor wore in Cleopatra.

HAMBURGER U
Patti poses in a film still from an industrial short for McDonald's. Ray Croc founded Hamburger U, "The Harvard of the fast food industry," in 1961.

CHARACTER ACTRESS
(Top) Patti in a promotion still for the play "The Little Hut" with Bob Michaels, left, and Lew Prentice, right. Funny Face. (Above and left) Two of the headshots Patti used to land roles on TV and in movies.

I don't know if that's true. She was more well-known as the "pen dart murderer" in "Get Smart." She was on "That Girl" and "All in the Family." She did a lot of commercials and a ton of radio. She was an amazing mimic, too. She did Marilyn Monroe and Katharine Hepburn. Her Katharine Hepburn was so good that for a radio ad she did, Katharine Hepburn complained.

My mother was larger than life. She was kind of an Auntie Mame character and an amazing friend to hundreds of people in the industry. We would have parties a lot. She tried to help them and their careers. **Laurel:** She was just a wonderful talent scout and had a huge heart. If someone she met and liked wanted to meet somebody or be fixed up on a date or didn't have a nice dress, my mom was like a one-person wish-fulfillment center. She would, within her powers, do whatever it took to make that someone happy. She kind of ended up as a little pied piper with a nice following, because people appreciated the fact that if they came to California and didn't know anybody they got invited to Patti's parties.

She had celebrities in and out of her home with those parties, glamorous surroundings, glamorous cars and clothes. My mom just sparkled with that. She loved to hold court at the polo lounge of the Beverly Hills Hotel or at the Bel Air Hotel, places she thought were so beautiful. She would encamp herself and make friends with all of the waiters and maître d', and the man who played piano at the Beverly Hills Hotel would take her requests.

Even though my sister and I didn't choose to live in such glamorous surroundings or follow that path, it still was a good role model for confidence. She had that kind of feeling that life isn't a dress rehearsal and you need to live as full a life and love as many people and not be hung up about too many mores. She really knew what she wanted and never faltered ever.

GLAMOUR GIRL
Patti was never a leading lady, but she had steady work in television and voiceovers in Hollywood.

Meet Irene Scheidt Finnican

MISS SUBWAYS JUNE 1950

I was fortunate to get a position just out of high school at the New York Stock Exchange at a front desk, where I was the first person people would see when they came in to the personnel department. At that time everyone wore hats, gloves and heels and took pride in their appearance. I worked on Wall Street from 1946 to 1955 and loved the hustle and bustle. There was a New York Stock Exchange strike in 1948 and I had to pass picket lines to go to work. Bullhorns were at your eardrums when entering the building. They area was roped off, so that you had to pass a picket line three or four deep. These men would follow you the whole block when you tried to enter the subway. A lot of people stayed overnight in the building and it was very scary. You had to be very careful going home.

Our elevator operator was asked to pick a person, who he thought was attractive, to enter the Office Orchid contest.

IRENE SCHEIDT FINNICAN with her dog at her daughter's home in Palm City, Florida 2009.

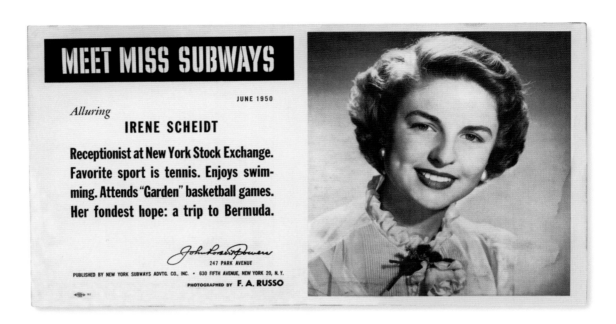

MEET MISS SUBWAYS

JUNE 1950

Alluring

IRENE SCHEIDT

Receptionist at New York Stock Exchange. Favorite sport is tennis. Enjoys swimming. Attends "Garden" basketball games. Her fondest hope: a trip to Bermuda.

247 PARK AVENUE

PUBLISHED BY NEW YORK SUBWAYS ADVTG. CO., INC. • 630 FIFTH AVENUE, NEW YORK 20, N. Y.

PHOTOGRAPHED BY **F. A. RUSSO**

He apparently elected me, and we went to the Latin Quarter where Rudy Vallee presented everyone with an orchid. I happened to be one of the 10 finalists, and of these 10 finalists, five were eliminated, and we five who were eliminated became very good friends. After Miss Orchid I became Miss Surfmaid at Rockaway Beach, June of 1949. A photographer from the *New York Journal-American* recognized me at the beach from the Miss Orchid contest and said, "If you put a bathing suit on, I'll take your picture." A girl I didn't even know took her bathing suit off and loaned it to me for the photo shoot. I sat on a jetty and he took my picture. With today's sanitary codes, this would never take place.

Then one day while going to work on the subway, a man came through the car and said, "You see that lady up there? She's Miss Subways." He worked for John Robert Powers, the modeling agency. He gave me a business card with his telephone number and address. My mother thought it was a scam, but we called, and it was legitimate. Through the contest I got a trip to Bermuda. I still have the photo from the *New York Daily Mirror* of me boarding the plane. A real estate agency in Glendale sponsored this trip because they wanted the advertising. They gave Miss Subways her "fondest hope"— a trip to Bermuda.

Then, I just put all of the articles and photos in envelopes in a box. Do you think I made much of it? At that time, it was just part of my life unfolding. I was busy and preparing to get married. I met my husband in 1952, and we got married the following year. We met at a dance at the Knights of Columbus in Brooklyn. My husband was a super dancer and a great singer. He was in the wrong job as a Police Lieutenant for New York City. He did sing with the New York City Police Glee Club until it disbanded.

We moved to East Meadow, Long Island, where I worked for a driving school. I did everything—answered the phone, scheduled the lessons, gave lessons. By then I had learned to drive. My husband taught me. He said, "Here are the keys, honey. Drive me to

work." It was crazy, but that's a New York City police officer for you. When I taught driving it was so different. We had dual control cars. I thought, if I ever told them how I learned on a New York State parkway, they'd be shocked.

In the 1980s I started working as a paraprofessional for autistic children at a public school that had a section for Special Education. We not only taught lessons but how to dress properly. I was also going to Queens College for secretarial work because to go from a paraprofessional to secretary increased my salary. I was eventually assigned to the Board of Education office in Manhattan.

CAREER GIRL
Irene, a receptionist at the New York Stock Exchange and volunteer for the New York City Cancer Committee, was a finalist in the Office Orchard Contest, where Rudy Vallee presented her with an orchid at the famed Latin Quarter.

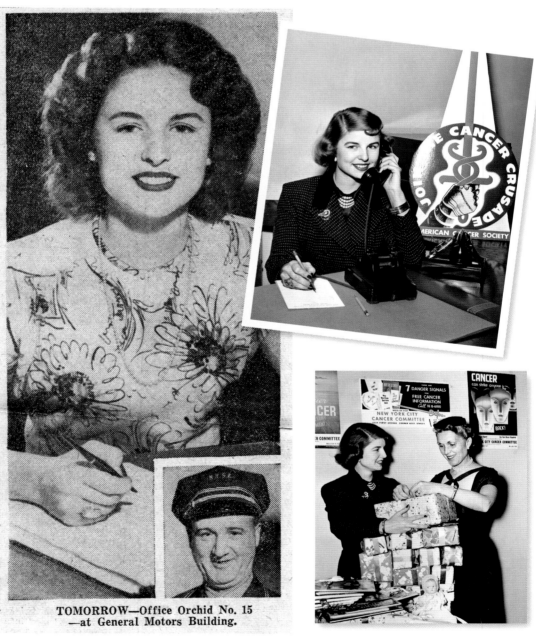

Office Orchid ...No. 14

The great financiers that keep their fingers on the financial pulse of the world at the New York Stock Exchange Building, 11 Wall st., command a great deal of attention.

But they don't attract half as much as lovely Miss Irene Scheidt, 20, personnel department receptionist in that great stock and bond trading center.

"Sure she's our prettiest, but she has the nicest disposition in the world," said chief starter William Broderick. "That's why she gets my vote.

A falling market doesn't dim the day for the brokers when Irene comes around. A great natural beauty, she is 5 feet 3 inches tall, weighs 120 lbs. and her hazel eyes complement her ligvht brown wavy hair.

Miss Scheidt, who lives at 77-13 65th st., Glendale, is a graduate of Richmond High School and studied personnel administration at N. Y. University. An ardent basketball fan, she plays piano "but only for my own entertainment."

A former child model, she thinks the finance world more glamorous than a modeling career. Her busy day is spent in pre-employment interviewing and figuring out the personnel payroll.

TOMORROW—Office Orchid No. 15 —at General Motors Building.

From Orchid to Surfmaid

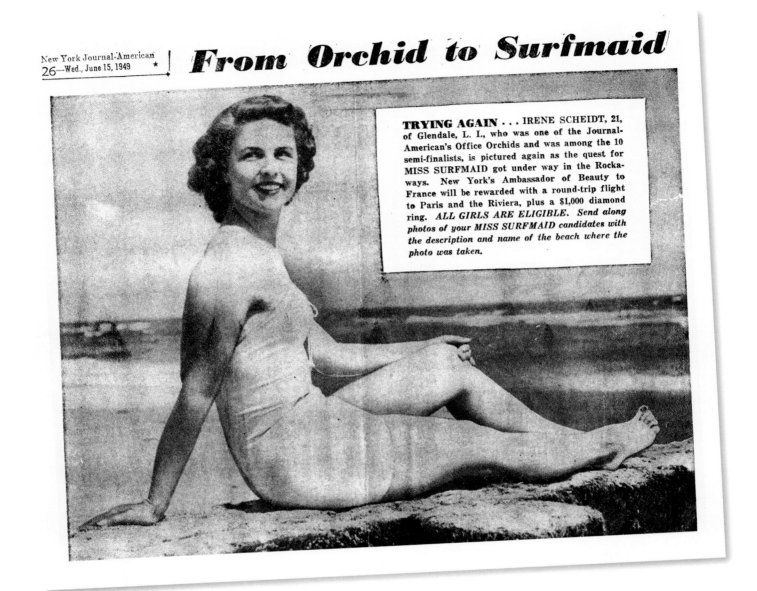

New York Journal-American
26—Wed., June 15, 1949 ★

TRYING AGAIN . . . IRENE SCHEIDT, 21, of Glendale, L. I., who was one of the Journal-American's Office Orchids and was among the 10 semi-finalists, is pictured again as the quest for MISS SURFMAID got under way in the Rockaways. New York's Ambassador of Beauty to France will be rewarded with a round-trip flight to Paris and the Riviera, plus a $1,000 diamond ring. *ALL GIRLS ARE ELIGIBLE. Send along photos of your MISS SURFMAID candidates with the description and name of the beach where the photo was taken.*

ROCKAWAY BEACH
Irene borrowed a bathing suit from a stranger to become a contender for Miss Surfmaid in 1949.

All of our friends and family followed my daughter Nancy, a registered nurse, to Florida. When I had a heart attack in 2005, I drove myself to the hospital emergency room at South Hospital because Nancy worked at North Hospital and I was afraid to worry her. They airlifted me in 9.5 minutes to another hospital in West Palm Beach where three stents were inserted, and I'm as good as new.

I went back to work because every day you wake up and say, "Why am I here?" I chose working for a rehab center, and it was very fulfilling. My dog, Freddie, went with me daily and helped cheer up the wheelchair patients that came to the reception desk. Now, I am retired—for the third time. At 84, I smell the flowers and am happy to be sharing this Miss Subways moment. Now I have a new "fondest hope," which is a seat at the finale of "Dancing with the Stars."

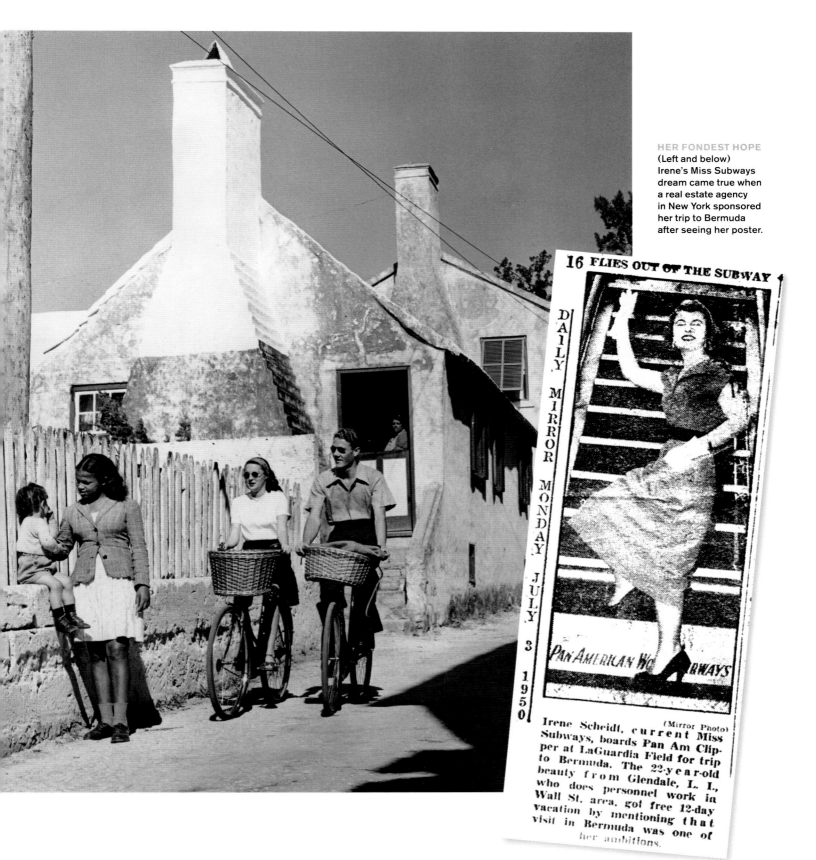

HER FONDEST HOPE
(Left and below)
Irene's Miss Subways
dream came true when
a real estate agency
in New York sponsored
her trip to Bermuda
after seeing her poster.

16 FLIES OUT OF THE SUBWAY

DAILY MIRROR MONDAY JULY 3 1950

PAN AMERICAN WO BWAYS

(Mirror Photo)
Irene Scheidt, current Miss
Subways, boards Pan Am Clip-
per at LaGuardia Field for trip
to Bermuda. The 22-year-old
beauty from Glendale, L. I.,
who does personnel work in
Wall St. area, got free 12-day
vacation by mentioning that
visit in Bermuda was one of
her ambitions.

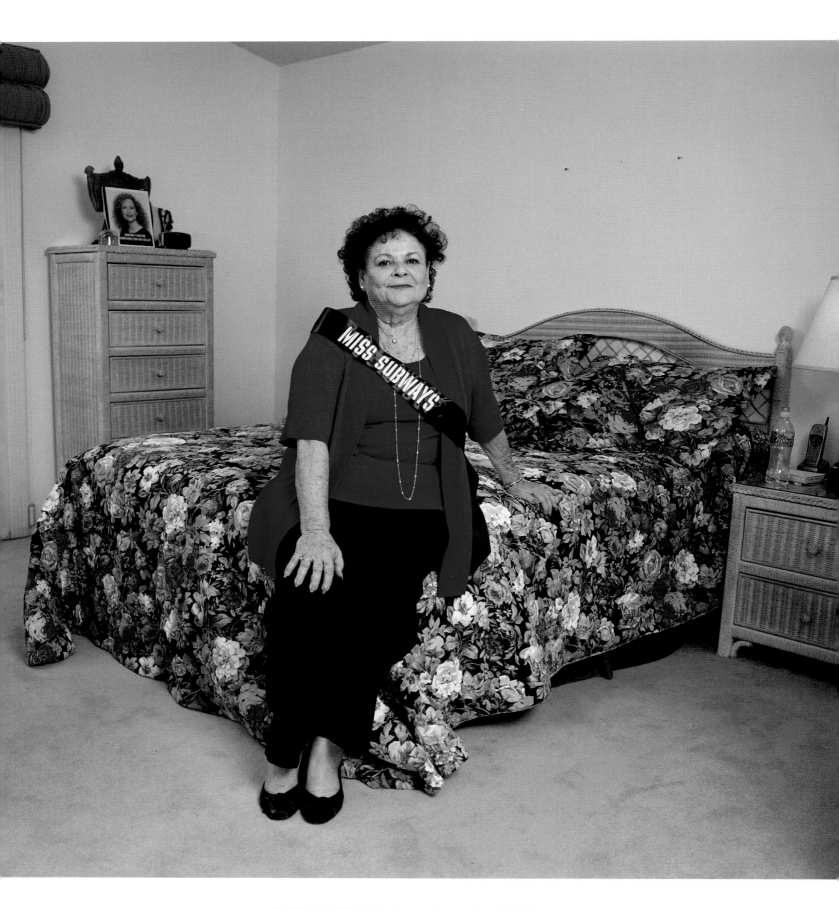

FRANCES CARTON at her home in Coconut Creek, Florida 2009.

Meet Frances Carton

MISS SUBWAYS JANUARY 1951

When I was six months old, I had my ears pierced, but when I came to the United States at the age of four, I refused to wear earrings. I didn't want anyone to think I was a foreigner. At that time, children here didn't wear earrings. You came to the United States and you wanted to be American. I didn't put earrings on again until my eldest daughter was 16 and had a pair made for me.

I was surprised that my Miss Subways poster said I was born in Cuba. I wasn't going to lie and say I was born in America, but none of my friends knew. We didn't speak Spanish at home in East New York, Brooklyn. We spoke Yiddish. My mother was from Poland. My parents married in Poland and went to Cuba in 1928. They were trying to save enough money to bring my mother's family over. She had four sisters and two brothers and her mother. Her father had died earlier. After a couple of years, my father left Cuba for New York to start work here. He was a tailor and my mother was a seamstress. My mother was able to send $10 a month to Poland, but her mother wrote back, "Don't send any money because we're not getting it." They weren't able to leave Poland. Unfortunately, her whole family was wiped out in the concentration camps.

I got married in 1947, right after I finished high school when I was 17. I had gotten a scholarship to study art at Cooper Union, but since I was getting married, I didn't go. My husband mailed in my high school graduation picture to the Miss Subways contest. I had been ill at the time and I was bedridden when they called me to come in for an interview for Miss Subways. I said, "No, I think you have the wrong person. I'm not a

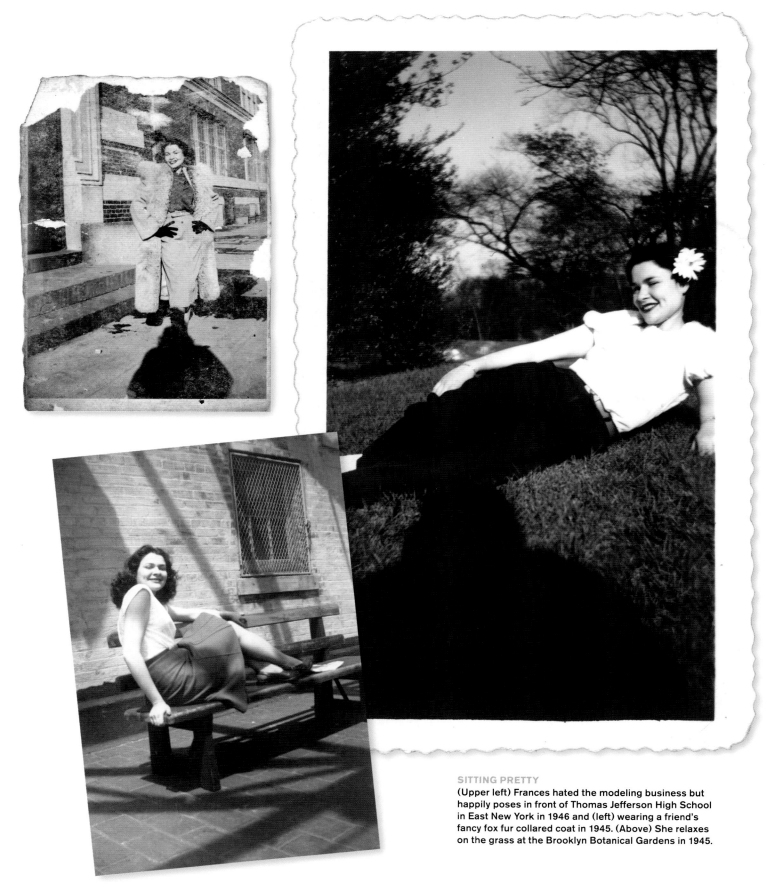

SITTING PRETTY
(Upper left) Frances hated the modeling business but happily poses in front of Thomas Jefferson High School in East New York in 1946 and (left) wearing a friend's fancy fox fur collared coat in 1945. (Above) She relaxes on the grass at the Brooklyn Botanical Gardens in 1945.

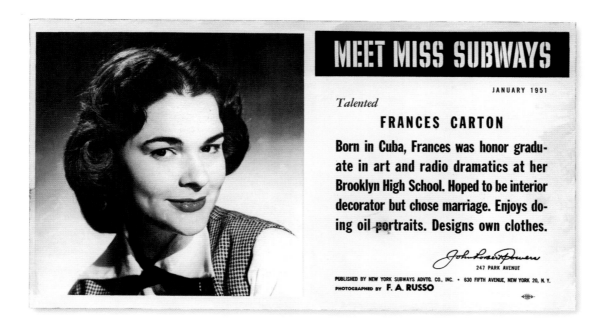

MEET MISS SUBWAYS

JANUARY 1951

Talented

FRANCES CARTON

Born in Cuba, Frances was honor gradu-
ate in art and radio dramatics at her
Brooklyn High School. Hoped to be interior
decorator but chose marriage. Enjoys do-
ing oil portraits. Designs own clothes.

247 PARK AVENUE

PUBLISHED BY NEW YORK SUBWAYS ADVTG. CO., INC. • 630 FIFTH AVENUE, NEW YORK 20, N. Y.
PHOTOGRAPHED BY **F. A. RUSSO**

Miss for Miss Subways. I'm married." They said they sometimes had married women. I said, "No, I'm sure if you keep looking, you'll find the right one." They insisted, so finally I made the appointment, and again I had to cancel because I still wasn't well enough to go. I thought that would be the end of that, but they called me again and I went in. My poster actually stayed up from January through April because there was a subway strike and they didn't take anything down.

I did some modeling of junior coats and suits and rainwear for a clothing company after that. I hated it. One of the girls was really competitive. I remember I was told to show a certain outfit, but before I had a chance to go back into the dressing area, she already put on my outfit. After that I went back to my first job as a dental assistant, and that's where I ended my career. I kept working all through because my husband was going to school at the time for engineering. We moved to Long Island when we had two little girls. I didn't mind moving from Brooklyn because I couldn't stand where we lived, but Long Island was cow country. We faced very difficult times there because one of the big war plants was out on strike and there was just no money. My husband would go out and fix TVs and not get paid. Later he got a job with "Good Morning America," working up from maintenance to senior video operator. He had his own studio and had to make sure that all the film from California, Chicago or wherever all had the same colors. He had to be in at 2 o'clock in the morning. I would drive him to the train station.

My husband and I didn't go to college, but to me it was important for my daughters to get an education. Jewish mothers are that way. Both my daughters are attorneys. I remember when my older daughter, Sharon, called my younger one, Robyn, and said, "I think you should take up law because you'd be great at it." And Robyn asked me, "If I become pregnant would you be willing to watch the baby while I go to law school?" I said yes, and that's what I did for three years. That granddaughter is now also an attorney.

Meet MISS TURNSTILES
Sono Osato

"ON THE TOWN," 1944

I danced as a child always. Then when my mother took us to France for two years—she had a French background, my father was Japanese—we went to see Diaghilev's Ballet Russes. I said, I want to do that with those people. When I got back to America I studied one day a week: Saturday. The Russian girls went to class five days a week but in America, little girls just did Saturdays. I joined Diaghilev when I was 14 and learned to dance there. I used to sleep backstage. I was still young. When you're that young you're so ignorant that you do things you wouldn't do when you're 18. Everything was all new and strange and wonderful.

I was one of the first Americans to join the company. I stayed for six years. The company brought the culture to America. We toured America and Canada—90 cities in two months. We went to places like Butte, Montana and Hershey,

SONO OSATO in her apartment in Manhattan, New York 2008.

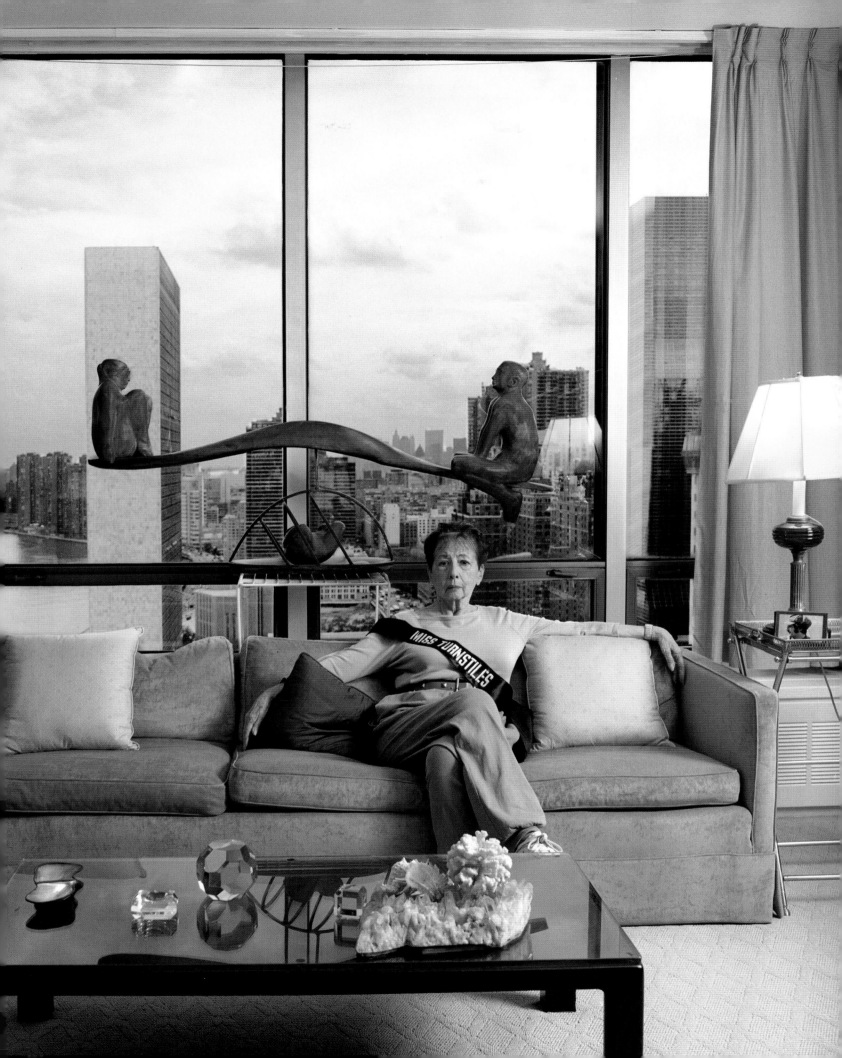

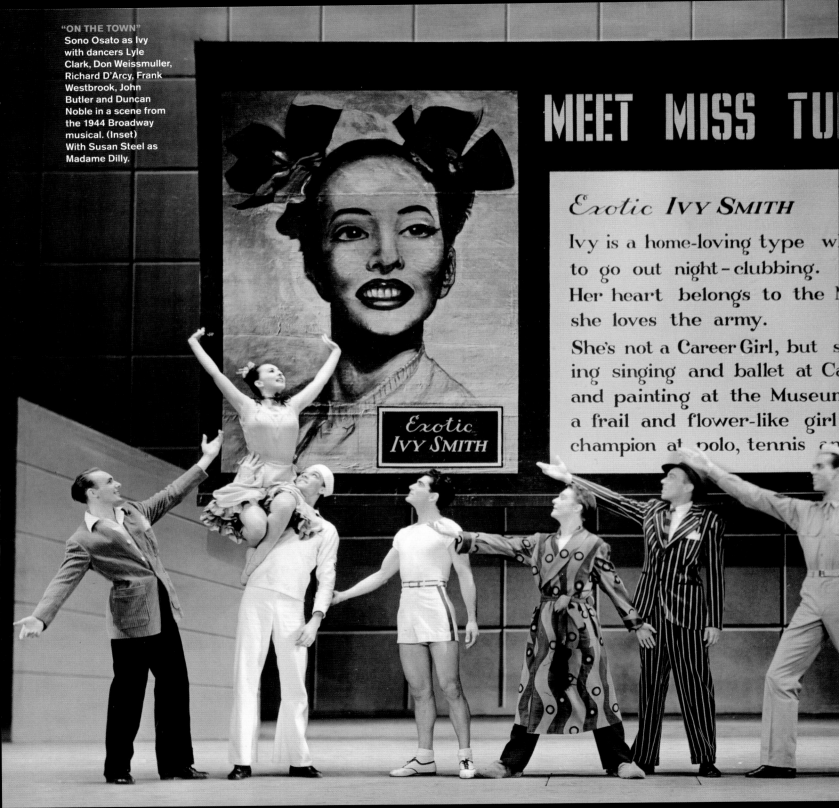

MEET MISS TU

Exotic **IVY SMITH**

Ivy is a home-loving type w
to go out night-clubbing.
Her heart belongs to the N
she loves the army.
She's not a Career Girl, but s
ing singing and ballet at Ca
and painting at the Museum
a frail and flower-like girl
champion at polo, tennis a

Exotic IVY SMITH

Pennsylvania. People who didn't even know the word "ballet" actually got to see it. There was vaudeville, tap dancing, jazz dancing in nightclubs, but no ballet companies. It was the height of the Depression, so even orchestra seats cost no more than $2.

I didn't know about Miss Subways until I played Miss Turnstiles on Broadway. As Miss Turnstiles, I was playing this all-American girl in the middle of a war with Japan. It was really very unusual considering my background as someone half-Japanese. My father was in an internment camp. A Japanese reporter several years ago wanted to interview me for a piece he wanted to call "Miracle on Broadway," a title I hated right from the beginning. I said, "There was nothing miraculous about it." I said, "Had I been in Japan, I would have been arrested and put in jail because I was half American."

You don't know where the idea comes from to cast someone. But it was interesting in the middle of a Pacific war to play an all-American girl, an ambitious ballerina who was dancing the hoochie cooch in her brassiere and little tiny pants and veil and doing this ridiculous thing at Coney Island to pay for lessons at Carnegie Hall. The three women in "On the Town" were all very unusual. Nancy Walker was sublime. She played a very tough lady cab driver in the war and she made all the advancements to the sailor. The sailor was so young and innocent he would never invite a girl up to his place—that was her hit song, "Come Up to My Place." She had already done a Broadway show and a movie. She among us was the real pro actress. And Betty Comden was a woman anthropologist. They were not common Broadway women. There was always the ingénue in shows—the sweet little girl. That was my part. But I thought I'm not going to act all innocent, sweet lovey-dovey. I just couldn't. I was really embarrassed. So I tried to make this girl different.

"On the Town" was the second and last big successful musical I was in. I was actually married when I was in "On the Town." I was 27, and by then I was very tired. After 10 months I was too exhausted, the same words, the same music, the same dance, performance after performance. I said, "I can't wait to have babies." When I had my sons, it was full time work. I couldn't go to class to keep in shape. There was feeding or new shoes. I wanted to do the mothering. That was even scarier than performing, especially when they cried. It took a long time for me to stop worrying some disaster was going to happen.

I guess I was too busy to really think about what I had done. I often used to think about Margot Fonteyn, the English ballerina, who was my exact age. She danced when her body was telling her not to dance. She was completely paralyzed and she died alone in Houston, Texas. The living conditions of ballet dancers today are more secure than ours were. It's amazing there are any artists. They've chosen a difficult life. It's not about money.

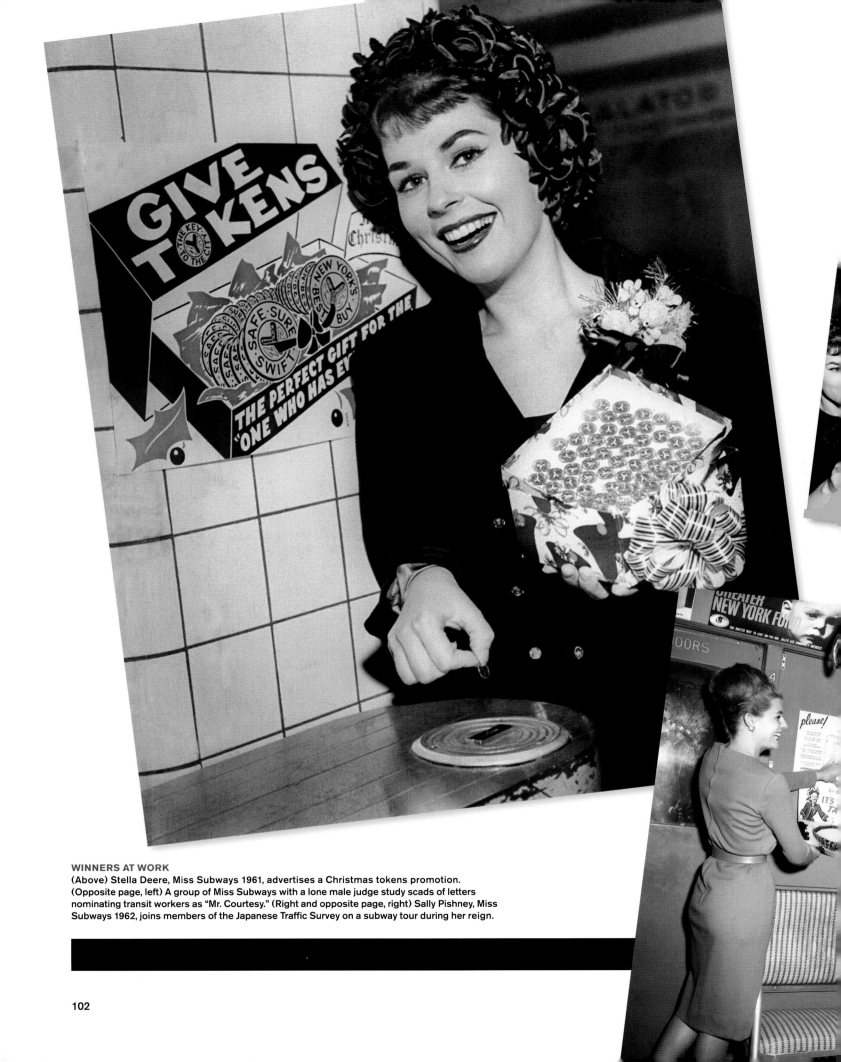

WINNERS AT WORK
(Above) Stella Deere, Miss Subways 1961, advertises a Christmas tokens promotion.
(Opposite page, left) A group of Miss Subways with a lone male judge study scads of letters
nominating transit workers as "Mr. Courtesy." (Right and opposite page, right) Sally Pishney, Miss
Subways 1962, joins members of the Japanese Traffic Survey on a subway tour during her reign.

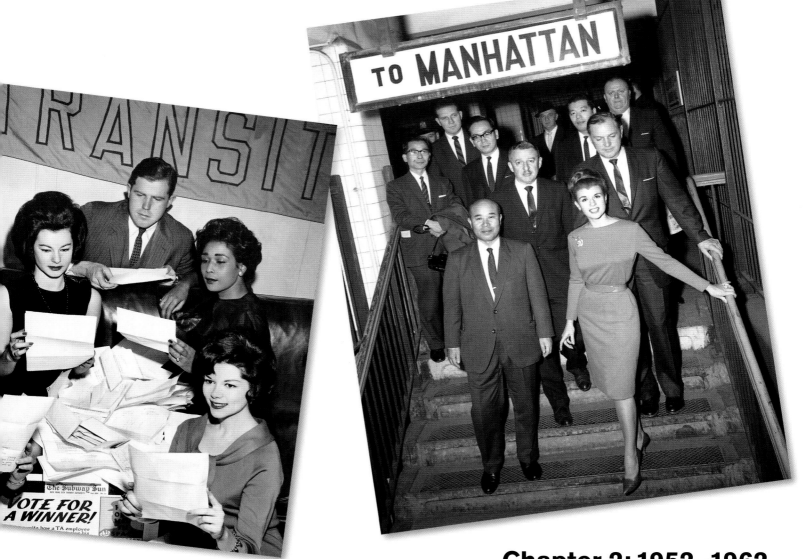

NEXT STOP:

School Teachers, Stewardesses, and Suburban Housewives Hold a Two-Month Reign

Miss Subways continued riding its wave of popularity into the contest's second decade but changes were afoot behind the scenes.

Real estate businessman Walter O'Malley bought New York Subways Advertising Company from the owners of Wrigley gum in 1950, the same year he bought the Brooklyn Dodgers baseball team. Just two years later, the subway's operating deficit spiked from $1.2 million to a whopping $24.8 million, setting the stage for another major shift in the transit system. In 1953, the Republican-led state government created the New York City Transit Authority as a separate public corporation to manage and run all city-owned subways, buses and trolleys, taking the control away from the municipal authority that had operated the transit system since 1940. The hope was to restore business-like management to the failing operation, but under this new structure—where elected officials were no longer accountable for transit decisions—the seeds were planted for subsequent deterioration.

At the same time, government funds once slated for mass transit had shifted to highway construction and car ownership was on the rise. Population was shifting out of the city, and the suburbs were blooming. In 1950, 63 percent of the New York metro area's population lived in the city, but by 1960 that number dipped to 54 percent. Many of our Miss Subways were part of this shift. They found themselves in Long Island and Westchester, New Jersey and Connecticut. This was, perhaps, a mixed blessing: while the suburbs were seen as the place for a good, upwardly mobile life, the isolation also stirred unrest and unease. Gail Burke recounts becoming obsessed with whitening the artificial grout on her linoleum floor and later

having to fight her husband into letting her get a job. Marie Leonard, stifled by Long Island life, eventually divorced and returned to the city. Her children, however, preferring the suburbs, returned to live with their dad, while Marie reverse commuted after work, visiting daily to make sure they did their homework.

For some, the Miss Subways contest offered the excitement and special treatment they craved. In 1952, winners' reigns doubled, so their posters ran for two months instead of one. Contest winners were still treated like celebrities, especially in their neighborhoods. Kids in her Washington Heights neighborhood would run up to Mary Gardiner, shouting "Miss Subways! Miss Subways!" and hold her hand walking with her through the streets. John Robert Powers began working with photographer Michael Barbero, who shot stars like Grace Kelly, Zsa Zsa Gabor and the contestants for Miss Rheingold, another popular beauty contest at the time. When Powers pulled out of the contest—his name disappears from Miss Subways posters in 1960—Barbero picked up the mantel for a time, and many of the winners recall him helping them land other modeling gigs.

Some women did not feel celebrated by Miss Subways, however. Even though the contest had been integrated fairly early, African American women still felt underrepresented, and in 1952, a group of black subway employees calling themselves the Harlem Transit Committee began holding their own "Miss Transit" beauty contest, which lasted several years. Compared to other beauty contests, though, Miss Subways was progressive in its focus on New York's working-class women and their various backgrounds.

The winners in these years were teachers, stewardesses and steno takers during an era where women's jobs were still limited in scope. While work opportunities may have increased, many options were still placed off-limits, whether by employers, husbands, or fathers. Shirley Martin landed a job with TWA meeting height and weight requirements, but once she married, she was out. Evelyn Tasch

TRANSPORTATION AMBASSADOR Sally Pishney, Miss Subways 1962, with members of the Japanese Traffic Survey on their tour of the New York City transit system.

left a prestigious graduate school program in art history to move for her husband's engineering job, cutting her own career short to stay home with a baby. Eleanor Nash was an FBI secretary who dreamed of being a policewoman—something her father, a police officer himself, forbid.

In the 1950s, most women attending college had no specific career plans, and they dropped out in large numbers to marry. Women's participation in the labor force did grow in this decade, but the increase came largely from middle-class married women, especially over the age of 35, returning to the work force after their children were grown. They didn't necessarily have careers per se, but often worked part time in pink collar jobs, like secretarial work, and they were mainly doing it to help further family

goals with mortgage or college payments. Help wanted ads in *The New York Times* didn't stop segregating listing by gender until 1968. Despite these restrictions, women started to see the possibility that they could be equal in the workplace. Take Marie Leonard: as a secretary for a real estate company, she trained the men starting out as building managers. One day she realized she could do the job better and finally assumed the position herself. And while Eleanor Nash did not join the police department against her father's wishes, she became chief of staff for a congressman, a job so completely "male" at that time that she set up a networking group for women in similar positions. Things were not necessarily getting easier, but women were paving the way for the next generation.

ALLELUIA. IT WAS NECESSARY
FOR CHRIST TO SUFFER AND
RISE FROM THE DEAD, AND
THUS TO ENTER HIS GLORY
ALLELUIA.

Meet Peggy Byrne

MISS SUBWAYS MARCH–APRIL 1952

My sister Mary Jane, who was always pregnant, was constantly sending my picture in to some kind of beauty contest. I actually won Miss Heights Downtown of Brooklyn, which was a big thing. I never wanted to be in a bathing suit in public because I really didn't have any ninnies, as we called breasts at that time. But there I was on top of the Atlantis at Coney Island in the Miss Brooklyn contest, wearing one. I was up there with 25 other young ladies, and Steve Allen was the emcee. We had to walk past the band, and when we got to the judges, I turned around for the band—I guess they were rooting for me.

My sister, of course, was the one who sent my picture in to Miss Subways. I remember Mary Jane saying, "Peggy would you like to be Miss Subways?" And I said, "Am I?" She

PEGGY BYRNE at Church of Our Saviour, New York, New York 2007.

Blue-eyed Blonde Wins 'Miss Heights-Downtown' Title

Judges Select 2 Students as Runners Up

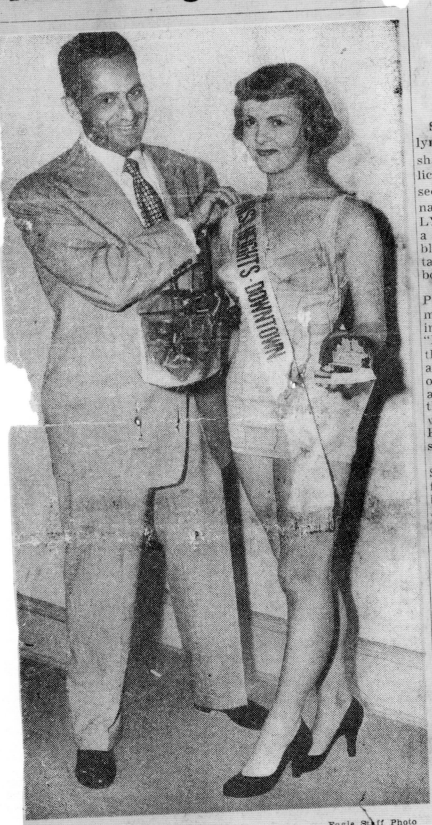

WUR-OOOPH—TV humorist Herb Sheldon, a Brooklyn boy himself, tries not to be distracted as he pins "Miss Heights-Downtown" ribbon on lovely Peggy Byrne, 18, who will compete with other locality ribbon girls Aug. 30 for MISS BROOKLYN honors.

Eagle Staff Photo

Stunning samples of Brooklyn's finest natural resource shaped into a perfectly delicious line last night for the second of the locality preliminaries in the MISS BROOKLYN contest, and it looked like a trend toward twinkle-eyed blondes definitely has been established in the battle of the borough beauties.

Dimpled, Dresden-blue-eyed Peggy Byrne, a petite sweet-mannered typist for a Brooklyn insurance office, was selected "Miss Heights-Downtown" by the learned-in-lady-lore laddies at the Barney Ross Sun Deck on the Coney Island Boardwalk at Stillwell Ave. Winner of the pulchritude pageant last week was vivacious Moana Holt, "Miss Flatbush," also a strawberry blonde.

Quipped TV humorist Herb Sheldon, who emceed the affair, "This is a fine way to bring the strawberry season to an end."

Distinguished Panel

Charmingly hidden in an aqua swim suit, 18-year-old Peggy Byrne's vital statistics read like football scores at the half. They were 34 bust, 22 waist and 28 hips. And the kids at Prospect Heights H. S., Peggy's alma mater, will be pleased to know that the statistics were all in the right place.

The panel of judges included Ray Heatherton, radio and TV personality and singing proprietor of WOR's "Heatherton House"; Elinore Sheehan, who copped "Miss Brooklyn" honors at the 1939 World's Fair and later won a career in modeling for herself; Lester Wolff, producer of some of WPIX-TV's leading features; Steve Lambert, the Brooklyn Eagle's authority on femme affairs, and Saul Richfield, public relations expert.

The throngs viewing the event from the Boardwalk and from the brightly-lit roof of the Atlantis Nite Club cheered wildly when judges announced that

MEET MISS SUBWAYS

MARCH-APRIL 1952

Blue-eyed

PEGGY BYRNE

This petite Brooklyn-born colleen is studying to be an insurance broker. Plans to wed her childhood sweetheart, an Army Private. Her older brother is a Tank Destroyer Pfc. in Korea.

John Robert Powers
247 PARK AVENUE

PUBLISHED BY NEW YORK SUBWAYS ADVERTISING CO., • INC. 630 FIFTH AVENUE, NEW YORK 20, N. Y.

Photographed by Michael Barbero of **F. A. RUSSO**

said, "Well, you have a meeting in the morning with John Robert Powers." He was the very top in modeling agencies. When I went there for the interview, I said I was studying to be an insurance broker. A lie. I said I was going to marry a boyfriend who was a PFC in Korea. That was a lie. And the poster said my brother was a tank destroyer in Korea. That wasn't true either. There were no tank destroyers in Korea, but he did fight there. He was quite annoyed that was on the poster. They just gleaned what they wrote from the interview: I'm the one who made up the lies. I thought it was glamorous. I thought my family would be proud of me if I said "insurance broker." Actually, I probably wanted to be a go-go dancer, but I also wanted daddy's approval. I should have said "wants to be an opera singer or wants to be a college professor or astronaut." I didn't have any intention of marrying that boyfriend. We did get engaged, but I ended up breaking his heart. It was a long time ago. I was so young, so innocent. But I'm sorry about that.

My poster was on every subway and every bus in March and April of 1952, and my friends and I used to stand in front of it, and say, "Oh, look at her, isn't she exquisite? Isn't she divine?" And of course no one recognized me. The whole two months, maybe two people recognized me when I was standing there. But I was very popular in the neighborhood, like Miss America. You didn't do anything as a Miss Subways, just basked in the glory of being one. I did get lots of mail from insurance companies that wanted me to take courses and work for them. That was funny. But that was about it. Sometimes we would find kind of sweet notes on posters—"At last, a good looking one"—but sometimes there would be a stiletto going through my nose with blood dripping down. Sometimes you'd find a picture of a guy pasted next to it with a phone number.

I married at 18, and I actually did go to work for an insurance company. My husband had cancer, so we couldn't have kids. My sister had seven. I'm close with them. One is Peggy Noonan, the well-known political commentator. She was named for me. I

LOCAL BEAUTY QUEEN (Opposite page) TV humorist Herb Sheldon pins Peggy, 18, the winner in the Miss Brooklyn Heights-Downtown pageant, a lead up to the Miss Brooklyn contest.

FIRST COMMUNION (Above) Peggy celebrates this religious milestone at age six on Christmas day.

MODEL EMPLOYEE
(Right) Working as an accounting supervisor at the advertising agency Fuller & Smith & Ross, Peggy found herself cast in a client's ad for milk. (Below) In an undated snapshot, Peggy, who had dyed her hair red before her Miss Subways photo, was back to blonde.

went to work in advertising in 1959 and then was snatched away by a filmmaker. By then my marriage was over, and I went to school in the '70s to get a degree in accounting. I did accounting for movies. I worked there until December 2005 and then came to the Church of Our Saviour as the director of operations. I do the accounting, plus all the parish events. I never really saved enough money to retire, so I have to keep working.

I'm still a babe. I like to live a healthy life. I stopped drinking and stopped smoking cigarettes, though I didn't do all that at once. I exercise four days a week. I have a personal trainer, and two days a week we climb 50 stairs, 15 reps. The trainer showed me, in a Cindy Adams column, that the New Jersey Nets basketball team was auditioning senior dancers, ages 61–80. So, I went. There were 15 of us selected to be NETSational Dancers. We would come out in red vinyl raincoats and dance to "Singin' in the Rain." And then the music would stop and we'd fling off the raincoats and do a hip-hop routine. The crowd could not believe seeing these 15 seniors dancing hip-hop. They went wild.

FAMOUS FAMILY
(Above left) Peggy visits her niece, the best-selling author and *Wall Street Journal* columnist Peggy Noonan, in Great Falls, VA 1990.

GOTTA DANCE
(Left) Peggy shows off her moves as part of the New Jersey Nets' senior hip-hop dance team, the NETSationals. (Above) The documentary charting their debut was a film festival favorite.

Meet Mary Gardiner Timoney

MISS SUBWAYS MAY–JUNE 1953

All the little kids used to meet me coming home from whatever modeling assignment I was on for the day. They'd shout, "Miss Subways! Miss Subways!" They'd hold my hand and walk with me. They thought it was the greatest thing since sliced bread. I was a local heroine. It was different back then. Everyone rode the subways. The cars were not dirty. Nobody was drawing mustaches or blacking out the teeth.

Being Miss Subways was not something I ever planned. I was a very shy girl. I grew up in Washington Heights, about a block down from the Columbia Presbyterian Medical Center. My sister and I used to baby-sit for the interns and doctors. When I was 19 years old I worked as a secretary for an airline, and at the Christmas party they took pictures of every table. My boss cut me out of the group picture and

MARY GARDINER TIMONEY at her retirement community in Toms River, New Jersey 2007.

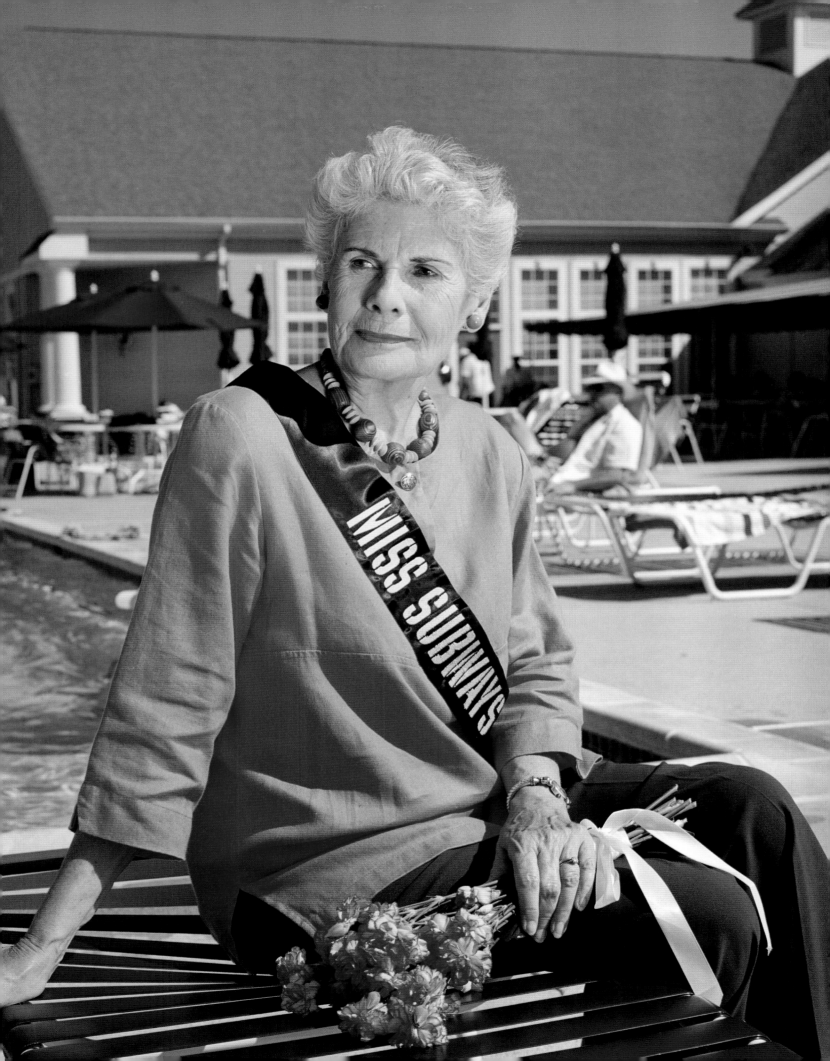

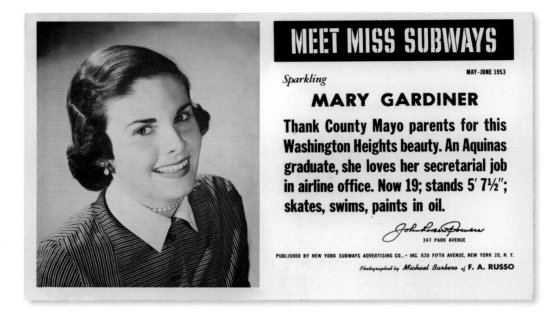

MEET MISS SUBWAYS

MAY-JUNE 1953

Sparkling
MARY GARDINER
Thank County Mayo parents for this Washington Heights beauty. An Aquinas graduate, she loves her secretarial job in airline office. Now 19; stands 5' 7½"; skates, swims, paints in oil.

John Robert Powers
247 PARK AVENUE

PUBLISHED BY NEW YORK SUBWAYS ADVERTISING CO., • INC. 530 FIFTH AVENUE, NEW YORK 20, N. Y.

Photographed by Michael Barbero of F. A. RUSSO

TOP VALUE
Mary makes an appearance in a stamp savers booklet.

sent me in to John Robert Powers. I got a card in the mail saying, "You're a finalist in the Miss Subways contest." It wasn't until then that I knew what she had done.

The Miss Subways contest triggered a terrific career. A friend who was a nanny for a producer at Radio City Music Hall showed him one of my posters. He said, "What is she doing behind a desk? Send her to me." He was having a fashion show with 25 models as part of his stage show. I took a leave of absence from my job with the airline, and I worked with all those girls, two or three shows a day, for six weeks. Everyone there said you should go to this model agency or that one. A year later, I was stopped at Jones Beach and asked to be photographed for the Miss Surfmaid contest, sponsored by *The New York Journal-American.* At the end of the summer I was chosen as the winner at the Stork Club. I won a car, a trip to Rome with my mother, and a $1,000 bottle of Sortilege perfume that I still have. It was unbelievable. I was still very timid and couldn't get up the courage to talk to people. The night we had interviews for Surfmaid, I didn't think I could do it. Of course, I was 5' 8" and 110 pounds, so I guess I had the tall, lanky, kind of a body that was the look in those days. I was photogenic and I had good teeth. That made me a commercial model rather than a fashion model. When I came back from Rome, the agency I had signed with really started to promote me. I did ads for toothpaste, beer, cigarettes and soap. I was a model on Bess Meyerson's television show called "The Big Payoff." I did "The Perry Como Show." I did the cover for *The New York Mirror* for Valentine's Day, 1954. I had something in *Vogue* in 1956. Lowenstein Fabric sent me to Jamaica for my first location job. I toured the country with General Motors for the Motorama Fisher Body show—they hired five Fisher Body Girls. I did a lot of work for *Reader's Digest.* I was on the cover for *The New York Times* for a marketing promotion for Mercedes Benz, done in front of the Public Library in New York. The big lion is next to me. I also came close to being a Miss Rheingold. Out of 10 semifinalists they chose six

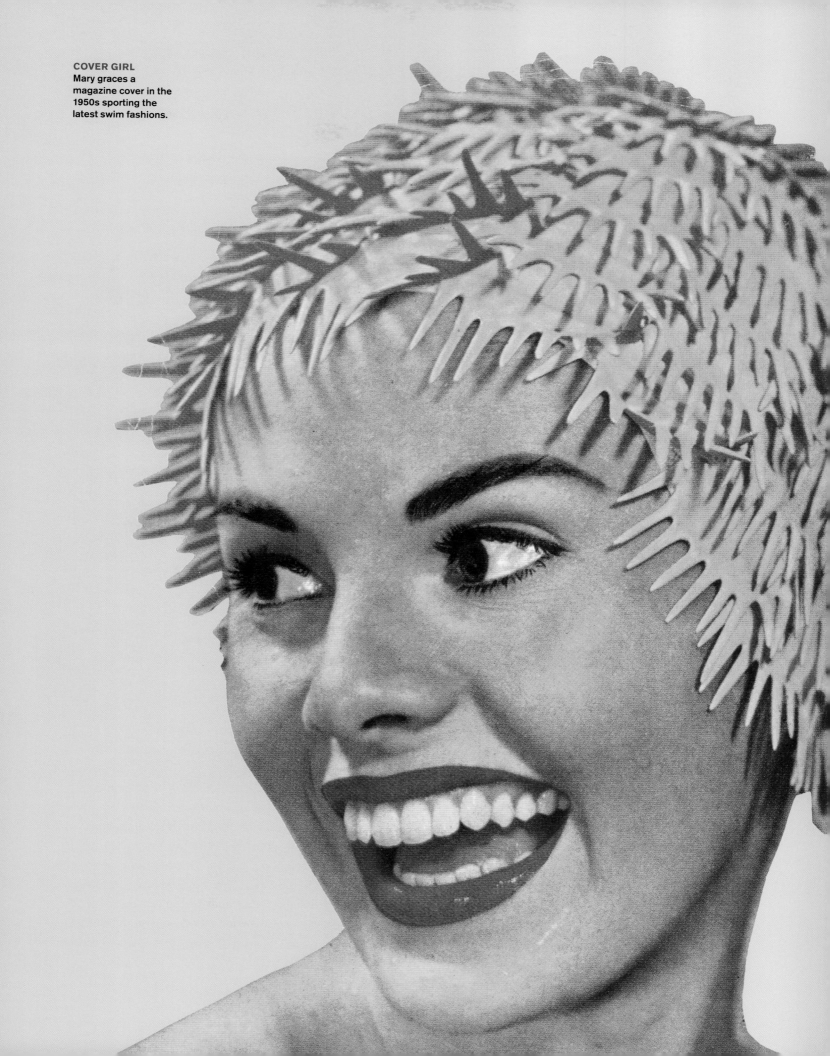

CAREER HIGHLIGHTS
(Left to right) "The Big Surprise" TV show on NBC; modeling Top Value stamps; wearing Ava Gardner's "Barefoot Contessa" gown in Rome during a trip for winning Miss Surfmaid; a fashion shoot for *Fifty Plus* magazine in 1986.

girls who were in the running for Miss Rheingold and would get their pictures up in the bars and the delicatessens. I was one of the final 10, but not the final six—two years in a row. At that time I was married and I was expecting, so it's okay it didn't happen.

My early career was limited to the 1950s, but I was very busy. I got married in June of 1956 and had four children over the next eight years. The first two did commercials when they were babies. It was different then. They didn't have children's agencies like they do today. They'd call model agencies and ask, "Do any of your models have babies this age?" Interestingly, those two children are actually actors in New York. I came back to modeling in the 1980s with the gray haired ladies, when they realized we could spend money too. Of course, at that point it's all geriatrics: aspirin, AARP, those types of things. I only stopped a few years ago. But you never know when they might call—I would be more than ready to step in front of the camera again.

KATHLEEN MCLEAN HOLMES at her home in Princeton, New Jersey 2010.

Meet Kathleen McLean Holmes

MISS SUBWAYS NOVEMBER–DECEMBER 1953

I was on the train every day, six times a day from the Bronx to the Fashion Institute of Technology, and along the way I would see people who probably did recognize me from the Miss Subways poster. It was just a neat thing to have happen to you when you're 19 years old. As a fashion student, I used to make all my own clothes. Once I remember going to a dance at Fordham College, and I had this black dress with a red bow on the back. Well, someone else in the distance had the same dress. Oh, I was so annoyed. I remember I came home, took the bow off, took strips of fabric across the back and put flowers on it, and no one ever had that dress. I was always trying to do the unusual. I wanted things to be a little different so life isn't boring. I never had to worry again about having something someone else had.

After I graduated from FIT, I worked for a lingerie company where I came up with the Bermuda short pajama. Then, in 1955, I got married and moved up to New Rochelle in Westchester County. I was taking the New York Central train to work, and eventually I had to give it up because it was too far. I worked until I had my first daughter, Tara Anne, and then I decided I couldn't leave her all day. Later on I had two more boys and a girl. I was designing for my children then. I used to design mother-daughter outfits and brother-sister matching outfits. I really had them dressed well. I remember going

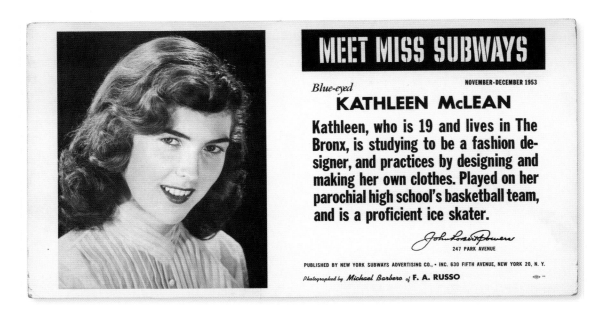

MEET MISS SUBWAYS

NOVEMBER-DECEMBER 1953

Blue-eyed
KATHLEEN McLEAN

Kathleen, who is 19 and lives in The Bronx, is studying to be a fashion designer, and practices by designing and making her own clothes. Played on her parochial high school's basketball team, and is a proficient ice skater.

John Robert Powers
247 PARK AVENUE

PUBLISHED BY NEW YORK SUBWAYS ADVERTISING CO., • INC. 630 FIFTH AVENUE, NEW YORK 20, N. Y.

Photographed by Michael Barbero of **F. A. RUSSO**

WEDDED BLISS
(Above) Kathleen married Bill Holmes on July 7, 1956 at Sts. Philip and James in Bronx, NY.

FIVE AND DIME
(Opposite page) Photo booth portraits of Kathleen taken in Manhattan in 1953, around the time she was Miss Subways.

into the city for a parade and my daughter was in those little black velvet tight zipper leg pants, and I made her a white fur coat and a hat to match her Capezio shoes.

I think you always have to make the best of what you have and don't want too much. I have found always be content with what you have and then you're happy. We kept on moving around. My husband worked for Bristol Meyers and he would get transferred and as he got transferred we went—but it was an enjoyable time because it was nice to have seen so much. We went from the Bronx to New Rochelle to Clifton Park—near Albany—to Syracuse to Indiana and then to Princeton. I've been in Princeton the last 19 years, married for 55.

We had the four children and then four grandchildren. But in everyone's life, a little rain must fall. My youngest daughter, Erin, passed away nine years ago. I think of her every day. I had been at her home the night before. She and her husband had just closed on a beautiful piece of property in Princeton. The next day I called. She didn't answer. That night her husband called and said I'm following the ambulance. She had passed out. She was diabetic and had an electrical pump for diabetes and it didn't turn off when she passed out. So she was in a coma from February to July, then she passed on. She was so thoughtful and such a generous person. She was so kind. But you know sooner or later we're all going to be together. I always say to my daughter Tara I'll probably live forever because Erin was so good and kind. I always think she was above what she had to be.

Erin skied with me all the time. We had a house in Lake George and we would go skiing over in Okemo, Vermont. My husband didn't ski because of his knees. He'd just stand there and always see these esses coming down. Erin just had such nice form. She looked like she was almost flying—a nice curve ess. When I ski now, I always say, I'm following your esses, Erin.

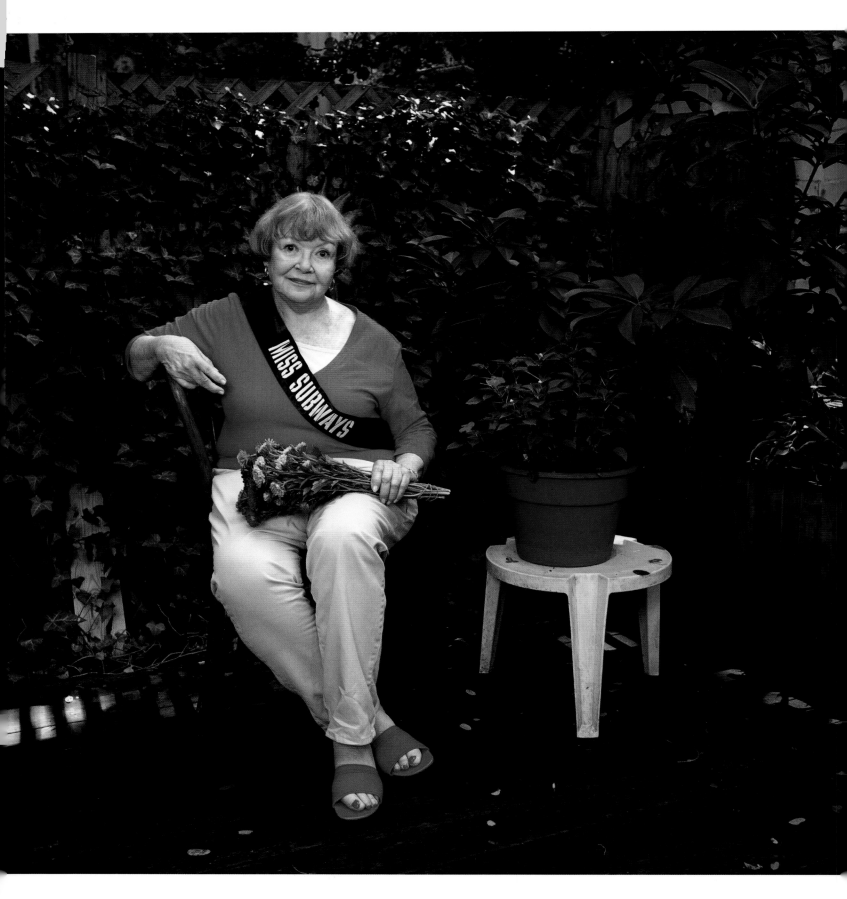

MARIE LEONARD COSTELLO in the garden at her apartment on West 23rd Street, New York, NY 2009.

Meet Marie Leonard Costello

MISS SUBWAYS NOVEMBER–DECEMBER 1955

In my Miss Subways poster I look like the 1950s. I look like Mamie Eisenhower, the president's wife at that time, with the little bangs and Peter Pan collar and little bows. I was wearing a beige shantung dress with a tight little waist and a big full skirt and a petticoat. It was a beautiful outfit. I probably got it at Lord & Taylor. I always used to shop there.

My friend sent in a little photo we took in a booth in the subway station. We were just hanging out in an arcade in one of these little kiosks and posed and fussed and fooled around and out came four pictures for a quarter. It was amazing because you didn't have to have any talent to be Miss Subways. You didn't have to dance or sing or look great in a bathing suit. You just had to be cute.

I was 20 years old and living in Astoria, Queens at the time, working as a medical assistant. I got some offers to model. I did book covers. I cut the ribbon at a new subway station with guys in suits. I got an invitation from TWA to apply to be a stewardess, but I wore glasses. Stewardesses in those days weren't allowed to wear glasses and it was a pre-contacts world, so I didn't get accepted. After I married, I continued working as a medical assistant until I became pregnant. I was doing X-rays, and I thought, "This isn't a very good idea." Then when I had my first child, I went back to modeling for book cover illustrators. I had gone back to a size 6 in 10 minutes. It was amazing. I was active. I was in two bowling leagues. That's what people did those days for fun.

We stayed in Astoria for a while, and then we moved in 1961 to Plainview, Long Island. I continued modeling until 1965, but it was hard to get a babysitter. It was fine when you were in Astoria and it was 15 minutes away, but not when you've got all this arranging

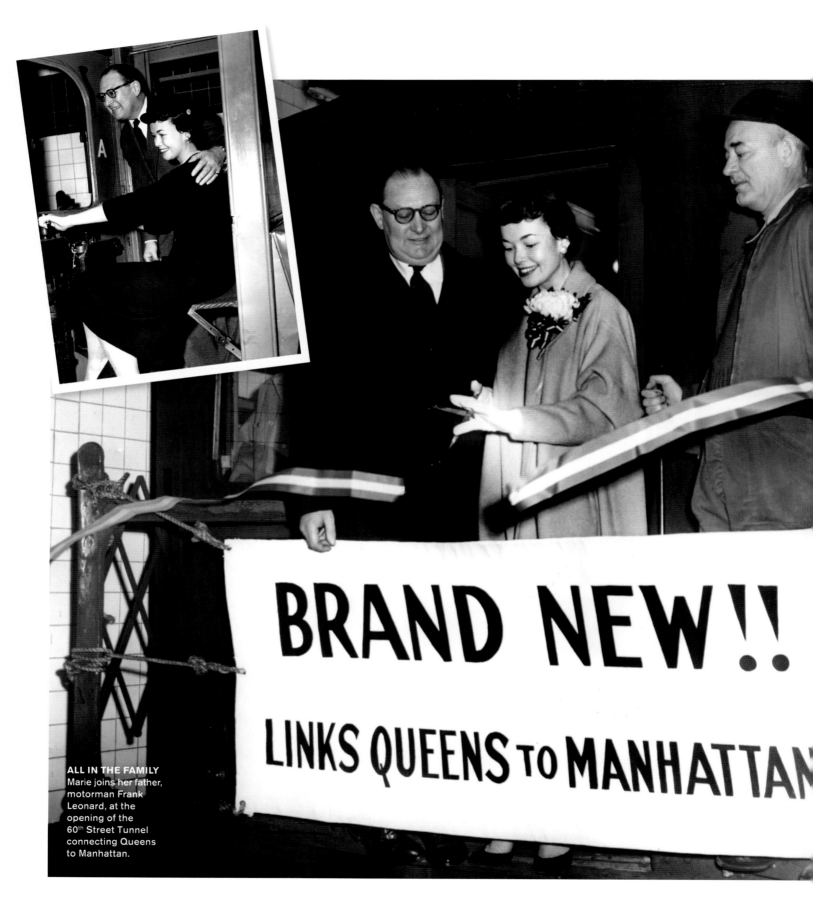

ALL IN THE FAMILY
Marie joins her father, motorman Frank Leonard, at the opening of the 60th Street Tunnel connecting Queens to Manhattan.

BRAND NEW!!

LINKS QUEENS TO MANHATTAN

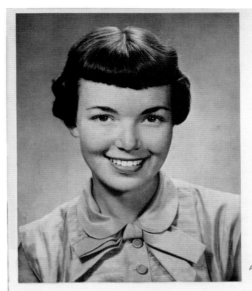

MEET MISS SUBWAYS

SPONSORED BY NEW YORK SUBWAYS ADVERTISING CO., INC. · 630 FIFTH AVENUE, NEW YORK 20, N. Y.

NOVEMBER-DECEMBER 1955

"Freckles"

MARIE LEONARD

This 5'7" brunette, who has intriguing green eyes, is a certified medical assistant and an X-ray technician. Likes bowling, dancing, reading and collecting jazz records.

John Robert Powers
247 PARK AVENUE

Photographed by Michael Barbero

to do. So I stopped. Everyone moved to Long Island, unfortunately. I used to meet all these people who'd say, "I haven't been in the city in 20 years," and they were so proud of themselves. I thought it was embarrassing. I missed the city. I started a theater group with four or five of us that came into New York every month. Tickets were $2 back then.

After nine years in Long Island, I got divorced and moved back to the city. I got an apartment and a job in the sales office at Excercycle. I went there and told them I could type when I couldn't. I get there on my first day all dressed up—heels, hat, bag, everything—and I don't know how to turn this thing on. I thought, I'm going to get fired before I even begin. So I called the IBM phone number on the little sticker for service. When he comes, of course it's a little button on the side to turn it on. What an auspicious beginning.

Eventually I got remarried. We lived in the city with my kids for a while but they were very unhappy. So, back to Long Island they went, to their dad. I did a reverse commute five times a week where I'd leave work in Manhattan and go out there to make sure they did their homework and had dinner.

When Exercycle moved to Connecticut, I went to work for Douglas Elliman, the real estate firm, starting out as a receptionist and moving up to the engineering department. I started out as a secretary really, but I learned that job literally from the basement up. When they had a new building coming in, they had to do an engineering study, from the basement drain to the rooftop. They used to give me all these green young men to train. I finally said, I'm tired of this. I'm going to do it myself. There weren't too many women managers when I began. I think we're good at it because we have a special little touch. I've seen a man go in and say, "Well, we've got a leak here." I go in and say, "Oh, the poor sheets. Take everything to the cleaners and dry the rug—the whole thing." A woman looks at everything differently. I'm not with Elliman anymore, but I'm still doing the same thing. Now I manage 11 buildings.

Meet Marie Crittenden Kettler

MISS SUBWAYS JANUARY–FEBRUARY 1957

When I was younger I thought it would be such fun to be a singer in the movies, but I knew I had to finish my education. My father said, "God forbid, something happens to your voice, dear, you better have another way to make a living." I said, "I guess you're right, dad."

I graduated from college in 1952 and taught at a Catholic school. Then I needed some money, not holy cards, so I got a job with the public school system. I was working on my Masters in education, which I never did finish. It was just too much. I was working in Teaneck in the public school system, and I was studying voice, drama, dance, everything. I was extremely busy. I did whatever I could to make money. I modeled. I think Michael Barbero, the photographer for Miss Subways, had seen my picture some

MARIE CRITTENDEN KETTLER on the porch of her home in Woodcliff Lake, New Jersey 2009.

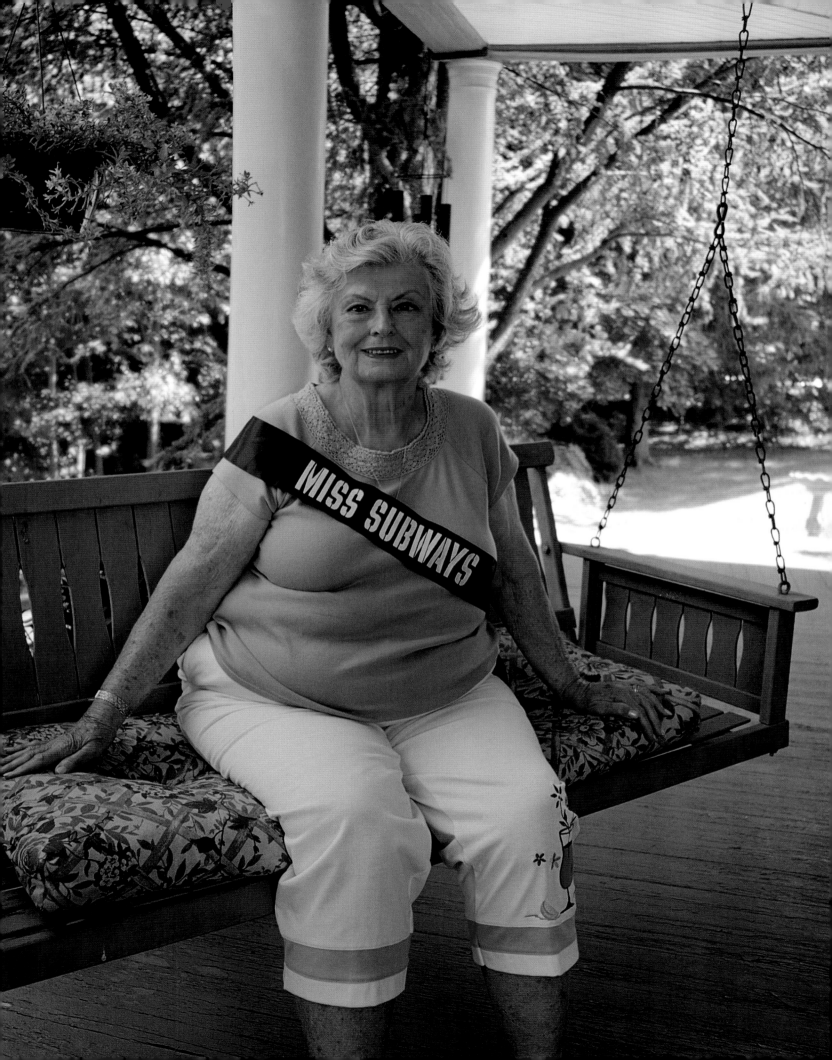

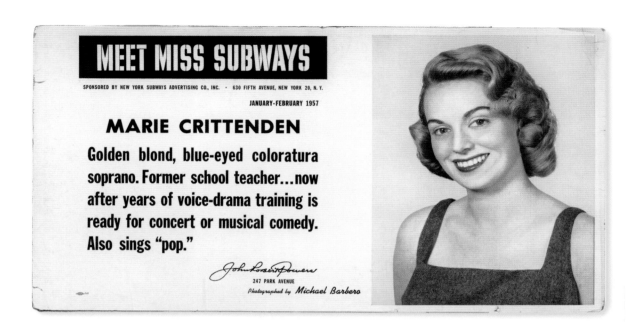

place or he was a friend of somebody who had seen my picture. I really don't remember the details anymore, isn't that funny? It went through the John Robert Powers model agency, and they liked the picture and it went up. My dad used to sit under my picture because he worked down on Wall Street, and he'd say, "That's my daughter." The next year, in 1958, I also became Miss Patterson, New Jersey and that was really neat.

I didn't give up on singing. I joined "The Perry Como Show" in 1959. I was one of The Ray Charles Singers. When I got the job, I was a blonde. And they said, "Would you mind going red?" So, I did. I got married in 1960, had my daughter Marie-Jean in 1961 and went back to work. Then I had Sarah in 1963. Ray was annoyed I got pregnant again because he didn't want to get another person to substitute in the group. After Sarah was born, I went back to sing a lot of tapes, but I didn't go back to the show, and there was a good reason: they decided they would take the show on the road. Every three weeks they'd go to a big city rather than have us do a weekly show. They were trying to cut down on singers and dancers and they'd dub over and over and over. You'd come in on a Tuesday morning and you'd just sit down and sing it on tape.

Once I finished with that, I sang in Carnegie Hall in big groups—never a soloist. But it was a great way to make a living, especially with children because I could get a sitter and if it was a weekend thing, my husband, Bern, would meet me. He was a wonderful audience. People used to say, "You didn't marry someone in the business?" Are you kidding? Why would I want to do that? I married someone who was a good audience and a great provider. We had the best of both worlds. I enjoyed my career thoroughly. Once I stopped going into the city, which was after Tom was born in 1965, there wasn't much going on anyhow.

We moved to Woodcliff Lake, New Jersey. We became involved in getting pledges to start a parish. They needed someone to do the music, and who better than a professional?

MISS PATERSON
Marie won this New Jersey pageant in 1958, the year after she was Miss Subways.

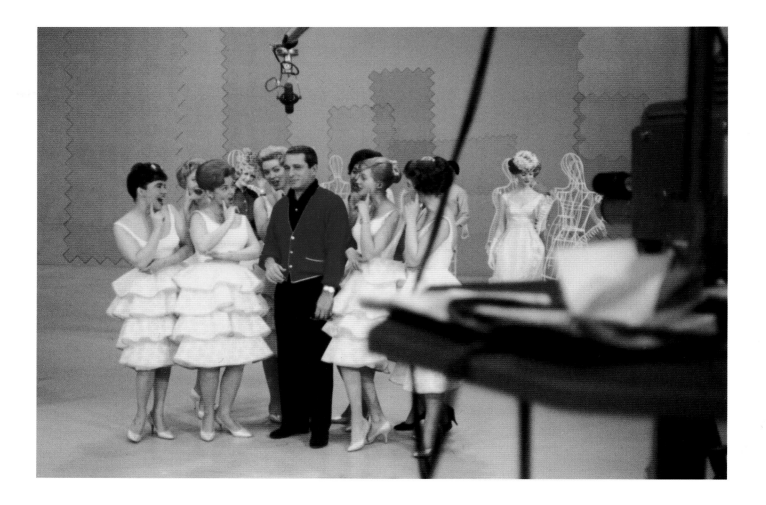

RAY CHARLES SINGER
From 1959–1963, Marie, the redhead, was one of the top sopranos with this singing group, featured on "The Perry Como Show."

I had the choir meetings in my home before we had the actual, physical building. People would come to the parish at Christmas, Easter, and Thanksgiving, just to hear the special music. I directed for 38 years. Eventually, I think they wanted a younger woman. I retired gracefully, but I'm still involved. I also taught religious education for 25 years. I was on the regional board for education, which encompasses two big high schools. It's nice to be involved and give back to the community. Bern was mayor of this town for 15 years. He used to be in the food business. He was the food manager for Eastern Macaroni, which is Rice-a-Roni, the San Francisco treat. We put our kids through college on Rice-a-Roni.

I kept my hair red all those years. Unfortunately, I had cancer in 1999, and I asked the doctor who had administered chemo, "Do you think the hair dye chemicals would be bad to mix with the chemo?" He said, "I don't think so. But why not save your money? You're going to be bald in two weeks, dear." "I am?" I asked. He said, "What you should do is go out and get a wig." So I did. And I wore that wig until the first or second week of June of 2000, and then I just couldn't stand it any longer. I ripped it off one day after Mass. And the congregation went, "Oh," and then they started to applaud because it was such a hot, muggy day. So that's how I lost my red hair.

SOPRANO HIGH NOTES
(Left) Marie dresses up for "The Perry Como Show", and (below) she stands in third from left in the front row with the other Ray Charles Singers from the famed TV program. (Above) Marie plays spunky maiden Hilda in a 1958 rendition of the musical comedy "Plain and Fancy" at the St. John Terrell's Music Circus in Lambertville, New Jersey.

Meet Nancy Denison Wagner

MISS SUBWAYS JANUARY–FEBRUARY 1958

My father was from Baltimore, Maryland, and we lived there until I was in third grade. When we were getting ready to move to New York, we lived in a boarding house, and there was a jockey that lived there. He took us over to Pimlico race track where he introduced me to horses. I fell in love with them—I just thought they were beautiful. My aunt and uncle used to go to the races. I never could go because I was too little, but they used to talk about it. I always wanted to own a racehorse. I eventually did, but not until later in life.

After I graduated college, I was living at home with my parents in Garden City, Long Island and thinking about modeling. I went to a local store where I got a job modeling at lunchtime. Then I was Miss Subways, and the photographer who took my picture for the contest, Michael Barbero,

NANCY DENISON WAGNER with her horse, Hear me Roar, Starview Stable, New York 2010.

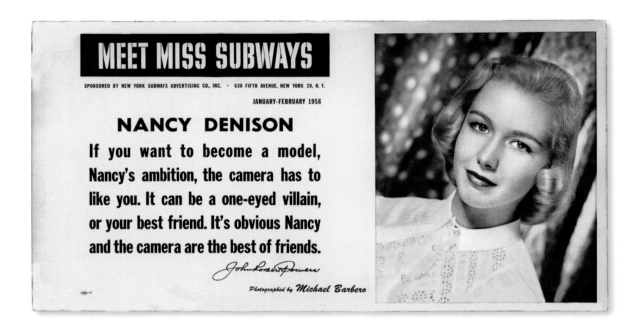

MEET MISS SUBWAYS

SPONSORED BY NEW YORK SUBWAYS ADVERTISING CO., INC. · 630 FIFTH AVENUE, NEW YORK 20, N. Y.

JANUARY-FEBRUARY 1958

NANCY DENISON

If you want to become a model, Nancy's ambition, the camera has to like you. It can be a one-eyed villain, or your best friend. It's obvious Nancy and the camera are the best of friends.

John Robert Powers

Photographed by Michael Barbero

really got me started and sent me to an agency. I did a 7-Up ad that was in all the magazines. I was on Bess Meyerson's "The Big Payoff" television show, where you modeled the fur coats and stuff. Then I entered a contest for Miss Remington Rand lady shavers, and Jerry Ford, from the famous modeling agency, was one of the judges, and I won that. Remington Rand was a big deal. I did their TV commercials for a whole year—they were on "Gunsmoke." I had a lot of fun. I liked not having an office job. I felt lucky that I was able to get good modeling jobs and do pretty well. But I knew I didn't want to model forever. I really wanted to get married like everybody else. When I was 21, I did, and I had a baby 10 months later. Then I had another little boy.

I really found it difficult to stay home all the time. I wanted to do something besides just be a mother. Saks Fifth Avenue asked me to do a fashion show for one of the charities in town in Garden City. After the show, the fashion director at Saks asked me to model three days a week. This job was perfect because it wasn't all the time and I loved the beautiful clothes and being out with people. None of my friends at the time worked. I felt a little like a pioneer because not many women did, at least in my group. I worked for Saks for 10 years and I had four children. I was a busy lady.

Sometimes when your kids grow up you have to really think about what you want to do with the rest of your life. I tried a lot of different things. I worked at a travel agency and I went to school to be a counselor after that. Finally, I thought back to my childhood and the thing I really loved: horse racing. I just took action, and my husband and I invested in a few racehorses.

We got divorced when my last son went off to college, after being married for 30 years. It's not something I did very easily, but it had to happen. It takes a while to be clear and ready. I continued to have an interest in horses after my divorce and wanted to go out on my own. It's very expensive to own a racehorse on your own, though. I couldn't

afford that. So I called the Thoroughbred Racing Association and went to the horse farms of Saratoga to meet people who had syndicates, which are like partnerships for horse owners. I could afford to be a partner. I ended up getting into a partnership with three others and a trainer. It turned out our horse was really good. He won six stakes races and he went to the Breeders' Cup two years in a row. He was a great sprinter.

Horses are great athletes. They give you everything they have. Sometimes I go by myself to the races, and I just sit and watch them. To me it's like going to the beach. It's very peaceful. I only have one horse at the moment—the one I had my picture taken with. She's up at Saratoga now for the summer. I'll go up there to see her run. Her name is Hear Me Roar. It's a great name, isn't it?

TEST SHOTS
Michael Barbero, the Miss Subways photographer, got Nancy in with a modeling agency. Some portraits from her portfolio show Nancy at age 19–20.

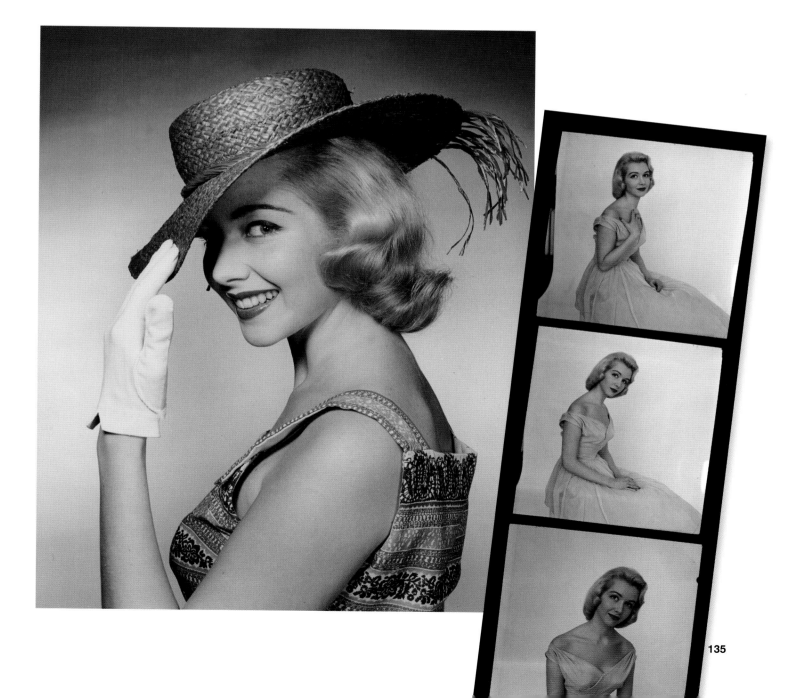

135

KATHRYN KEELER PAULSON on the porch of her home in Greenwich, Connecticut 2011.

Meet Kathryn Keeler Paulson

MISS SUBWAYS SEPTEMBER–OCTOBER 1958

My sister, Mary, and I were really young when we were Miss Subways. Our brief modeling career started in 1956 when we went to Erasmus High School in Brooklyn. I became Miss Erasmus. It meant I had good posture and all kinds of healthy things. We had 1,200 girls in our school and they would come around to gym class and eliminate people. Mary got eliminated, but I never did. I was featured on the front page of the *New York Herald Tribune*.

Then our mother sent us to modeling school and we were with the Harry Conover agency when we were 16. I remember having to leave school early sometimes to go on jobs in Manhattan. It was fun. Imagine two 16-year-olds walking down Madison Avenue. But we didn't have a lot of training for it. The ad agencies would ask you all these questions and tear us apart. It was like being thrown to the wolves. Mary was tougher. Mary did more modeling than I did. She would make the rounds. It wasn't my cup of tea. I was the quiet one. I was the preppy. She was the peg pants. But it was really fun to be Miss Subways together. If you're a teenager, it's a confidence-building thing.

Later, Mary and I worked for Milliken textiles as receptionists. My brother worked at Milliken, too. We came from a large family and we were all expected to contribute.

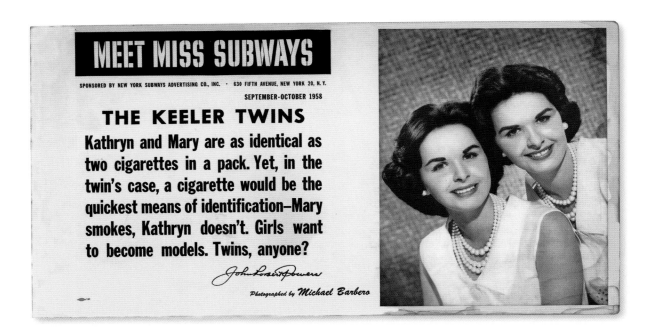

MEET MISS SUBWAYS

SPONSORED BY NEW YORK SUBWAYS ADVERTISING CO., INC. · 630 FIFTH AVENUE, NEW YORK 20, N. Y.

SEPTEMBER-OCTOBER 1958

THE KEELER TWINS

Kathryn and Mary are as identical as two cigarettes in a pack. Yet, in the twin's case, a cigarette would be the quickest means of identification—Mary smokes, Kathryn doesn't. Girls want to become models. Twins, anyone?

John Robert Powers

Photographed by *Michael Barbero*

Milliken liked us to wear clothes made from some of their fabrics. We rode the subways in those days and when we wore our Milliken outfits people would stare at us.

I also worked for TWA as a stewardess. I did that for two years and then I got married and I stopped. I married an advertising executive and had five children and 12 grandchildren. We lived in Rye, New York, and then we moved to Greenwich, Connecticut. Mary lived in Connecticut, too. She married her high school sweetheart and had three boys. Most of us didn't have to work when we got married. In our day, it didn't cost as much to buy a house. The gals have it harder today. They have to get up every day and work and raise kids. My daughter, Terry, is expecting her third child, and she works in the city.

Because women do so much more in business today than they did in the 1950s, I can understand why they stopped the contest. There's a time and a place for everything. Today, it's not as innocent. The women's movement changed everything. It changed the way we look at beauty queens. And that's okay. But women do need to be complimented and get confidence in whatever way they can. So, I think for us, we were very lucky. All these women are still taking care of themselves. We should all still be taking care of ourselves. A lot of the women I've met at Miss Subways reunions had second careers and the confidence and know-it-all to do it.

I eventually returned to work, too. At some point, my sister suggested I get a real estate license. So I did. And then, once I had it, one of my best friends said, "Come work for me." I've worked as a real estate agent in Greenwich, since 1990—I waited until my youngest was a senior in high school. I never think of it as a career, but it is hard and all consuming. Times are slow right now. Still, working, it keeps you in shape. I'll just keep going until someone doesn't want to go out looking at homes with an old lady.

Mary and I were in a family of six kids, four girls and two boys. We were kind of intimidating to our other siblings because we were like a unit. Twins are a special thing.

We looked at each other and could just communicate—we couldn't help it. Mary died of breast cancer in 1993, 13 years after she was first diagnosed. I still can't believe it. It feels like yesterday. She was a smoker, like the poster said. But nobody in those days knew there was any danger. She never gave it up. Who knows if it was connected? Now, you take preventive measures.

I enjoy my grandkids. They keep me young. Mary never had any grandkids. Makes you wonder. I miss her terribly. I'm only half a Miss Subways winner, so I haven't been enthusiastic about the contest because it's still sad for me. We were very close.

SEEING DOUBLE
Kathryn and her identical twin sister, Mary, went to modeling school then signed with the Harry Conover agency at 16. While they did some photo shoots together, Mary went on to do more modeling than shy Kathryn.

ADRIENNE MARIE CELLA CARONE outside her home in Palm Beach Gardens, Florida 2009.

Meet Adrienne Marie Cella Carone

MISS SUBWAYS JANUARY–FEBRUARY 1959

I was born and raised in Greenwich Village when Greenwich Village was a village. I left in the late 1950s, and in the 60s, the Village really changed. My dad's family has been there for over 175 years now. My father made his career there and never left. He was a Supreme Court judge for the city of New York. While I was attending college, I was what today they call a paralegal. Back then you were called the right arm of the lawyer. So that's basically where I was. I did a lot of the background paperwork, plus the usual at that time, typing. I went to private schools—St. Josephs academy, Marymount, NYU—and then I spent two years at Fordham in elementary education and art. I was voted Miss Fordham in 1956. I worked small modeling shows back then, but I didn't aspire to be a model. I did it mostly to keep in shape. I don't even remember how the opportunity arose to become Miss Subways.

I left Fordham to get married in November of 1959 and then I had three children, born within three years of each other. I was very busy. It was a very wonderful time for me. I enjoyed my children. I was young. I had the energy and could keep up with them. I was in a good position. I didn't have to work. I did do the window designs for a friend who owned a craft store, but it wasn't a full time job by any means.

I wanted to complete my education though. There was no question about it. When you spend a number of years raising three children you seem to forget the level of education you had prior. When my children were getting to the age where they were going to be making college selections, I wanted to pursue that higher education and move on intellectually as well. So, maybe 20 years after I left college I completed my education with a double major in psychology and art at Adelphi on Long Island, near where we lived.

MODEL WIFE
Voted Miss Fordham in 1956, Marie did some small modeling jobs during her school days to stay in shape. (Above) Despite enjoying her studies, she left the University in 1958 to get married, though she did return when her children were grown.

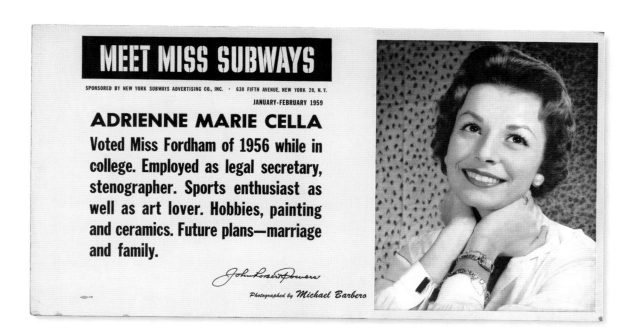

At the time I had three teenagers, so it was busy for me, but I timed my classes during the day so that I was always home for the children. I stayed up most nights, writing papers. It was a wonderful experience. I'm glad I did it. It was stimulation, which was absolutely necessary. It's challenging when you're in a classroom not of your peers, but with kids maybe a year older than your own. But it was so well worth it. It was a great feeling of satisfaction to know that the capability was still there. I graduated magna cum laude.

School was also a good diversion because of the circumstances at home. When you enter a union you expect it to last a lifetime, and my first marriage did last 20 years, but it was not a happy union. It was dissolved in 1980, and my happiness began when I met my second husband. We married in 1985 and pursued a tremendous amount of travel. He was a doctor and worked for the Joint Commission on Accreditation of Healthcare Organizations, the unit that surveys all the hospitals across the country. We had the opportunity to travel across the country and back, north and south, east and west. He was a cruise enthusiast, so there were multiple cruises, too. After graduating, I had worked in a psychiatric clinic and thought about doing my master's degree, but my life changed completely with my second husband and I stopped working. My children were adults, although the responsibility never ends with the children, which you find out in time. But life does change. His health was not good. After a few years of snow-birding in Florida, we moved here permanently for the climate. We stole three years, but then I lost him nine years ago.

I never talked much about being Miss Subways with him. At the time I won, anything like that was a big deal. You feel you're so exquisite, and then you look at yourself several years later and say, 'Who's that?" My mom was a model prior to her marriage in 1931. When she passed away I looked at her and said, "You have a heck of a lot of nerve taking that skin with you." She didn't have a flaw—not a flaw and she was 92. I take after my father, who was allergic to strawberries.

Meet Ellen Hart Sturm

MISS SUBWAYS MARCH–APRIL 1959

I was voted prettiest girl in Jamaica High School. Everybody told me I should send my picture to Miss Subways. So, I did. I remember running up and down the stairs of my house, I was so excited. I thought this was going to be the start of a huge career in show business. I had intentions of becoming a famous singer on Broadway. But it was a whole different era back then. If you didn't get married you were an old maid, so I did get married very soon. It was 1962 and I just turned 21. I got pregnant right away because in those days we knew so little about sex. I had two sons, Kenneth and Ronald.

When my sons were 13 and 17, I decided to go back to work. I had been playing a lot of tennis but it wasn't fully occupying my time. I was kind of frustrated in that respect. My husband owned a very small coffee shop near City Hall, and I decided to go into the business when we expanded. I

ELLEN HART STURM with her singing wait staff at Ellen's Stardust Diner on Broadway, New York, New York 2007.

MEET MISS SUBWAYS

SPONSORED BY NEW YORK SUBWAYS ADVERTISING CO., INC. · 630 FIFTH AVENUE, NEW YORK 20, N.Y.

MARCH-APRIL 1959

ELLEN HART

Ellen has appeared in school plays and plans to pursue an acting career after graduation from High School in June. Most of her spare time is devoted to acting, singing and speech lessons.

John Robert Powers

Photographed by Michael Barbero

ALL DRESSED UP
Ellen recalls being Miss Subways in a different era, when the fare was a dime and women wore gloves.

turned it into Ellen's Café. Because it was opposite City Hall, the politicians would come in, so I met Mayor Edward Koch and Mayor David Dinkins. I had my Miss Subways poster hanging there, and I decided it would be great to have a Miss Subways reunion. I hadn't met any of them and I thought it would be interesting to see who they were. I had been organizing a lot of events at the café. We had a 115th anniversary party for the coffee percolator. We had an Elvis look-alike contest. For the mayor's birthdays we'd have as many cakes as their birthday and gave them to charity. So I thought it would be a big hoot to have a Miss Subways reunion. At the time, I was working with a public relations guy, and he helped me gather everyone together for the first reunion in 1983.

We no longer have that café because the building became a condo, like so many other buildings down town. We opened another diner on 56th Street and Sixth Avenue modeled on the '50's retro diners in California. But the landlord got very greedy at the end of our lease, so we moved to 51st Street and Broadway. Because I sing, the idea was to have a singing wait staff, which made it a lot more fun. We also opened the Iridium Jazz Club in the basement, where we had the guitar legend, Les Paul, on Monday nights and our Sunday jazz brunch. I would sing at the brunch. So, I did get to do my thing on Broadway because Ellen's Stardust is located on Broadway.

My fantasy on the Miss Subways poster said I was going to be a famous singer. But I didn't work hard enough to be a star. You have to give up everything. You have to travel and pursue it in the business sense, too. It's show business—a lot of people don't have the business angle to the show. I did sing in the Catskill Mountains. I sang in Rockland County when it was the country and they had bungalow colonies there. I sang the National Anthem for the Rangers and Knicks games in the 1980s. I sang the National Anthem for a firehouse when it opened in Brooklyn. At the diner, we have some fabulous waiters. We have people that are in "Jersey Boys," the "Lion King" in England. We have

people who get fabulous acting jobs, but a lot of them come back because the work is not continuous. It's very tough. We see people who have great voices, but they don't go out for the auditions. They'd rather party or whatever. It's also very hard when you have a job.

I must have gotten about 120 women at my first reunion. That was the biggest turnout because many of the women were still alive at the time. They were younger and hadn't moved out of the state yet. They all came and they left me their posters—I think I have the largest collection. We must have had five or six reunions since. We always had a reason. "On the Town" with "Miss Turnstiles" was re-opening on Broadway, and Betty Comden and Adolph Green showed up. I had a reunion to celebrate my 50th anniversary as Miss Subways. It was a wonderful day. Our oldest attendee was 85 and the youngest 58. How quickly the years go by! I remember when the subway cost a dime and we would dress up and wear our white gloves. We wouldn't go on the subways in jeans, that's for sure. I never ride the subways anymore.

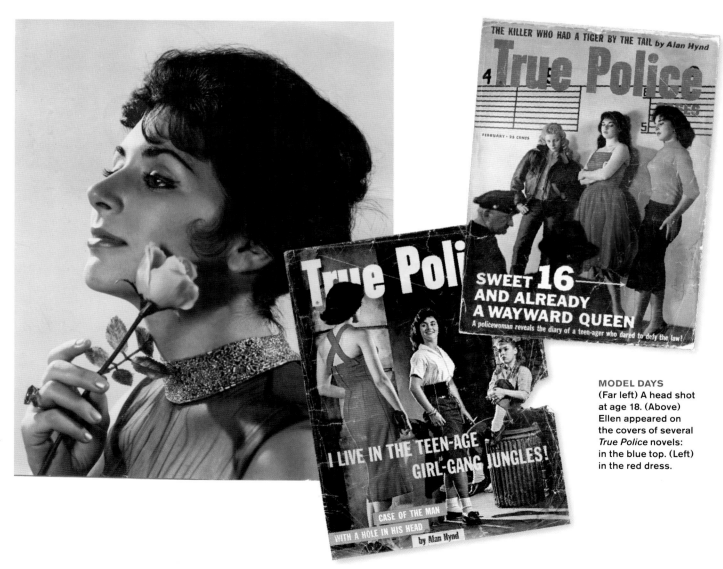

MODEL DAYS
(Far left) A head shot at age 18. (Above) Ellen appeared on the covers of several *True Police* novels: in the blue top. (Left) in the red dress.

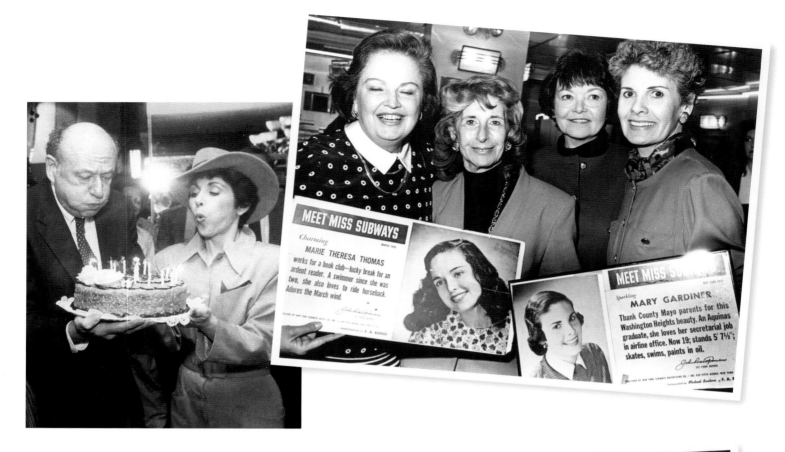

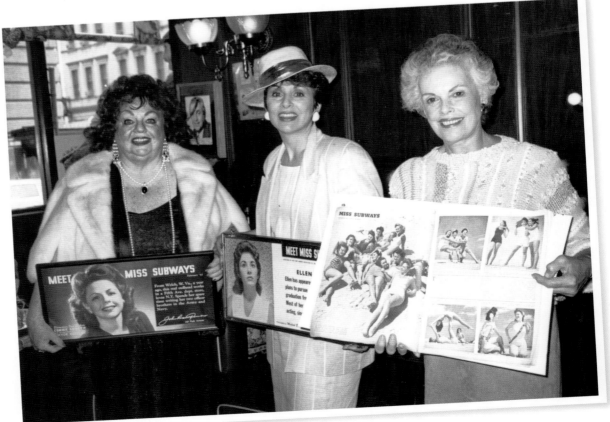

POWER PLAYER
(Above) Mayor Ed Koch celebrates his birthday with Ellen at Ellen's Coffee Shop near City Hall.

REUNION
(Right top and bottom) Ellen has organized several Miss Subways reunions at her restaurant, which boasts the most complete Miss Subways poster collection anywhere. Winners pose with their posters at these events. (Opposite page) Ellen cuts the cake.

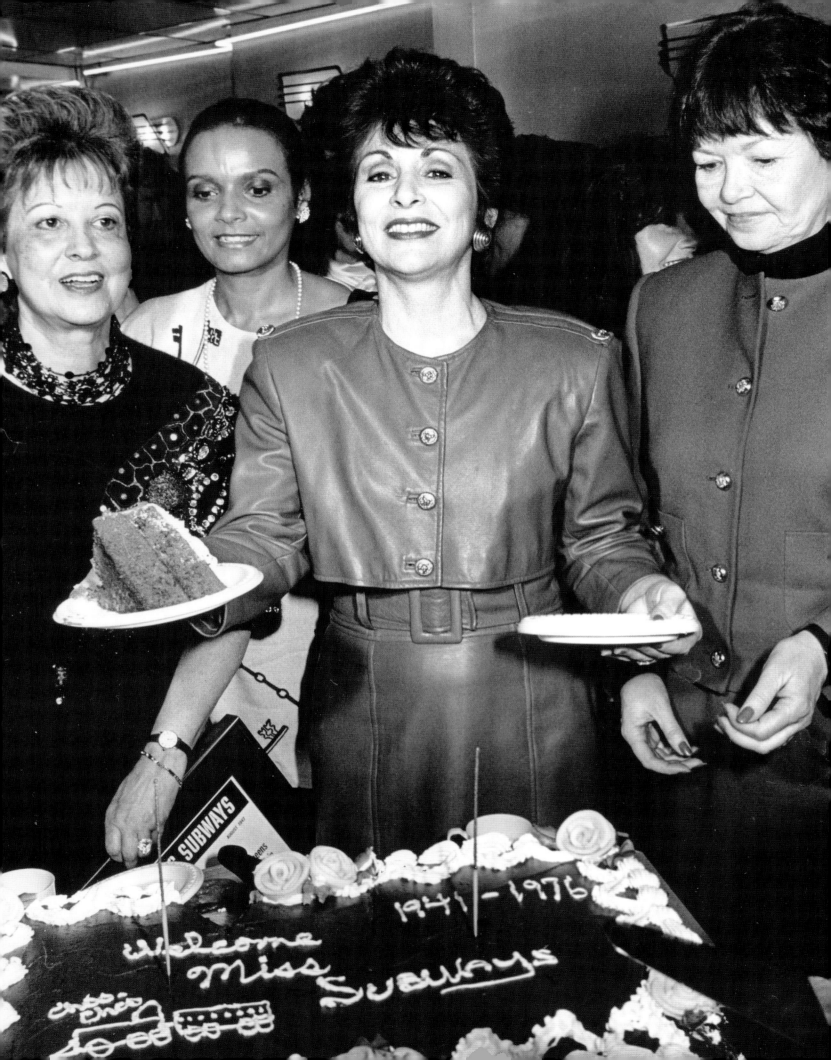

ON LOCATION
A bevy of Miss
Subways winners
gather on the steps
to the local subway
station during a
reunion at Ellen's
Stardust Diner.

Meet Gail Burke Zorpette

MISS SUBWAYS MAY–JUNE 1959

I was going down the elevator one day when a gentleman said to me—he was very courteous—"I don't want to upset you, but I am an agent and if you're interested in modeling, here's my card." I took the card. He was with John Robert Powers. I was 19 years old and terrified, but I went with my mother. He had some print jobs, some magazines and a record album cover. I was engaged already, and I did a little bit of modeling because I thought every dollar I could bring to the marriage would be good.

I got married to my high school sweetheart in June 1959, when my Miss Subways poster was up, and moved to Bridgeport, Connecticut. I left everything in New York, and I never looked back. I guess it was easier to get started in Connecticut. We got a little apartment in Bridgeport and started having children and then moved to Stratford

GAIL BURKE ZORPETTE in the garden at her home in Stratford, CT 2011.

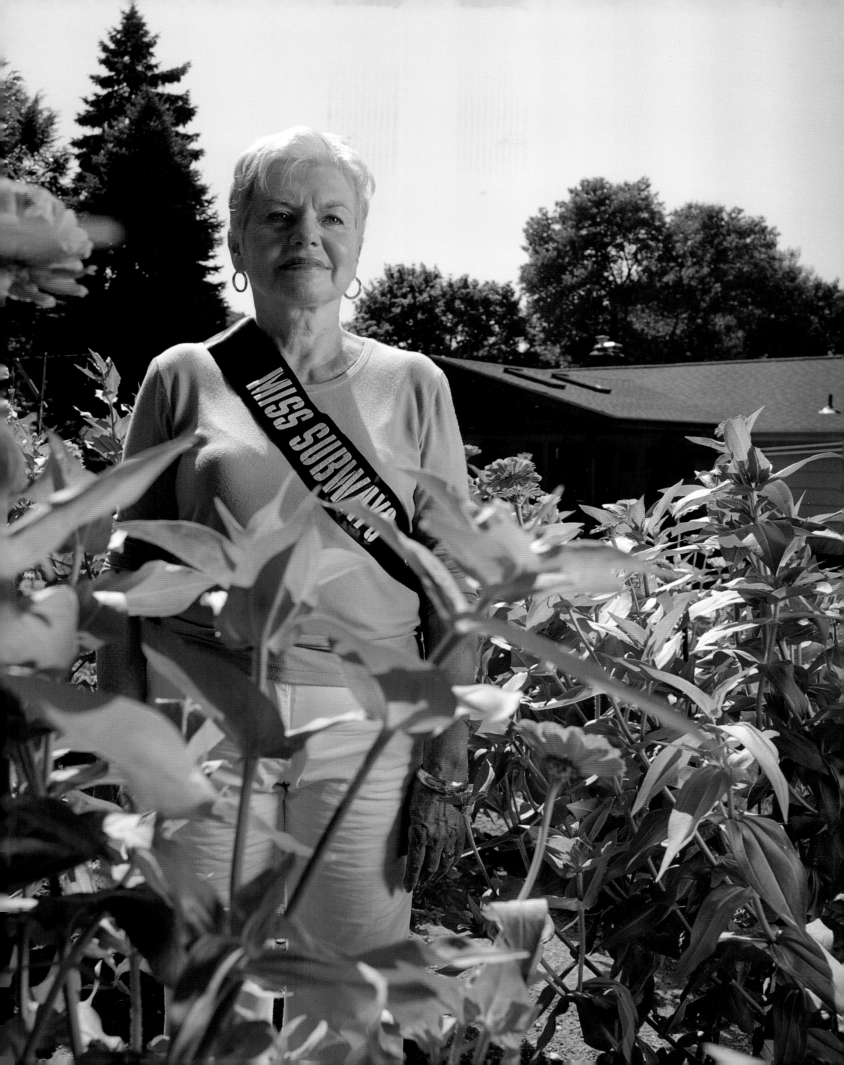

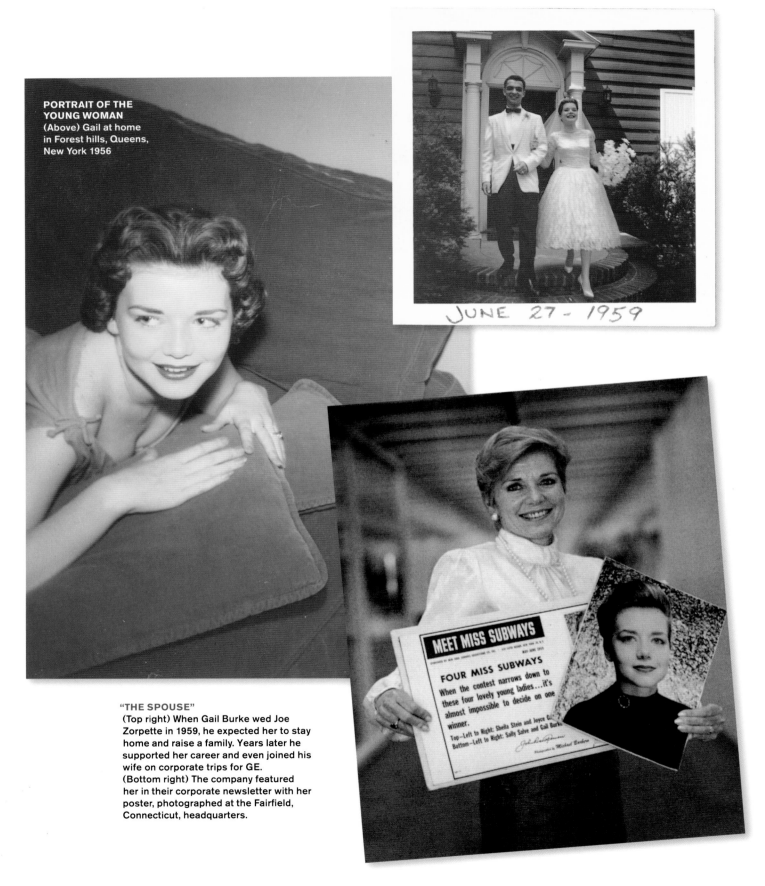

PORTRAIT OF THE YOUNG WOMAN
(Above) Gail at home in Forest hills, Queens, New York 1956

JUNE 27 - 1959

MEET MISS SUBWAYS

FOUR MISS SUBWAYS
When the contest narrows down to these four lovely young ladies...it's almost impossible to decide on one winner.

"THE SPOUSE"
(Top right) When Gail Burke wed Joe Zorpette in 1959, he expected her to stay home and raise a family. Years later he supported her career and even joined his wife on corporate trips for GE.
(Bottom right) The company featured her in their corporate newsletter with her poster, photographed at the Fairfield, Connecticut, headquarters.

primarily because the schools were better. Joe worked for the power plant here. Getting married and having children, it was just something you did. I guess as a woman everybody assumed—and I assumed—I wasn't going to work. I never made enough to pay for a nanny. I could not see another person, whether a stranger or family, taking care of my child anyway. For a while I did have some part time jobs. I took in sewing. I would do alterations for women. I would make curtains. I felt like a real pioneer woman.

But it wasn't enough. I remember when we lived in Bridgeport we had this linoleum on the floor in the kitchen with white artificial grout, and it bothered me that the grout got dirty. I would get down on my hands and knees with a toothbrush to clean it. Then I got a floor buffer. I was crazy about the artificial grout on my floors. I had a lot of energy and I got bored quickly. It was not a good time for women. My daughter, who is watching "Mad Men" now, says, "I don't know how you lived then." I can't watch it. It makes me nervous. I never was one to watch television because I was afraid it would rot my brain, and I was afraid of becoming addicted to soap operas, like some of my friends. When my kids started getting older, about 10 or 11, there came a time when I would finish with my house work and cleaning and I knew what we were going to have for dinner and didn't have money to shop and I just had time. I said, "I think I need something else." And my husband said, "No, you don't need anything else. You should be here in case the kids need you."

My husband would say, "We don't need the money." And at that point we didn't, but I wanted to do better. I wanted more. I wanted my kids to have more. They were bright, and that meant college. I told my husband, "Either you're going to have to come visit me when I have a breakdown from doing nothing for lack of use or I am going out and getting a job." I got a job for a local newspaper setting type. The place I worked also set the newspaper for the corporate headquarters for GE. I knew a guy there who worked

SHY GIRL — *but* HOT DATE

I hated being bashful—blushing all the time... But in the dark at night in a parked car—I found one sure way to get boys to notice me!

● It's a horrible life being bashful! I guess you've heard the old saying about the people who are so thin-skinned they blush if you look at them cross-eyed. Well, I was one of those. I was so self-conscious that clear up until the time I got out of high school, before the terrible thing happened to me to change my life and everything about me, I didn't have one peaceful minute because I thought everybody was looking right at me. That's the way a person with an inferiority complex is. They are so self-conscious they just keep watching to see who is watching them, and then when they catch the person really looking, they nearly suffocate with the pain of blushing and being half afraid and wondering how they can run out on the embarrassing situation.

Bashful people have to have some compensations, some crutches I guess you'd really call them, to fall back on just to keep from doing something desperate and to get some pleasure out of life somehow. I wasn't any different from any other bashful person. Just like most of us I had my daydreams to pacify me when the going got too tough. Another thing, I had my love of nature. There was nothing I liked better than heading for the big pine woods just beyond our field, where I could throw myself down on the fragrant, soft needles and cry my heart out or paint my dreams. In summer the birds would be singing, the air would be balmy, and I'd feel like I was in another place—like heaven was, maybe. In winter I'd sit on an old fallen log and try to forget the cold while I got on with my dreaming.

Every girl has to have a hero for her dreams. Mine was Bruce Hart.

Oh, not that it mattered—to him. He was as far away as the stars where I was concerned. He was popular. He could get most any girl he wanted. He had the girls right where he wanted them, in the palm of his hand, and he knew his power. Of course, he didn't give me a second glance—not until that night at Christian Endeavor. And even then it was just by chance, just a funny twist of fate.

I guess I'd about died if I couldn't have at least seen my

20 SEPTEMBER, 1958

ULTIMATE STORY 21

MODEL DAYS
(Above and right) Discovered by an agent in an elevator at 19, Gail took some magazine jobs hoping to bring a little money to her fledgling family. (Opposite page) Gail also appeared on record covers, including "Let's Dance."

Everything I touched turned bad... even my lovemaking!

GASPING with real terror, barely able to navigate the narrow, circular stairway that led to the psychiatrist's office, I half-walked, half-crawled to the top. Having made the admission that there was something very wrong with me, I was anxious to see this man, and yet I was terribly afraid of what he might discover.

The old fashioned glass door at the head of the stairs opened to a small, cheerless foyer. I looked furtively around me, my heart pounding alarmingly. I seemed unable to suck enough air into my lungs. And then, a calm, low-pitched male voice invited me in to a larger, brighter room. Seated in an armchair, was a small bespectacled man. Could such a mild appearing man be able to unravel the tangled skeins of my life? He arose, came toward me, hand extended in friendship. How I hoped he would be the friend I needed so desperately.

"Have a cigarette?" the doctor asked pleasantly.

"No, thank you, I don't smoke," I said. "But I do have other bad habits," I added ruefully.

He motioned to the couch. "Would you like to lie down?"

"No, thank you," I answered tonelessly, suddenly frightened at the thought of putting myself in such a vulnerable position. I sat down on a small chair, rather defiantly. My eyes discovered a shiny white pad on the doctor's desk. Would it soon be littered with the refuse of my life, the filthy details that even I wouldn't think

24

"Somehow when we're together I have the feeling you're never with me... that you don't care enough about my feelings," Emmy said, blushing.

"You're a CLUMSY LOVER!" (A YOUNG WIF... TRAGIC STORY

for GE, and at one point I asked him about openings. I went for an interview and got a job as a secretary. I thought I was on top of the world. I had several jobs there. Our whole standard of living took a very positive and really wonderful turn.

I loved everything about working. Getting up, being busy, accomplishing, getting a paycheck, meeting all these people. I remember the struggle of not being so happy with being home and not knowing what could really make me happy. You sort of had to fight the whole world. If I hadn't started locally, I couldn't have done any of it. I would drop the kids at school, set type all morning, go home to give the kids lunch, bring them back to school for the afternoon and go back to work. I didn't think of myself as ambitious, but I guess I was.

I was fortunate in that my husband sort of wanted it the old way, but he understood I couldn't do that. We reached a point later when he said, "It was really good that you liked to work." GE would send me on trips where I could bring a spouse. Most of the other people were men, so they brought their wives. My husband would sit with the wives. He would say, "I love being a spouse."

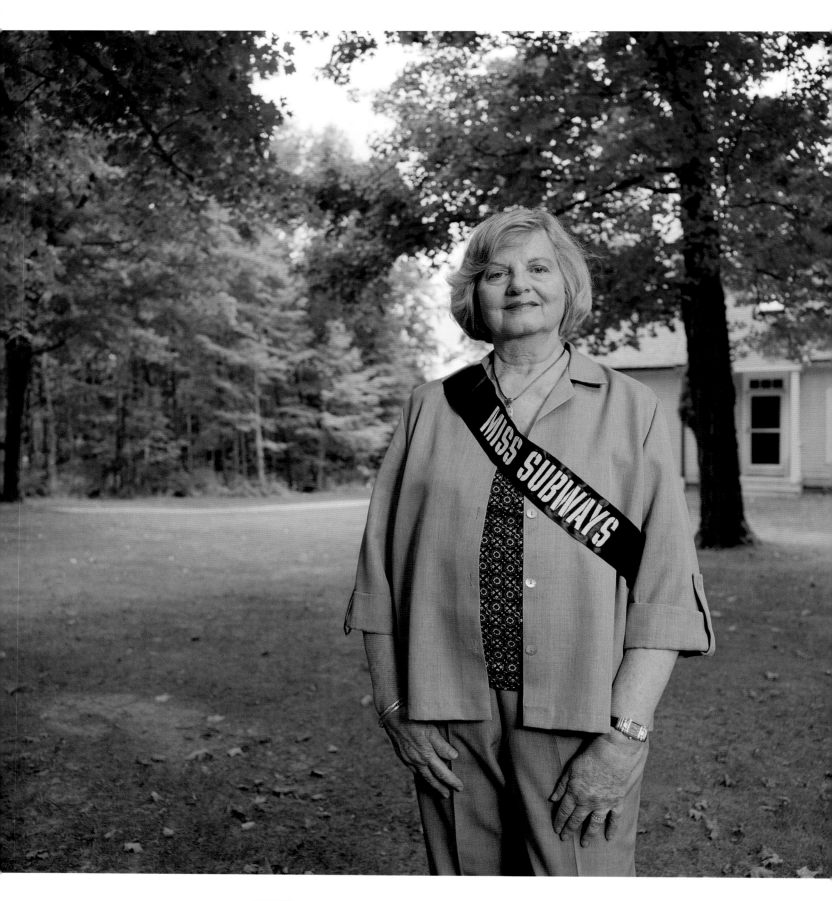

DEANNE GOLDMAN SALZ at her home in Shaftsbury, Vermont 2011.

Meet Deanne Goldman Salz

MISS SUBWAYS JANUARY–FEBRUARY 1960

When I was Miss Subways in 1960, I was living with my parents in the Midwood section of Brooklyn and teaching in Coney Island. I always knew I wanted to be a teacher, and kindergarten was what I was drawn to. I liked young children, and I played the piano. At that time, as part of the teaching exam you had to play the piano. You had to go to a school that you'd never been in before, and you had to teach a lesson and a song to a class of children you had never met. When I started in Coney Island, we were two teachers in a room, and we had 50 children in the morning and 50 others in the afternoon. It was many, many kids. In the room at that time, you had a piano and you had different centers: you had a block corner, you had dollhouses, you had art with easels, you had puzzles and games. And at the time, formal teaching of reading was not allowed. I didn't agree with that, but they wanted it just to be a growing experience for the children. I don't think kindergartens have pianos in the room anymore. It's no longer required. The kindergarten experience that I knew is gone. It's now much more of a first grade time with formal activities and homework and not the socializing and fun time that it used to be.

My mother had been a first grade teacher, and when I started teaching kindergarten, we were one of four mother-daughter combinations in that school. When my mother taught in the '40s and '50s, she always went to school wearing a hat and gloves every day. When I taught, you were not allowed to wear slacks or pants of any type. My principal advised us not to wear too much makeup. A friend who wore her hair in a ponytail was told that was inappropriate. The rules were kind of different back then. In the '70s things

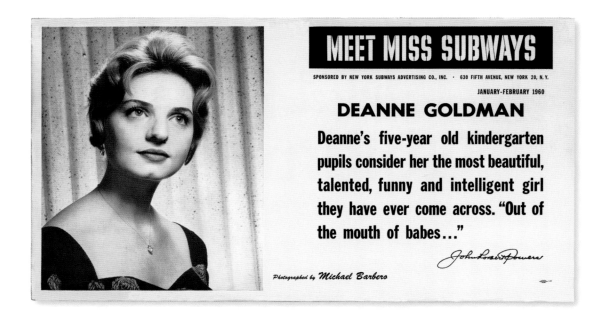

MEET MISS SUBWAYS

SPONSORED BY NEW YORK SUBWAYS ADVERTISING CO., INC. · 630 FIFTH AVENUE, NEW YORK 20, N. Y.

JANUARY-FEBRUARY 1960

DEANNE GOLDMAN

Deanne's five-year old kindergarten pupils consider her the most beautiful, talented, funny and intelligent girl they have ever come across. "Out of the mouth of babes…"

John Robert Powers

Photographed by Michael Barbero

started easing up. It became okay to wear a pantsuit to school, and a man didn't have to wear a jacket and tie. I think the intention was that you would connect in a better way with kids if you didn't look so different from them, but I'm not sure that was right.

I came in to the school system right after the teachers' union came in. Sick leave, sabbatical, vacation, class size, salary—things that teachers take for granted now all changed tremendously. The salary when I began wasn't a lot, but I had a car, and when I moved out of my parents' home to Brooklyn Heights, I was able to afford my $120 a month rent. I had a great apartment on Montague Street, right on the water with a roof garden on top. I had a friend who lived in the building, so that was an incentive because she was already there. And I just thought it was a good idea for me to be out on my own. I was there for about three years, and then I met my husband and we got married.

We met at the Concord Hotel, which was a very popular Catskills resort at the time. I was there for the weekend and he had been skiing nearby and stopped in to look around on his way back to New York. I was sitting at the bar with someone I had just met who turned out to be his cousin. I needed a ride back to the city, and my future husband offered to drive me back.

We lived on Ocean Parkway in Brooklyn, and after my son was born, I was home with him for five years. Then my old principal called to say she had an opening in a kindergarten class in a school near my house. The timing was good: since my son would be in kindergarten, I was able at that point to go back. I didn't experience that feeling of guilt of having to leave an infant to go to work. I retired in 1991 after 29 years of teaching. Then I worked nine years after that as a museum teacher at the National Society for Colonial Dames in New York on East 71st Street in Manhattan. I would dress up in colonial costume, with the dress and the cap, and I would teach kids the minuet and New York history. It was always fun. The children always asked me if I slept in the colonial house at night.

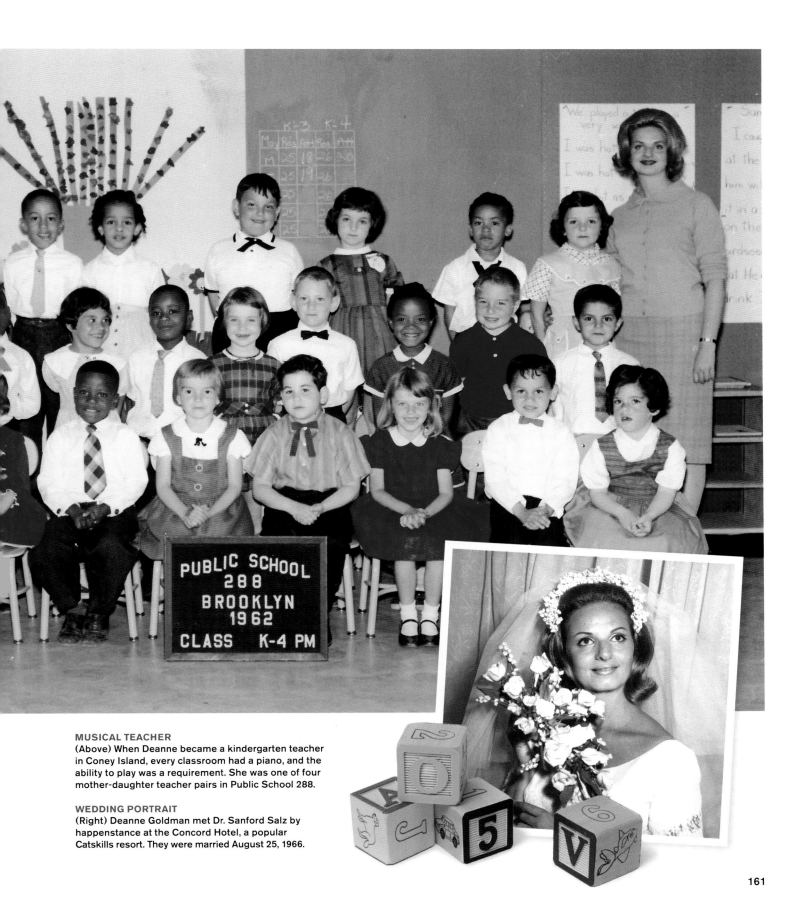

MUSICAL TEACHER
(Above) When Deanne became a kindergarten teacher in Coney Island, every classroom had a piano, and the ability to play was a requirement. She was one of four mother-daughter teacher pairs in Public School 288.

WEDDING PORTRAIT
(Right) Deanne Goldman met Dr. Sanford Salz by happenstance at the Concord Hotel, a popular Catskills resort. They were married August 25, 1966.

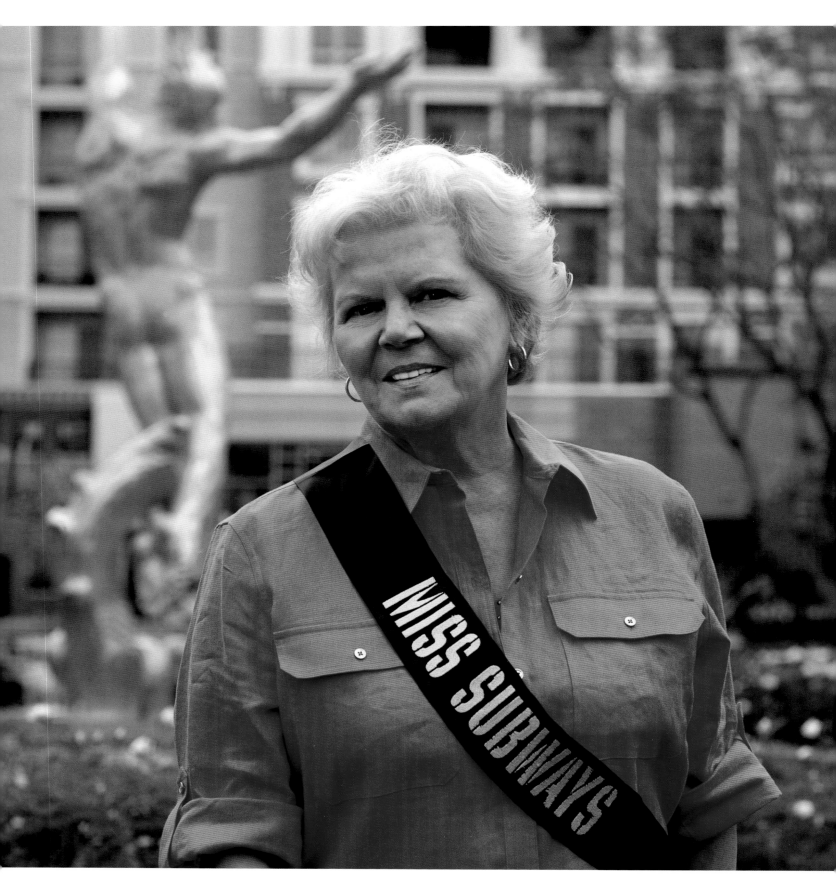

SHIRLEY MARTIN in Glendale, California 2010.

Meet *Shirley Martin*

MISS SUBWAYS MAY–JUNE 1960

I was raised and went to school in California. When I was in college, teaching was considered a noble profession and most of my friends were going into that, but I wanted to travel. I applied to be a flight attendant for TWA—or a hostess, as we were called. I went to Kansas City for training. It was quite a process back then. You had to meet very strict criteria. I think they only took five out of 200 applicants. You had to be a certain height, a certain weight. I was about 5'6" and 120 pounds at the time. You couldn't have chipped nail polish if you were flying or they would ground you. You had to wear a girdle—even though I was very thin at the time. They didn't want anything jiggling, I guess. My girlfriend gained a few pounds, and they grounded her until she lost them. Nowadays they can't do that, of course. It used to be more of a glamour job. Now it's more of a safety job and you have to be trained differently.

When I first moved to New York with a bunch of flight attendants we lived in Great Neck, Long Island, and we worked at Idlewild Airport—it wasn't yet called JFK. But I really wanted to live in the city. That's where everything was happening. So, two of us TWA girls and three American Airlines girls moved to Riverside Drive. It was a huge, beautiful co-op that overlooked the Hudson River. I don't remember what we paid, but

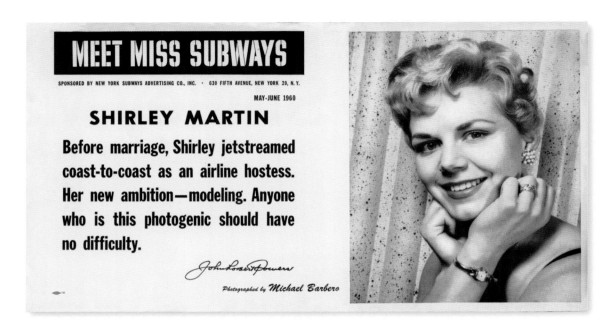

MEET MISS SUBWAYS

SPONSORED BY NEW YORK SUBWAYS ADVERTISING CO., INC. · 630 FIFTH AVENUE, NEW YORK 20, N. Y.

MAY-JUNE 1960

SHIRLEY MARTIN

Before marriage, Shirley jetstreamed coast-to-coast as an airline hostess. Her new ambition—modeling. Anyone who is this photogenic should have no difficulty.

John Robert Powers

Photographed by Michael Barbero

we didn't make that much. I remember going to Saks Fifth Avenue to buy my first coat. I opened a charge account, and I bought a double-breasted black wool coat with a fur collar. That was my first purchase by a charge account. I was so proud of it.

I was Miss TWA New York, and the winner was supposed to go to Europe to the World's Fair. However, just about then I decided to get married, and at the time, if you got married you could no longer fly, so I never got that trip to Europe. I met my husband, Ray, at Toots Shor's Restaurant. It was a famous restaurant in New York where a lot of celebrities and sports people used to hang out. Of course, many years later the airlines decided the policy was not right, and all the people terminated because they got married could get their jobs back. By then it was a moot point for me. I wasn't going to go back to work flying with a couple of children.

I was having my hair done at Saks once when this lady says, "Have you ever modeled?" I had modeled when I was living in California, and I did a little acting when I was growing up and when I was in college. She gave me her card and said, "Why don't you give me a call because we're always looking for new Miss Subways." I didn't think anything of it. I went home and told my husband, and he said, "I'll send in one of the pictures that you took when you were modeling." He sent in one of the pictures and they called me in for an interview. I got a couple of nice write-ups in newspapers. One columnist wrote, "Shirley Martin could stay Miss Subways all year long as far as I'm concerned."

By the time my poster went up, I was pregnant with my first child. I did have some modeling offers, but I couldn't accept them since I was expecting. I hadn't planned on working after I was married necessarily. Actually, my husband didn't want me to, and it just wasn't what you did back then. You got married, you stayed home and you took care of the kids until you got sick of that.

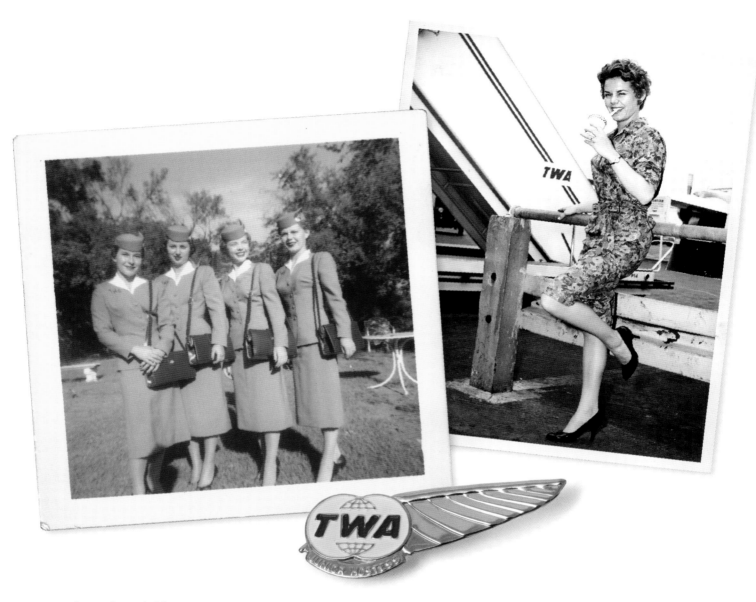

Three of my children were born in New York. We moved to California because my husband was traveling there so much for work, and my daughter was born in Los Angeles. I was very active when the children were growing up in the PTA and charity organizations. I also coached my daughter's softball team and the cheerleaders from my son's football team. When the Olympics came to Los Angeles, I worked as a VIP hostess for incoming teams and dignitaries. I didn't have to work while my children were young, but even after all the charity work I felt there was something missing. I had a second career when they were grown, working at a health and wellness center. I help people take care of their health or lose weight or lower their cholesterol. And I'm very grateful to have this job now. I work out of a home office because my husband has advanced Parkinson's disease. I'm not able to get out and about as much. That's why I'm glad we were able to travel when we did. He took me to Europe. After losing out on the Miss TWA trip, I told him he owed me that.

MISS TWA
Shirley worked for the airline and lived with her fellow stewardesses on Riverside Drive. She won Miss TWA New York, but married before she could take her winning trip to Europe.

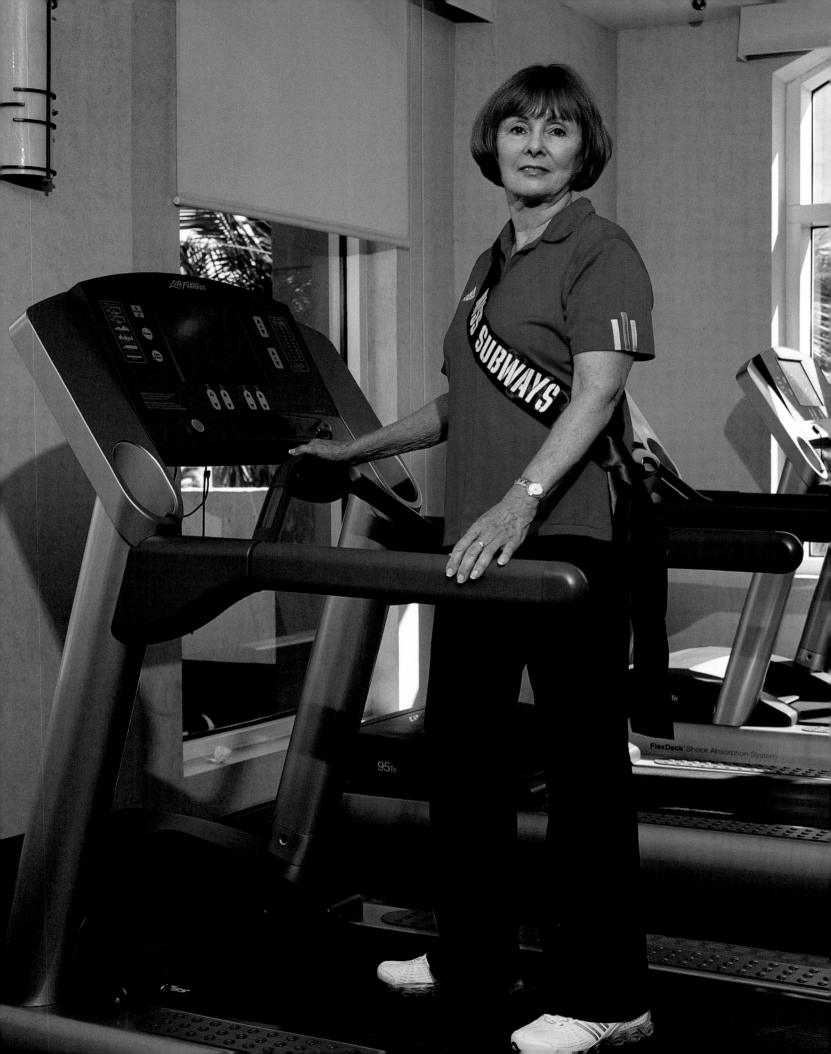

Meet Eleanor Nash Brown

MISS SUBWAYS NOVEMBER–DECEMBER 1960

My father didn't approve of modeling. As a New York City transit policeman he knew some of the things that went on in that type of business. I only did it part time because he didn't want me in it full time. I really wanted to be a police officer like my father, but he absolutely forbade that, so I went to work for the FBI instead. My Miss Subways poster said I was an expert with a rifle. They put rifle down on the poster, but really it was pistol-shooting, .22s. The FBI doesn't have a bowling team, so you belong to the pistol club. I stayed there about a year and a half, as a clerk. I did steno, some typing. They didn't have women agents at that time.

I didn't go to college until later on, after I was married. In certain families the thinking was that women didn't

ELEANOR NASH BROWN at the gym where she is a personal trainer for seniors, Fort Lauderdale, Florida 2009.

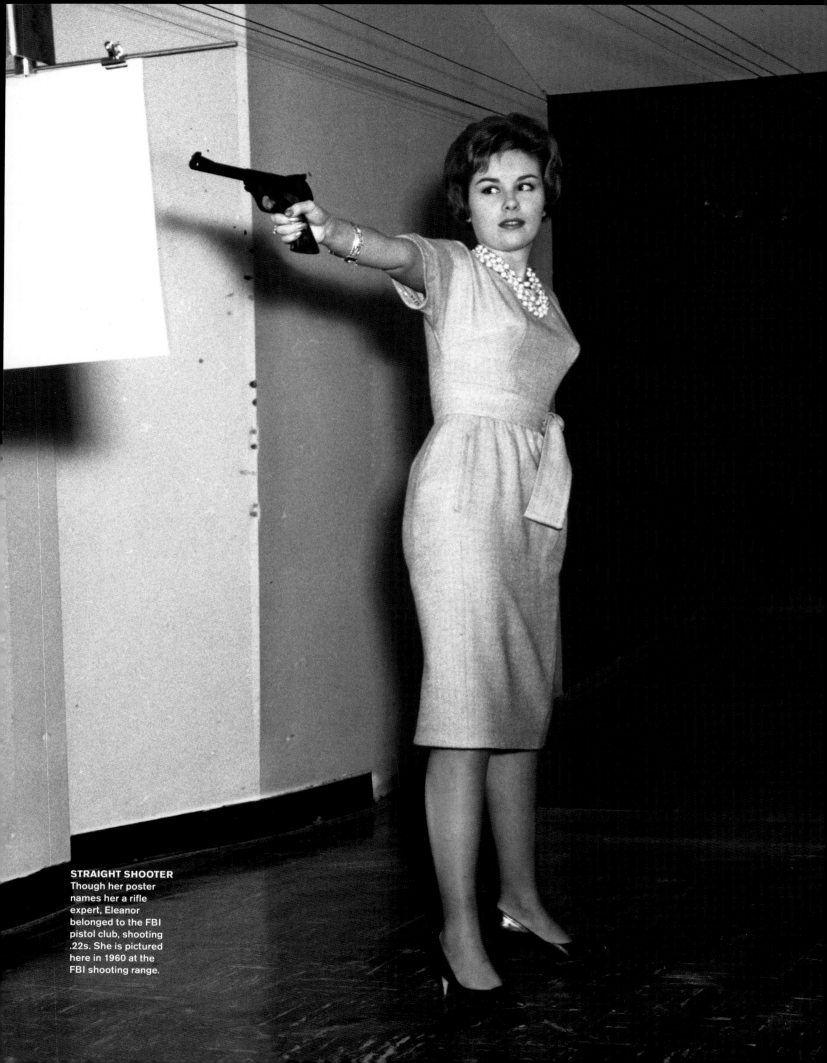

STRAIGHT SHOOTER
Though her poster names her a rifle expert, Eleanor belonged to the FBI pistol club, shooting .22s. She is pictured here in 1960 at the FBI shooting range.

MEET MISS SUBWAYS

SPONSORED BY NEW YORK SUBWAYS ADVERTISING CO., INC. · 630 FIFTH AVENUE, NEW YORK 20, N.Y.

NOVEMBER-DECEMBER 1960

ELEANOR NASH

Young, beautiful and an expert with a rifle. A clerical employee in the FBI, Eleanor joined the Pistol Club and consistently scores in the 90's. Other interests—theatre, art and traveling.

Photographed by Michael Barbero

need to go to college, that it would be a waste of money. If there was a boy in the family, that boy would definitely go. So, I didn't go to college and neither did my sister. I went to work for accountants and lawyers. I continued doing a little bit of modeling. I entered different beauty contests. I became Miss Manhattan. I was runner up in Miss Upstate New York near Grossinger's hotel in the Catskills. I met my husband there, and that's how I ended up moving up to the Hudson Valley.

We got married in 1967 and had two children together. My husband didn't want me to work, but I always wanted to. I became involved in volunteer work at my children's nursery school. When I got divorced in 1978 I started a consumer organization called the Concerned Consumers of the Hudson Valley. We were fighting for lower electric rates. We put out a petition at a candy store where everyone picked up their newspaper and we got 5,000 signatures in one weekend. Then we started learning the process and figured out that you need to be in government if you want to make real change.

I became active with a Democratic candidate. I helped get him elected and worked for him for a while. Then people asked me to run for the county legislature, which was always dominated by Republicans. I literally went from the kitchen to running for public office. No one expected me to win. Everyone kept on saying, you're not going to win the first time, but the second time you'll have a better chance. I kept thinking, are they nuts? I'm not going through all this work to not win. And I did win. From there, I worked for a state assemblyman, and then a congressman. When the assemblyman ran for congress, he brought me to Washington as his chief of staff.

In Washington at that time—in 1992—there were not many women who held that position. We were all new to it. I started this informal networking group for women chiefs of staff to talk about a lot of the problems we weren't used to solving—staff issues, organizing events, getting the media there. We had maybe a dozen or so women, and

MODEL DAUGHTER
(Above) Earlier work included shoots for advertisements, like this one for ski wear. (Above left) As Miss Manhattan Eleanor was runner up in the competition, held at Grossinger's Catskill resort. She is pictured here with the winner and Paul Grossinger, among others.

little by little, every two years someone would leave, maybe because their congressman didn't win. It dwindled down to five or six of us.

While I was on Capitol Hill, I was very stressed out. Politics is a reactive business. Everything I did reflected on the congressman, so there was a lot of stress involved in managing the staff, keeping the congressman briefed all the time—who he's going to meet, what he's going to do, hour to hour. I felt my body getting sick. My stomach wasn't good. I decided to exercise, and I hired a trainer. The first trainer I hired was young and his head was swinging this way and that way when I was working out. He wasn't interested in working out. He was interested in looking at all the girls there. Then I hired a trainer who was more mature, Julius. He became one of my mentors. He said, "You can be a trainer, too." He knew I was going to retire and encouraged me to go back to school. I decided to target the over 50 crowd. After I got all my certifications, I became very popular with older people, who were afraid to work out with younger trainers because they were afraid they might get hurt. I was called the "nurturing trainer."
I ended up working for the Capitol Hill Club and then at the Alexandria Club.

I moved down to Florida because my mother was here and she had a fall when she was in her 80s. She went into assisted living and I had to come to oversee everything. I started to pick up clients here. I work 20 hours a week. I could probably have launched a whole company down here. There are loads of elderly people here looking for trainers, but you get to an age where you want balance in your life.

BUNNY BUSINESS
(Top) Eleanor only modeled part time because her
father, a police officer, did not approve of the industry.
Still, her career went into the 1960s with local work
in Redondo Beach. (Left) Eleanor as a Playboy Bunny
on the cover of *SIR!* magazine in the late 1950s.
(Above) Another bunny image from *SIR!* magazine.

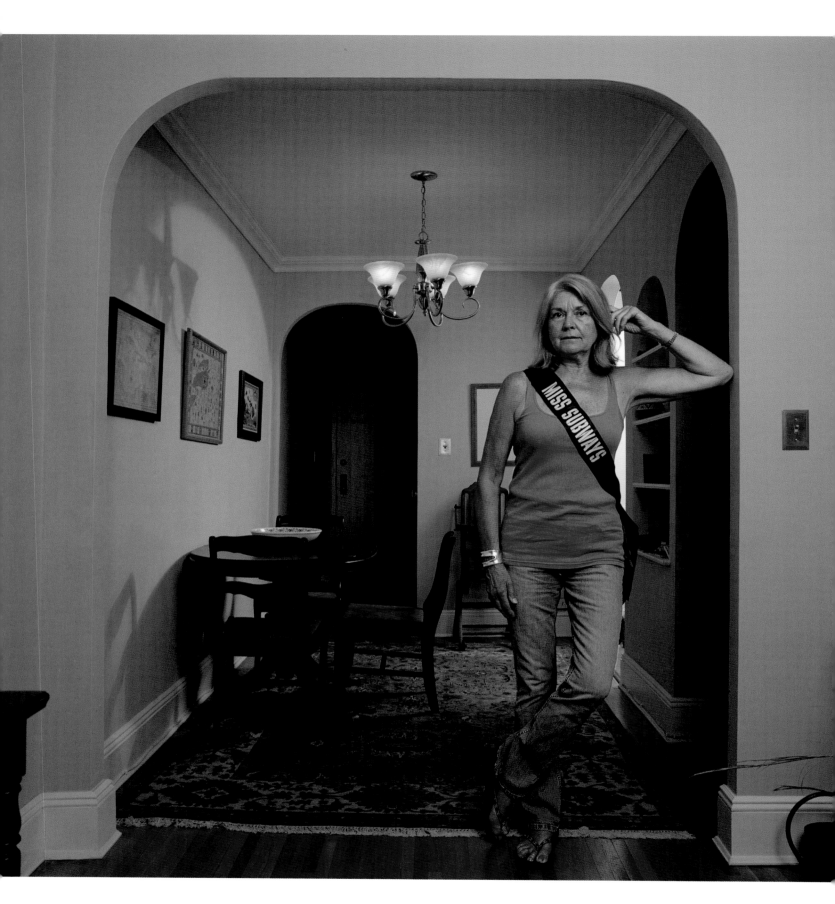

DOLORES MITCHELL BYRNE in her apartment in Manhasset, New York 2010.

Meet Dolores Mitchell Byrne

MISS SUBWAYS JANUARY–FEBRUARY 1961

From the time I was 12 years old, my brother used to call me "stretch." I got very tall and lanky and skinny. Everybody said, "You should be a model." So, that was kind of my goal. My older sister sent my picture into the Miss Subways contest, and that was it. I modeled for many years. I wasn't famous, but I had a good working relationship with the catalogue studios, which is where the good money was. It beat working 9 to 5. It was work though. You had to get a book with your pictures and go see photographers and go see advertising agencies and things like that. In the beginning, it's a little bit tough because you have to wait for your money. With my first check I bought a sewing machine so I could make my own clothes. I was still at home with my parents, which was a great help. I stayed in Jackson Heights with my family until I got married when I was 22.

My husband was a cop in the Ninth Precinct, which is on East Fifth Street in Manhattan. My sister's husband had the locker next to his, and her husband kept on saying, "Terry, I got a sister-in-law that's a model. Would you like to meet her? She's single." He said, "I'm not interested." Her husband kept at him. He brought a magazine I was in, and Terry said, "Okay, give me her phone number." When we met it was like in "The Godfather," when Michael Corleone meets Apollonia, and the thunderbolt strikes. We went out, and that was the end of it.

I continued modeling until I had my three kids, and then the whole family modeled. There were only two families in New York that came as a package. So we had a pretty good career. We weren't modeling clothing. We were doing products, so we had to supply

MEET MISS SUBWAYS

SPONSORED BY NEW YORK SUBWAYS ADVERTISING CO., INC. · 630 FIFTH AVENUE, NEW YORK 20, N.Y.

JANUARY-FEBRUARY 1961

DOLORES MITCHELL

Outdoor activities such as swimming, riding and waterskiing are Dolores' special interests. Another interest— modeling. Any agency looking for the "outdoor" type?

Photographed by Michael Barbero

our own wardrobes. The night before I'd be washing and ironing and coordinating outfits for the kids. My husband was a detective, and detectives have more leeway with hours than other cops do. He was able to arrange his time off to model. His first shoot was for an ad for a security company or something like that. He had the right look—it was authentic. The photographer was Bert Stern, who was very famous and always had his work in *Vogue*. I asked my husband, "Can you go back and say, I'd like you to meet my wife?" Didn't happen. As a family, we were trying to get into Ford, which was the pinnacle of modeling agencies, but they just wanted our son. He was seven at the time. They said they'd keep him busy five days a week. We let him decide, told him it could be a big thing. He said, "No. I'd rather stay home and play soccer." I said, "You got it kid."

We lived in Stuyvesant Town in Manhattan for 10 years, from 1965 to 1975, but with three kids in a two-bedroom apartment, it was time to leave. We moved to Manhasset on Long Island. I quit modeling and became a pharmaceutical sales rep part time, and then I sold beauty aids for a subsidiary of 3M. I was a natural in sales. I found it easier selling products than selling myself as a model. When I was about 40 I went to work for 3M. On a sales call to a dermatologist, I met the senior salesman for business communications products. The dermatologist told him later, "She's the only representative that comes every six weeks like she's supposed to. Nobody else ever comes." So he saw that I was consistent.

When we began selling fax equipment, I got into selling to the Transit Authority by writing a letter to the president of the MTA, playing up my history with the subways—I go back with the subways a long, long way. In the letter I said, "I'm a former Miss Subways, my father worked his whole life for the Transit Authority, my parents met working for the Interboro Rapid Transit. By the way, I sell these fax machines." Eventually I took them from renting two fax machines a year to owning probably 100 machines. They were one of my best customers.

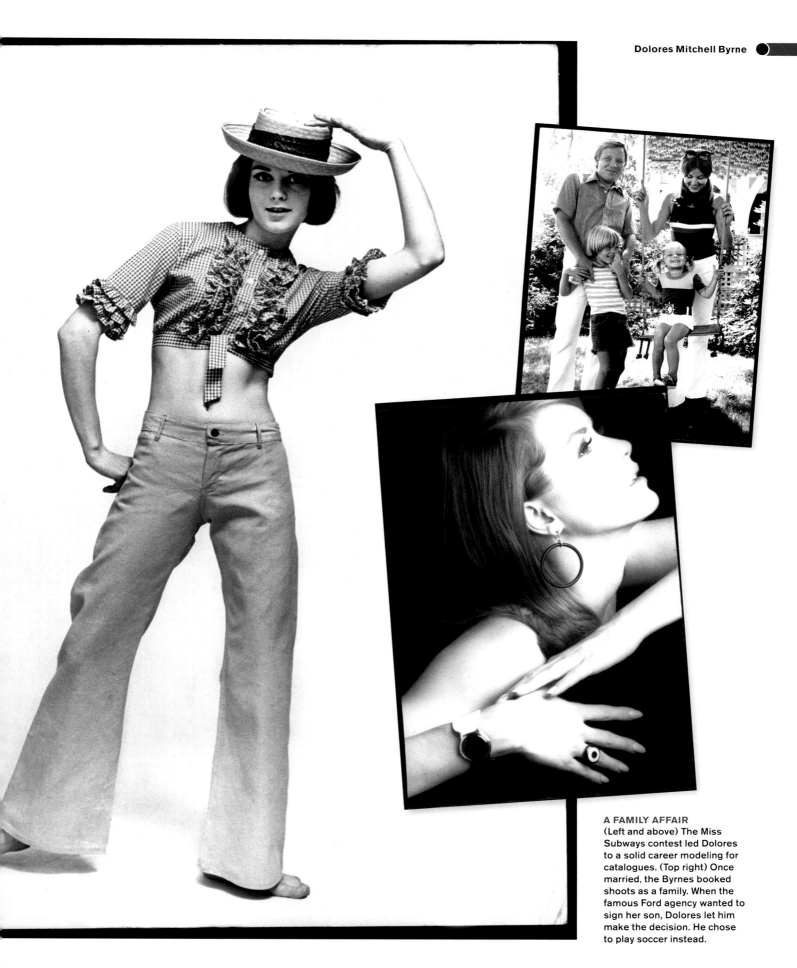

A FAMILY AFFAIR
(Left and above) The Miss Subways contest led Dolores to a solid career modeling for catalogues. (Top right) Once married, the Byrnes booked shoots as a family. When the famous Ford agency wanted to sign her son, Dolores let him make the decision. He chose to play soccer instead.

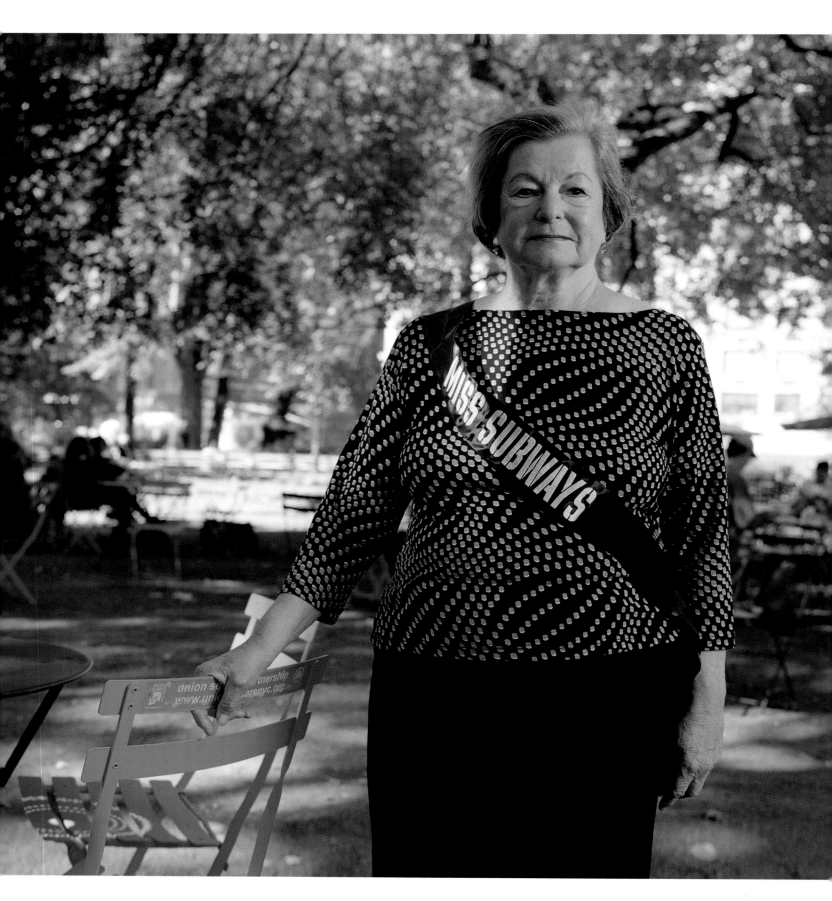

EVELYN TASCH LAURIE in Union Square, New York, New York 2011.

Meet **Evelyn Tasch Laurie**

MISS SUBWAYS JANUARY–FEBRUARY 1962

My brother more or less dared me to send my picture in to the Miss Subways contest. The Miss Subways photographer, Michael Barbero, took a picture of me that they didn't end up using. It was a nice photo—I had my hair done and everything—but the Jewish star I had on my necklace was showing, and they told me they couldn't use it. I didn't care then—it was a totally different era. We were just going through Civil Rights in the South. They ended up using a photo I didn't like, but I was engaged at the time, and he loved it. He had bragging rights. That was better than me being a nuclear physicist.

I had no intention of being a model. I had just graduated from Brooklyn College with a degree in art history, and I got a job in the library at the Museum of Contemporary Crafts on West 53rd Street. I was attending graduate school at NYU's Institute of Fine Arts to be an art conservator. But I moved to Boston for my husband's engineering career, and they didn't have a school for that there at the time. I didn't mind because in my day, once you had a baby you stayed home. I was not frustrated in the least.

A friend of mine from the Institute of Fine Arts became an art conservator at Sotheby's. She told me some of the girls worked until they got married, and then, after they left, they didn't bother cashing their last paychecks. They knew they would become socialites. I did have friends in high school and college whose biggest goal in life was to move to Long Island and get the diamond tennis bracelet.

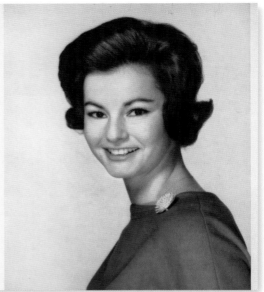

MEET MISS SUBWAYS

SPONSORED BY NEW YORK SUBWAYS ADVERTISING CO., INC. · 630 FIFTH AVENUE, NEW YORK 20, N. Y.

JANUARY-FEBRUARY 1962

EVELYN TASCH

Evelyn is a native of Brooklyn. She commutes daily, on the subway, to her job as a research librarian.

Photographed by **Michael Barbero**

I had different responsibilities. After I got divorced I went to work for a guy who ran a sports club and started organizing singles parties and getaways. I was sort of like a travel agent. I sold trips to France to go skiing. I helped run the parties in Boston. The city had a reputation for being an old place, but it was full of young people. I lived in Boston for eight years then I moved back to New York in the early 1970s. I figured if I moved back to New York, my son would have family around. I got a job on Wall Street with one of the big eight accounting firms. Being practical, I had to go for the salary, not the field. Maybe I was better off not having too much of a choice because it sort of grounded me. I knew what I had to do, and I was able to give my son a lot of good stuff— computer camp in the summer, college without a loan. I remember when the accounting firm promoted their first woman partner. The men who were partners had their own private bathroom. When they got up to go to the bathroom they had to put their jacket on. They couldn't walk down the hall in their shirt and tie. But there was no bathroom for the woman partner.

I stayed in finance and went to work for Lehman Brothers. I was working for Lehman at the World Financial Center on 9/11. I used to like to get to work early, so I was at my desk at 8:30 when everything started to happen. I had just walked through 1 World Trade to get to my building because there was a bridge connecting them. Luckily we got out of the building in time. The way 1 World Trade fell, my area was badly damaged. The girders went into my building like needles in a pincushion. Actually, that was the third bombing I went through with Lehman Brothers. When I first started, Lehman was on William Street and we heard a big boom and we looked at the window. The FALN from Puerto Rico had blown up Fraunces Tavern in 1975. And in 1993, I was on the 10th floor of the World Financial Center when they bombed the World Trade basement. I retired two years before Lehman went under.

I left New York when I retired. When apartments were reasonable in Manhattan, I still had a son living at home, and I had to be in a good school district, so it was just easier to stay in Brooklyn until he went off to college. I was seduced into moving to Las Vegas because I could get a very nice place to live cheap. My son was living in Phoenix at the time, so this was near him. I didn't realize I would have to change my whole personality. I don't play cards. I live in a golf course community, which is very nice. You won't believe how green it is there. But I have a lot of allergies to sagebrush and mulberry trees. I was able to rent a very nice house in Vegas for only $1,000 a month, but I would trade it for an alcove studio in Manhattan tomorrow.

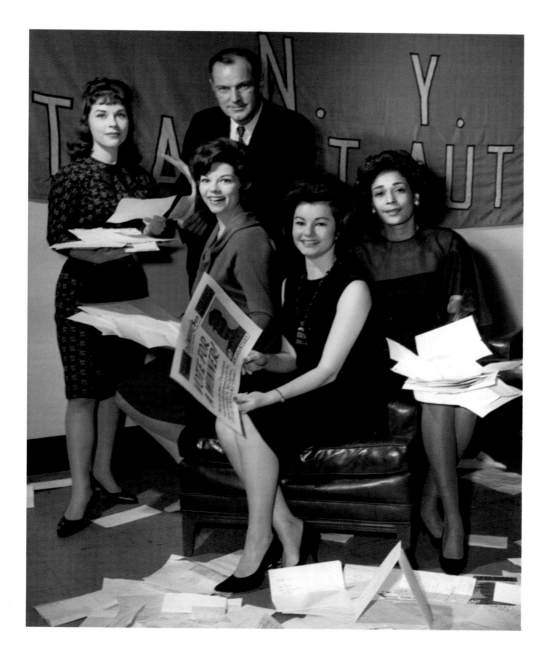

MR. COURTESY
Evelyn joins other Miss Subways and a male judge to select finalists in a campaign for favorite transit workers.

Bartender Jerry Shockat, aboard 'Dream Car,' Is Ready to Pour

It's Just Like the Rush Hour Any Day (But With Class)

NewsDay - Jan 18, 1962

Subways Are Not for Sipping

Champagne was bubbling over on a subway train, of all places, as the Transit Authority tried an incongruous publicity gimmick yesterday to promote cleanliness in subways. Here's how it went.

Soft pastel lights filter through claret curtains and tint the plush red carpet. The scent of camelias perfume the air. A cork pops and glasses clink lightly. As they sip their champagne, he leans toward her and their hands touch for an instant. "Will you . . ." he whispers softly, ". . . will you Tell me when we reach 14th Street? That's where I get off."

By Robert Mayer

New York—A new fantasy opened here yesterday—an under-Broadway production called "The Dream Subway Car." It closed—a total flop—after a run of 41 minutes.

The show was staged in one car of an eight-car IRT train by the Junior Chamber of Commerce on behalf of the Transit Authority. The theme was simple—to publicize a keep-the-subways-clean campaign. But the moral, as it turned out, was that subways are not for sipping, or that champagne and straphanging do not mix.

The settings of the dream car were tasteful—red door-to-door carpeting, purple and claret curtains, flower boxes of camellias and carnations (in the shape of trash cans, but why quibble?), a mahogany bar by the center exit. The props were also tasteful—Chateau Renault champagne (alcohol 12½% by volume). And five shapely young ladies, all winners of the Miss Subways contest, were aboard to serve the drinks. Idling empty in the Times Square station, the train was about as dreamy as a subway can get.

Then they let in the cast of hundreds—transit officials, commerce people, photographers, reporters—and the fantasy became a farce. The seats were filled. The standing room was filled. Elbows flew. Knees shoved. A glass broke. Petals dropped. Champagne spilled. It was the rush hour, with class.

"I've never seen a subway this crowded," said the current Miss Subways, Evelyn Tasch. "It's a bit congested," agreed the imported bartender, Jerry Shocket, who normally pours drinks at comparatively placid Roseland.

"I'm crocked, I can't walk straight any more," said one shaky former Miss Subways. "It's the subway that's moving, silly," replied another.

It was. From Times Square to South Ferry and back the train bubbled along, making all local stops along the way—and spilling someone's champagne each time. The masses were barred from the dream car, but judging by their comments they didn't mind much. "For me its for the dogs," said one man. "Give me service, don't give me no flowers," said another. "I just want to get home," added a third.

The cynical spirit even engulfed the motorman, James Ruane, who liked the fancy car. He tossed the Transit Authority a left-handed bouquet by saying, "It's a step in the right direction. It's about time they did something nice."

Entertainment was provided by the regular conductor, Abraham Steinberg, who broadcast homey homilies while announcing the stations. He intoned at point: "Next stop is good old Christopher Street in the Village—site of New York University. The more you learn the more you earn."

When the train returned to Times Square it was stripped of the bar, the curtains and the flowers. The carpeting was left intact- for the durability test by the manufacturer. By afternoon, all that remained of the dream train was a carful of flower petals, pretzel crumbs, papers and dirt—and dozens of posters reminding that "This subway is yours. Help keep it clean!"

Five 'Miss Subways' Try to Hold Their Champagne Glasses Steady

Workman Sweeps Dirt off

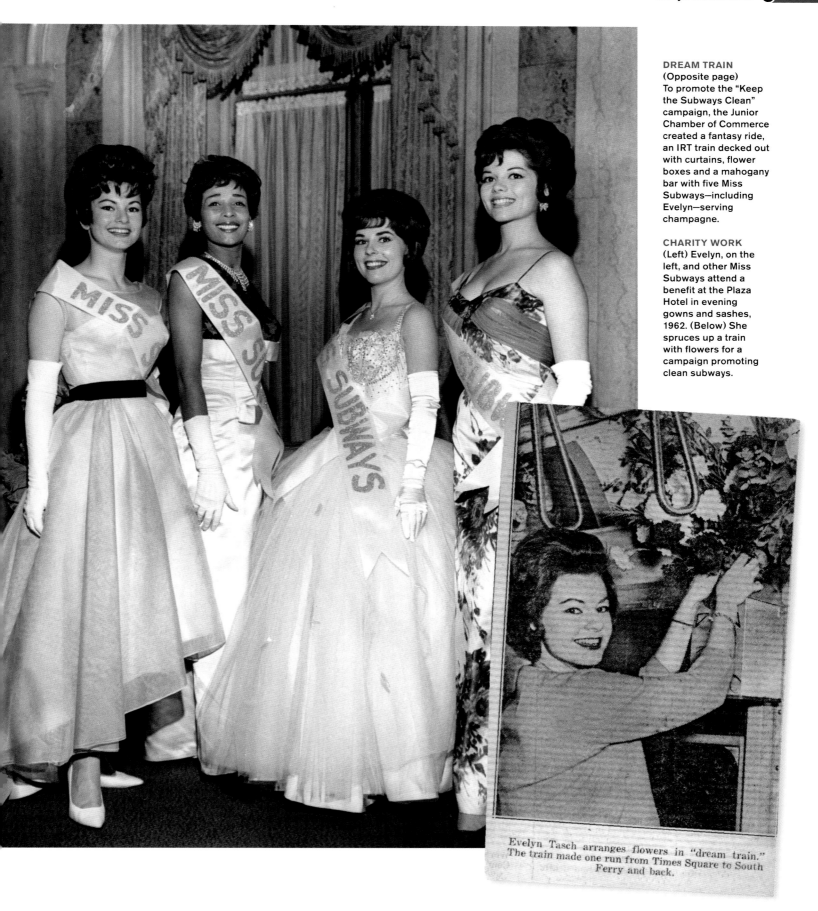

DREAM TRAIN
(Opposite page)
To promote the "Keep the Subways Clean" campaign, the Junior Chamber of Commerce created a fantasy ride, an IRT train decked out with curtains, flower boxes and a mahogany bar with five Miss Subways—including Evelyn—serving champagne.

CHARITY WORK
(Left) Evelyn, on the left, and other Miss Subways attend a benefit at the Plaza Hotel in evening gowns and sashes, 1962. (Below) She spruces up a train with flowers for a campaign promoting clean subways.

Evelyn Tasch arranges flowers in "dream train." The train made one run from Times Square to South Ferry and back.

Cast your postcard vote today - pick the next two "MISS

JOSEPHINE LAZZARO
Secretary,
St. Vincent's Hospital

AYANA LAWSON
Head teller,
National Bank of No. America

SUSAN SCHWARTZ
Student,
Queens College

VIRGEN LOPEZ
Housewife

GUILLERMINA B
Secretary,
Sperduto, Priskie &

Write the names of TWO of these finalists on a postcard (Only ONE Postcard Per Voter Allowed)
your name and address and mail before April 30, 1975 to... N.Y. SUBWAYS ADVERTISING CO., INC. 780 Third Avenue, New York, N.Y. 10017

GET OUT THE VOTE
Beginning in 1963, Miss Subways winners were selected by a public vote from six finalists. Some candidates lobbied hard, getting postcards in the hands of friends, family and co-workers.

PEOPLE'S CHOICE
(Opposite page) Ann Napolitano was the first winner of the post-card vote. Escorted by her future husband Frank Evangelist—second couple from the right—Ann attends the 1964 Miss Subways Lighthouse Charity Ball.

Meet "MISS SUBWAYS" *

ANN NAPOLITANO

Petite Ann, first winner of the public postcard vote, is a secretary at Doyle·Dane·Bernbach·Inc., an advertising agency.

She enjoys tennis and bicycling . . . and devotes time each week as a recreation volunteer at Bellevue Hospital.

** service mark of* NEW YORK SUBWAYS ADVERTISING CO. INC. *630 Fifth Avenue, New York 20*
An O'Ryan & Batchelder Operation

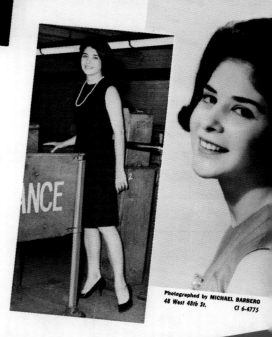

Photographed by MICHAEL BARBERO
48 West 48th St. CI 6-4775

Cast your postcard vote today - pick the next two "MISS SUBWAY

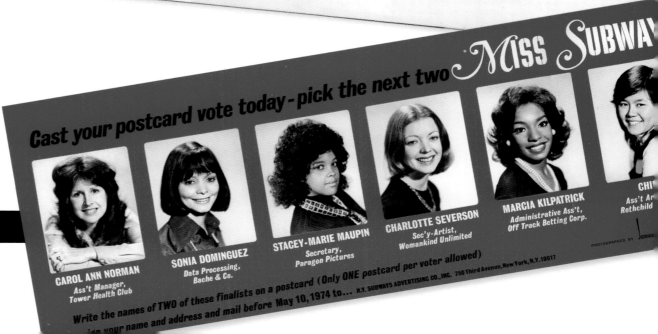

CAROL ANN NORMAN
Ass't Manager,
Tower Health Club

SONIA DOMINGUEZ
Data Processing,
Bache & Co.

STACEY-MARIE MAUPIN
Secretary,
Paragon Pictures

CHARLOTTE SEVERSON
Sec'y-Artist,
Womankind Unlimited

MARCIA KILPATRICK
Administrative Ass't,
Off Track Betting Corp.

CHI
Ass't Ar
Rothchild

Write the names of TWO of these finalists on a postcard (Only ONE postcard per voter allowed)
in your name and address and mail before May 10, 1974 to... N.Y. SUBWAYS ADVERTISING CO., INC. 750 Third Avenue, New York, N.Y. 10017

THE PUBLIC VOTING ERA:

From Bee-Hived Secretaries to Straight-Haired Pilots

Miss Subways embraced a more democratic turn in 1963. Rather than a modeling agency selecting the winners, the choice was now up to subway riders. Headshots of six women, with their names and occupations printed underneath, ran on a poster for about one month with a call to cast a postcard vote for the top two candidates.

The winner and runner-up would become the next two Miss Subways and their posters would each grace the trains for an average of five months at a time.

The change to a public vote was devised after New York Subways Advertising once again changed hands, this time to O'Ryan and Batchelder. Through the contest's remaining 14 years, Bernard Spaulding, sales director for New York Subways Advertising, took over the process of culling through hundreds of pictures that family, friends, colleagues or the hopefuls themselves sent in and selecting the six finalists through interviews. The revamped contest was designed to reflect the working woman even more than before. Spaulding once said, "Prettiness is passé. It's personality and interesting pursuits that count."

Women lobbied hard for the position. Maureen Walsh's mother made sure to give postcards to all of the customers at her supermarket checkout line. The Wall Street firm that Sonia Dominguez worked for mobilized its foreign offices to mail in postcards on her behalf. Marcia Kilpatrick's entire family canvassed their workplaces from top to bottom. These women still hoped that the publicity from being Miss Subways could help them in some way. And sometimes it did. Marcia was able to parlay her win into landing a spot in a prestigious African American acting company and scoring her own radio show. There were certainly new opportunities for visibility as many of the Miss Subways from this era were given more ceremonial duties than before. Former Miss Subways were the guests of honor at a station christening boasting boxed lunch and champagne on the platform. Maureen Walsh represented the transit system at a movie premiere of "Finian's Rainbow," not to mention Richard Nixon's 1969 presidential inauguration. Ayana Lawson did radio promos with Muhammad Ali for one of his fights.

The finalists on the voting posters were often an incredibly diverse group of women. The year that Lawson, an African American bank teller, and Josephine Lazzaro, an Italian American secretary, were voted in, the other contenders included two Latinas (a housewife and a secretary), a Caribbean American (a bilingual typist) and a student with a common Jewish last name (Schwartz). Contest organizers never explicitly said that the women were selected to promote a diverse image of the city, but the city was becoming increasingly diverse during this time, as the non-white population grew from 10 percent in 1950 to 23 percent in 1970 and then to 48 percent in 1980. For Marcia Kilpatrick, winning the contest was tied to her race consciousness. She felt she was representing not just herself or her family, but "her people." When she saw her poster before it ran, her skin looked light. Combined with her Scottish-sounding last name, she feared she would be mistaken for white, and asked Spaulding to darken her photograph. He agreed. Immigration patterns were also changing at this time. While the turn of the 20th century brought Southern

and Eastern Europeans to New York, new laws that went into effect in 1965 brought a wave of immigrants from Latin America, the Caribbean and Asia. When Sonia Dominguez became the first Dominican Miss Subways in 1974, the win was celebrated not only in her new neighborhood of Morningside Heights but also in her former country: the president of the Dominican Republic invited her to his palace.

When this final era of Miss Subways began, in 1963, Betty Friedan's *The Feminine Mystique* hit bookshelves, laying bare the discontent and "problem that has no name" among women of the 1950s and early 1960s and launching second-wave feminism. This latest fight for women's equality focused on sexuality, family, and reproductive rights, and strove to integrate women fully into the workplace. By 1970, 43 percent of all women held jobs, up from 34 percent in 1950 and 28 percent in 1940. By 1980, 52 percent of the nation's women were working. Many Miss Subways moved beyond part-time pink collar work to careers once considered the purview of men. Maureen Walsh returned to college later in life and then went on to law school—taking the bar exam with the daughter of another former Miss Subways. Rosalind Cinclini went back to school after 20 years in a comfortable job as an executive assistant—a bout with breast cancer brought about the desire to be a social worker. While more jobs may have opened to the women of this era, they were not always easily accepted in their chosen field, professional or recreational. Heide Hafner entered Miss Subways because she thought it would help encourage more women to follow her favorite hobby of flying planes, though she recounts stories of male pilots refusing to fly with her. She eventually became a nurse. Eileen Ryan went back to work at the age of 40 as a postal worker when her children were all in school. As the only female working with 20 men, she faced a good deal of harassment, but credited her perseverance to her experiences competing in beauty contests.

This final crop of Miss Subways, often having proved their competitive mettle during the postcard voting process, maintained that spark throughout their lives. Few saw their reigns as Miss Subways in the same light as traditional beauty pageants. Josephine Lazzaro, for instance, recalls writing angry letters to Miss America but never equated Miss Subways with being a "meat contest." Nonetheless, women's lib pushed Miss Subways to the end of its line. Coupled with New York City's fiscal crisis, these forces took the fun out of Miss Subways and the contest dwindled from just two winners a year to none. By 1975, the Metropolitan Transportation Authority (MTA)—a state-run entity that took over the system in the 1960s—was running a deficit of nearly $500 million. Subway conditions, along with other services in the city, were deplorable after years of deferred maintenance. Ridership fell to a six-decade low. The ladies' posters were often marred by graffiti. They were no longer proud to reign over a system that was falling apart and riddled with crime and grime. At the same time, a growing chorus of feminist groups demanded to end the Miss Subways contest, or at least change it to "Ms. Subways." In 1974, New York art prankster Hank Stromberg staged a guerilla project, pasting up "Mr. Subways" posters on trains, much to the dismay of the MTA. A perplexed MTA spokesman responding to the stunt told *New York* magazine, "On what basis can you have a beauty competition among men?" A scathing article in that same magazine two years later, titled "Token Women," recounted how a 1973 winner was approached by a man in a disco, who quipped, "You're Miss Subways; how big is your tunnel?"

> This final crop of Miss Subways, often having proven their competitive mettle during the postcard voting process, maintained that spark throughout their lives.

Meet Sanora Selsey

MISS SUBWAYS JANUARY–MARCH 1964

I grew up in a housing project in Brooklyn. It was very mixed—there were blacks, Italians, many Jews. I had many friends of different cultures and ethnic backgrounds until I was about 15, and then all of a sudden families began to move. Housing developments were set up so you would get yourself back on your feet and then go, but the one where I lived became very black because we were not able to move as rapidly. That said something to me. We got stuck in there.

The cautions started very early—what you had to do to survive all the things that are put in your path to stop you from moving ahead and getting what you wanted. Not me necessarily, but people who look like me. I wanted to be an interior decorator, but it never would have worked. I would have been hungry. The social climate was not ready to accept a black interior decorator. I used to buy many of the

SANORA SELSEY with her granddaughter at her home in Brooklyn, New York 2012.

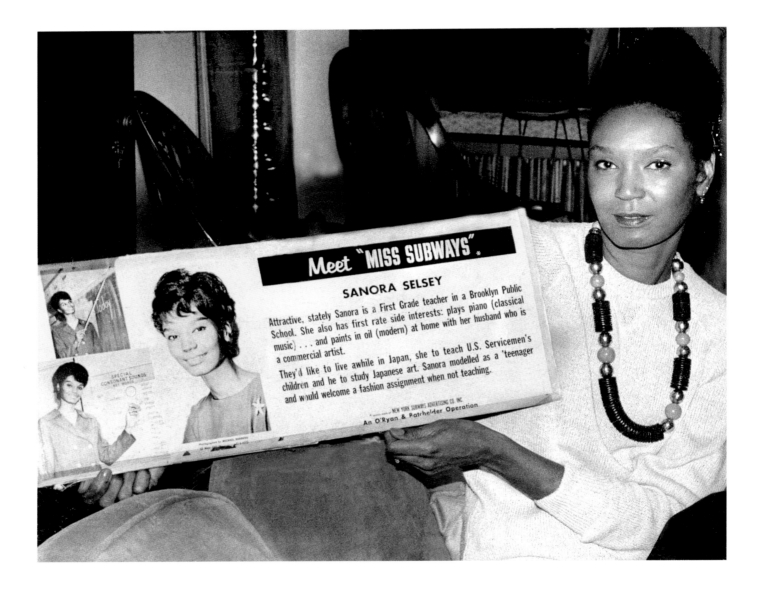

Meet "MISS SUBWAYS"

SANORA SELSEY

Attractive, stately Sanora is a First Grade teacher in a Brooklyn Public School. She also has first rate side interests: plays piano (classical music) . . . and paints in oil (modern) at home with her husband who is a commercial artist.

They'd like to live awhile in Japan, she to teach U.S. Servicemen's children and he to study Japanese art. Sanora modelled as a 'teenager and would welcome a fashion assignment when not teaching.

NEW YORK SUBWAYS ADVERTISING CO. INC.
An O'Ryan & Batchelder Operation

fashion magazines, and I remember one fashion magazine indicated they would have their first black model inside. I was modeling at the same time, and I thought, "Well, someone needs someone of color in their magazine." I'm going through the magazine—where is she? Where is she? She was there but had a huge sombrero over her face. It was because the South had indicated to the magazine that they would stop buying it. So, that's the era. I really didn't think that I would be or could be Miss Subways, either—I had never really seen a black Miss Subways. When I was selected I thought: The token was there. And that was it. It was so they could say, "We did it. Yay for us."

I have a feeling that everything having to do with me being Miss Subways and my picture being there was because of my father. He was employed with the postal service, and I think he may have stacked the mail that was coming in. They would take a ruler and an inch equaled so many postcards. So I was chosen as one of the finalists that the

city voted on. When I got the letter saying I was Miss Subways, I said to my dad, "Did you have anything to do with this?" And all he did was smile.

I was a teacher of early childhood education at the time, and the Transit Authority came and took my picture in the classroom. The Board of Education picked up on it, and I was out at the World's Fair at the podium talking to the teachers in the city. That was fun to do. I got a lot of letters from a lot of quirky people. Would you marry me? I'd like to take you somewhere. Where do you live? Would you go out with me? When I rode the subway, I tried to be careful not to sit under the poster. I didn't want to attract attention. Men would say, "Hi there. Is that you?" I'd say, "No." "Well it looks like you, darling. Can I get your number?" "No." People didn't seem to be as looped as they are now. I don't think I'd want to be up there now. The thing is I never said anything to anyone and they would come busting into my office at school. "Sanora, is that you on the subway?" At church, people would say to my mother, "Ruth, is that your daughter in the subway? Why didn't you tell anyone?" "Well, you see it now," she'd say.

I knew it wasn't going to take me anywhere. Instead I was out there busting my butt going to school. My mother was always saying, "Go to school." Her thing was you grow up to take care of yourself. If you're married, that's wonderful. If the marriage doesn't work, you can take care of yourself. I knew that I had to go to school and have a degree. I knew in order for me to not be refused a particular job, I was going to have the pieces of paper. I wanted a bachelor's degree and a master's degree and I have both.

My husband was a commercial artist. We grew up in the same housing project. We met when I was in high school and knew each other for seven or eight years before we got married. When we moved to this house in Clinton Hill 39 years ago, my husband didn't want to come. We had been living around the corner with our two kids, in a building that just went co-op. I said, "I'm going around the corner. You can come if you'd

LOOKING PRETTY
(Below left) Sanora, second from left, attends a high school dance. (Below) An early snapshot. Sanora grew up in an integrated public housing complex in Brooklyn but remembers when other families started to move out except black families.

CELEBRATING THELMA
(Below) Miss Subways, left to right, Sanora Selsey, Thelma Porter, and Sondra Harris attend a send-off for Porter, the first African American winner, before she moves to California.

HEAD SHOT
(Right) Despite a dearth of opportunities for black models in the 1960s, Sanora found work in front of the cameras while also focusing on a career in education.

like. We'll see you when we see you." I took all the furniture. I left him a plate, a saucer, a cup, a knife, a fork and a spoon, one pot and a pan. When I got the building I sent him one engraved invitation. "Mr. Joseph Selsey you are cordially invited to join your family at 260 Clinton Ave." And he came with his bags. Buying the building was the best move I ever made. I was so determined to do what I felt was right. The neighborhood has changed and I was going to be here when it changed and was no longer predominantly black. I bear with the taxes to stay here.

I'm still working. But the rules have changed. I work when I want to and for as long as I want to doing teacher training workshops. When I retired from the city—after being a teacher, a teacher trainer, working for the Department of Youth and the Department of Homeless Services—I felt like I had done my 30-something years. I am not going to get on the subway again if I don't have to. I have a car, so I will drive into Manhattan and pay the $40 or $50 parking fee. It's all about me and what I want to do.

Fashions of The Times

Fall Edition

The New York Times Magazine

HIGH CONTRAST
Sanora felt that her modeling days and selection as Miss Subways was a form of tokenism and that she was featured when the powers that be needed to check off a box.

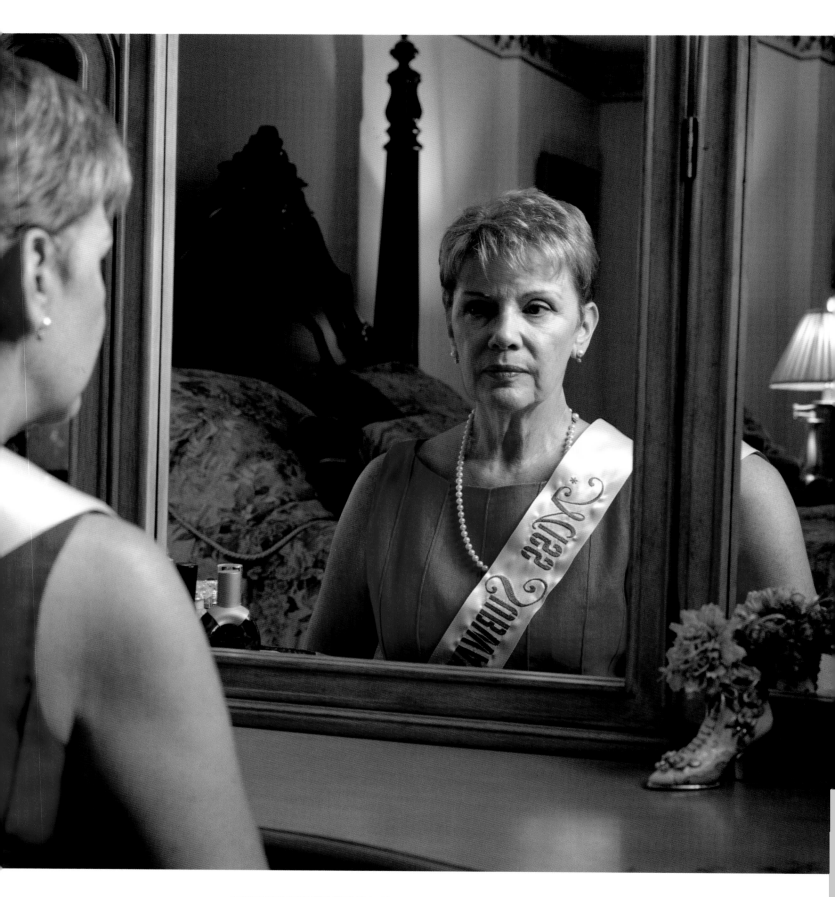

ROSALIND CINCLINI CATENA at her apartment in Westbury, New York 2008.

Meet *Meet* Rosalind Cinclini Catena

I was Miss Subways during the 25th anniversary of the contest and my poster was picked up by a newspaper and syndicated, so it went all around the country. I got all kinds of fan mail. I was working at ABC as a secretary in the program department, and they were screening all my calls. Jay Barney, an actor at the time, called and wanted to take me out. Somebody else called to propose. I had a chance to go on "The Les Crane Show," which was before Johnny Carson, but similar. ABC wanted me on the program—I was one of their own—but I had come down with the flu. I couldn't make it, and the opportunity passed. I still got a lot of free publicity off of the poster, though. I signed up with a couple of model agencies. I got some print work and some other offers while the poster was up. I wanted to do runway, but I wasn't tall enough. It was a good thing I was living at home in the Bronx.

I went to City College when I was younger, but I didn't graduate. At the time, my father wanted me to finish, and he would have paid for it, but I just wasn't into it. I thought I'd probably get married, and two years after Miss Subways, when I was 24, I did. We got married and later divorced. We lived apart for a long time. He remarried, and divorced again and I was seeing someone else for a long time but eventually broke off the relationship. After 17 years apart, my ex-husband and I started keeping in touch, and somehow we got together again. We're living together now, not married, and it is

Meet *Miss Subways* Rosalind Cinclini

Those who voted Rosalind a winner will be pleased to know you helped her realize a long-held ambition. Contest publicity propelled her from a typist into a full-time professional career. She is now a photographic magazine model; intends to specialize in junior fashions.

Rosalind is 22 years young, 5'5" and has brown hair and brown eyes. She majored in speech at CCNY. Likes the theatre, playing piano (popular tunes) and ice-skating.

* *miss subways is a servicemark of* NEW YORK SUBWAYS ADVERTISING CO., INC. an O'RYAN & BATCHELDER Operation *Photographed by* MICHAEL BARRERO 48 West 48th St. • CI 6-4775

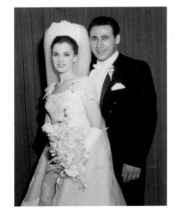

WEDDING BELLS
(Above) Rosalind Cinclini and Silvio Catena married on June 18, 1966 at the Belmont Plaza. She and her husband eventually divorced, only to date again years later.

FIGURE BEAUTY MAGAZINE
(Opposite page) In 1965, Rosalind is featured demonstrating exercises. The magazine featured a number of Miss Subways.

working. I don't think about the years in between. I was busy, building my career. My daughter was in school. There was a lot going on there.

I've worked all my life, mostly secretarial work, with the exception of when I was raising my daughter. I worked in Lake Success, Long Island, near my home, as an executive assistant for the president and CEO of an international shipping company. I worked for him for 20 years, and followed him from one company to another. Shipping was an old boys club, so there was really nowhere else for me to go there. I think when you do something for 20 years, you feel, I don't want to use the word stuck, but you want to do something else. Even though I was very established, I was interested in a second career.

Fifteen years ago I survived breast cancer. I had a mastectomy and chemotherapy. My cancer was detected early, so it worked out okay. I put a positive spin on it. During my recovery I got into group therapy at Adelphi University, and after about a year, the social workers asked if I wanted to volunteer for their breast cancer hotline. I started volunteering two hours a week on the phone, helping other women who called in with all types of issues. That propelled me to want to give back and continue to help others. Because social workers trained me, I thought, "I'll try that," and I wound up going to school for social work. I went to Adelphi at night when I was still working at the shipping company.

Going back to school and immersing myself in something really kept me going. My daughter was here with me, too, so my life was very full, which I think helped me heal and maybe helped in my survival. Luckily, my employer knew me, and when I was feeling fatigued from work and school I could take a day off. It took a lot of courage to return to school and do graduate work when I was older. It was a big step for me to leave my job—letting go was not easy. But I had this passion to become a social worker and try a second career. I really could retire at this point. But I'd like to use my degree. I didn't get my social work license right away. I haven't gotten it yet. It's a very difficult test. It's like passing the bar. I've done everything except stand on my head.

9 MINUTE-A-DAY PLAN
TO A BETTER FIGURE *(continued)*

This exercise first tightens then relaxes abdomen muscles. Both abdomen and waist get a workout. On hands and knees, first round your back, tightening abdomen muscles. Then let abdomen sag and back arch in extreme swayback position. Repeat series 6 times, holding each position 4 counts.

Time: 1 minute

Knee pushups are for arms and shoulders, abdomen, even buttock muscles. Lie flat on stomach, knees bent; slowly rise up, keeping back flat, tummy in. Then lower to floor. Do 10, very slowly.

Time: 1 minute

9 MINUTE-A-DAY PLAN
TO A BETTER FIGURE
(continued)

Waist circles are good insurance for the waistline and keep the abdomen flat, too. Stand with hands on hips, abdomen in, buttocks under. Circle first to the right, moving just from waist. Then circle around to front and then to the left, coming back to an erect position. Do 10 slow waist circles.

Time: 1 minute

Another waist twist that Rosalind not only practices at home, but in the office, too, during the day. She saves this exercise till last, then she is ready to shower and dress for the office. Sit in chair, with knees and feet together. Bend just from the waist to the right, bringing both hands as close to floor as possible. Then reverse leg position, and bend to the left side. Do 10 bends, each side.

Time: 1 minute

Total time for all nine: 9 minutes

Meet Donna DeMarta

My grandparents came from the same little town in Italy. My grandfather came to New York in the late 1800s, when he was 7 years old. My grandmother was 10 years old at the time, but their marriage was already arranged. When she was sent over six years later, she didn't even know what was happening. She had a boyfriend in Italy. It was very heartbreaking. Her family would never give her the letters that he wrote to her.

My grandparents got married when he was 17 and she was 20. They had 11 children. They were two of the most wonderful people you could meet. Every Sunday you had to go to grandma and grandpa's house for dinner, and my grandpa would let us taste wine while he played the mandolin. He was a barber on Arthur Avenue in the Bronx. I wouldn't say we were poverty level, but it was close.

DONNA DEMARTA **at home in Riverdale, New York 2010.**

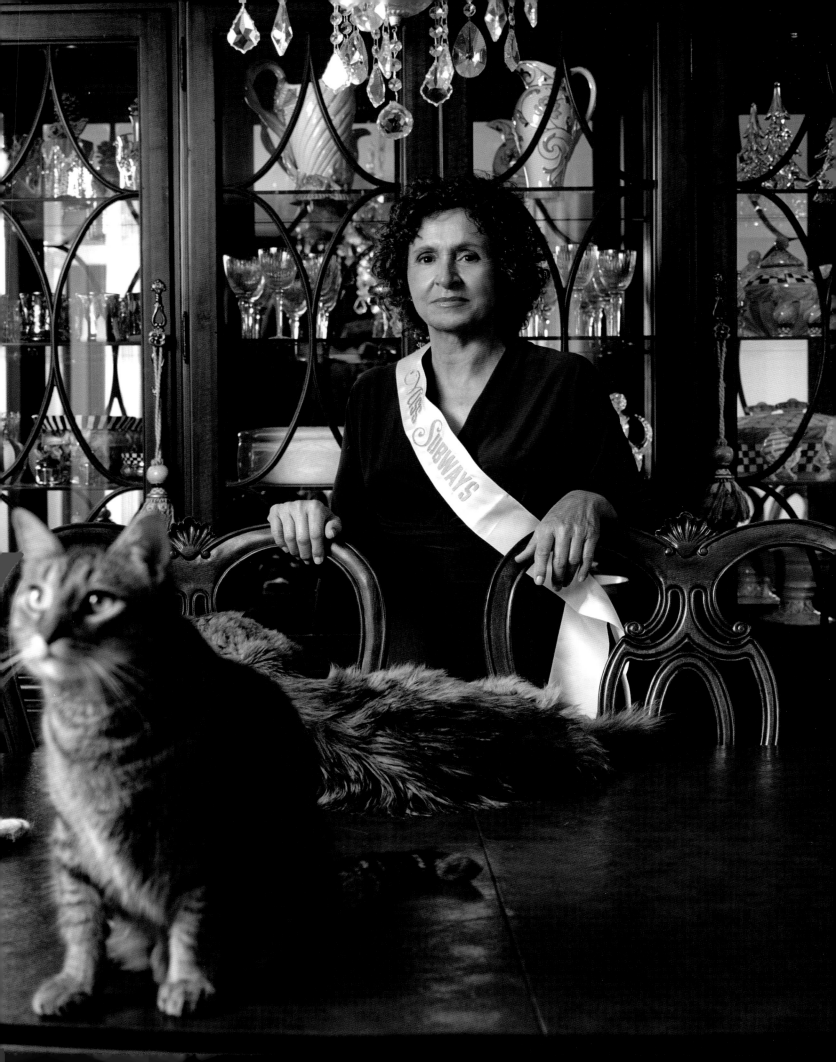

Meet *MISS SUBWAYS Donna De Marta

Her cousin entered Donna's name in the contest with a letter saying, among other nice things: "Donna is dependable, sincere and has a vivacious personality. One of her favorite pastimes is cooking. She loves it and can cook a meal, in my opinion, fit for a king. Her specialty, of course, is Italian food." (We're afraid Donna's not going to be single for long after this gets around).

Donna's a receptionist-secretary at American Bulk Carriers, Inc. She has ambitions to model or become an airline stewardess.

My mother remembered waiting on bread lines in the freezing cold. She was a seamstress her whole life, but she really should have opened a restaurant. She could cook. When my father came back from WWII—he was very patriotic and actually joined after Pearl Harbor—he did a couple of different jobs until my mother wanted him to get something with a pension and steady income. First he was a bus driver, then a motorman.

I never went to college, and I'm not knocking it. College education is absolutely wonderful and, today, absolutely necessary. But I often say I should teach a course in common sense. I see kids who don't know to come in from the rain or put an umbrella over their head. Growing up on Arthur Avenue was a lesson for what's coming in life. You get your street smarts. It was, at one point, 100 percent wall-to-wall Italian. I just loved it. We had Joe Pesci and Rocky Graziano. Dion DiMucci, of Dion and the Belmonts, lived two blocks from me. My mother knew his mother from the neighborhood, and his mother asked my mother, "If I have a girl can I name her Donna?" I was three months at the time. My mother said, "Of course." And she did. That song, "Donna, the Prima Donna" is about Dion's sister.

My cousin entered my picture in the Miss Subways contest. I didn't know about it at the time. She told me afterwards. It was a big deal to me. I even got a job offer from it. The poster said I wanted to be an airline stewardess and an airline called. My mother asked me to please not take the job because planes crash, so, I didn't take it. I was at CBS as a secretary at the time and I really liked it. I was always a secretary. I had chances for promotion, but I never took them. I just liked what I did.

In my twenties, I met someone and moved to Atlanta where I married and, unfortunately, divorced. He was a millionaire. Imagine me, from poverty on Arthur Avenue with my two little baby poodles and a big backyard. It was like Cinderella or something. He always thought it was about the money. But it wasn't. He was a good bit older than me, nine years, and he had grown children, so he didn't want any more. I didn't care.

I was crazy about him. After it was over, I stayed in Atlanta for 10 more years. But I was always a fish out of water. Atlanta was like a beautiful-looking woman with no personality. I really wanted to have the New York heartbeat again. Also, my mother was getting older, and I wanted to be with her.

When I came back in 1993, I got reacquainted with my friends from Arthur Avenue. There's a guy in my neighborhood, Nicholas Origanizzi, who we used to call Red for his hair color. Now it's grayish red because we're all getting up there. He still says, "Do you know she was Miss Subways?" I try to stop him: "Do you realize everyone is going to know how old I am?" When people hear you were a Miss Subways in 1966, they start adding. You can actually see it. "Oh my God this is how old she is." But he'd say, "She really was. A girl from the neighborhood was up there." One of my girlfriends would introduce me as "Miss Hole." She'd say, "Well, subways are in holes, aren't they?"

The real highlight of my life came from being Miss Subways. It was 1970, before I left for Atlanta. Frank Sinatra was retiring from the music world, and I decided to send

him my Miss Subways poster. He was in "On the Town," after all, where one of the characters was enamored with a Miss Subways. Less than a month later, I answered my phone at CBS and a man said in a very gruff voice, "Donna, this is Jilly Rizzo. Frank wanted to thank you for the nice note." Jilly Rizzo was Frank Sinatra's best friend. I asked if there was any way I could meet Frank in person one day. He said, "Why don't you keep in touch with my secretary Irene? You never know, Donna, I could probably do it for you." Well, it took almost two years. She called me one day and told me to come to Jilly's West, his nightclub, the week of such and such. "He can't promise you which night but Frank will definitely be there." So I went every single night after work, and it finally happened. Jilly came out and touched me on the shoulder and said, "Frank is here." I was hysterical when we met. I just fell down into his arms. He hugged me and thanked me for the letter.

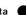

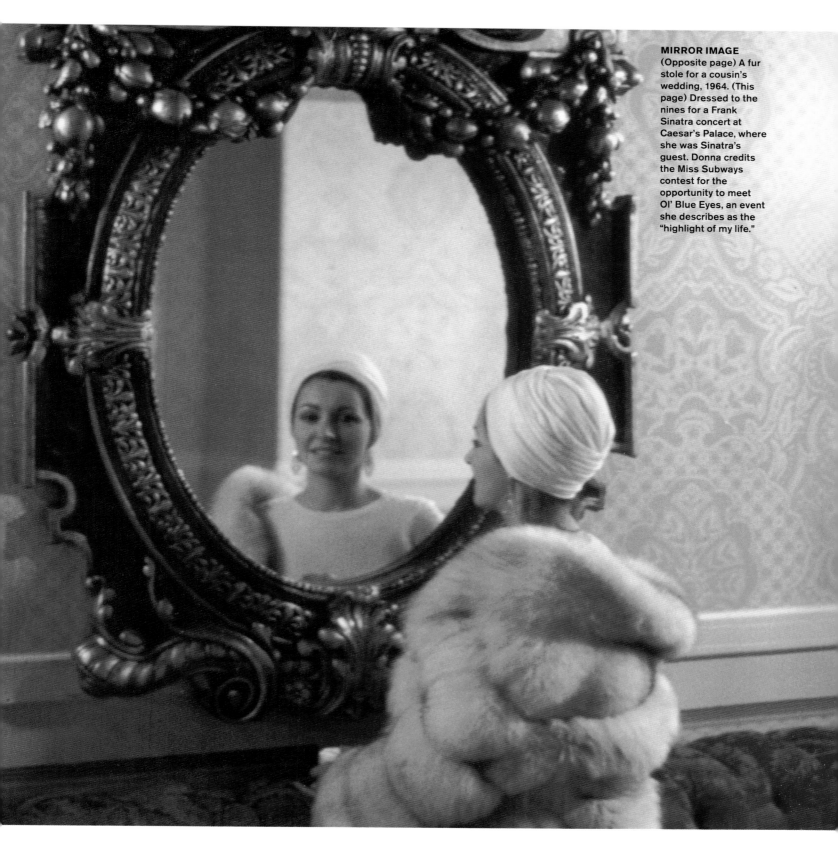

MIRROR IMAGE (Opposite page) A fur stole for a cousin's wedding, 1964. (This page) Dressed to the nines for a Frank Sinatra concert at Caesar's Palace, where she was Sinatra's guest. Donna credits the Miss Subways contest for the opportunity to meet Ol' Blue Eyes, an event she describes as the "highlight of my life."

Meet *Miss Subways* Eileen Kent

Would you believe blondes have more fun? This one does...making the most of Fun City's myriad happenings: attending the theater, art galleries and enjoying musical events (Eileen's great grandfather was a composer). When not busy putting people 'in the driver's seat' at Hertz Rent-A-Car, Eileen likes to read...bowl...or to spend a weekend skiing. She's traveled to the ends of the US and to Bermuda and Mexico. Eileen's goal: photographic modeling.

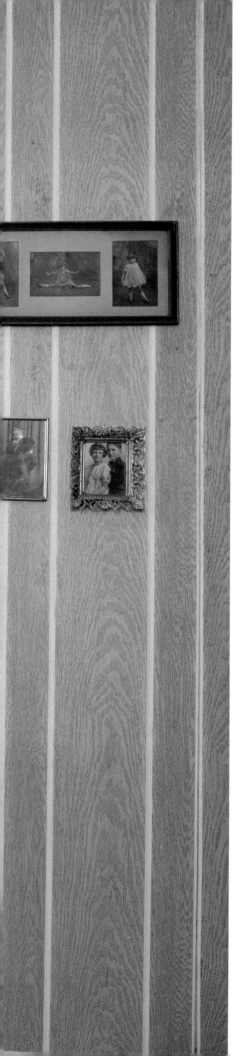

Meet Eileen Kent Smith

MISS SUBWAYS FEBRUARY–JUNE 1967

I was born six days after D-Day. All the mail had stopped, so my father, who was a soldier at the time, didn't officially know about me until three months later, when he came home. It was hard for my mother, but she had very devoted parents. We had a close-knit family. We lived here in New Hyde Park when I was younger. Then we moved to Jamaica Estates for three years but moved back because my mother wanted to be near her sister, who was just down the block. My father went into insurance when he returned from the war, and that's where he retired from because that's what people did then. They stayed with one company.

My mother was a good role model for me. She always made a good appearance, and she worked in the 1950s, when women didn't work. She was a supervisor for Nassau County's communications department. She liked working. I was the only child in class whose mother worked, but her office was close, so we didn't feel like she wasn't around. She was really ahead of her time.

When I was Miss Subways, I was working for Hertz Rent-a-Car in Manhattan. It was my mother who sent my

EILEEN KENT SMITH in her childhood home in New Hyde Park, New York 2009.

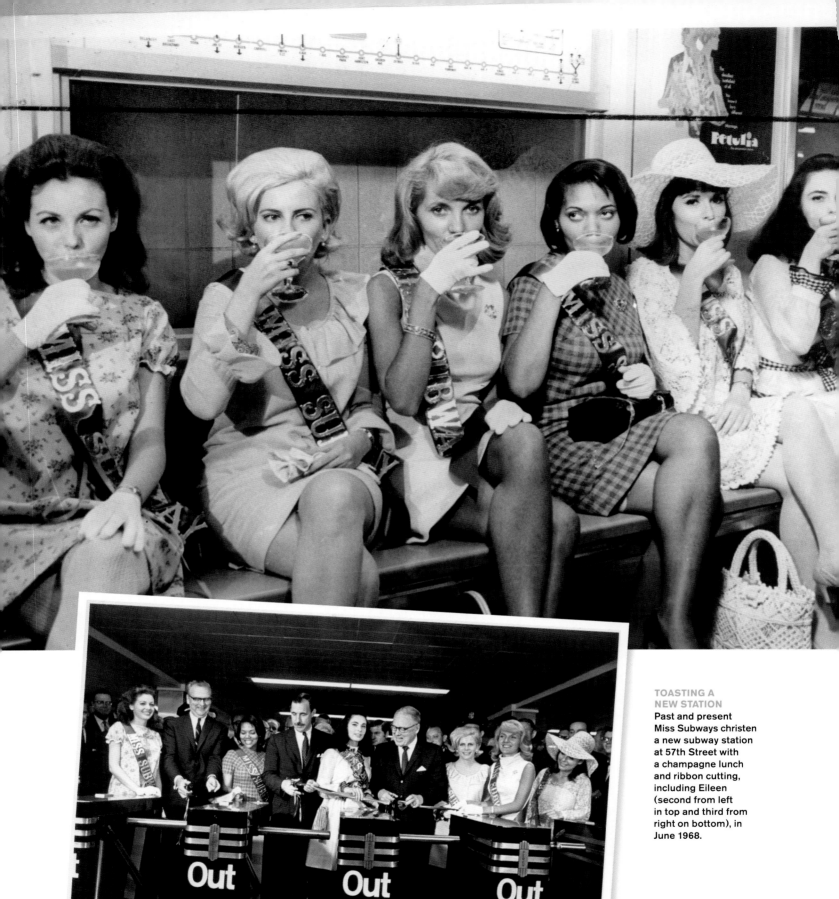

TOASTING A NEW STATION
Past and present Miss Subways christen a new subway station at 57th Street with a champagne lunch and ribbon cutting, including Eileen (second from left in top and third from right on bottom), in June 1968.

Out Out Out

Meet *Miss Subways* Eileen Kent

Would you believe blondes have more fun? This one does...making the most of Fun City's myriad happenings: attending the theater, art galleries and enjoying musical events (Eileen's great grandfather was a composer).

When not busy putting people 'in the driver's seat' at Hertz Rent-A-Car, Eileen likes to read...bowl...or to spend a weekend skiing. She's traveled to the ends of the US and to Bermuda and Mexico. Eileen's goal: photographic modeling.

*MISS SUBWAYS IS A SERVICE MARK OF NEW YORK SUBWAYS ADVERTISING CO., INC.

Photographed by MICHAEL BARBERO 48 West 48th St. • CI 6-4775

picture in to the contest, unknown to me. Later, she would always refer to me as "Eileen, Miss Subways." That's what mothers do. I didn't want to go into modeling. I could have been a photographic model—I didn't have the height for anything else—but I preferred the business world. I had a very nice job as the New York regional training manager for Hertz. I had a company car, so I would drive in to Manhattan. I liked working in Manhattan. There's a real energy to it. I hired and trained the people who worked in the stores, in Manhattan and out at the airports. I had an office with a window. I had a secretary. I traveled all over the place. As a matter of fact, four weeks after I got married, I had to go to Chicago for a few weeks and leave my husband behind. I was married for seven years before I had my first baby. That was unusual. So I guess I was a little trendsetter like my mom. But I wasn't willing to travel anymore once I had kids. I didn't want to leave them with someone else, so I quit Hertz.

I didn't feel badly about giving up the job even though it was great. Jobs come and go. When my daughter, Kerry, was 8 and her brother, Kyle, was 4, I got a job very locally at an accounting firm, which meant I was able to go to all their school plays, all their parent teacher conferences. I wasn't gone the whole day. That worked out fine for me until they grew up, as they always do. When Kerry was 13, she started babysitting in the summer, and I said to her, "You should put half that money away and save it." And she said, "No, I'm putting 90 percent away because when I'm 16 I'm going to buy a car." Guess what she did at 16? She bought a car. It was a used car, but a car. She's always been focused.

Kerry lives in Manhattan now. She sells computer software. When she was only 26 she bought her own place: two bedrooms, two baths five blocks from Lincoln Center. When they brought back Ms. Subways for the 100th anniversary of the subway system in 2004, my girlfriend's daughter, who was working in the city, told me about it. I discussed it with my mother and, of course, she said, "We have to get Kerry to do this." Kerry thought it would be a lark and that nothing would happen, but it did happen. She was one of four finalists for "Ms. Subways."

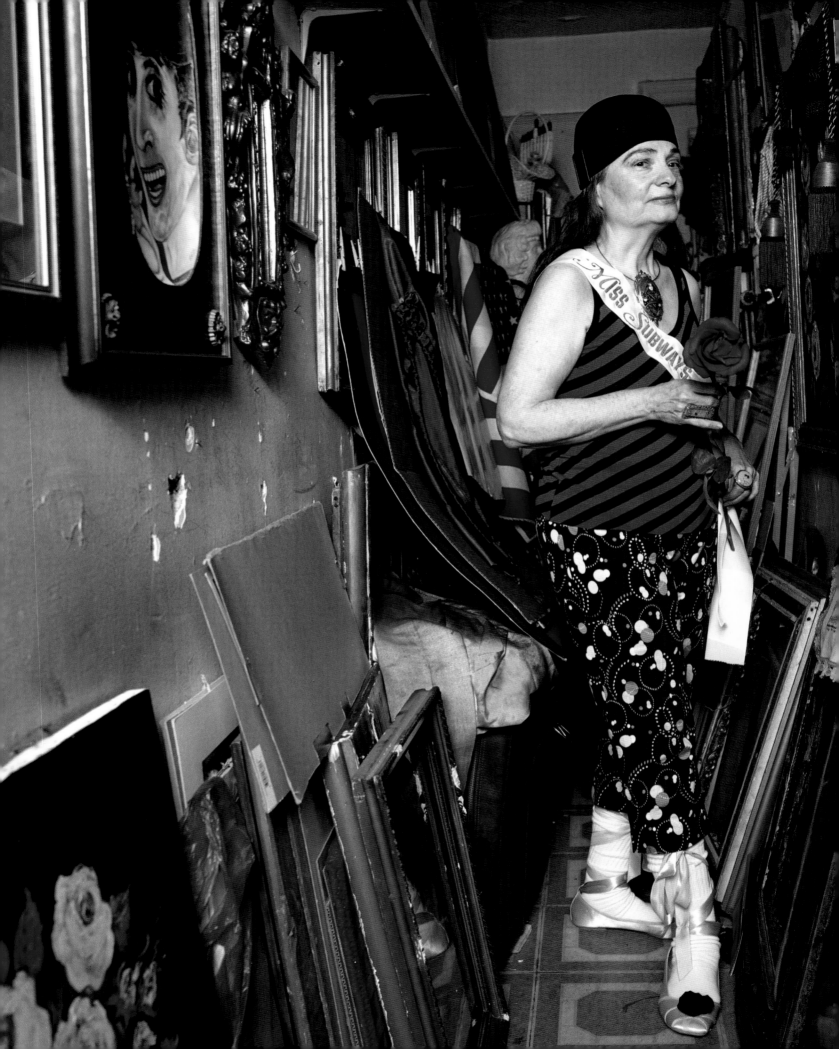

Meet Neddy Garde

MISS SUBWAYS DECEMBER 1967–JANUARY 1968

Growing up in Flatbush, Brooklyn, my friends were from the Fruit of the Loom family and other prominent families. I went to the Officers' Club quite a bit with friends. A lot of physicians' children were friends of mine. It just so happened that way because my dad had an antiques store, and the customers used to come in and we went to school together. I was with millionaires even though I wasn't one. They liked me. They appreciated me. They liked my advice.

Being Miss Subways was a big deal. I sent the picture in and then it was reviewed by a committee headed by Bernard Spaulding. I was among hundreds of entries, and then I was chosen as a semi-finalist and seem to have gotten the most votes. I had interviews on radio and TV. But I intended to go ahead with my career whether I won this contest or not. I had plans, ambitions, goals. Being an artist is my love. When I was six years old, I made up my mind that marriage would come much later because this

NEDDY GARDE in her apartment in Brooklyn, New York 2007.

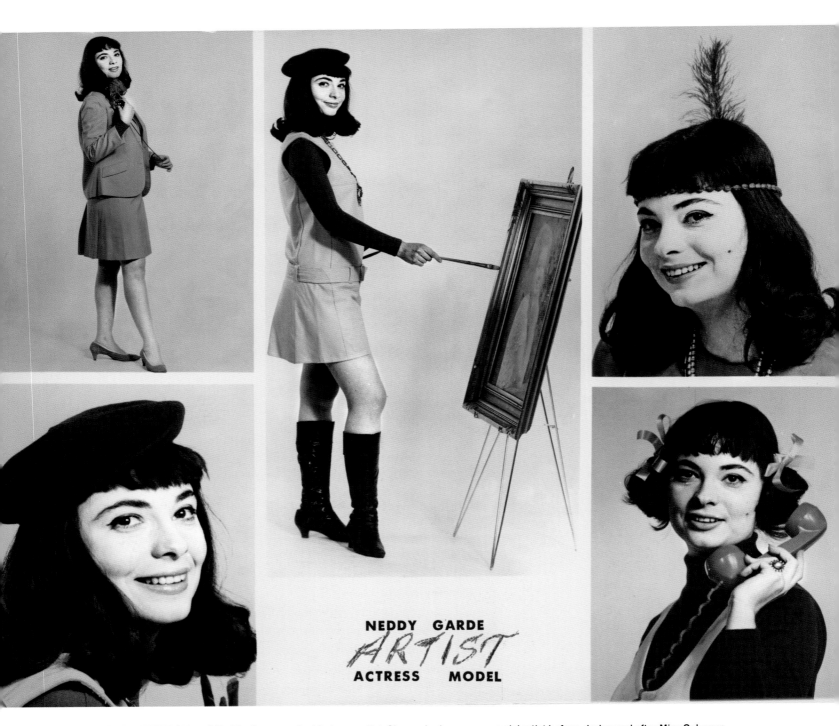

NEDDY GARDE
ARTIST
ACTRESS MODEL

MODEL ARTIST (Above) Neddy always aspired to be an artist. She worked as a commercial artist before, during and after Miss Subways, and her modeling cards showcase her creative persona.

Meet *Miss Subways* Neddy Garde

Individualist Neddy is a free-lance artist creating decorative items for top NY and out-of-town department stores. Her specialty: painting miniature porcelains, a skill acquired by intensive study in France. What began as a hobby proved so successful Neddy had to take a leave of absence from college.

For relaxation, Neddy plays the piano; has a keen interest in all the arts. Withal, marriage and family are Neddy's main life-design.

PHOTOGRAPHED BY James J. Kriegsmann PHOTOGRAPHER OF CELEBRITIES

* MISS SUBWAYS IS A SERVICE MARK OF NEW YORK SUBWAYS ADVERTISING CO., INC.

was something I had to do. I received my intensive art training in the USA. The poster said France but that was a misprint. I got everything here. And I had no intention of getting married at that time. That was also a misprint. Marriage was not in my focus. If I had met somebody I really cared for, yes, but I was working all of the time. I wanted to become an accomplished artist and reach my goal.

I was a commercial artist before, during, and after Miss Subways. I worked at Tiffany's selling silver. Then I was a designer for Fortunoff. I started there in 1970, when I was very young. I started off with 12 pieces—hand-painted porcelain brooches, rings, pins, earrings. A woman there said, "Nobody can do anything like this. No human being." For me it came easy. I don't know why. I've done hundreds of pieces. I formed my own jewelry company, Loubunee—the combination of my father's name, Louis, my mother's name, Bunny, and my name. I signed my work Loubunee Neddy. My father helped me with my artwork and jewelry. He was a silversmith and goldsmith and he contributed a lot of books to my education. Both my parents were great assets to me. My mother was an artist, too. She painted furniture. She painted small flowers in gold leaf on dressers.

I also took up textiles, and I got a scholarship at the Phoenix School of Design on East 36th street and Lexington Avenue. I did two years of work in three months. It was a conservatory. I wanted something quiet, like a European education. I couldn't go to the Fashion Institute of Technology with all the noise. I needed something very quiet so I could concentrate. My teacher put me on the pencil for a long time. Everybody else couldn't stand it. It was too boring for them. But I enjoyed it. I sent a painting to President Lyndon Johnson. I still have a letter from his secretary. She wrote, "President Johnson loved your Easter remembrance. And we wish you success." A Chinese ambassador's wife from the United Nations purchased a king-size ring I made. I've done work for Johnny Cash and June Carter. I did work for Marcel Marceau. I donated a $36,000 brooch to a kidney foundation so they could have a kidney machine. It was a brooch the size of a fist that had a lady in a hat with pink coral roses. I wanted them to have it.

THE ARTIST AND HER WORK
Neddy models her hand painted jewelry for *New York Woman* magazine, May 1988. (Bottom.) A detail of her Loubunee line— the name comes from a combination of her parent's names and her own.

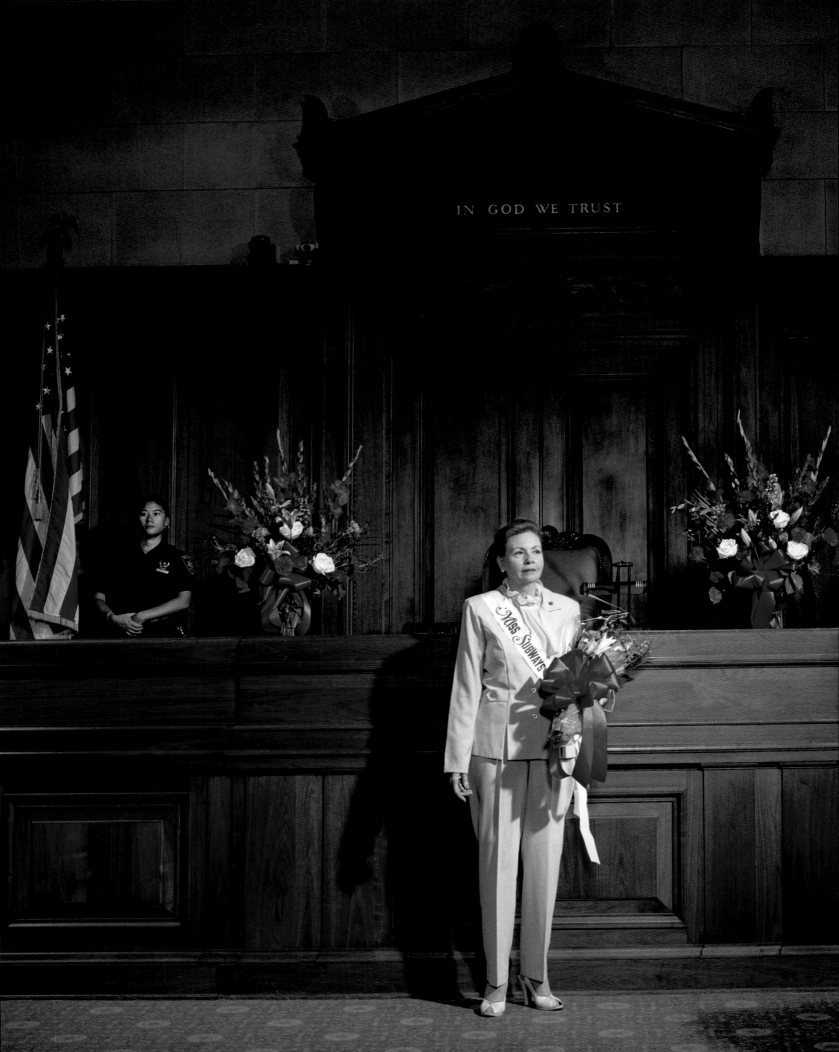

IN GOD WE TRUST

Meet Maureen Walsh Roaldsen

MISS SUBWAYS FEBRUARY–AUGUST 1968

I'm a third generation Brooklynite. My dad's people were born in Greenwich Village on Varick Street, and then they came to Brooklyn. My grandfather was a fireman in Coney Island. When they retired the fire horses, they moved to Sheepshead Bay. Years ago, Brooklyn was the country, and when my grandfather met my grandmother and said he was taking her all the way to Brooklyn, my great-grandmother cried so bitterly, he had to take her too. My mother's people were always in Flatbush. My Nana came in 1887 from Ireland, and lived on Church Avenue and Veronica Place. I was born in Flatbush.

I worked as a hostess at the dining club in Shea Stadium, and one of my co-workers who had been a Miss Subways encouraged me to enter my name in the contest. I was 22 years old at the time. My mother was working as a part-time checker in the neighborhood supermarket—she

Meet *MISS SUBWAYS Maureen Walsh

Beautiful, Brooklyn-bred Maureen has historical roots beyond the NY 'melting pot': her great granduncle was a Union general in the Civil War and later governor of Montana. Besides being a fulltime secretary at Downstate Medical Center, Maureen puts her Barbizon School training to use by modeling at industrial trade shows and being a hostess at Shea Stadium. She's also won or been a finalist in other beauty contests. And she enjoys travel: Europe *four* times, no less!

* MISS SUBWAYS IS A SERVICE MARK OF NEW YORK SUBWAYS ADVERTISING CO., INC.

PHOTOGRAPHED BY James J. Kriegsmann PHOTOGRAPHER OF CELEBRITIES

worked from 9 a.m. to 2 p.m. so she was there for my brother when he came home from school—and whenever someone was at the checkout, she'd say, "Here's a postcard, vote for my daughter."

My poster said, "She enjoys travel. Europe four times, no less." In those days that was quite an accomplishment. Young women had just started to travel and do things the generation before didn't participate in. We were able to work, we had money, and we were able to do a little more than our mothers had. I worked full time as a secretary at Downstate Medical Center. As Miss Subways, I represented New York. I went to President Richard Nixon's inauguration. I remember meeting Fred Astaire at the premiere of "Finian's Rainbow" at the Ziegfeld Theatre. It was only for a few seconds, but I always remembered it. Occasionally, for a photo op, we would show up and they'd have us wear a sash. But I didn't wear it back and forth to work.

My mother was a frequent subway rider, and on my poster she once saw that my teeth were blacked out and I had a mustache. That wasn't typical of the times. Back then people took pride in their stations. You could use the restrooms. I remember when they opened the 57th Street station subway officials did a box lunch that they served us on the train. We all dressed up. We had champagne. They set up tables with red and white tablecloths. I couldn't envision something like that happening today, though people from outside New York are still fascinated by the subways. When my husband's relatives came from Norway a few years ago the first thing they wanted to do was ride the subway at rush hour in Manhattan. Then they bought a T-shirt that said, "I survived the New York City subway." I explained that it got old if you did it five days a week.

I started at Downstate in 1962. Years later while I was still working there I went to Brooklyn College in the evening because I always had a deep down desire to become an attorney. I did a special baccalaureate degree for adults and then started law school in 1985. Not only did I go to night school, but I also won the Political Science award for both day and evening students. When I went to a reception one of the deans introduced

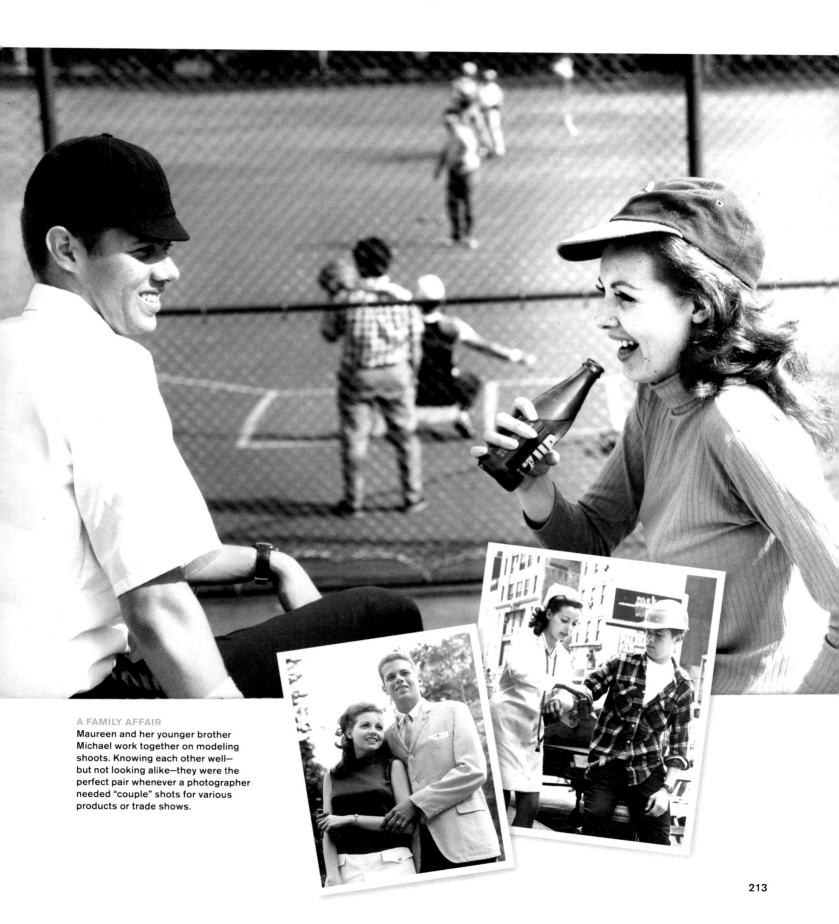

A FAMILY AFFAIR
Maureen and her younger brother Michael work together on modeling shoots. Knowing each other well—but not looking alike—they were the perfect pair whenever a photographer needed "couple" shots for various products or trade shows.

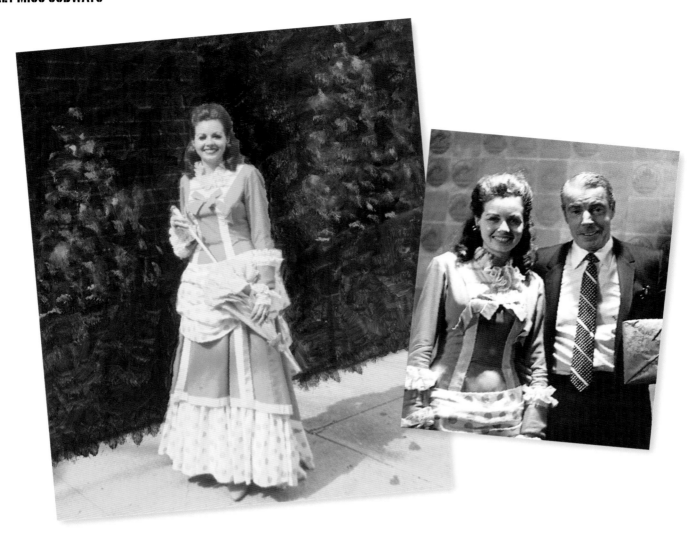

SHEA DAYS
(Above) As a Diamond Club hostess at the New York Met's old baseball stadium, Maureen dressed in vintage costumes for "Old-Timers Games" to escort the "Old Timers" out on the field. (Right) She was a favorite with Joe DiMaggio.

me as a Miss Subways, though it had been twenty years. It was part of New York's consciousness from that generation.

When the contest first started in the 1940s, it was more beauty-pageant style. But when we were selected, we went through a series of interviews. They wanted to make sure we were articulate, that we could present ourselves in public. The contest stopped because of the women's lib movement in the 1970s. At that time Miss Subways was mistakenly lumped in with the other beauty pageants. There was this idea that it was demeaning to women, that there wasn't an audience for it. But we were women who had different interests. We had people from all walks of life. It wasn't, "Oh she's this height, this weight, this color eyes." No, it was about what we had accomplished and what we hoped to accomplish.

I'm now a court attorney, admitted to the Bar in 1991. I remember when I was taking the exam, I spoke to my husband on a public telephone between the morning and afternoon sessions, and he told me we received some information in the mail about a Miss Subways reunion. I said, "Oh, a Miss Subways reunion? When I get home, I'll read it." A young lady tapped me on the shoulder and said, "You were a Miss Subways? So was my mother." As it turned out, I knew her mother, Mary Timoney. So there I was, taking the bar exam with one of the daughters of a former Miss Subways.

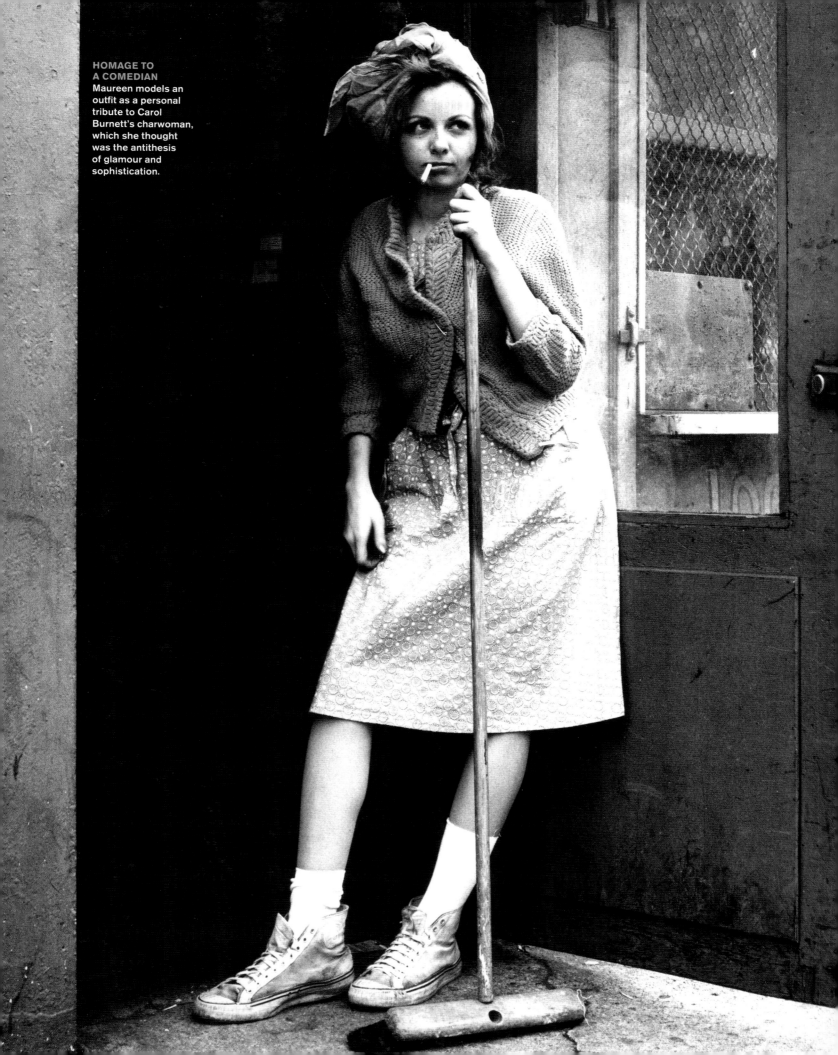

**HOMAGE TO
A COMEDIAN**
Maureen models an
outfit as a personal
tribute to Carol
Burnett's charwoman,
which she thought
was the antithesis
of glamour and
sophistication.

EILEEN RYAN KEATING with Postmaster Frank Wallner at the Greenvale Post Office, Greenvale, New York 2008.

Meet Eileen Ryan Keating

MISS SUBWAYS JULY–AUGUST 1969

My mom had me when she was 40. She always thought she was old. Now it's the thing to do, having children at that age. I had a sister, but my sister died when she was 13 and I was 2 years old. Then my dad died when I was 7, so it was just my mother and me.

My mom was a fireball. She was a tiny, 5-foot-tall lady. We would always go places together. She was my energy. I started going to beauty contests when I was 18, and my mom would come with me. I would get up on the stage where you had to say your name and how old you were and what you did, and I would just freeze. My mom said, "You should get out there and project yourself." And a beauty contest judge even said, "Take a speech course at the local college." So I did. After I took the courses, I was able to see what he was talking about. I was in a shell—an eggshell. Modeling helped bring me out. I was doing conventions, like the Fancy Food and Confection, the Toy Show, the Auto Show. I used to be very shy and introverted. People can't believe it now.

I was still doing a few contests as a hobby when I started working at the John F. Kennedy Airport as a secretary for a Trans Caribbean pilot. A judge from one of those contests said to me, "Why don't you go in for Miss Subways?" I never even had really known about it. So I contacted Bernard Spaulding, and he told me to come in. The public

Meet *MISS SUBWAYS* Eileen Ryan

Winning beauty contests is nothing new for stately Eileen. She's won 7 on Long Island, from Miss Nassau to Miss L. I. Irish-American.

A secretary at Trans-Caribbean Airways, Eileen often free-trips to sun and sand of Puerto Rico on weekends. Lucky girl.

Eileen is also (you guessed it) a part-time model. She keeps in trim via swim/ski/golf. Other interests: modern dance, piano and ceramics.

PHOTOGRAPHED BY James J. Kriegsmann PHOTOGRAPHER OF CELEBRITIES

* MISS SUBWAYS is a service mark of NEW YORK SUBWAYS ADVERTISING CO., INC.

had to vote, so I mentioned it at work. The crew from Trans Caribbean would come in and vote. It worked out great. The airline did a nice write-up in the newsletter. I was a temporary celebrity. Wherever I went, people frequenting the subway would mention, "Was that you?"

I got married when I was 24, the October after I was Miss Subways. Then Trans Caribbean merged with American Airlines, and I didn't want to work in the city at that time. I got pregnant with my first son and we bought a house out here in Long Island. I have two boys and a daughter. When my three kids were younger, I did promotions for Macy's, Abraham & Strauss, Bloomingdales, Lord & Taylor. I would do the perfume spraying and makeup for the customers. Afterwards, I worked for a lawyer as a notary, and I have my real estate license too. All part time. The kids took up a big span, that's for sure. Then you need to find a new career when they're on their own. I was 27 when the first was born and didn't go back to work full time until I was 40.

When my youngest son was just a baby my neighbor recommended a job at the post office. I didn't want to do it. I kept postponing it, and they kept calling me. They put you on a list, and when your name comes up...Well, I finally went when my son was five. Back then you had to do both sides, the carrier and the clerk side, and there were split shifts. I would go to work at 4 a.m. and work until noon, then go home and come back around 3 p.m. until closing at 6 p.m. It was very grueling. I would be out carrying the mail and then close on the clerk side.

It was very difficult in the beginning. They didn't really accept women on the job. It was the same in the police department where my husband worked for 35 years. When I first started, I was with 20 men, and I was the only woman. They said, "If you're going to work here you have to do a man's work because you're getting paid for a man's work." They really harassed me, but I persevered and stuck it out. I'm not the kind of person you can say no to. I'll just barrel through the barrier. I thought, "They're just making it difficult for me." And as difficult as they made it, I was more determined to carry on. I don't give up

Meet Miss Subways Eileen R

Winning beauty contests is nothing new for stately Eileen. She's w
Long Island, from Miss Nassau to Miss L. I. Irish-American.

A secretary at Trans-Caribbean Airways, Eileen often free-trips
and sand of Puerto Rico on weekends. Lucky girl.

Eileen is also (you guessed it) a part-time model. She keeps in tr
swim/ski/golf. Other interests: modern dance, piano and ceramic

NEW YORK SUBWAYS ADVERTISING CO., INC.

easily. I guess I'm very competitive. I've won a lot of contests here at the post office, like most express mails or most priority mails. You learn from each situation, whether business or beauty contests. I de-stress by swimming every day in the summer, in the morning before work and then after work. It gives me more energy and helps me to better handle customers. We have a pool at the house. In the winter I go to the gym after work.

My daughter, she's a triathlete. I think she gets a lot of that from me. She went to Annapolis and is a lieutenant commander on the admiral staff in intelligence. When she started in Annapolis there weren't that many women in the class. A lot of them dropped out. She had grueling experiences, too.

CHARMED
Eileen receives her
Miss Subways bracelet
for winning the title.

Meet Sonia Dominguez

We came from the Dominican Republic to Morningside Heights. My mother came first. Me and my two sisters came later. My mother never worked in my country but when she came here she had to work. She didn't speak English and she didn't have any degree, so she did factory work. It was a big change. In my country, my father was a mayor. In my 15th year, I was the queen of the San Andres festival. It's a big festival they do every year when you're going to enter society, when you're going from teenager to a lady. Here they call it a ball. Over there, they call it estreno. It's the first time you wear a gown. It's really nice.

In my country, I was going to be an actress. When I came here, I tried to do some modeling but I was a little short, about 5'3". I had my secretary degree from the Domin-

SONIA DOMINGUEZ in her apartment in Manhattan, New York 2007.

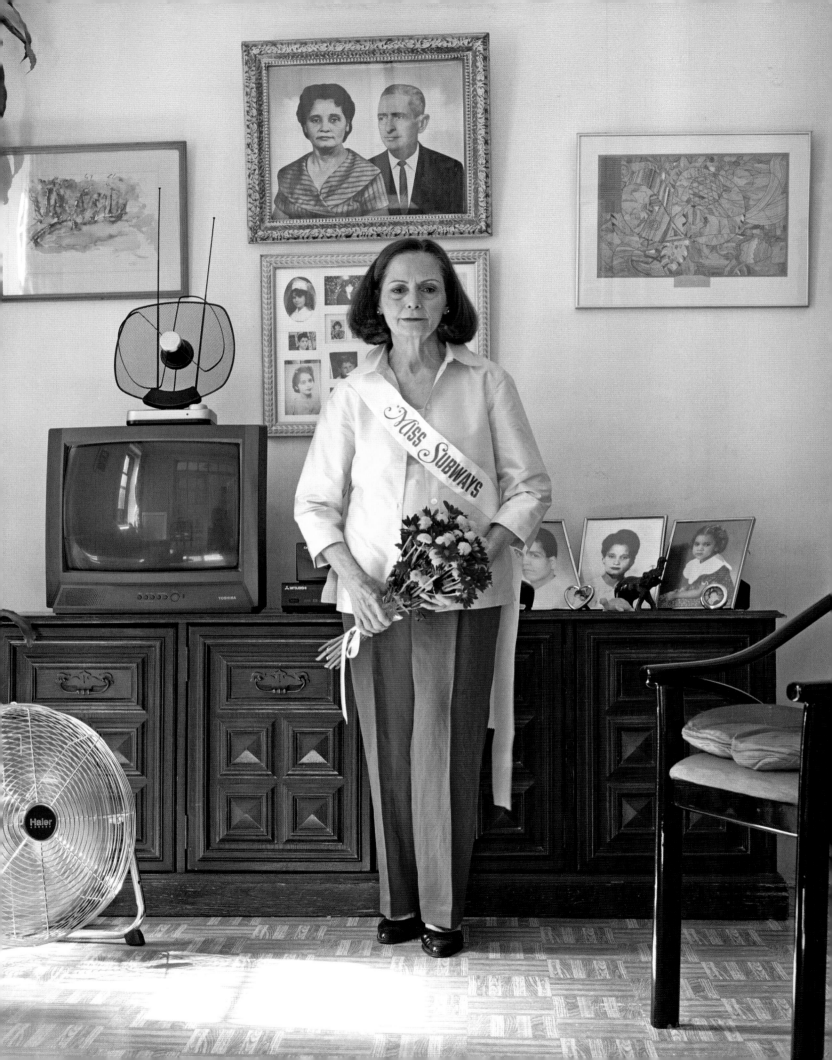

Meet *MISS SUBWAYS Sonia Dominguez

Sonia's been a New Yorker for nine years. Born in Esperanza, Dominican Republic (where her father was mayor) she has pleasant memories of riding horses in local exhibitions and being crowned Queen of the annual San Andrés Festival.

Sonia works in data processing at Bache & Co. and takes part-time courses at Columbia. Attending the ballet, theater and art museums are her diversions. Sonia's also a fine cook; would like to write a cookbook of favorite Dominican dishes if time permitted. Of course, she would *make* the time for fashion or commercial modeling.

PHOTOGRAPHED BY James J. Kriegsmann PHOTOGRAPHER OF CELEBRITIES

* NEW YORK SUBWAYS ADVERTISING CO., INC.

ican Republic. I took a class here at IBM in data processing. I went to a school to learn English. I still have a strong accent, but I try my best. My first job was on Wall Street, at Beche & Co. Later on I moved to Merrill Lynch. From there, I joined the Red Cross. I spent seven years there. That was my last job. After 9/11 they laid people off. I want to go back to work, but at the moment I'm not working.

I was in New York nine years before I became Miss Subways. In those days, they put the ads on the subway and people voted. My good friend sent in my picture. My company, Beche, tried to get all the branches all around the world to send votes—even from Hong Kong. A lot of friends and family sent in votes. People were really enthusiastic to do that. It was fun for me. It's always nice to win something. It's not all about money. I didn't get anything from it, except satisfaction. I was the first Dominican to win the contest. I had an invitation from the president of my country to come to the palace. I had a lot of parties in my neighborhood because they were very proud.

Morningside Heights is changing. Chase Manhattan, Bank of America, Commerce Bank: They're all coming. A lot of bars and American businesses are opening. Most of the small bodegas run by Spanish people are gone because of the rent. My landlord tried to raise the rent in our apartment even though they really don't fix too much when you need it. All the time you have to complain, you have to call them. They don't pay attention to the old tenants. Only after we had a fire two years ago they fixed the apartment a little. The building did add a camera for security because we have a lot of Columbia students now.

This block is a family block. People live here for many, many years. Everybody knows you. My oldest sister is living now in Florida. My other sister lives here with me and my mother. My nephew, Julio, used to live here with us but now has his own apartment. He moved when he went to college. First he went to NYU then he went to Columbia for medical school. He didn't finish yet. I took some courses at Columbia for minorities, but then they discontinued the program. Whenever I see a program I try.

I like to learn. My poster said I wanted to write a cookbook. I cook everything, not only rice and beans. I like to make soup—chicken soup, beef soup. I make fish and chicken in every way. A publisher was going to do a book with food from different countries and asked me to be part of it, but I couldn't because of my English. So, I haven't done a cookbook yet. I need more time.

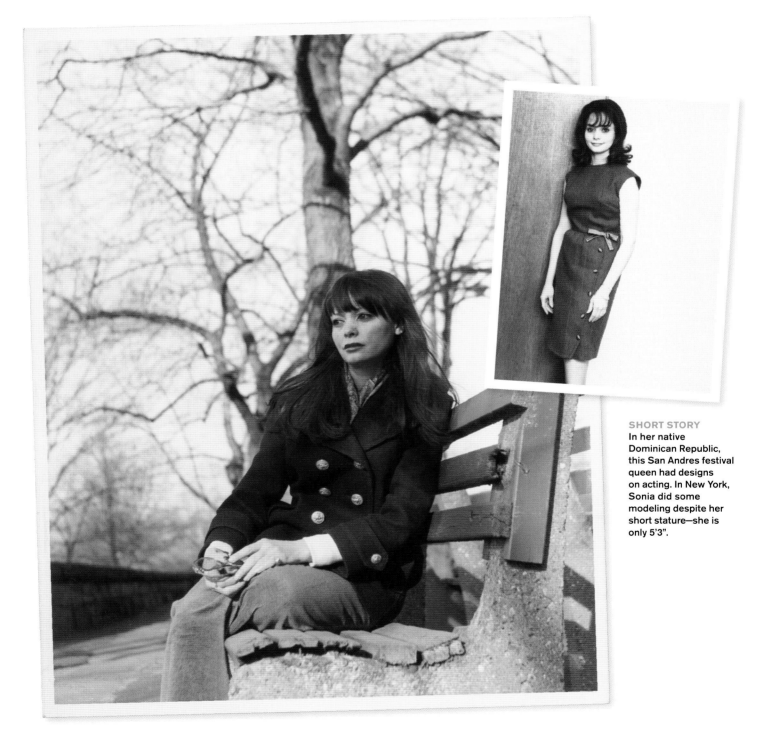

SHORT STORY
In her native Dominican Republic, this San Andres festival queen had designs on acting. In New York, Sonia did some modeling despite her short stature—she is only 5'3".

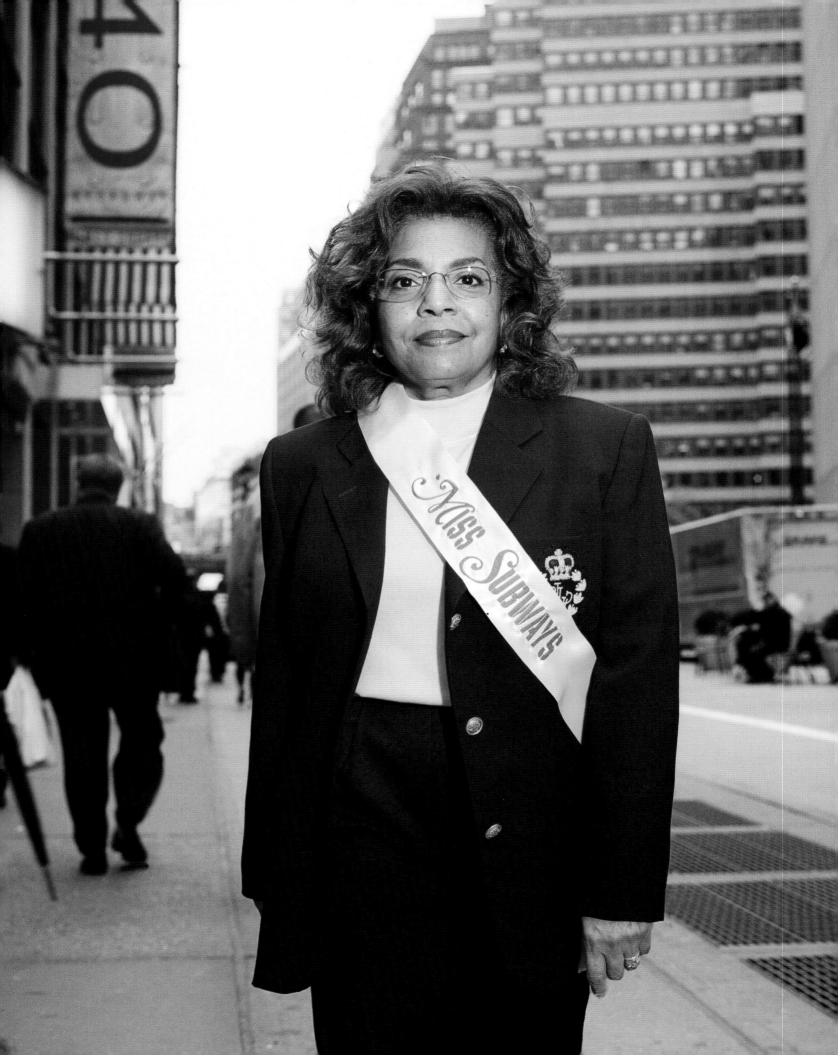

Meet Marcia Kilpatrick Hocker

My mother and father were in Harlem when Harlem was the entertainment capital of the world. Their Saturday nights were dancing live to Count Basie and Duke Ellington at the Y, and later on, as they got older, at the Savoy. So I heard jazz from my mother's womb. I've been singing since I was three years old. When I was going into the ninth grade my family moved to St. Albans, Queens. We were three blocks up from Count Basie. Right across the street was Mercer Ellington, Duke Ellington's son. In the other direction was Illinois Jacquet, the saxophonist who played with Lionel Hampton. Next to him was Wild Bill Davis, an outstanding jazz organist. Even James Brown lived out there for a little while. It was just amazing.

I wanted to be Miss Subways because I wanted to be discovered. I wanted to do commercials and be an actress

MARCIA KILPATRICK HOCKER on the street in Midtown Manhattan, New York 2010.

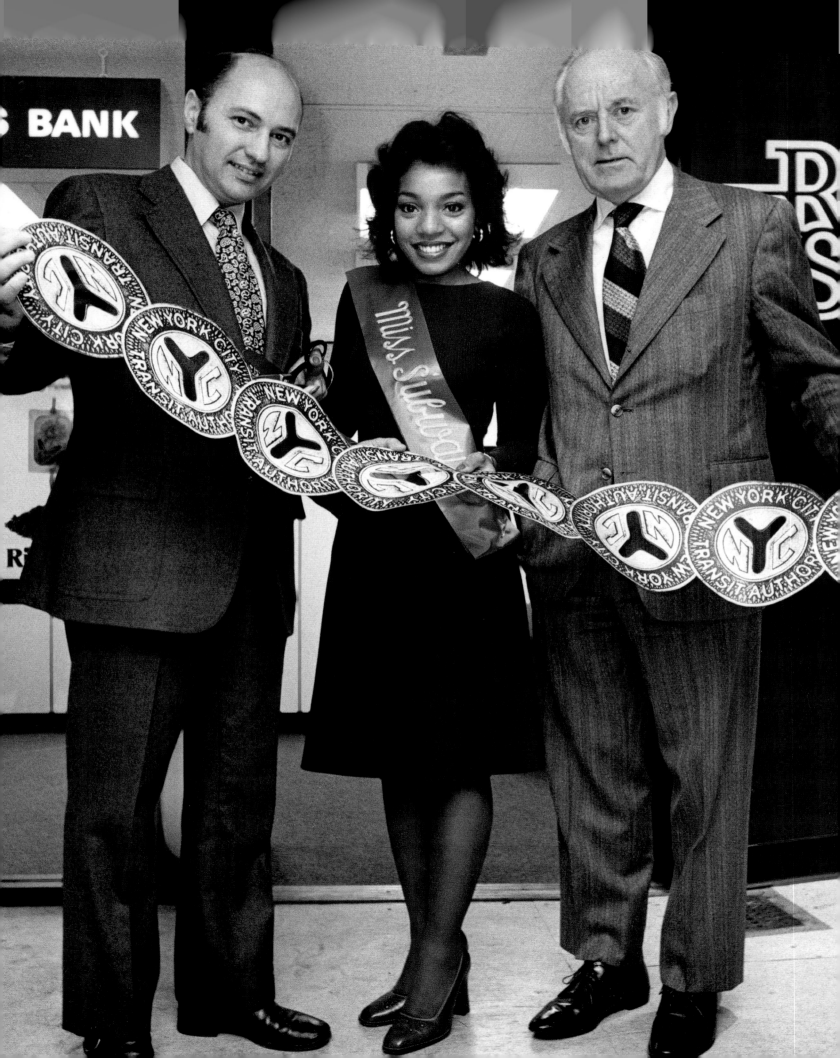

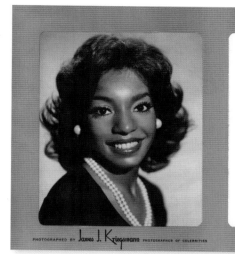

Meet *MISS SUBWAYS* Marcia Kilpatrick

"Marci", as she prefers to be called, is making the most of her abilities in several ways. Interested in a career as an actress, she hopes to be studying with the Negro Ensemble Company this fall. Marci also feels highly qualified to do TV commercials. Basically, she's taking psych and personnel courses nights at NYU. Days, she's an administrative assistant at Off-Track Betting headquarters.

Pleasures are tennis, horseback riding, traveling and, best of all, photography, where Marci fulfills an artistic, sensitive nature with studies of sunsets, plants, birds and water.

PHOTOGRAPHED BY James J. Kriegmann PHOTOGRAPHER OF CELEBRITIES

NEW YORK SUBWAYS ADVERTISING CO., INC.

and sing and dance and all of that. The contest was like a campaign you have to run. You had to get people to vote, make it easy for them. You can't expect the people to go and get the postcard from the post office, address it to the New York City Subways Advertising, flip the thing over and say, "I vote for Marcia Kilpatrick," and then sign it and write their name and address. They're not going to do it. So I had them stacked where I worked at the headquarters of Off Track Betting at 1501 Broadway. I'd have Isadore Herman on the executive floor help make the stack. All they had to do was flip it over and sign their names. People told me they signed their dog's name, the parrot, the cat, their grand-mother. My mother worked for the second largest textile house in the garment district. My dad was with NYPD at the 109 Precinct. My sister worked at a law firm, my brother worked at a bank. They all handed out postcards. My mother, sister, and I had a business where we taught grooming: the Kilpatrick Charm and Modeling School. We had 156 parlors at the time in the metropolitan area. They all had the postcards.

Bernard Spaulding from New York City Subways Advertising had me come down to his office to see my poster before it went up. I said, "Oh my, it's so light. Nobody is going to know it's me. Black folks won't know that one of their own won." My last name is Kilpatrick, which could confuse people. I said, 'It's a great shot, but I have no color. Can you darken it up a little?" He said, "Oh sure, we can do that." So they really darkened it. It's much darker than I am. I look like deep chocolate. That's okay. I'd rather that than for it to be with no color. I was representing myself, my family, and my people. We were told when we became of age that we were born with a strike against us.

When I became Miss Subways I moved to Manhattan. I got proposals. I had a column called "You're Looking Good" about good grooming in the *Community Views* newspaper, which was the official publication of block associations throughout New York, covering all five boroughs. I got a radio show that aired in Pleasantville and Atlantic City, New Jersey called "The Best of Everything." I also got to audition for the Negro Ensemble Company, which is the largest black repertory theater in the country.

CUTTING RIBBONS
(Opposite page)
Marcia represents Miss Subways at the grand opening of the East River Savings Bank branch in Midtown Manhattan, 1974. Two bank officers assist.

I worked with James Moody, who is the teacher in the original "Fame" movie. I studied there for two-plus years. It was really an inside look at myself and being able to find out who I am and where my limits were and maybe drawing some new limits.

I left New York in 1981 when I got married. My husband was quite the diplomat. We moved to Maryland for about a year, where he was first secretary in the political section of the State Department. We lived in Bogotá, Colombia, then off to New Zealand, and then we came home to Maryland for about 10 years. When my husband got a calling to the ministry and we went off to Portland, Oregon I had no idea what to expect. It was quite nice to be surprised by the wonderful jazz that's out there, the theater, the fabulous restaurants. It's like New York. We were always doing things for my husband's career, but I've got my own things. I got to do a great deal of singing as a soloist in the church. I have a radio show in Portland called "A Mellow Groove." I am not one to play avant garde or abstract jazz, music to have a headache by. Everything that I play is melodious, engaging. I ended up doing a lot of counseling, too, conflict resolution, crisis management.

When we were hit on 9/11, I was here in New York, and when I got back home a month later, totally wiped out from this whole experience, my church put me on a speaking circuit. My husband said, "Well honey, you're their connection to New York, they want to know what it was like." I spoke in my church. Next thing I know, I'm speaking at the high school. Next I'm speaking at somebody else's church. I've always found a way to share. I think that we are supposed to help each other grow.

RADIO WAVES
(Below left) A radio show host herself, here Marcia joins, from left, legendary soul singer Donny Hathaway, prominent DJ and community activist Eddie O'Jay and Atlantic Record's Barbara Harris at a promotion reception for Hathaway.

ON BROADWAY
(Below right) Marcia celebrates the 100th performance of the 1975 Tony-nominated musical "Dance with Me", which is set in a New York City subway station.

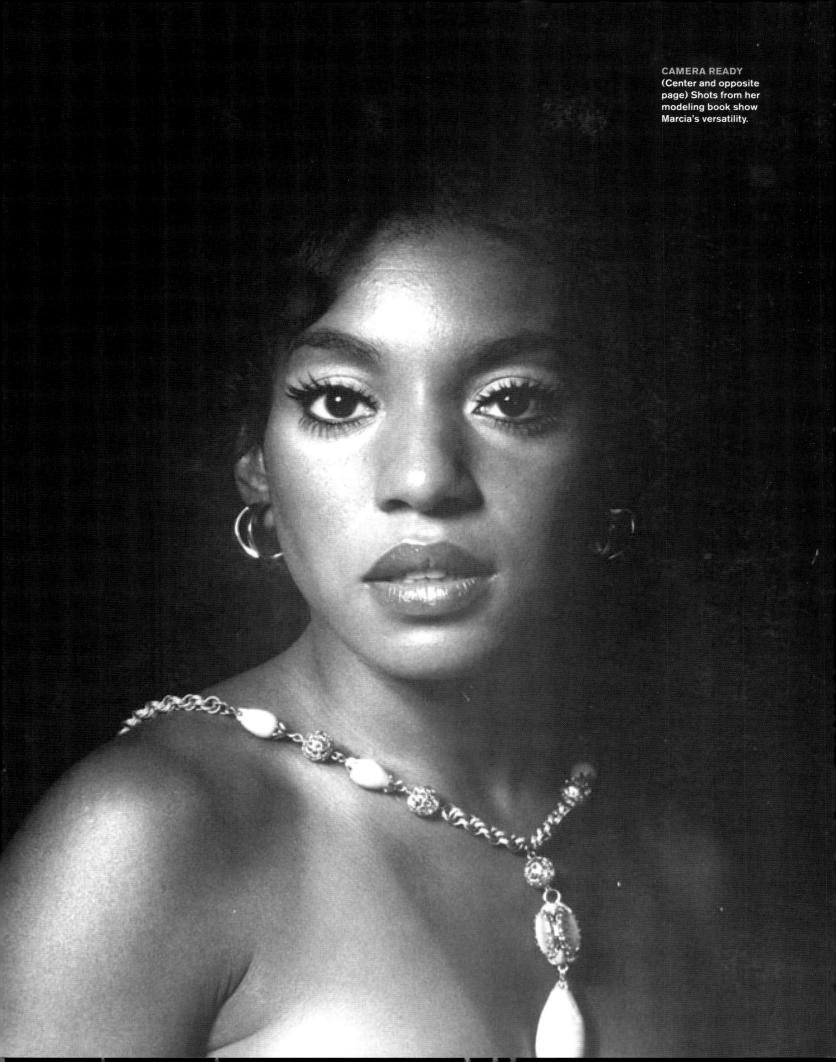

Meet Ayana Scott Lawson

MISS SUBWAYS APRIL–OCTOBER 1975

There was only one year of Miss Subways after me. I felt all these years they should have continued. Women's lib really hurt the contest, but they should have just had a Miss Subways and a Mr. Subways. It would help a lot of young models, actresses, or whatever career to get exposure. I know it helped me—it was just like a free advertisement. I was doing some freelance modeling at the time and trying to get into acting, which was tough when you didn't have an agency. But after the contest, I got more work. I did a Rheingold beer commercial on television. I did a Tide commercial too.

Being Miss Subways was great. I met Muhammad Ali. We did some promos with a radio station for his fight. The contest organizers gave us a token bracelet and a celebration. One time I was sitting right under my poster—because I wanted people to see me—and one guy kept staring at me. I wanted to crack up. He finally approached me: "Is that you?" and I went, "Yup." He had me autograph his newspaper. It was good times.

I never signed with an agency, but I did have an agent for a while. He started trying to rip me off, so I said, "Forget

AYANA SCOTT LAWSON in front of her apartment building in Manhattan, New York 2007.

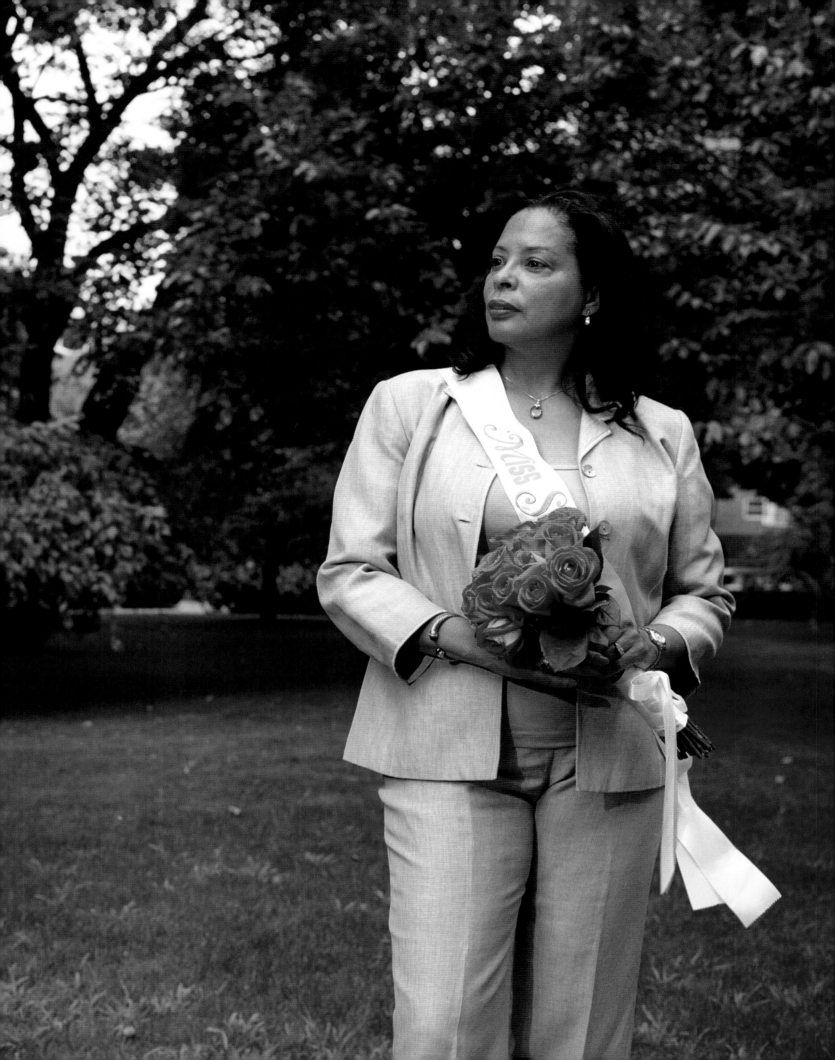

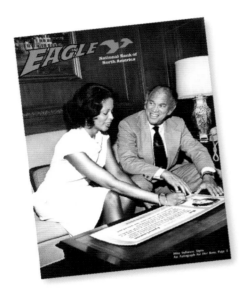

FREE AGENT
(Right) A portrait from the modeling book of Ayana, who sought gigs without an agent. (Above) Once working as a bank teller, she found herself in company pictures: Signing an autograph for her boss as Miss Subways in *Eagle* magazine, National Bank of North America, and posing as a Customer Service Representative.

Meet *Miss Subways* **Ayana Lawson**

Ayana's a budding young actress. She's devoted a lot of time to training in drama technique, voice, dance and modeling. Thus far, she's had roles in four off-Broadway plays and in two movies.

To support herself fulltime, Ayana works as head teller at a branch of National Bank of North America. This fall, she plans to take some social work courses at Fordham U.

Ayana likes to cook, ride bikes, dance, roller-skate and paint.

PHOTOGRAPHED BY James J. Kriegsmann PHOTOGRAPHER OF CELEBRITIES

* MISS SUBWAYS is a service mark of NEW YORK SUBWAYS ADVERTISING CO., INC.

that." When you do modeling as a freelancer your salary is not guaranteed. Sometimes you'd get a check and sometimes that check would bounce. My husband at the time, Jerry Lawson, was the lead singer of The Persuasions and I would do background singing with the band. We were doing okay, but we had a daughter. We needed money to put her through school. Then I was in a car accident and kind of hurt my feet. After my feet got a little messed up, I said, "Let me get a full-time job." So I concentrated on the corporate world and that was it with my modeling career.

I started as a teller at the National Bank of America, and I'm still with the bank 34 years later. I had a nice brownstone in Bedford-Stuyvesant, Brooklyn, but I moved to Manhattan 10 years ago to a complex for middle-income New Yorkers where I could walk to work. My brother used to live in the building next door and when he was living there he said, "Why don't you apply?" Back then the list was closed and they were only taking people who were in a certain union. I filled out the application anyway, and 13 years later they called me. By then I didn't want to move—I was happy in Brooklyn— but my mother said, "Take it."

Now people from Manhattan are moving to Brooklyn. Brooklyn has really changed. It's really building up. People are spending so much money renovating homes. When my grandmother moved to Bed-Stuy in 1952, she was the first African American on her block. My mother lives in that house now, and I visit her almost every weekend. I go in the back yard where we have a nice garden. There's peace and quiet, so I don't have to go out to the Hamptons.

I really don't want to retire in New York—I'm tired of the noise in Manhattan. I want to move to Charlotte or somewhere in the South, where my mother is from. But my mother is here now, my brother, and my daughter are here. That's why I'm here. I've been through three mergers at Bank of America. Now I'm a Senior Personal Banker and investment broker. I'll do four more years and then adios. Maybe I'll go back into advertising and print work, do something fun again.

JOSEPHINE LAZZARO O'HALLORAN with basset hound Bud in her backyard in Ewing, New Jersey 2009.

Meet Josephine Lazzaro O'Halloran

MISS SUBWAYS DECEMBER 1975–APRIL 1976

I always saw the Miss Subways posters when I was commuting from Long Island to my job as a secretary at St. Vincent's Hospital downtown, and I thought, "Hey I can do that. Why are they up there and I'm not?" I wasn't going to be a model. I had no aspirations of acting or anything like that. I just thought it would be cool to be up there and be famous for a short time. So I entered the contest. I had a bum Volkswagen and I thought—this was just in my head—I thought maybe there's a good prize. I didn't know why people entered it. I thought there had to be a reason. I didn't win a car. I won a charm bracelet and the bragging rights. But it was fun. Every doctor, every intern, everybody at the hospital knew me. I was invited to do a couple of cable TV shows and things like that.

When I was working at St. Vincent's I was going to school at NYU at night. They had a program where you could learn to be a physician's assistant. At the time, a physician's assistant was a new idea. The program was cool because you were right in the medical school working in the same places that the medical students worked. My poster for Miss Subways said something about trading typewriter for thermometer. It called me "the now-Yorker." I thought it was kind of corny. Maybe they were desperate for something to write. Maybe they were just as puzzled as I was about why I was there. People did gross things to the poster, defaced it with mustaches, glasses, fangs, but I didn't take it personally. The sad part was I moved away while all this was happening. I got married and we moved to Pittsburgh so I missed out on some of the fun. In school, we were just about to do spinal taps. I don't think I would have been able to do it, so it was just as well. But I loved New York. I remember the city being hot in the summer and smelling like cheddar cheese. I would be afraid to go in the subway at night some-

Meet *Miss Subways* Josephine Lazzaro

Josephine's very much a 'Now' Yorker. Secretary to the Head Pathologist at St. Vincent's Hospital, 'Joey' (to her family and friends) will trade her typewriter for a thermometer when she becomes a medical assistant next year.

For sheer fun, 'Joey' takes ballet and modern dance lessons, practices yoga, bakes bread, takes camping trips, is writing a childrens' book and enjoys playing soccer. An altogether person, but she admits Woody Allen breaks her up.

PHOTOGRAPHED BY James J. Kriegsmann PHOTOGRAPHER OF CELEBRITIES NEW YORK SUBWAYS ADVERTISING CO., INC.

times. But it was great. And the Village, where I worked, was fun. It wasn't like now. It wasn't a tourist trap. It was a place where people worked and lived.

I didn't go to college right after high school because I got engaged. The person I was going to marry didn't want me to get a job. When I started working at Madison Square Garden selling season subscriptions for hockey and basketball I met a girl—a best friend to this day—who said, "You're getting married? What are you, crazy?" I'm glad it didn't happen. I met my husband at the Garden. He sold subscriptions, too. When I broke off my engagement, I said to him, "Do you have any friends? Let me know." And he said, "How about me?" We dated for a while, but then he moved to Pittsburgh. Later I sent him a Christmas card. We got to be friends again. He said he fell in love with me when one time I jumped over something and he saw my blue underwear. I always just wore whatever was popular at the time, and everything back then was really short. Now, I can't imagine how many people must have seen my underwear. We got married and I moved out to Pittsburgh, but just for six months. When we came back, I was lucky enough to get back into St. Vincent's. Then I had my son, and I stopped working. I stayed home and I went to college, and when my son started school I got a job as an instructional assistant at a school. I liked it because of the hours. I'm home by 3 p.m.

Several years after I was Miss Subways, David Letterman decided he was going to do something about the contest. So, they called and said he would like me to be on the show. I was so naïve. Right before the show, they called and said he would have been making fun of me, so they cut it. But it was in the TV guide that I was going to be on. Just as well. What's funny is that I used to write letters to the editors all the time, and I wrote one blasting Miss America. I called it a "meat contest." I was pissed off: "How dare they have these contests?" How hypocritical of me, I guess. But it was like I had been awakened. It was in the '70s or '80s when I wrote it. I didn't think of Miss Subways as a beauty contest. It was just a fun thing that was truly a New York thing. Most people now have no idea what it is. When the teacher I work with told the kids about it, they thought it was a Subway sandwich thing.

Meet Our Girl On The IRT

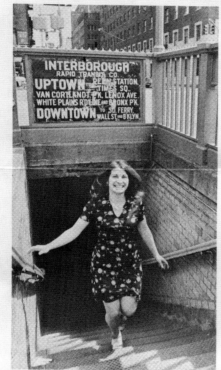

Josephine Lazzaro, our Miss Subways?

Meet Josephine "Joey" Lazzaro. If she looks familiar it may be because you've seen her face smiling down at you from the Miss Subways posters affixed to hundreds of subway cars traveling New York's underground.

Miss Lazzaro, who hails from Massapequa Park, Long Island, is a secretary in the Pathology Department. She's also an evening student in New York University's Medical Assistant program. Citing her ambitious handling of a full-time job plus going to school as important factors in the judges selecting her as one of the six finalists, the pretty contestant admits, "Career goals are very important when it comes to the judges' final evaluation."

Beauty contests are not exactly new to Miss Lazzaro, 24, who was a contestant in a Miss Teenage America Pageant at Palisades Park, New Jersey, nine years ago. This time her fate lies in the votes of millions of New Yorkers who ride the subways every day casting postcard ballots for their favorite contestant. She laughingly admits that one of the more amusing aspects of being in the contest is watching her friends' faces when they board the train and notice her face on the poster.

In addition to her friends' enthusiasm, Miss Lazzaro's family is quite naturally proud and excited. "My little brother has all his friends sending in postcards," she says.

Though hardworking, Miss Lazzaro takes time for some leisure, too. She enjoys tennis, going to the ballet and traveling. Her trips have taken her to Italy and the Caribbean.

Although acting and modeling offers are already starting to come in, Miss Lazzaro says she doesn't plan to accept anything which might jeopardize her position at St. Vincent's.

THE BEEPER
(Above) The monthly newsletter for employees of Manhattan's St. Vincent's Hospital and Medical Center featured their very own Miss Subways in May 1975.

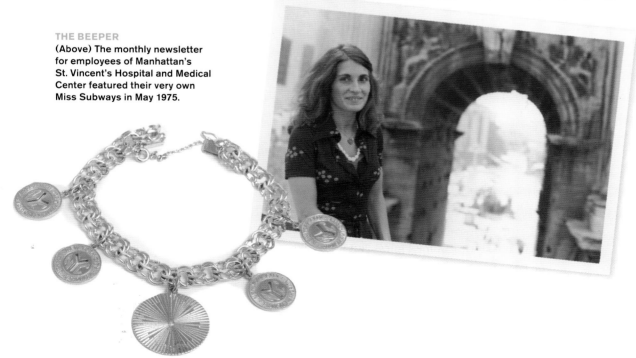

MODEST PRIZE
(Far left) Needing a new car, Josephine entered the contest hoping for a big prize. Instead she settled for the Miss Subways bracelet and the "bragging rights."

WORLD TRAVELER
(Left) Josephine on a trip to Rome, 1971.

Meet Heide Hafner

MISS SUBWAYS MAY–OCTOBER 1976

I grew up on a military base. My father was in the army. I always wanted to be a nurse, and when I got out of high school I said to my father, "I'd like to join the army to become a nurse and let them pay for it." He said, "Oh, no you won't. They're all lesbians." I didn't know what that meant, but it didn't sound too good the way he was stating it. So I said, let me think of something else. I went through a magazine and saw an ad for the Weaver Airline School in Kansas City. It was a six-month stint, and then I was ready for a job as a stewardess. American Airlines offered me a job out in California. It seemed so far away from home in Pennsylvania. So, I asked the school if they had anything else they could offer me. I ended up in Washington, D.C. with the FBI instead of being an airline stewardess. I worked in fingerprinting.

HEIDE HAFNER with a Cessna 172 plane in Stroudsburg, Pennsylvania 2011.

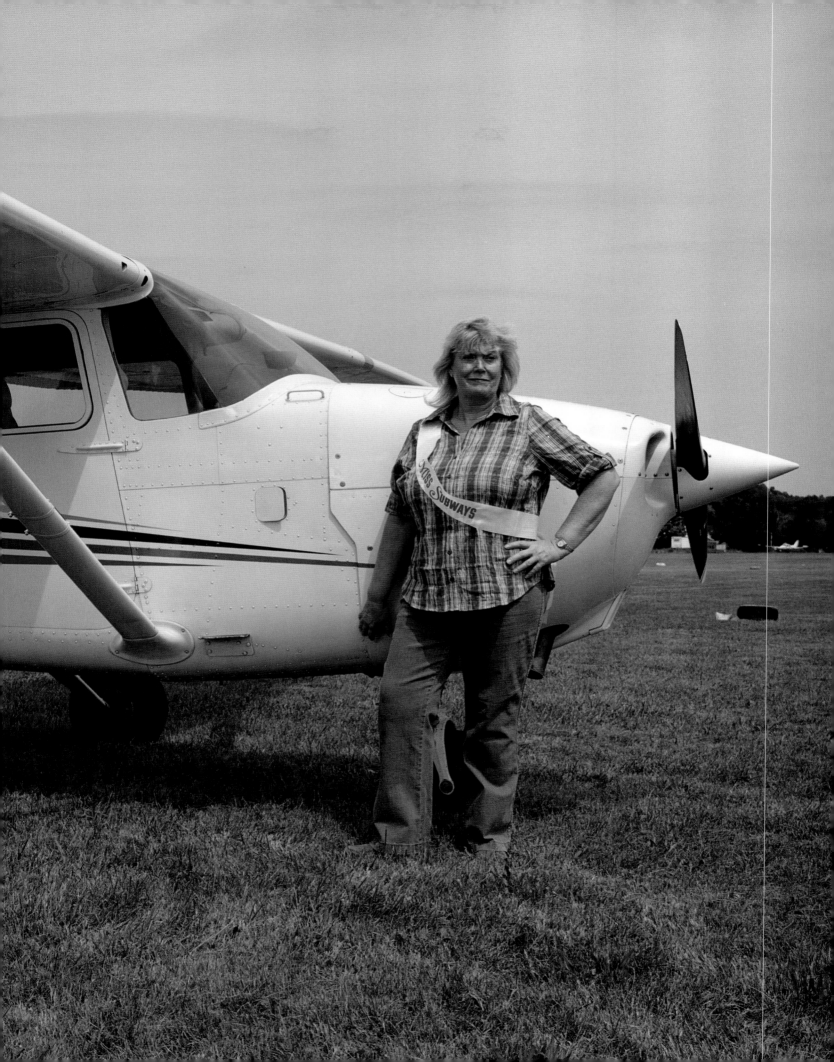

At the heart of the system are 17 Panasonic monitors, one Panasonic video recorder and control panel located in a video monitor room. The operator simultaneously monitors all of the store's 17 live cameras and for a closer look she can zoom in with 150mm lenses.

S. KLEIN'S NEW VIDEO MONITOR SYSTEM HAS VERSATILE USES

S. Klein stepped up its security with the installation of a new complex of cameras and monitors in its Westchester store. This system not only catches crooks but has a number of other uses: making training films, controlling in-store traffic, and insuring the success of in-store promotions.

S. Klein's says that it can prevent the following thefts and at a security savings of 300 man-hours: Till-tapping, collusion between drivers and receiving clerks, stock-room thieves impersonating employees, customer-cashier collusion, possible hold-ups of messengers making money pickups, and plain old shoplifting.

How is it done? The answer: a new video security system customed-tailored for S. Klein and installed in its Westchester, New York store.

At the heart of Klein's system is the video monitor room, occupying only 45 square feet. Within it

are 17 Panasonic video monitors, one Panasonic video recorder, and a control panel. From this room, says Bert Lang, corporate security director, "one person, properly trained, can now outproduce an entire team of detectives working 300 man-hours a week."

From her desk in the monitor room, the operator can simultaneously monitor all of the store's 17 live cameras. There are also 9 inexpensive dummies used as psychological deterrents. For a closer look at a specific situation, she can remotely control, tilt and pan on 2 of the cameras and control zoom on 2 of them. She can also

tape from 4 critical cameras at will. In addition, she can record audio information (such as time and date) along with the video image, and dispatch store detectives to the scene by one-way voice radio. Telephones also give her instant communication with cashiers and other personnel through the store.

Using a joy-stick on the control panel to aim the camera, and a remote-controlled zoom lens to zero in on specific areas, the operator can often document such small actions as pulling off or switching of price tickets; she can also read employee identification badges, and

September 1971

Meet *Miss Subways* Heide Hafner

Weekdays, Heide subways to her job at Potamkin Cadillac but weekends she zooms into the wild blue yonder! She has a private pilots license and recently co-piloted a plane in the women's cross-country air race. After 2,915 miles, 23 hours, nine stops and bad weather, Heide modestly termed it "most challenging."

Her goal: a flight instructors rating. Down-to-earth pastimes: chess, tennis and reading. Some gal!

PHOTOGRAPHED BY *James J. Kriegsmann* PHOTOGRAPHER OF CELEBRITIES

* MISS SUBWAYS is a service mark of **NEW YORK SUBWAYS ADVERTISING CO., INC.**

After a couple of years with the FBI I said, "I'm really bored. What else can you offer me?" They said you have to wait another eight years to get a promotion and I didn't want to wait. I wanted to be a special agent. I was gearing up for it, taking a couple of courses at George Washington University, but I found out I was wasting my time. J. Edgar Hoover was still in charge and he wouldn't allow any women to be special agents. But I learned to fly through the FBI. The bureau had an aviation club and a ski club. I tried cross-country skiing. I didn't like it. Aviation sounded exciting. I got hooked on flying right away. I had a couple of close calls. We all do at one time in the beginning.

I met my husband during that time—I spoke German fluently and he was a Spanish Norwegian linguist for the Navy. We left D.C. and went to New York where I got out of the government and went to work for S. Klein department stores. I traveled to all the stores in Pennsylvania, New Jersey and New York testing for shrinkage control, or inventory control. You go in there and switch tags, see if the store catches it, or you try to see if you can catch anyone stealing. I did that for a couple of years until they closed down. We were living on a 28-foot motor sailor in the Flushing marina in Queens. My husband said, "Let's go sail the seven seas." He wanted to go to the Caribbean. I said, "I'll fly there. I'll be there sunbathing, getting a nice tan by the time you get the boat down there." I couldn't do it any more, with the shower on the marina. I had to do a 500-yard dash in the wintertime to go take a shower. My husband hooked up with some big bosom Puerto Rican woman and I divorced him. I said, "You can have the boat. I'll take the Karmann Ghia. Adios, have a good life."

I moved into an apartment in Flushing and got a job at Potamkin, a car dealership, and continued flying. I did the Powder Puff derby in 1976, a 2,917-mile cross-country race for women pilots only. We had about 250 women that participated. Some unfortunately didn't make it. Some ran out of gas. I felt bad for them. You always have to make sure you have gas. I used to fly in my heels and with my dogs. People used to say, "How can you fly in your heels? You really need to feel the rudders." I can feel it. They're like any other shoe.

SPECIAL AGENT
(Opposite page)
After a stint finger-printing with the FBI, Heide found new opportunities in theft control for S. Klein's Department store. Here, Hafner monitors all of the store's 17 security cameras, stopping any would-be crooks.

My cocker spaniels were a little nervous in the beginning. But they enjoyed the ride.

When I won the Miss Subways contest, I didn't want to be a dopey beauty queen. I just wanted to promote aviation. It was my first love, more or less. In order to win, I went and bought 500 postcards, pre-stamped everything and I got all the customers coming to Potamkin to mail them in. By that time, Miss Subways was losing its glamour. But we didn't want the glamour scene any more. We want to do something more professional-oriented. I was happy with the results, just to know I got aviation out there.

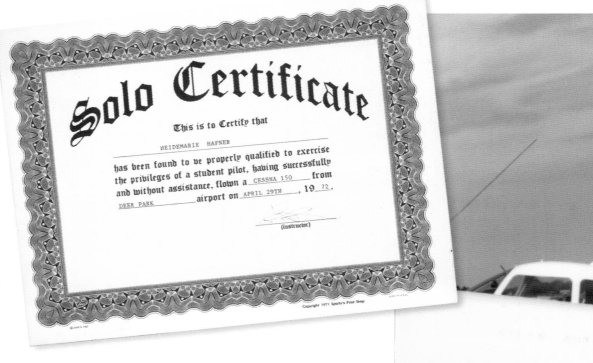

When I won the contest I got a lot of inquiries and weird phone calls. This one attorney called me and said, "I want to take you down to South America and mine for an emerald." Then another guy from Canada had a plane and said, "We'll just fly around." I said, "I'll take a rain check." I used to meet them all at lunchtime so I could get the hell out of there if I didn't feel comfortable. I even got a call from Penthouse. They said, 'We'll send a limousine over, and we'll bring money and clothing." I said, "My husband's a cop." That ended that. I used to make up stories like that all the time. You have to survive in New York.

We got pretty good coverage as pilots, considering air racing was unique in those days. I did the Angel Derby race from Columbus, Ohio to the Bahamas. That, like the Powder Puff, was strictly for women. Some of the guys didn't want to race with us anyway. They thought we didn't know what we were doing. You had to fight your way sometimes. When I was going for my seaplane rating, this old fart took me up but didn't want to land and sign me off because I was female. I said, "You have to sign me off. I did everything right." Some of these old goats just didn't like women in aviation. They were just awful. We had maybe 450 pilots back in '77, but now we've got over 4,000 women pilots. So we've got a pretty big group and they're strong.

Eventually I became a nurse—I never gave up on that. It took a while. I took one course a semester because I didn't want any student loans. I was probably the oldest nurse that graduated. Now I work in a nursing home in the Poconos, where I've lived for 30 years. They made me a supervisor after one year. I'm in charge of 126 people and the whole building. If anything mechanical happens, a bed breaks, a fire, I'm in charge.

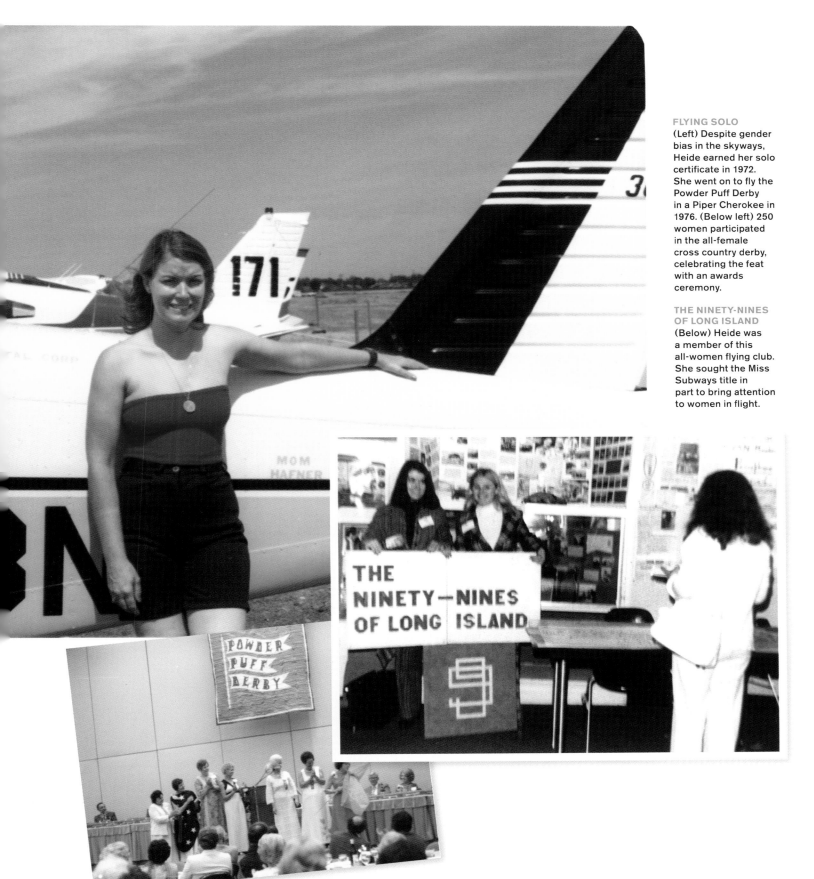

FLYING SOLO
(Left) Despite gender bias in the skyways, Heide earned her solo certificate in 1972. She went on to fly the Powder Puff Derby in a Piper Cherokee in 1976. (Below left) 250 women participated in the all-female cross country derby, celebrating the feat with an awards ceremony.

THE NINETY-NINES OF LONG ISLAND
(Below) Heide was a member of this all-women flying club. She sought the Miss Subways title in part to bring attention to women in flight.

POWDER PUFF DERBY

THE NINETY—NINES OF LONG ISLAND

THE MANY FACES OF MISS SUBWAYS

We have recovered 146 Miss Subways posters from an estimated
200 winners. There are still posters missing, but this is the most complete archive
to date for the contest whose records have been lost to time.

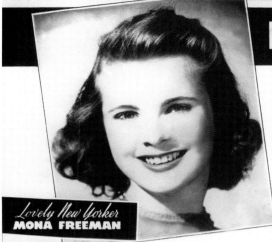

MEET MISS SUBWAYS

of MAY, 1941
selected by JOHN ROBERT POWERS
Famous Beauty Authority

Attending high school, vivacious Mona Freeman writes for her school paper, lives in Pelham. Her ambition is to be a top notch magazine illustrator. She's interested in school dramatics, Broadway and Hollywood please note!

Each month Mr. Powers selects Miss Subways from among those who use the greatest transportation system in the world. Look around this car. Next month's selection may be riding with you.

Lovely New Yorker
MONA FREEMAN

MEET MISS SUBWAYS

October 1941
Helen Borgia has earned her law degree at Fordham—hopes to practice Law. Lives on Riverside Drive—subways regularly. Says her brothers are much better looking, likes to cook—wear distinctive hats.

John Robert Powers
247 Park Avenue

P. S. Miss Borgia shares honors this month with another (look around the car) local beauty. I'd appreciate your comments as to my selections.

Glamorous New Yorker
HELEN BORGIA

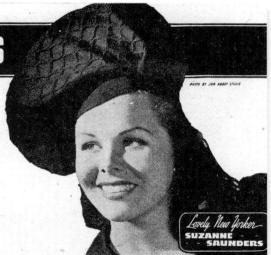

MEET MISS SUBWAYS

November 1941
Muriel Schott is changing her name to Suzanne Saunders. A Brooklyn girl, Madison High graduate, with secretarial training, hopes to become a successful model, get a Hollywood screen test. Loves to swim, play handball.

John Robert Powers
247 Park Avenue

Lovely New Yorker
SUZANNE SAUNDERS

MONA FREEMAN
May–September

HELEN BORGIA
October

SUZANNE SAUNDERS
November

RUTH ERICSSON
December

Page 33

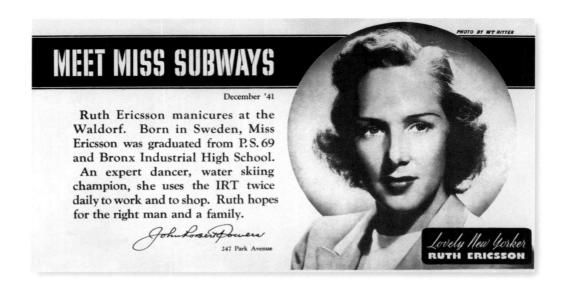

1942

ELAINE KUSINS
March

Page 37

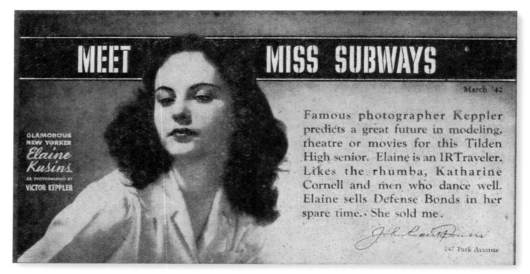

DOROTHEA MATE
June

Page 43

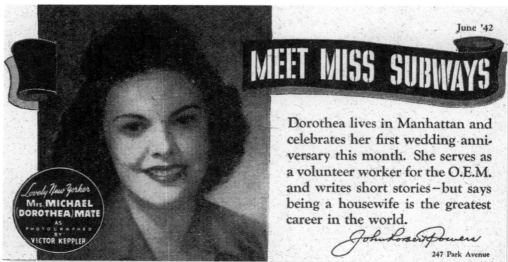

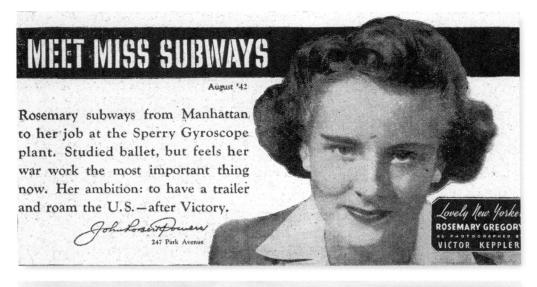

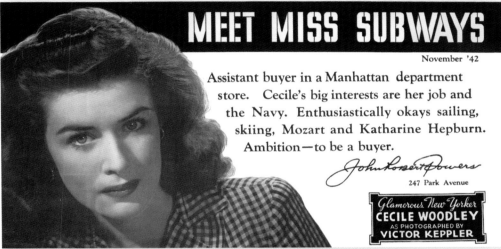

ROSEMARY GREGORY
August

CECILE WOODLEY
November

MARGUERITE McAULIFFE
December

Not shown:
BARBARA DAVIS
STELLA MIKRUT

1943

EDNA THOMPSON
January

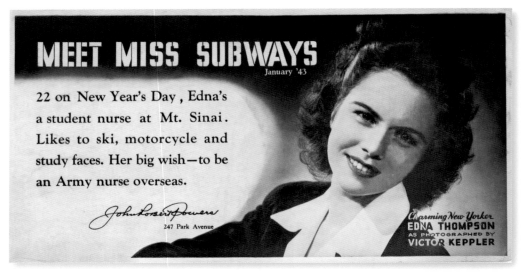

CONNIE SAMETH
February

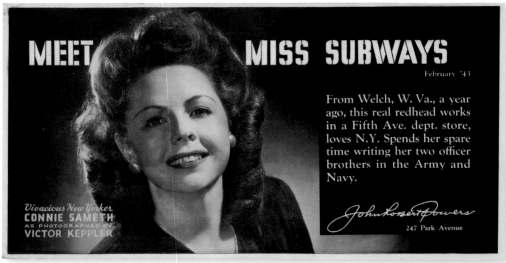

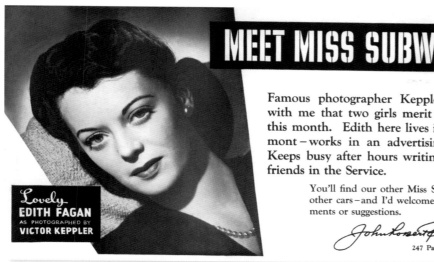

MEET MISS SUBWAYS

MARCH, 1943

Famous photographer Keppler agrees with me that two girls merit selection this month. Edith here lives in Larchmont – works in an advertising office. Keeps busy after hours writing to boy friends in the Service.

You'll find our other Miss Subways in other cars – and I'd welcome your comments or suggestions.

John Robert Powers
247 Park Avenue

Lovely
EDITH FAGAN
AS PHOTOGRAPHED BY
VICTOR KEPPLER

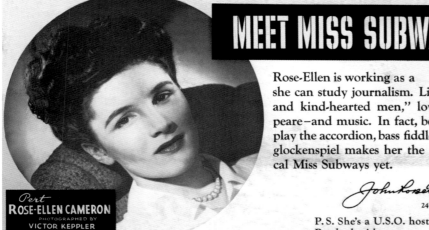

MEET MISS SUBWAYS

APRIL 1943

Rose-Ellen is working as a she can study journalism. Likes "strong and kind-hearted men," loves Shakespeare – and music. In fact, being able to play the accordion, bass fiddle, 'cello and glockenspiel makes her the most musical Miss Subways yet.

John Robert Powers
247 Park Avenue

P.S. She's a U.S.O. hostess and War Bond salesgirl, too.

Pert
ROSE-ELLEN CAMERON
PHOTOGRAPHED BY
VICTOR KEPPLER

MEET MISS SUBWAYS

JUNE, 1943

Five feet two, eyes blue-green, this young secretary is a Brooklynite. Likes Chinese food. Admires Navy men. Confesses her pet extravagance is phonograph records – especially Frank Sinatra's.

John Robert Powers
247 Park Avenue

Petite New Yorker
EVELYN FRIEDMAN
AS PHOTOGRAPHED BY
Muky

TERA KATHRYN DAVIS
August

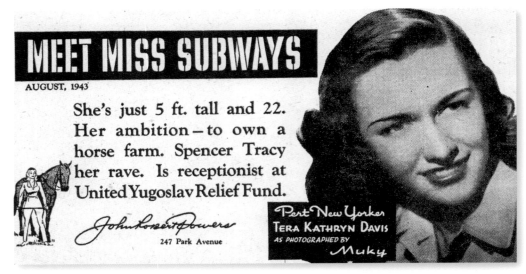

Not shown:
EVELYN CLARK FADEN

1944

ANNE McCONNELL
January

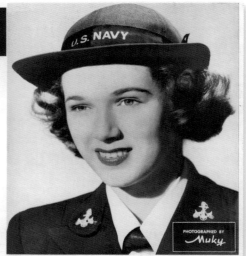

MEET MISS SUBWAYS

FEBRUARY, 1944

Attractive Joan Cashman

Joan says she's a chatterbox and doodler. Loves cold weather, bowling, Ann Sheridan and being told she looks like her. Saw 32 shows within 2 years.

John Robert Powers
247 PARK AVENUE

PUBLISHED BY NEW YORK SUBWAYS ADVERTISING CO., INC., 630 FIFTH AVE., N. Y. C. 20

PHOTOGRAPHED BY *Muky*

MEET MISS SUBWAYS

MARCH, 1944

Lovely Eileen Henry

A Sophomore at Brooklyn College, Eileen wants to be a radio director. You'll find her in Madison Square Garden at almost every basketball game. She admits she's a jitterbug and loves spaghetti.

John Robert Powers
247 PARK AVENUE

PUBLISHED BY NEW YORK SUBWAYS ADVERTISING CO., INC., 630 FIFTH AVE., N. Y. C. 20

PHOTOGRAPHED BY *Muky*

MEET MISS SUBWAYS

MAY, 1944

Dawna, Doris & Dorothy Clawson

Those brown-haired, blue-eyed triplets have lived in Queens, Staten Island, Manhattan and for 9 years subwayed daily to voice lessons. Now just 18, have sung at every camp within 50 miles— but their hearts belong to Navy.

John Robert Powers
247 PARK AVENUE

PUBLISHED BY NEW YORK SUBWAYS ADVERTISING CO., INC., 630 FIFTH AVE., N. Y. C. 20

PHOTOGRAPHED BY *Muky*

JOAN CASHMAN
February

EILEEN HENRY
March

**DAWNA, DORIS,
AND DOROTHY CLAWSON**
May

WINIFRED McALEER
June

Page 43

MEET MISS SUBWAYS

JUNE 1944

Petite Winifred McAleer

Winifred, who is just nineteen lives in Jackson Heights, works as a secretary. As a hobby she paints portraits and is one of the most attractive portrait subjects I've seen

John Robert Powers
247 PARK AVENUE

PUBLISHED BY NEW YORK SUBWAYS ADVERTISING CO., INC., 630 FIFTH AVE., N. Y

PEGGY HEALY
July

MEET MISS SUBWAYS

JULY 1944

GRACEFUL Peggy Healy

Peg lives in the Bronx. She was chosen Pin-Up Girl of the defense plant where she works as a payroll clerk. She's tall, dark and delightful.

John Robert Powers
247 PARK AVENUE

PUBLISHED BY NEW YORK SUBWAYS ADVERTISING CO., INC., 630 FIFTH AVE., N.Y.C. 20

MARY RADCHUCK
August

MEET MISS SUBWAYS

AUGUST 1944

LOVELY Mary Radchuck

Russian by birth, Mary has a throaty voice and blue eyes. This Queens College co-ed has charm, beauty and brains. She's studying to be an interpreter.

John Robert Powers
247 PARK AVENUE

PUBLISHED BY NEW YORK SUBWAYS ADVERTISING CO., INC., 630 FIFTH AVE., N.Y.C. 20

Not shown:
HELEN MAZLEY KENNY
ANNE PALMER
JOAN VOHS April

1945

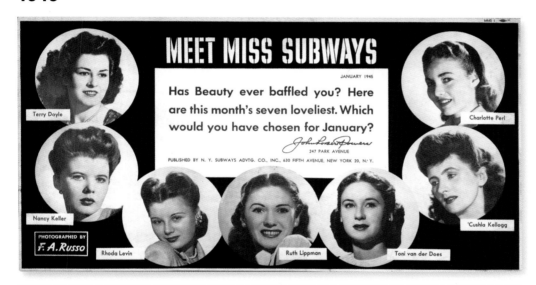

TERRY DOYLE
NANCY KELLER
RHODA LEVIN
RUTH LIPPMAN
TONI VAN DER DOES
CUSHLA KELLOGG
CHARLOTTE PERL
January

Ruth Lippman Page 55

JEAN GROGAN
February

RITA CUDDY
April

MEET MISS SUBWAYS

APRIL 1945

LOVELY RITA CUDDY

Blue-eyed Rita is a Junior at the College of Mount St. Vincent. She majors in biology, and hopes to be an oculist.

John Robert Powers
247 PARK AVENUE
PUBLISHED BY NEW YORK SUBWAYS ADVTG. CO., INC. • 630 FIFTH AVENUE, NEW YORK 20, N. Y.

PHOTOGRAPHED BY *F. A. Russo*

FLORENCE LURIEA
July

MEET MISS SUBWAYS

JULY 1945

Petite
FLORENCE LURIEA

She likes her job of meeting thousands of people nightly as Information Clerk at one of our railroad stations. Florence dates for breakfast and studies for a career daytimes.

John Robert Powers
247 PARK AVENUE
PUBLISHED BY NEW YORK SUBWAYS ADVTG. CO., INC. • 630 FIFTH AVENUE, NEW YORK 20, N. Y.

PHOTOGRAPHED BY **F. A. RUSSO**

MARIAN HARTMAN
August

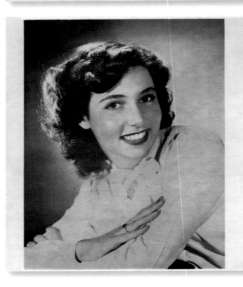

MEET MISS SUBWAYS

AUGUST 1945

Glamorous
MARIAN HARTMAN

Post-war plans for Marian include Social Work — aiding handicapped veterans. She's a dark-eyed beauty of 19 with a gracious smile. HE must be tall and a good dancer.

John Robert Powers
247 PARK AVENUE
PUBLISHED BY NEW YORK SUBWAYS ADVTG. CO., INC. • 630 FIFTH AVENUE, NEW YORK 20, N. Y.

PHOTOGRAPHED BY **F. A. RUSSO**

1946

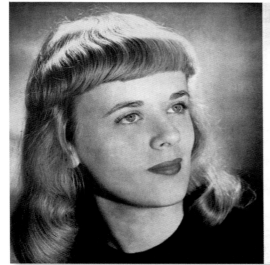

MEET MISS SUBWAYS

JANUARY 1946

Blond
JEANNE CLARK

This Bronx beauty covets no glamour career, prefers her secretarial job. "Likes": skating, swimming, dancing, tweeds, moccasins, seafood, cokes, and movies.

John Robert Powers
247 PARK AVENUE

PUBLISHED BY NEW YORK SUBWAYS ADVTG. CO., INC. 630 FIFTH AVENUE, NEW YORK 20, N. Y.

PHOTOGRAPHED BY **F. A. RUSSO**

JEANNE CLARK
January

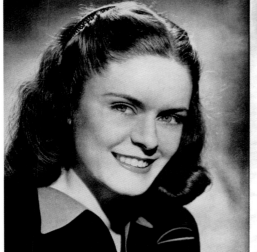

MEET MISS SUBWAYS

FEBRUARY 1946

Blue-eyed
BETTE TAGGART

Born in Ireland, this talented commercial artist's idea of a career is to marry, travel and paint the American scene. Makes own clothes, likes skating, ballet, musicals, and steak.

John Robert Powers
247 PARK AVENUE

PUBLISHED BY NEW YORK SUBWAYS ADVTG. CO., INC. • 630 FIFTH AVENUE, NEW YORK 20, N. Y.

PHOTOGRAPHED BY **F. A. RUSSO**

BETTE TAGGART
February

MARIE THERESA THOMAS
March

Page 61

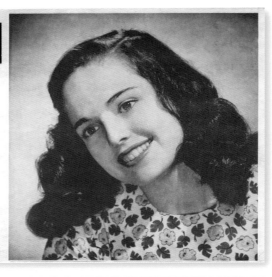

MEET MISS SUBWAYS

MARCH 1946

Charming

MARIE THERESA THOMAS

works for a book club—lucky break for an ardent reader. A swimmer since she was two, she also loves to ride horseback. Adores the March wind.

247 PARK AVENUE

PUBLISHED BY NEW YORK SUBWAYS ADVTG. CO., INC. • 630 FIFTH AVENUE, NEW YORK 20, N.Y.

PHOTOGRAPHED BY **F. A. RUSSO**

JOANNE VAN COTT
April

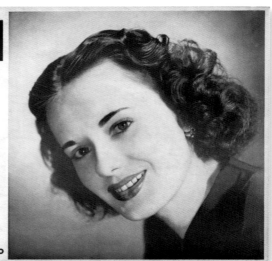

MEET MISS SUBWAYS

APRIL 1946

Alluring

JOANNE VAN COTT

is crazy about her job in a Dutch government office. Is famous for her appetite for chocolate cake. Loves to color Easter eggs. Her ambition: to have her seaman return from Tokyo.

247 PARK AVENUE

PUBLISHED BY NEW YORK SUBWAYS ADVTG. CO., INC. • 630 FIFTH AVENUE, NEW YORK 20, N.Y.

PHOTOGRAPHED BY **F. A. RUSSO**

DANIA CROSS
May

MEET MISS SUBWAYS

MAY 1946

DANIA CROSS

Her naval service included the rehabilitation of blinded servicemen — teaching Braille, typing, handcrafts... As a civilian she will continue to work with the blind.

247 PARK AVENUE

PUBLISHED BY NEW YORK SUBWAYS ADVTG. CO., INC. • 630 FIFTH AVENUE, NEW YORK 20, N.Y.

PHOTOGRAPHED BY **F. A. RUSSO**

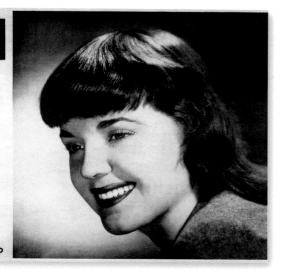

MEET MISS SUBWAYS

JUNE 1946

LANIE HARPER

A Manhattan resident, she prefers rural life — county fairs to night clubs, "cow's milk" to milkwagon milk. Her job? Picks props (such as pigs) for a radio program.

John Robert Powers
247 PARK AVENUE

PUBLISHED BY NEW YORK SUBWAYS ADVTG. CO., INC. • 630 FIFTH AVENUE, NEW YORK 20, N. Y.

PHOTOGRAPHED BY **F. A. RUSSO**

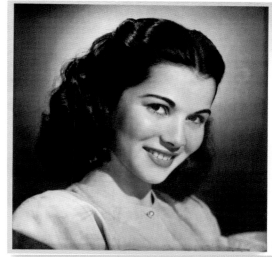

MEET MISS SUBWAYS

JULY 1946

Creative
ENID BERKOWITZ

Art student at Hunter College — interested in advertising and costume design — makes own clothes — plugging for B.A. but would settle for M.R.S.

John Robert Powers
247 PARK AVENUE

PUBLISHED BY NEW YORK SUBWAYS ADVTG. CO., INC. • 630 FIFTH AVENUE, NEW YORK 20, N. Y.

PHOTOGRAPHED BY **F. A. RUSSO**

MEET MISS SUBWAYS

AUGUST 1946

Attractive
ALINE NEWLAND

Receptionist at large advertising agency — a Yankee fan. Interests: Movies, television, the theatre, dancing, dogs. Ambition: to go to Hawaii with husband — ex-Coast Guardsman.

John Robert Powers
247 PARK AVENUE

PUBLISHED BY NEW YORK SUBWAYS ADVTG. CO., INC. • 630 FIFTH AVENUE, NEW YORK 20, N. Y.

PHOTOGRAPHED BY **F. A. RUSSO**

PATRICIA BURKE MAHER
September

MEET MISS SUBWAYS

SEPTEMBER 1946

Vivacious
PATRICIA BURKE

Is starting exciting new secretarial position — bowls a neat 200 — crochets her own hats and is enthusiastic stamp collector. Her "steady" is an ex-Navy man.

John Robert Powers
247 PARK AVENUE

PUBLISHED BY NEW YORK SUBWAYS ADVTG. CO., INC. • 630 FIFTH AVENUE, NEW YORK 20, N. Y.

PHOTOGRAPHED BY **F. A. RUSSO**

MARY VILLACORTA
October

MEET MISS SUBWAYS

OCTOBER 1946

Lovely
MARY VILLACORTA

Was born in Guatemala, now resides in Jackson Heights. Is secretary to general manager of radio station — particularly enjoys Spanish folk songs — ambition is to sing professionally.

John Robert Powers
247 PARK AVENUE

PUBLISHED BY NEW YORK SUBWAYS ADVTG. CO., INC. • 630 FIFTH AVENUE, NEW YORK 20, N. Y.

PHOTOGRAPHED BY **F. A. RUSSO**

KAY LANDING
November

MEET MISS SUBWAYS

NOVEMBER 1946

Lovely
KAY LANDING

Stewardess for Pan American — just returned from jaunt to Africa — interested in foreign countries and peoples — enjoys classical music and reading as recreation.

John Robert Powers
247 PARK AVENUE

PUBLISHED BY NEW YORK SUBWAYS ADVTG. CO., INC. • 630 FIFTH AVENUE, NEW YORK 20, N. Y.

MEET MISS SUBWAYS

DECEMBER 1946

Vivacious
SHIRLEY LEVINE

A scholarship student at N.Y.U. Has many interests, particularly the theatre and foreign foods. Practical as well as pretty, is planning a career as Spanish interpreter.

John Robert Powers
247 PARK AVENUE

PUBLISHED BY NEW YORK SUBWAYS ADVTG. CO., INC. • 630 FIFTH AVENUE, NEW YORK 20, N.Y.

PHOTOGRAPHED BY **F. A. RUSSO**

Not shown:
RITA BRUNEL

1947

MEET MISS SUBWAYS

JANUARY 1947

Sweet
IRIS VICTOR

Studies art and aspires to be a commercial artist or a model. Her hobby is designing clothes for herself. Enjoys winter sports and dreams of skiing in Switzerland some day.

John Robert Powers
247 PARK AVENUE

PUBLISHED BY NEW YORK SUBWAYS ADVTG. CO., INC. • 630 FIFTH AVENUE, NEW YORK 20, N.Y.

PHOTOGRAPHED BY **F. A. RUSSO**

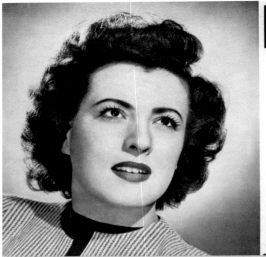

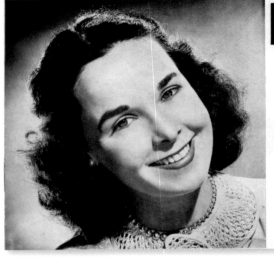

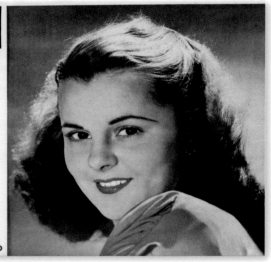

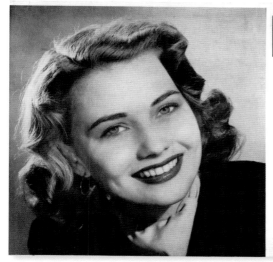

MEET MISS SUBWAYS

JULY 1947

Pert
JEANNE GIBSON

A very modern "Gibson Girl" from Kentucky, suh, who designs hats, collects poems, makes her own clothes and is mad about horses. Favorite author—Edgar Allan Poe. Ambition—to become expert designer.

John Robert Powers
247 PARK AVENUE

PUBLISHED BY NEW YORK SUBWAYS ADVTG. CO., INC. • 630 FIFTH AVENUE, NEW YORK 20, N. Y.

PHOTOGRAPHED BY **F. A. RUSSO**

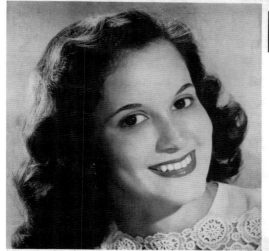

MEET MISS SUBWAYS

AUGUST 1947

Comely
JOAN ATTINSON

Elected Queen of the Campus at Queens College—Iota Alpha Pi Girl—Interested in Spanish and plans Mexican Trip—Sings, plays the piano and likes to rhumba—Boy friend is former Air Corps man.

John Robert Powers
247 PARK AVENUE

PUBLISHED BY NEW YORK SUBWAYS ADVTG. CO., INC. • 630 FIFTH AVENUE, NEW YORK 20, N. Y.

PHOTOGRAPHED BY **F. A. RUSSO**

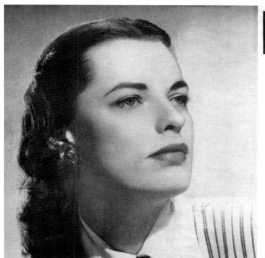

MEET MISS SUBWAYS

SEPTEMBER 1947

Writer
JUNE WALLACE THOMSON

Puppy love for New York and newspaper aspirations brought her here. Got Columbia's M.S. degree. Her articles have appeared in national magazines. Hobby—attempting recipes she writes about. Ambition—playwrighting.

John Robert Powers
247 PARK AVENUE

PUBLISHED BY NEW YORK SUBWAYS ADVTG. CO., INC. • 630 FIFTH AVENUE, NEW YORK 20, N. Y.

PHOTOGRAPHED BY **F. A. RUSSO**

JEANNE GIBSON
July

JOAN ATTINSON
August

JUNE WALLACE THOMSON
September

261

MERRY CONDON
October

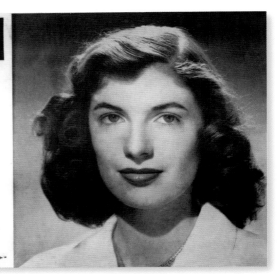

Lovely
MERRY CONDON

OCTOBER 1947

Was graduated from Queens College with honors in the field of psychology. Favorite recreation—dancing the rhumba. Favorite sports—tennis and miniature golf. Ambition—to delve into the field of psychoanalysis.

John Robert Powers
247 PARK AVENUE

PUBLISHED BY NEW YORK SUBWAYS ADVTG. CO., INC. · 630 FIFTH AVENUE, NEW YORK 20, N.Y.
PHOTOGRAPHED BY **F. A. RUSSO**

Not shown:
HARRIET SOBEL May
DOROTHY CARROLL June
CLAIRE CASSARD November
GENE FARLEY December

1948

LYNNE LYONS
January

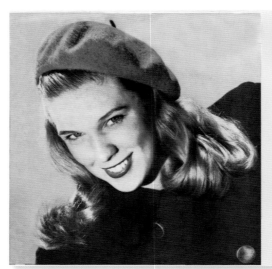

MEET MISS SUBWAYS

JANUARY 1948

Sparkling
LYNNE LYONS
Studied Dramatics at New School and American Academy. Ambition: to direct and star in own show. Prefers stage to movies. Shares apartment with budding ballerina. Hobby: Interior decorating

John Robert Powers
247 PARK AVENUE

PUBLISHED BY NEW YORK SUBWAYS ADVTG. CO., INC. · 630 FIFTH AVENUE, NEW YORK 20, N.Y.
PHOTOGRAPHED BY **F. A. RUSSO**

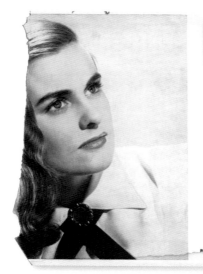

MEET MISS SUBWAYS

FEBRUARY 1948

Golden-haired
MARIE McNALLY

Works for leading oil corporation. Enjoys music of Duke Ellington, and is an ardent baseball fan. Has recently mastered art of making argyle socks for favorite beau— a Fordham man.

John Robert Powers
247 PARK AVENUE

PUBLISHED BY NEW YORK SUBWAYS ADVTG. CO., INC. • 630 FIFTH AVENUE, NEW YORK 20, N. Y.

PHOTOGRAPHED BY **F. A. RUSSO**

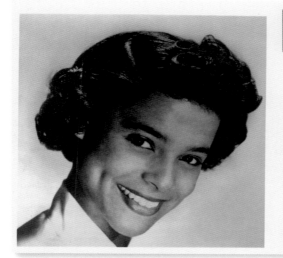

MEET MISS SUBWAYS

APRIL 1948

Vivacious
THELMA PORTER

Psychology student at Brooklyn College and part-time nurse receptionist in dentist's office. Is active in social welfare work and ardent church worker. Sings in a choral group and is a Gershwin devotee.

John Robert Powers
247 PARK AVENUE

PUBLISHED BY NEW YORK SUBWAYS ADVTG. CO., INC. • 630 FIFTH AVENUE, NEW YORK 20, N. Y.

PHOTOGRAPHED BY **F. A. RUSSO**

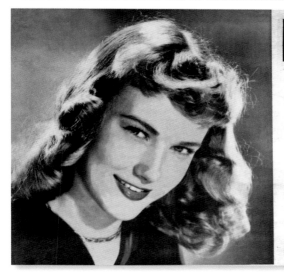

MEET MISS SUBWAYS

MAY 1948

Winsome
JOAN M. LYMAN

Private secretary in motion picture company. Studied Art at Hunter College and aspires to be top-notch fashion illustrator. Loves to bake and excels in chocolate layer cake.

John Robert Powers
247 PARK AVENUE

PUBLISHED BY NEW YORK SUBWAYS ADVTG. CO., INC. • 630 FIFTH AVENUE, NEW YORK 20, N. Y.

PHOTOGRAPHED BY **F. A. RUSSO**

MARIE McNALLY
February

THELMA PORTER
April

JOAN M. LYMAN
May

ALICE SMITH CARLSON
June

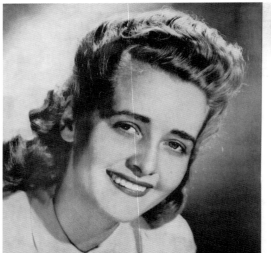

MEET MISS SUBWAYS

JUNE 1948

Charming
ALICE SMITH CARLSON

Brooklyn housewife who loves domesticity —sews and enjoys testing new recipes. Is fond of playing golf and traveling with husband. Ambition is to have her own home in the country.

247 PARK AVENUE
PUBLISHED BY NEW YORK SUBWAYS ADVTG. CO., INC. • 630 FIFTH AVENUE, NEW YORK 20, N. Y.

PHOTOGRAPHED BY **F. A. RUSSO**

FRANCES GALLIC
July

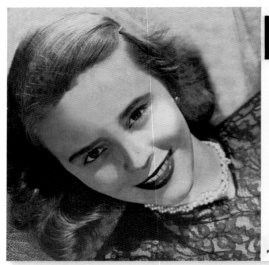

MEET MISS SUBWAYS

JULY 1948

Beauteous
FRANCES GALLIC

Attends Fordham University and was last year's Queen of Senior Ball. Is working way through college as receptionist. Now majoring in Speech and aspires to be television actress.

247 PARK AVENUE
PUBLISHED BY NEW YORK SUBWAYS ADVTG. CO., INC. • 630 FIFTH AVENUE, NEW YORK 20, N. Y.

PHOTOGRAPHED BY **F. A. RUSSO**

DOLORES A. BEAVER
August

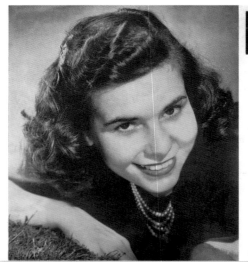

MEET MISS SUBWAYS

AUGUST 1948

Winning
DOLORES A. BEAVER

Enthusiastic about her position at a public utility company. Was cheer leader in Astoria, L. I. High School. Worked on farm, post-war, in Farm Cadet Corps. Aspires to be airline stewardess.

247 PARK AVENUE
PUBLISHED BY NEW YORK SUBWAYS ADVTG. CO., INC. • 630 FIFTH AVENUE, NEW YORK 20, N. Y.

PHOTOGRAPHED BY **F. A. RUSSO**

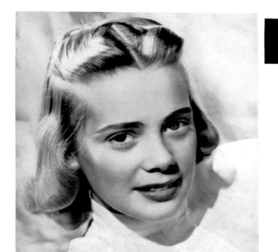

MEET MISS SUBWAYS

SEPTEMBER 1948

Flaxen-haired
ROSEMARY WILSON

Ad agency receptionist but aspires to become fashion copywriter. Serious about her ex-Marine beau who is also her swimming and diving instructor. Ultimate ambition—happy marriage and home in California.

John Robert Powers
247 PARK AVENUE

PUBLISHED BY NEW YORK SUBWAYS ADVTG. CO., INC. • 630 FIFTH AVENUE, NEW YORK 20, N. Y.

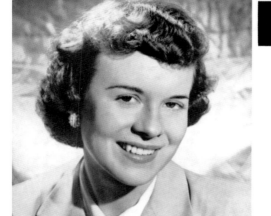

MEET MISS SUBWAYS

OCTOBER 1948

Captivating
MARILYN BELL

Secretary to credit manager of nationally known textile manufacturers. Recently selected as typical career girl by leading N.Y. newspaper. Is rabid baseball fan — best beau pitches for Boston Red Sox Club.

John Robert Powers
247 PARK AVENUE

PUBLISHED BY NEW YORK SUBWAYS ADVTG. CO., INC. • 630 FIFTH AVENUE, NEW YORK 20, N. Y.

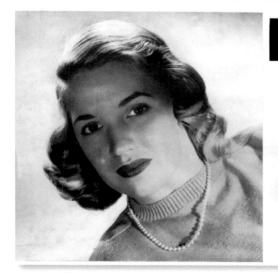

MEET MISS SUBWAYS

NOVEMBER 1948

Radiant
JANET BARKER

Started as a member of Little Theatre group in home state of Florida. Now drama student and television amateur. Enthusiastic golfer and proud possessor of an "A" pin from her West Point Cadet.

John Robert Powers
247 PARK AVENUE

PUBLISHED BY NEW YORK SUBWAYS ADVTG. CO., INC. • 630 FIFTH AVENUE, NEW YORK 20, N. Y.

PHOTOGRAPHED BY **F. A. RUSSO**

ROSEMARY WILSON
September

MARILYN BELL
October

JANET BARKER
November

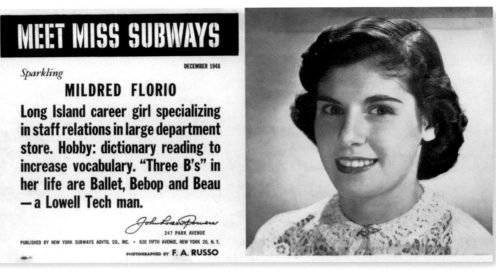

Not shown:
JEANNE-MARIE BAUMER March

1949

ELAINE LEVINE
September

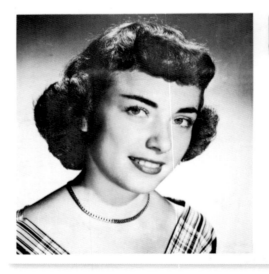

MEET MISS SUBWAYS

OCTOBER 1949

Charming

HARRIET YOUNG

Secretary at Adelphi College. A student of Music, she likes everything from Beethoven to Bebop. Ambition: to own a new car and see America!

John Robert Powers
247 PARK AVENUE
PUBLISHED BY NEW YORK SUBWAYS ADVTG. CO., INC. • 630 FIFTH AVENUE, NEW YORK 20, N. Y.
PHOTOGRAPHED BY **F. A. RUSSO**

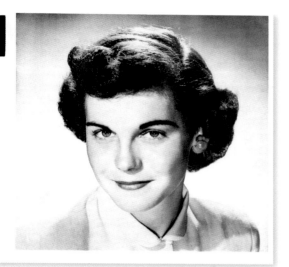

MEET MISS SUBWAYS

NOVEMBER 1949

Exotic

HELEN LEE

At Columbia she majored in Chinese. Now she's studying voice—training her mezzo-soprano—hopes for a musical comedy career. Favorite pastime: Interior decorating (modern)—and football games (escorted by Yale beau).

John Robert Powers
247 PARK AVENUE
PUBLISHED BY NEW YORK SUBWAYS ADVTG. CO., INC. • 630 FIFTH AVENUE, NEW YORK 20, N. Y.
PHOTOGRAPHED BY **F. A. RUSSO**

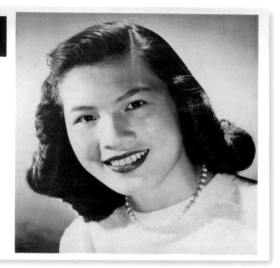

MEET MISS SUBWAYS

DECEMBER 1949

Charming

JANET SHANLEY

Voted best looking girl in graduating class at Jamaica High School. Major interest: collecting landscapes and writing poetry! Was awarded medal for excellence in athletics. Ambition: modeling.

John Robert Powers
247 PARK AVENUE
PUBLISHED BY NEW YORK SUBWAYS ADVTG. CO., INC. • 630 FIFTH AVENUE, NEW YORK 20, N. Y.
PHOTOGRAPHED BY **F. A. RUSSO**

HARRIET YOUNG
October

HELEN LEE
November

JANET SHANLEY
December

1950

MIMI ROSS
January

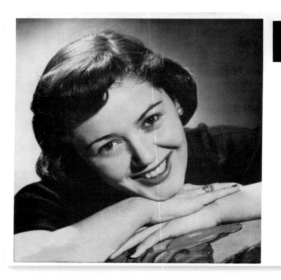

MEET MISS SUBWAYS

JANUARY 1950

Petite

MIMI ROSS

Member of prominent radio personality's staff. Attends 5 broadcasts plus 1 telecast per week. Loves job because it's so unpredictable. Favorite recreation: ice skating. Ambition: to travel.

John Robert Powers
247 PARK AVENUE

PUBLISHED BY NEW YORK SUBWAYS ADVTG. CO., INC. • 630 FIFTH AVENUE, NEW YORK 20, N. Y.
PHOTOGRAPHED BY **F. A. RUSSO**

SARALEE SINGER
February

Page 77

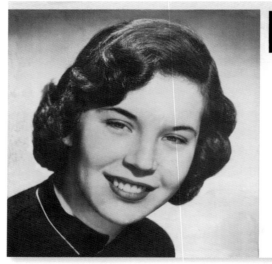

MEET MISS SUBWAYS

FEBRUARY 1950

Charming

SARALEE SINGER

Senior at Brooklyn College...preparing to teach elementary school. Recently married her childhood sweetheart. Both love sports: skiing in winter and sailing in summer.

John Robert Powers
247 PARK AVENUE

PUBLISHED BY NEW YORK SUBWAYS ADVTG. CO., INC. • 630 FIFTH AVENUE, NEW YORK 20, N. Y.
PHOTOGRAPHED BY **F. A. RUSSO**

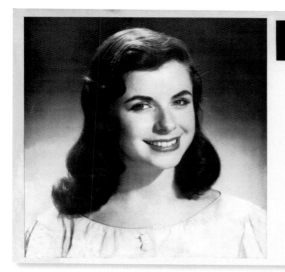

MEET MISS SUBWAYS

MAY 1950

Sweet 'n Lovely

PATTI FREEMAN

N.Y.U. Sophomore majoring in Dramatic Art—also student of oil painting. Wears pin of West Point Cadet...his Company voted her prettiest girlfriend. Ambition: success in both theatre and marriage.

John Robert Powers
247 PARK AVENUE

PUBLISHED BY NEW YORK SUBWAYS ADVTG. CO., INC. • 630 FIFTH AVENUE, NEW YORK 20, N. Y.
PHOTOGRAPHED BY **F. A. RUSSO**

MEET MISS SUBWAYS

JUNE 1950

Alluring

IRENE SCHEIDT

Receptionist at New York Stock Exchange. Favorite sport is tennis. Enjoys swimming. Attends "Garden" basketball games. Her fondest hope: a trip to Bermuda.

John Robert Powers
247 PARK AVENUE

PUBLISHED BY NEW YORK SUBWAYS ADVTG. CO., INC. • 630 FIFTH AVENUE, NEW YORK 20, N. Y.
PHOTOGRAPHED BY **F. A. RUSSO**

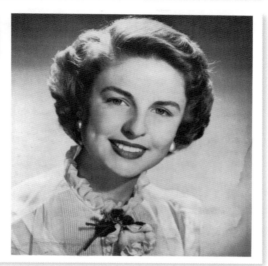

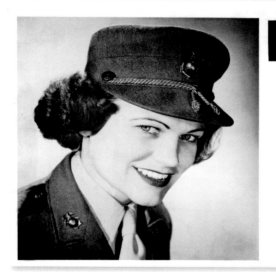

MEET MISS SUBWAYS

JULY 1950

Sparkling

ANNE PEREGRIM

Daughter of Pennsylvania coal miner—is now Recruiting Sergeant at Manhattan Marine Corps office. Enjoys serious music ...enthusiastic about air travel. Fondest hope: to become a commissioned officer.

John Robert Powers
247 PARK AVENUE

PUBLISHED BY NEW YORK SUBWAYS ADVTG. CO., INC. • 630 FIFTH AVENUE, NEW YORK 20, N. Y.
PHOTOGRAPHED BY **F. A. RUSSO**

JANET FERGUSON
August

PAT DE LIETO
October

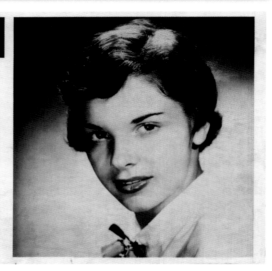

MEET MISS SUBWAYS

AUGUST 1950

Demure

JANET FERGUSON

Secretary to president of National Sales Executives association. Psychology major at Hunter . . . likes to make Swedish pancakes. Ambition: world travel before trading typewriter for kitchen apron.

John Robert Powers
247 PARK AVENUE

PUBLISHED BY NEW YORK SUBWAYS ADVTG. CO., INC. • 630 FIFTH AVENUE, NEW YORK 20, N.Y.

PHOTOGRAPHED BY **F. A. RUSSO**

MEET MISS SUBWAYS

OCTOBER 1950

Vivacious

PAT DE LIETO

Student of Ballet since childhood, Pat aspires to become a professional. Collects recordings of Tschaikowsky and Chopin. Likes traveling and is saving for a new convertible. Wears pin of Adelphi senior.

John Robert Powers
247 PARK AVENUE

PUBLISHED BY NEW YORK SUBWAYS ADVTG. CO., INC. • 630 FIFTH AVENUE, NEW YORK 20, N.Y.

PHOTOGRAPHED BY **F. A. RUSSO**

Not shown:
ANGELA NORRIS March *Page 83*
MARGIE MARRA April
SERYL BOTNICK September
BEVERLEY GERARD November
CATHERINE MONAHAN December

270

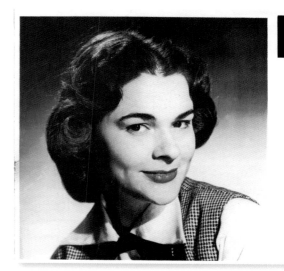

MEET MISS SUBWAYS

JANUARY 1951

Talented

FRANCES CARTON

Born in Cuba, Frances was honor graduate in art and radio dramatics at her Brooklyn High School. Hoped to be interior decorator but chose marriage. Enjoys doing oil portraits. Designs own clothes.

John Robert Powers
247 PARK AVENUE

PUBLISHED BY NEW YORK SUBWAYS ADVTG. CO., INC. • 630 FIFTH AVENUE, NEW YORK 20, N. Y.
PHOTOGRAPHED BY **F. A. RUSSO**

FRANCES CARTON
January

Page 101

MEET MISS SUBWAYS

FEBRUARY, 1951

Blonde

MARJORIE MILLER

Sells perfume in leading Brooklyn department store. Born in Newfoundland of a seafaring family, Marjorie yearns for a sea voyage. Favorite recreation – reading modern novels and detective stories.

John Robert Powers
247 PARK AVENUE

PUBLISHED BY NEW YORK SUBWAYS ADVTG. CO., INC. • 630 FIFTH AVENUE, NEW YORK 20, N. Y.
PHOTOGRAPHED BY **F. A. RUSSO**

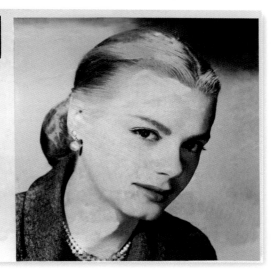

MARJORIE MILLER
February

MEET MISS SUBWAYS

MAY-JUNE 1951

Petite

PFC. PAULA RUSZKAI

Enlisted in Women's Army Corps in '49. Now stationed at Governor's Island. Hopes for orders requiring travel (if husband, a Corporal, goes too). Likes new blue-gray WAC uniforms. Loves her mother's graham cracker crust pies.

John Robert Powers
247 PARK AVENUE

PUBLISHED BY NEW YORK SUBWAYS ADVTG. CO., INC. • 630 FIFTH AVENUE, NEW YORK 20, N. Y.
PHOTOGRAPHED BY **F. A. RUSSO**

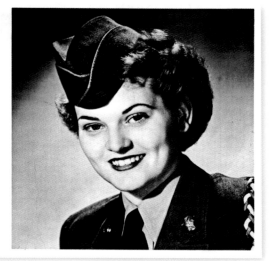

PAULA RUSZKAI
May–June

PERSIDE STEFANINI
July–August

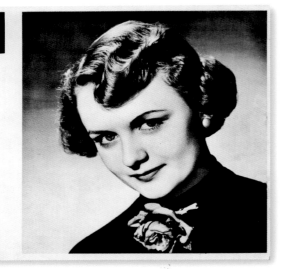

MEET MISS SUBWAYS

JULY–AUGUST 1951

Talented

PERSIDE STEFANINI

Graduate of H. S. of Industrial Art. At 21 conducts successful advertising design studio. Speaks Italian, French. Studied violin (11 yrs.), ballet, figure skating, oil painting. Recently visited relatives in Italy.

John Robert Powers
247 PARK AVENUE

PUBLISHED BY NEW YORK SUBWAYS ADVTG. CO., INC. • 630 FIFTH AVENUE, NEW YORK 20, N. Y.
PHOTOGRAPHED BY **F. A. RUSSO**

JEAN HAGEN
September–October

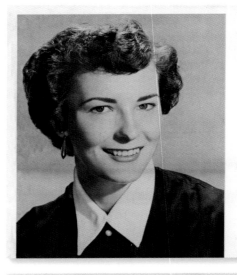

MEET MISS SUBWAYS

SEPT.-OCT. 1951

Brownette

JEAN HAGEN

Lives in Brooklyn but works in Manhattan for an oil company. She is a member of a popular amateur trio with good prospects of a professional singing career.

John Robert Powers
247 PARK AVENUE

PUBLISHED BY NEW YORK SUBWAYS ADVERTISING CO., • INC. 630 FIFTH AVENUE, NEW YORK 20, N. Y.

CONNIE KERMATH
November–December

MEET MISS SUBWAYS

NOV.-DEC. 1951

Golden Blonde

CONNIE KERMATH

Commutes daily, partly by subway, to Bergen Junior College. Favorite study: psychology. Hobby: landscape painting. But her consuming ambition is to be a dramatic actress on the legitimate stage.

John Robert Powers
247 PARK AVENUE

PUBLISHED BY NEW YORK SUBWAYS ADVERTISING CO., • INC. 630 FIFTH AVENUE, NEW YORK 20, N. Y.
Photographed by Michael Barbero of **F. A. RUSSO**

MEET MISS SUBWAYS

Fun-loving

JAN.-FEB. 1952

JANE CAMPUS

This brainy Bronx brunette, N.Y.U. honor graduate, is studying to be a dramatic actress. Loves Beethoven, reads music scores. All 'round athlete; has hiked, biked and choo-choo'd all over U.S.A. and Canada.

John Robert Powers
247 PARK AVENUE

PUBLISHED BY NEW YORK SUBWAYS ADVERTISING CO., INC. 630 FIFTH AVENUE, NEW YORK 20, N.Y.

Photographed by Michael Barbero of **F. A. RUSSO**

MEET MISS SUBWAYS

Blue-eyed

MARCH-APRIL 1952

PEGGY BYRNE

This petite Brooklyn-born colleen is studying to be an insurance broker. Plans to wed her childhood sweetheart, an Army Private. Her older brother is a Tank Destroyer Pfc. in Korea.

John Robert Powers
247 PARK AVENUE

PUBLISHED BY NEW YORK SUBWAYS ADVERTISING CO., • INC. 630 FIFTH AVENUE, NEW YORK 20, N.Y.

Photographed by Michael Barbero of **F. A. RUSSO**

MEET MISS SUBWAYS

Green-eyed

MAY-JUNE 1952

ANNE LANDOLT

This petite brunette is a secretary, living and working in Manhattan. A busy correspondent (in longhand), she writes daily to her fiancè, a Navy Airman 1st Class. Both saving for "a nice wedding" and home.

John Robert Powers
247 PARK AVENUE

PUBLISHED BY NEW YORK SUBWAYS ADVERTISING CO., • INC. 630 FIFTH AVENUE, NEW YORK 20, N.Y.

Photographed by Michael Barbero of **F. A. RUSSO**

JANE CAMPUS
January–February

PEGGY BYRNE
March–April

Page 113

ANNE LANDOLT
May–June

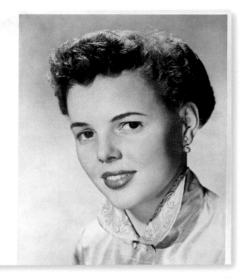

MEET MISS SUBWAYS

JULY-AUGUST 1952

Brown-eyed
JEAN THOMPSON

Jean, a Brooklyn girl and Dodger fan, works for an advertising agency. Says she is confirmed bargain hunter; shopping, her real hobby. Ambition: "To get married!" (He's working for a Master's degree at Columbia.)

John Robert Powers
247 PARK AVENUE

PUBLISHED BY NEW YORK SUBWAYS ADVERTISING CO., • INC. 630 FIFTH AVENUE, NEW YORK 20, N. Y

Photographed by Michael Barbero of **F. A. RUSSO**

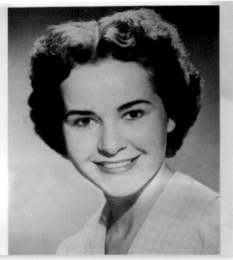

MEET MISS SUBWAYS

SEPTEMBER-OCTOBER 1952

Petite
VANITA BROWN

Beach-browned to match her hair and eyes, Vanita is a speech-and-dramatics graduate of U. of Nebraska, her home State. For past 2 years has been studying in New York for career as dramatic actress – her only ambition. Her heart belongs to no one.

John Robert Powers
247 PARK AVENUE

PUBLISHED BY NEW YORK SUBWAYS ADVERTISING CO., • INC. 630 FIFTH AVENUE, NEW YORK 20, N. Y.

MEET MISS SUBWAYS

NOVEMBER-DECEMBER 1952

Hazel-eyed
LUULE KULA

Luule, who escaped with her parents from her native Estonia, is a slender blonde with a refreshing personality – a 'lass with a delicate air'. Only 3 years in U. S., speaks English fluently and with an intriguing accent. Likes her job in downtown restaurant.

John Robert Powers
247 PARK AVENUE

PUBLISHED BY NEW YORK SUBWAYS ADVERTISING CO., • INC. 630 FIFTH AVENUE, NEW YORK 20, N. Y.

MEET MISS SUBWAYS

Soft spoken

JANUARY - FEBRUARY 1953

ANNE BURGESS

Born in New York, then lived most of childhood on grandparents' farm in North Carolina. Now Receptionist in busy Manhattan office. Swims, rides, makes most of her clothes. Active in her church's young people's society.

John Robert Powers
247 PARK AVENUE

PUBLISHED BY NEW YORK SUBWAYS ADVERTISING CO., • INC. 630 FIFTH AVENUE, NEW YORK 20, N. Y.

Photographed by **Michael Barbero** *of* **F. A. RUSSO**

MEET MISS SUBWAYS

Slender

MARCH - APRIL 1953

JANET MAGNI KULISAN

Native New Yorker, recently wed to World War II veteran—like herself, of Czech ancestry. Is active in their Sokol; avidly collects Czech recipes; owns 300 records. Has taught Sunday School 2 years.

John Robert Powers
247 PARK AVENUE

PUBLISHED BY NEW YORK SUBWAYS ADVERTISING CO., • INC. 630 FIFTH AVENUE, NEW YORK 20, N. Y.

Photographed by **Michael Barbero** *of* **F. A. RUSSO**

MEET MISS SUBWAYS

Sparkling

MAY-JUNE 1953

MARY GARDINER

Thank County Mayo parents for this Washington Heights beauty. An Aquinas graduate, she loves her secretarial job in airline office. Now 19; stands 5' 7½"; skates, swims, paints in oil.

John Robert Powers
247 PARK AVENUE

PUBLISHED BY NEW YORK SUBWAYS ADVERTISING CO., • INC. 630 FIFTH AVENUE, NEW YORK 20, N. Y.

ANNE BURGESS
January–February

JANET MAGNI KULISAN
March–April

MARY GARDINER
May–June

Page 119

MEET MISS SUBWAYS

JULY-AUGUST 1953

Petite
MARIE GRAHAM

This 5′ 1¼″ brunette (Size 9) is on sec-
retarial staff of a publisher of business
magazines. Lives in mid-Manhattan,
likes dancing, roller skating and other
active sports. Her great grandparents
came from Ireland.

John Robert Powers
247 PARK AVENUE

PUBLISHED BY NEW YORK SUBWAYS ADVERTISING CO., • INC. 630 FIFTH AVENUE, NEW YORK 20, N. Y.

Photographed by Michael Barbero of **F. A. RUSSO**

MEET MISS SUBWAYS

SEPTEMBER-OCTOBER 1953

Green-eyed
GWENN CLIFFORD

This busy secretary is a lyric soprano
and is studying, evenings, for a career
in opera. A slender brunette, 24 years
old, she draws, paints and sews skillfully,
plays the piano, and has a Bachelor of
Science degree.

John Robert Powers
247 PARK AVENUE

PUBLISHED BY NEW YORK SUBWAYS ADVERTISING CO., • INC. 630 FIFTH AVENUE, NEW YORK 20, N. Y.

Photographed by Michael Barbero of **F. A. RUSSO**

Page 125

MEET MISS SUBWAYS

NOVEMBER-DECEMBER 1953

Blue-eyed
KATHLEEN McLEAN

Kathleen, who is 19 and lives in The
Bronx, is studying to be a fashion de-
signer, and practices by designing and
making her own clothes. Played on her
parochial high school's basketball team,
and is a proficient ice skater.

John Robert Powers
247 PARK AVENUE

PUBLISHED BY NEW YORK SUBWAYS ADVERTISING CO., • INC. 630 FIFTH AVENUE, NEW YORK 20, N. Y.

Photographed by Michael Barbero of **F. A. RUSSO**

1954

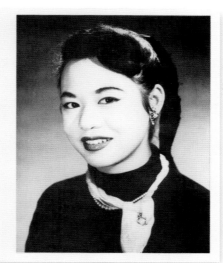

MEET MISS SUBWAYS

MAY-JUNE 1954

Petite

JULIETTE ROSE LEE

Born in Paris, spent childhood in Europe and China; in U.S. since 1947. Graduate of Julia Richman High School and Hunter College. Now a Physics technician at Columbia U. Ambitious to be a physicist.

John Robert Powers
247 PARK AVENUE

PUBLISHED BY NEW YORK SUBWAYS ADVERTISING CO., • INC. 630 FIFTH AVENUE, NEW YORK 20, N. Y.

Photographed by Michael Barbero of **F. A. RUSSO**

Not shown:
MARY ALICE GRAY January–February
ELEANOR WARD September–October

1955

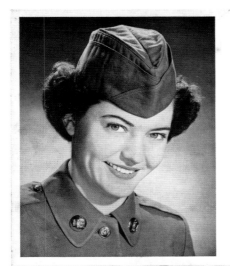

MEET MISS SUBWAYS

JANUARY-FEBRUARY 1955

Montana-born

PHYLLIS JOHNSON

This bright, smiling WAC Private writes press releases for the Public Information Office, Fort Jay, Governors Island. Phyllis wrote a novel when 15 years old. Sings, too —"mostly blues."

John Robert Powers
247 PARK AVENUE

PUBLISHED BY NEW YORK SUBWAYS ADVERTISING CO., INC. · 630 FIFTH AVENUE, NEW YORK 20, N. Y.

Photographed by Michael Barbero of **F. A. RUSSO**

RITA ROGERS
March–April 1955

MEET MISS SUBWAYS

Manhattan-born MARCH-APRIL 1955
RITA ROGERS

A sparkling, dark brunette, Rita was graduated cum laude last June from Notre Dame College of Staten Island. Works for a magazine. Likes fencing. Knits Argyll socks expertly.

John Robert Powers
247 PARK AVENUE

PUBLISHED BY NEW YORK SUBWAYS ADVERTISING CO., INC. · 630 FIFTH AVENUE, NEW YORK 20, N. Y.

Photographed by Michael Barbero of **F. A. RUSSO**

SUE RABINOWITZ
September–October

MEET MISS SUBWAYS

SPONSORED BY NEW YORK SUBWAYS ADVERTISING CO., INC. · 630 FIFTH AVENUE, NEW YORK 20, N. Y.

Sparkling SEPTEMBER-OCTOBER 1955
SUE RABINOWITZ

An Erasmus Hall graduate and editor of its Year Book, Sue is determined upon a college degree. Besides reading, likes singing, painting, swimming. Hopes to be a writer or an actress.

John Robert Powers
247 PARK AVENUE

Photographed by **Michael Barbero**

MARIE LEONARD
November–December

Page 129

MEET MISS SUBWAYS

SPONSORED BY NEW YORK SUBWAYS ADVERTISING CO., INC. · 630 FIFTH AVENUE, NEW YORK 20, N. Y.

"Freckles" NOVEMBER-DECEMBER 1955
MARIE LEONARD

This 5'7" brunette, who has intriguing green eyes, is a certified medical assistant and an X-ray technician. Likes bowling, dancing, reading and collecting jazz records.

John Robert Powers
247 PARK AVENUE

Photographed by **Michael Barbero**

Not shown:
ANGELO LEO May

1956

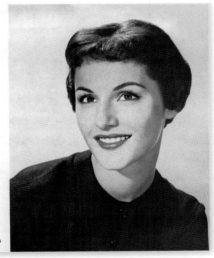

MEET MISS SUBWAYS

SPONSORED BY NEW YORK SUBWAYS ADVERTISING CO., INC. · 630 FIFTH AVENUE, NEW YORK 20, N.Y.

JANUARY-FEBRUARY 1956

Talented

LORETTA BOMBA

Now in the advertising department of a famous New York store, Loretta belongs to a Queens amateur dramatic group. She recently began formal study for a career as an actress.

John Robert Powers
247 PARK AVENUE
Photographed by Michael Barbero

LORETTA BOMBA
January–February

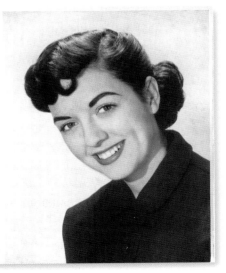

MEET MISS SUBWAYS

SPONSORED BY NEW YORK SUBWAYS ADVERTISING CO., INC. · 630 FIFTH AVENUE, NEW YORK 20, N.Y.

MARCH-APRIL 1956

Slender

KATHLEEN WALSHE

Kathy is employed by a Madison Avenue advertising agency. Her main hobby is horseback riding—chiefly around Lake George where she spends many weekends. Ambition: "to marry and raise a family."

John Robert Powers
247 PARK AVENUE
Photographed by Michael Barbero

KATHLEEN WALSHE
March–April

LOIS KEAN
May–June

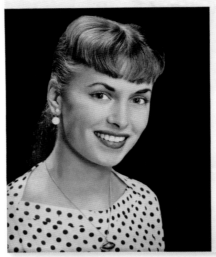

NANCY SERIS
July–August

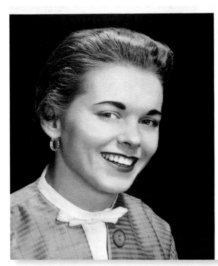

1957

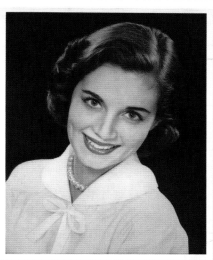

MEET MISS SUBWAYS

SPONSORED BY NEW YORK SUBWAYS ADVERTISING CO., INC. · 630 FIFTH AVENUE, NEW YORK 20, N. Y.

JANUARY–FEBRUARY 1957

MARIE CRITTENDEN

Golden blond, blue-eyed coloratura soprano. Former school teacher...now after years of voice-drama training is ready for concert or musical comedy. Also sings "pop."

John Robert Powers
247 PARK AVENUE
Photographed by Michael Barbero

MEET MISS SUBWAYS

SPONSORED BY NEW YORK SUBWAYS ADVERTISING CO., INC. · 630 FIFTH AVENUE, NEW YORK 20, N. Y.

MARCH–APRIL 1957

MADELEINE SEELIG

Married, mother of 2 young children. Traveled extensively — speaks 4 languages. Works in midtown airline office as bi-lingual secretary. Interested in TV model career.

John Robert Powers
247 PARK AVENUE
Photographed by Michael Barbero

MARIE CRITTENDEN
January–February

Page 133

MADELEINE SEELIG
March–April

1958

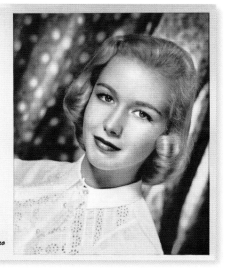

MEET MISS SUBWAYS

SPONSORED BY NEW YORK SUBWAYS ADVERTISING CO., INC. · 630 FIFTH AVENUE, NEW YORK 20, N. Y.

JANUARY–FEBRUARY 1958

NANCY DENISON

If you want to become a model, Nancy's ambition, the camera has to like you. It can be a one-eyed villain, or your best friend. It's obvious Nancy and the camera are the best of friends.

John Robert Powers
Photographed by Michael Barbero

NANCY DENISON
January–February

Page 139

MEET MISS SUBWAYS

SPONSORED BY NEW YORK SUBWAYS ADVERTISING CO., INC. · 630 FIFTH AVENUE, NEW YORK 20, N. Y.

MARCH-APRIL 1958

ELEANOR GALANIS

How many teen-aged mothers—2 children—do you know who photograph this well? Her husband and friends have urged her to become a model. Excellent advice.

John Robert Powers

Photographed by Michael Barbero

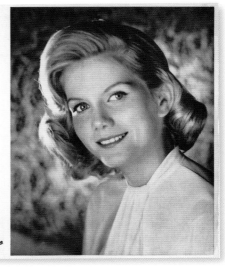

MEET MISS SUBWAYS

SPONSORED BY NEW YORK SUBWAYS ADVERTISING CO., INC. · 630 FIFTH AVENUE, NEW YORK 20, N. Y.

MAY-JUNE 1958

LYNNE GALVIN

Fire baton twirling, Lynne's hobby, demands ability, determination PLUS confidence. When you want to become a model, these personal characteristics are assets. It also helps to have won 14 beauty contests.

John Robert Powers

Photographed by Michael Barbero

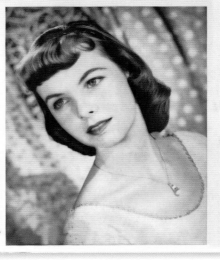

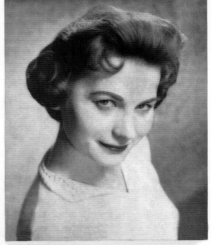

MEET MISS SUBWAYS

SPONSORED BY NEW YORK SUBWAYS ADVERTISING CO., INC. · 630 FIFTH AVENUE, NEW YORK 20, N. Y.

JULY-AUGUST 1958

JEAN ORLOWSKI

Beauty, self-assurance and brains should make Jean a successful tax accountant and lawyer. A senior at Long Island University—Jean's plans also include marriage along with her career.

John Robert Powers

Photographed by Michael Barbero

MEET MISS SUBWAYS

SPONSORED BY NEW YORK SUBWAYS ADVERTISING CO., INC. • 630 FIFTH AVENUE, NEW YORK 20, N.Y.

SEPTEMBER-OCTOBER 1958

THE KEELER TWINS

Kathryn and Mary are as identical as two cigarettes in a pack. Yet, in the twin's case, a cigarette would be the quickest means of identification–Mary smokes, Kathryn doesn't. Girls want to become models. Twins, anyone?

John Robert Powers

Photographed by Michael Barbero

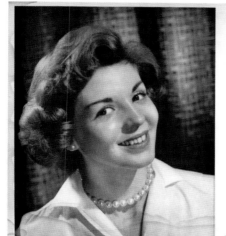

MEET MISS SUBWAYS

SPONSORED BY NEW YORK SUBWAYS ADVERTISING CO., INC. • 630 FIFTH AVENUE, NEW YORK 20, N.Y.

NOVEMBER-DECEMBER 1958

JOSEPHINE MILICI

"Jo" comes from a large family—10 children. Her long-range plans include marriage and a large family of her own—12 children. However, domesticity will wait while "Jo" pursues her immediate goal—modelling.

John Robert Powers

Photographed by Michael Barbero

1959

MEET MISS SUBWAYS

SPONSORED BY NEW YORK SUBWAYS ADVERTISING CO., INC. • 630 FIFTH AVENUE, NEW YORK 20, N.Y.

JANUARY-FEBRUARY 1959

ADRIENNE MARIE CELLA

Voted Miss Fordham of 1956 while in college. Employed as legal secretary, stenographer. Sports enthusiast as well as art lover. Hobbies, painting and ceramics. Future plans—marriage and family.

John Robert Powers

Photographed by Michael Barbero

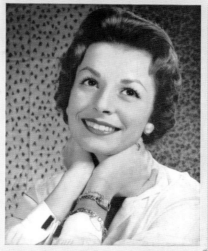

MEET MISS SUBWAYS

SPONSORED BY NEW YORK SUBWAYS ADVERTISING CO., INC. · 630 FIFTH AVENUE, NEW YORK 20, N.Y.

MARCH–APRIL 1959

ELLEN HART

Ellen has appeared in school plays and plans to pursue an acting career after graduation from High School in June. Most of her spare time is devoted to acting, singing and speech lessons.

John Robert Powers

Photographed by Michael Barbero

MEET MISS SUBWAYS

SPONSORED BY NEW YORK SUBWAYS ADVERTISING CO., INC. · 630 FIFTH AVENUE, NEW YORK 20, N.Y.

MAY–JUNE 1959

FOUR MISS SUBWAYS

When the contest narrows down to these four lovely young ladies…it's almost impossible to decide on one winner.

Top—Left to Right: Sheila Stein and Joyce Griffin
Bottom—Left to Right: Sally Salve and Gail Burke

John Robert Powers

Photographed by Michael Barbero

MEET MISS SUBWAYS

SPONSORED BY NEW YORK SUBWAYS ADVERTISING CO., INC. · 630 FIFTH AVENUE, NEW YORK 20, N.Y.

JULY–AUGUST 1959

HELEN STEINACHER

Helen is married and has a young son, Steven. Now employed as an executive secretary, Helen would like to become a model.

John Robert Powers

Photographed by Michael Barbero

MEET MISS SUBWAYS

SPONSORED BY NEW YORK SUBWAYS ADVERTISING CO., INC. · 630 FIFTH AVENUE, NEW YORK 20, N. Y.

JANUARY-FEBRUARY 1960

DEANNE GOLDMAN

Deanne's five-year old kindergarten pupils consider her the most beautiful, talented, funny and intelligent girl they have ever come across. "Out of the mouth of babes..."

John Robert Powers

Photographed by Michael Barbero

MEET MISS SUBWAYS

SPONSORED BY NEW YORK SUBWAYS ADVERTISING CO., INC. · 630 FIFTH AVENUE, NEW YORK 20, N. Y.

MARCH-APRIL 1960

PEGGY KELLY

How to Take a Good Photograph!

It's easy. Place a stunning blue-eyed redhead in front of the camera. Click —and that's it. (Serious shutter-bugs, naturally, will insist on color with red-heads like Peggy.)

John Robert Powers

Photographed by Michael Barbero

MEET MISS SUBWAYS

SPONSORED BY NEW YORK SUBWAYS ADVERTISING CO., INC. · 630 FIFTH AVENUE, NEW YORK 20, N. Y.

MAY-JUNE 1960

SHIRLEY MARTIN

Before marriage, Shirley jetstreamed coast-to-coast as an airline hostess. Her new ambition—modeling. Anyone who is this photogenic should have no difficulty.

John Robert Powers

Photographed by Michael Barbero

DEANNE GOLDMAN
January–February

Page 165

PEGGY KELLY
March–April

SHIRLEY MARTIN
May–June

Page 169

MEET MISS SUBWAYS

SPONSORED BY NEW YORK SUBWAYS ADVERTISING CO., INC. · 630 FIFTH AVENUE, NEW YORK 20, N. Y.

JULY-AUGUST 1960

BARBARA BUTLER

The return of the native—after the peripatetic life of an "Army Brat." Barbara is an editorial assistant with a leading national magazine. Her husband, whom she met at college, also works for a top magazine.

John Robert Powers

Photographed by Michael Barbero

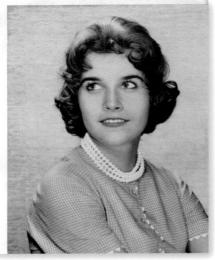

MEET MISS SUBWAYS

SPONSORED BY NEW YORK SUBWAYS ADVERTISING CO., INC. · 630 FIFTH AVENUE, NEW YORK 20, N. Y.

SEPTEMBER-OCTOBER 1960

ELIZABETH STERN

Elizabeth was born in Warsaw, Poland —1939. She was reborn at Idlewild Airport on Nov. 15, 1959. A 20 year search by her father had ended. Painful memories of the Ghetto, a war and a long separation would fade. For now, Elizabeth has a father.

Photographed by Michael Barbero

Page 173

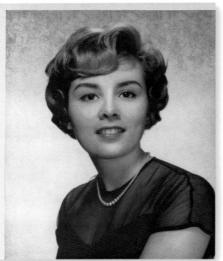

MEET MISS SUBWAYS

SPONSORED BY NEW YORK SUBWAYS ADVERTISING CO., INC. · 630 FIFTH AVENUE, NEW YORK 20, N. Y.

NOVEMBER-DECEMBER 1960

ELEANOR NASH

Young, beautiful and an expert with a rifle. A clerical employee in the FBI, Eleanor joined the Pistol Club and consistently scores in the 90's. Other interests—theatre, art and traveling.

Photographed by Michael Barbero

MEET MISS SUBWAYS

SPONSORED BY NEW YORK SUBWAYS ADVERTISING CO., INC. • 630 FIFTH AVENUE, NEW YORK 20, N. Y.

JANUARY–FEBRUARY 1961

DOLORES MITCHELL

Outdoor activities such as swimming, riding and waterskiing are Dolores' special interests. Another interest— modeling. Any agency looking for the "outdoor" type?

Photographed by Michael Barbero

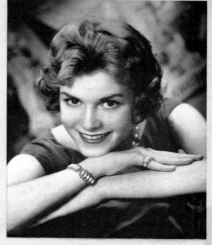

MEET MISS SUBWAYS

SPONSORED BY NEW YORK SUBWAYS ADVERTISING CO., INC. • 630 FIFTH AVENUE, NEW YORK 20, N. Y.

MARCH-APRIL 1961

JOAN RAFTERY

Joan, oldest of five colleens, is employed as a secretary by a steamship line on New York's waterfront. Her hobbies are collecting modern jazz records and miniature dolls from all over the world.

Photographed by Michael Barbero

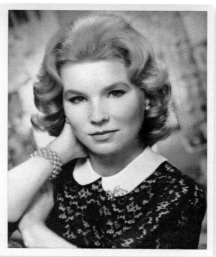

MEET MISS SUBWAYS

SPONSORED BY NEW YORK SUBWAYS ADVERTISING CO., INC. • 630 FIFTH AVENUE, NEW YORK 20, N. Y.

MAY-JUNE 1961

JUDIE SHAKTMAN

Judie, a Chicagoan by birth, visited her relatives in New York…and stayed to marry the boy next door. Ah, if only all you "boy next door" bachelors could be so fortunate!

Photographed by Michael Barbero

DOLORES MITCHELL
January–February

Page 179

JOAN RAFERTY
March–April

JUDIE SHAKTMAN
May–June

KATHY PREGENZER
July–August

MEET MISS SUBWAYS

SPONSORED BY NEW YORK SUBWAYS ADVERTISING CO., INC. · 630 FIFTH AVENUE, NEW YORK 20, N. Y.

JULY-AUGUST 1961

KATHY PREGENZER

Mike Barbero, the Miss Subways Photographer, takes about eight shots of our Miss Subways. This twenty year old beauty is so photogenic it was difficult to select the one best picture.

Photographed by Michael Barbero

VERNELL DENNIS
September–October

MEET MISS SUBWAYS

SPONSORED BY NEW YORK SUBWAYS ADVERTISING CO., INC. · 630 FIFTH AVENUE, NEW YORK 20, N. Y.

SEPT.-OCT. 1961

VERNELL DENNIS

Vernell, a native New Yorker, works in Manhattan as a bookkeeper. Her interests are varied—singing, sketching, designing, theatre. Her ambition—to model.

Photographed by Michael Barbero

STELLA DEERE
November–December

MEET MISS SUBWAYS

SPONSORED BY NEW YORK SUBWAYS ADVERTISING CO., INC. · 630 FIFTH AVENUE, NEW YORK 20, N. Y.

NOV.-DEC. 1961

STELLA DEERE

If cameras are a models best friend, Stella should quickly gain her modelling goal. It's obvious the camera fell in love at first click.

Photographed by Michael Barbero

MEET MISS SUBWAYS

SPONSORED BY NEW YORK SUBWAYS ADVERTISING CO., INC. · 630 FIFTH AVENUE, NEW YORK 20, N. Y.

JANUARY-FEBRUARY 1962

EVELYN TASCH

Evelyn is a native of Brooklyn. She commutes daily, on the subway, to her job as a research librarian.

Photographed by **Michael Barbero**

EVELYN TASCH
January–February

Page 183

MEET MISS SUBWAYS

SPONSORED BY NEW YORK SUBWAYS ADVERTISING CO., INC. · 630 FIFTH AVENUE, NEW YORK 20, N. Y.

MARCH-APRIL 1962

DOROTHY CALLAGHAN

Dorothy, a medical secretary, is an avid traveler. Last summer she was in Europe. The summer before, Hawaii. This year another distant part of the world will be rewarded by her presence.

Photographed by **Michael Barbero**

DOROTHY CALLAGHAN
March–April

MEET MISS SUBWAYS

SPONSORED BY NEW YORK SUBWAYS ADVERTISING CO., INC. · 630 FIFTH AVENUE, NEW YORK 20, N. Y.

MAY-JUNE 1962

SUE COLLINS

Talent, beauty and tenacity are the major weapons in the neophyte's siege on the seemingly impregnable world of Broadway. Now—Sue needs a little bit of luck...

Photographed by **Michael Barbero**

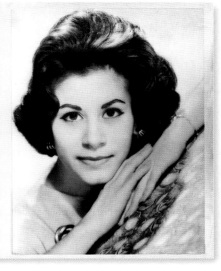

SUE COLLINS
May–June

MEET MISS SUBWAYS

SPONSORED BY NEW YORK SUBWAYS ADVERTISING CO., INC. · 630 FIFTH AVENUE, NEW YORK 20, N. Y.

SALLY PISHNEY

Airline stewardess Sally really jets around: Los Angeles, Chicago, New Orleans . . even to Europe . . . but she still thinks New York City is tops. A college drama major, she'd like to do TV commercials.

Photographed by **Michael Barbero**

1963

BARBARA SHEEHAN
July–August

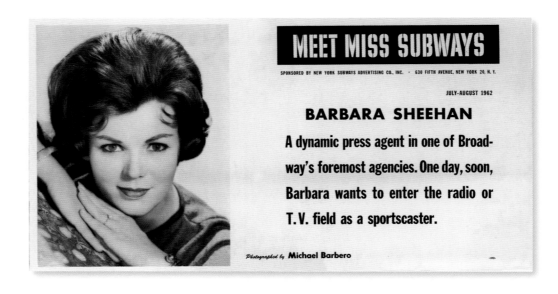

MEET MISS SUBWAYS

SPONSORED BY NEW YORK SUBWAYS ADVERTISING CO., INC. · 630 FIFTH AVENUE, NEW YORK 20, N. Y.

JULY-AUGUST 1962

BARBARA SHEEHAN

A dynamic press agent in one of Broadway's foremost agencies. One day, soon, Barbara wants to enter the radio or T.V. field as a sportscaster.

Photographed by **Michael Barbero**

Meet "MISS SUBWAYS"

CAROLE NEALON

Winsome is the word for Carole . . . a secretary at the Home Insurance Company of New York.

She is interested in interior decorating, particularly with an oriental theme. Carole collects Chinese vases and statues . . . and has about 300 musical records (favorite: Frank Sinatra).

*service mark of NEW YORK SUBWAYS ADVERTISING CO. INC. 630 Fifth Avenue, New York 20
An O'Ryan & Batchelder Operation

1964

Not shown:
SANORA SELSEY January–March *Page* 193
SANDRA HARRIS BRUNO September
ARLENE SCHULMAN

1965

Meet "MISS SUBWAYS"

ANN NAPOLITANO

Petite Ann, first winner of the public postcard vote, is a secretary at Doyle·Dane·Bernbach·Inc., an advertising agency.

She enjoys tennis and bicycling . . . and devotes time each week as a recreation volunteer at Bellevue Hospital.

*service mark of NEW YORK SUBWAYS ADVERTISING CO. INC. 630 Fifth Avenue, New York 20
An O'Ryan & Batchelder Operation

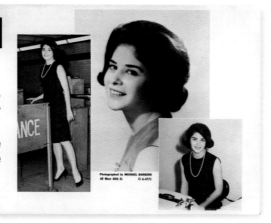

Meet "MISS SUBWAYS"

DIANA WALLACH

Blonde, green-eyed, smiling Diana is . . . radiant.

She subways weekdays to her job as secretary with the McGregor Sportswear people. But on weekends, guess where this Bronx beauty usually is? At Peekskill, riding horses. Diana is an accomplished equestrienne and even owned her own horse until recently. She also likes dancing. And reading (favorite author: Taylor Caldwell).

Diana would like to do TV commercials . . . then eventually marry and have a family near New York so that she can enjoy the City's liveliness and . . . raise horses.

* "MISS SUBWAYS" is a service mark of NEW YORK SUBWAYS ADVERTISING CO. INC.
An O'Ryan & Batchelder Operation

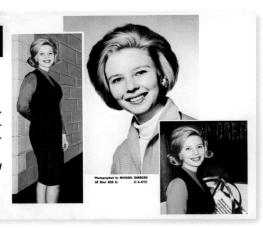

Meet *MISS SUBWAYS Rosalind Cinclini

Those who voted Rosalind a winner will be pleased to know you helped her realize a long-held ambition. Contest publicity propelled her from a typist into a full-time professional career. She is now a photographic magazine model; intends to specialize in junior fashions.

Rosalind is 22 years young, 5'5" and has brown hair and brown eyes. She majored in speech at CCNY. Likes the theatre, playing piano (popular tunes) and ice-skating.

* NEW YORK SUBWAYS ADVERTISING CO., INC. an O'RYAN & BATCHELDER Operation

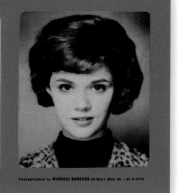

Meet *MISS SUBWAYS Judy Marshall

You couldn't meet a sweeter 'greeter' than Judy—whether at her main job as a receptionist at Kraft Foods—or her avocation as a hostess at Shea Stadium's Diamond Club. Working at Shea has made pert Judy an avid Met/Jet fan and enabled her to meet many famous and interesting people.

Judy hopes to satisfy her keen yearning to travel in the near future. And she has ambitions toward a career in public relations.

* NEW YORK SUBWAYS ADVERTISING CO., INC. An O'RYAN & BATCHELDER Operation

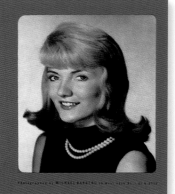

Not shown:
DIANA DAVIS
JUDY LEWIS

1966

Not shown:
JUDY RYAN August
CAROL PRICE

1967

Meet *Miss Subways* Donna De Marta

Her cousin entered Donna's name in the contest with a letter saying, among other nice things: "Donna is dependable, sincere and has a vivacious personality. One of her favorite pastimes is cooking. She loves it and can cook a meal, in my opinion, fit for a king. Her specialty, of course, is Italian food." (We're afraid Donna's not going to be single for long after this gets around).

Donna's a receptionist-secretary at American Bulk Carriers, Inc. She has ambitions to model or become an airline stewardess.

NEW YORK SUBWAYS ADVERTISING CO., INC.

Photographed by MICHAEL BARBERO 48 West 48th St. · CI 5-4775

Meet *Miss Subways* Eileen Kent

Would you believe blondes have more fun? This one does...making the most of Fun City's myriad happenings: attending the theater, art galleries and enjoying musical events (Eileen's great grandfather was a composer).

When not busy putting people 'in the driver's seat' at Hertz Rent-A-Car, Eileen likes to read...bowl...or to spend a weekend skiing. She's traveled to the ends of the US and to Bermuda and Mexico. Eileen's goal: photographic modeling.

NEW YORK SUBWAYS ADVERTISING CO., INC.

Photographed by MICHAEL BARBERO 48 West 48th St. · CI 5-4775

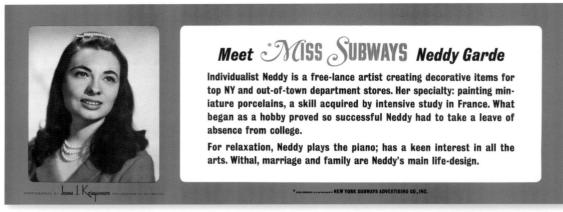

Meet *MISS SUBWAYS* Neddy Garde

Individualist Neddy is a free-lance artist creating decorative items for top NY and out-of-town department stores. Her specialty: painting miniature porcelains, a skill acquired by intensive study in France. What began as a hobby proved so successful Neddy had to take a leave of absence from college.

For relaxation, Neddy plays the piano; has a keen interest in all the arts. Withal, marriage and family are Neddy's main life-design.

NEW YORK SUBWAYS ADVERTISING CO., INC.

WYNONA BLACKMAN
January–June

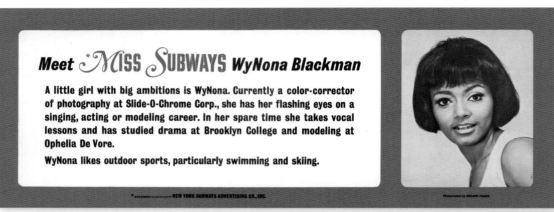

Meet *MISS SUBWAYS* WyNona Blackman

A little girl with big ambitions is WyNona. Currently a color-corrector of photography at Slide-O-Chrome Corp., she has her flashing eyes on a singing, acting or modeling career. In her spare time she takes vocal lessons and has studied drama at Brooklyn College and modeling at Ophelia De Vore.

WyNona likes outdoor sports, particularly swimming and skiing.

NEW YORK SUBWAYS ADVERTISING CO., INC.

Not shown:
BARBARA PEER

1968

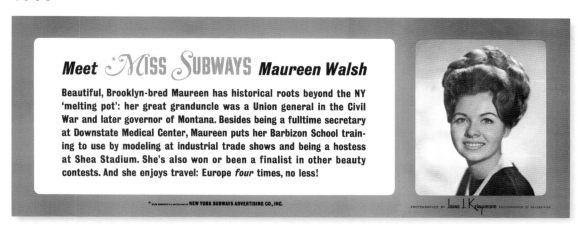

MAUREEN WALSH
February–August

Page 217

Meet *Miss Subways* Maureen Walsh

Beautiful, Brooklyn-bred Maureen has historical roots beyond the NY 'melting pot': her great granduncle was a Union general in the Civil War and later governor of Montana. Besides being a fulltime secretary at Downstate Medical Center, Maureen puts her Barbizon School training to use by modeling at industrial trade shows and being a hostess at Shea Stadium. She's also won or been a finalist in other beauty contests. And she enjoys travel: Europe *four* times, no less!

1969

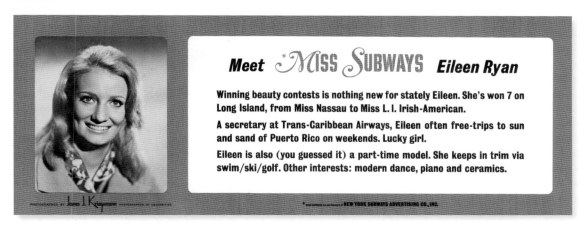

EILEEN RYAN
July–August

Page 223

Meet *Miss Subways* Eileen Ryan

Winning beauty contests is nothing new for stately Eileen. She's won 7 on Long Island, from Miss Nassau to Miss L. I. Irish-American.

A secretary at Trans-Caribbean Airways, Eileen often free-trips to sun and sand of Puerto Rico on weekends. Lucky girl.

Eileen is also (you guessed it) a part-time model. She keeps in trim via swim/ski/golf. Other interests: modern dance, piano and ceramics.

1970

Not shown:
EDNA DOORISH GENGO

1971

LINDA HEILBRONN
December

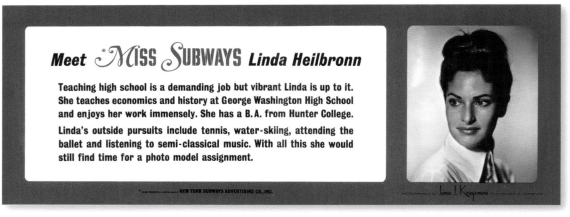

Meet Miss Subways Linda Heilbronn

Teaching high school is a demanding job but vibrant Linda is up to it. She teaches economics and history at George Washington High School and enjoys her work immensely. She has a B.A. from Hunter College.

Linda's outside pursuits include tennis, water-skiing, attending the ballet and listening to semi-classical music. With all this she would still find time for a photo model assignment.

NEW YORK SUBWAYS ADVERTISING CO., INC.

PATRICIA SCHILLING

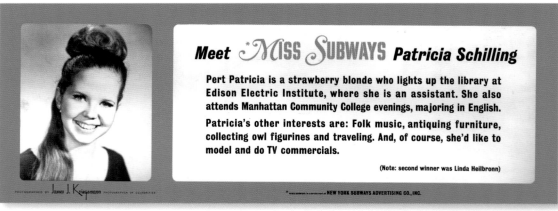

Meet Miss Subways Patricia Schilling

Pert Patricia is a strawberry blonde who lights up the library at Edison Electric Institute, where she is an assistant. She also attends Manhattan Community College evenings, majoring in English.

Patricia's other interests are: Folk music, antiquing furniture, collecting owl figurines and traveling. And, of course, she'd like to model and do TV commercials.

(Note: second winner was Linda Heilbronn)

NEW YORK SUBWAYS ADVERTISING CO., INC.

1972

JUDITH BURGESS
November

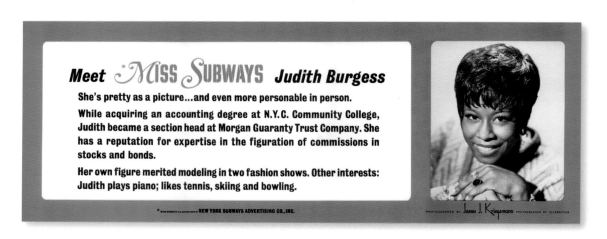

Meet Miss Subways Judith Burgess

She's pretty as a picture...and even more personable in person.

While acquiring an accounting degree at N.Y.C. Community College, Judith became a section head at Morgan Guaranty Trust Company. She has a reputation for expertise in the figuration of commissions in stocks and bonds.

Her own figure merited modeling in two fashion shows. Other interests: Judith plays piano; likes tennis, skiing and bowling.

NEW YORK SUBWAYS ADVERTISING CO., INC.

1973

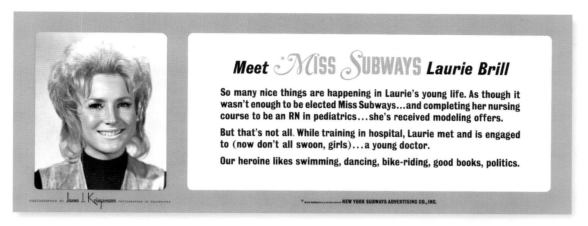

Meet *MISS SUBWAYS Laurie Brill*

So many nice things are happening in Laurie's young life. As though it wasn't enough to be elected Miss Subways...and completing her nursing course to be an RN in pediatrics...she's received modeling offers.

But that's not all. While training in hospital, Laurie met and is engaged to (now don't all swoon, girls)...a young doctor.

Our heroine likes swimming, dancing, bike-riding, good books, politics.

PHOTOGRAPHED BY James J. Kriegsmann PHOTOGRAPHER OF CELEBRITIES

*MISS SUBWAYS is a service mark of NEW YORK SUBWAYS ADVERTISING CO., INC.

Not shown:
CAROL BROWN
LINDA LANNA

1974

Page 227

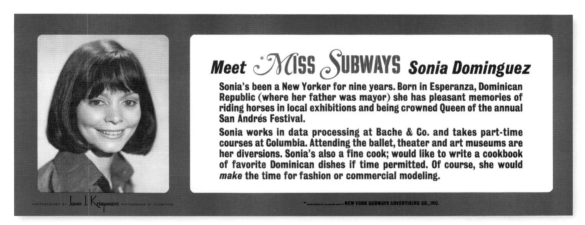

Meet *MISS SUBWAYS Sonia Dominguez*

Sonia's been a New Yorker for nine years. Born in Esperanza, Dominican Republic (where her father was mayor) she has pleasant memories of riding horses in local exhibitions and being crowned Queen of the annual San Andrés Festival.

Sonia works in data processing at Bache & Co. and takes part-time courses at Columbia. Attending the ballet, theater and art museums are her diversions. Sonia's also a fine cook; would like to write a cookbook of favorite Dominican dishes if time permitted. Of course, she would *make* the time for fashion or commercial modeling.

PHOTOGRAPHED BY James J. Kriegsmann PHOTOGRAPHER OF CELEBRITIES

*MISS SUBWAYS is a service mark of NEW YORK SUBWAYS ADVERTISING CO., INC.

1975

MARCIA KILPATRICK
November 1974–
April 1975

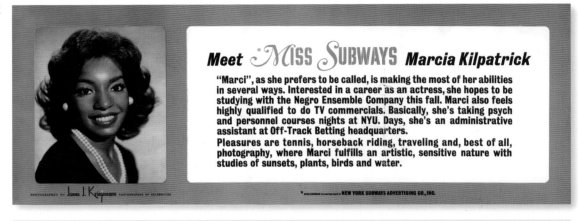

Meet *Miss Subways* **Marcia Kilpatrick**

"Marci", as she prefers to be called, is making the most of her abilities in several ways. Interested in a career as an actress, she hopes to be studying with the Negro Ensemble Company this fall. Marci also feels highly qualified to do TV commercials. Basically, she's taking psych and personnel courses nights at NYU. Days, she's an administrative assistant at Off-Track Betting headquarters.

Pleasures are tennis, horseback riding, traveling and, best of all, photography, where Marci fulfills an artistic, sensitive nature with studies of sunsets, plants, birds and water.

PHOTOGRAPHED BY James J. Kriegsmann PHOTOGRAPHER OF CELEBRITIES

*MISS SUBWAYS is a service mark of NEW YORK SUBWAYS ADVERTISING CO., INC.

AYANA LAWSON
May–October

Meet *Miss Subways* **Ayana Lawson**

Ayana's a budding young actress. She's devoted a lot of time to training in drama technique, voice, dance and modeling. Thus far, she's had roles in four off-Broadway plays and in two movies.

To support herself fulltime, Ayana works as head teller at a branch of National Bank of North America. This fall, she plans to take some social work courses at Fordham U.

Ayana likes to cook, ride bikes, dance, roller-skate and paint.

PHOTOGRAPHED BY James J. Kriegsmann PHOTOGRAPHER OF CELEBRITIES

*MISS SUBWAYS is a service mark of NEW YORK SUBWAYS ADVERTISING CO., INC.

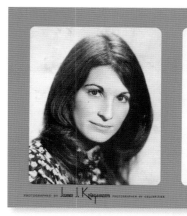

Meet *MISS SUBWAYS* *Josephine Lazzaro*

Josephine's very much a 'Now' Yorker. Secretary to the Head Pathologist at St. Vincent's Hospital, 'Joey' (to her family and friends) will trade her typewriter for a thermometer when she becomes a medical assistant next year.

For sheer fun, 'Joey' takes ballet and modern dance lessons, practices yoga, bakes bread, takes camping trips, is writing a childrens' book and enjoys playing soccer. An altogether person, but she admits Woody Allen breaks her up.

PHOTOGRAPHED BY *James J. Kriegsmann* PHOTOGRAPHER OF CELEBRITIES * MISS SUBWAYS is a service mark of NEW YORK SUBWAYS ADVERTISING CO., INC.

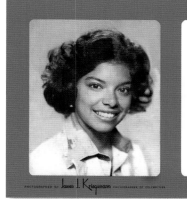

Meet *MISS SUBWAYS* *Laura Doran*

Laura's one of those magical New Yorkers who office-works by day (as a loan officer at Bank of Commerce)...and is transformed into a budding young actress at night. A graduate of HS of Music and Art, she studies modern dance at the American Dance Center, sings pop, plays classical piano and is a member of the Negro Ensemble Company. Laura..multi-talented, dynamic..and determined to succeed.

PHOTOGRAPHED BY *James J. Kriegsmann* PHOTOGRAPHER OF CELEBRITIES * MISS SUBWAYS is a service mark of NEW YORK SUBWAYS ADVERTISING CO., INC.

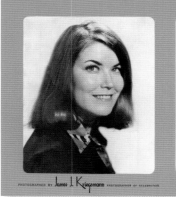

Meet *MISS SUBWAYS* *Heide Hafner*

Weekdays, Heide subways to her job at Potamkin Cadillac but weekends she zooms into the wild blue yonder! She has a private pilots license and recently co-piloted a plane in the women's cross-country air race. After 2,915 miles, 23 hours, nine stops and bad weather, Heide modestly termed it "most challenging."

Her goal: a flight instructors rating. Down-to-earth pastimes: chess, tennis and reading. Some gal!

PHOTOGRAPHED BY *James J. Kriegsmann* PHOTOGRAPHER OF CELEBRITIES * MISS SUBWAYS is a service mark of NEW YORK SUBWAYS ADVERTISING CO., INC.

Voting Posters

1962
WINNERS:
UNKNOWN

1963
WINNERS:
**CAROL NEALON
ANN NAPOLITANO**

1965
WINNERS:
**ROSALIND CINCLINI
JUDY MARSHALL
DIANA WALLACH**

1968
WINNERS:
**NEDDY GARDE
MAUREEN WALSH**

Who will be "MISS SUBWAYS" ??? Our Loveliest Subway Rider

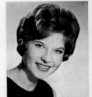 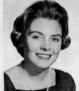 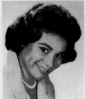 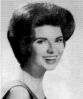 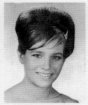 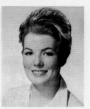

| MARILYNNE MULLANEY | MARY BASTON | DORIS LEE | PATRICIA McGUIRE | MICAELA NOORDEWIER | KAY McLAUGHLIN |
| Blue Cross | Equitable Life Assurance Soc. | Sioux City Packing Corp. | Trans World Airlines | American Express Co. | Four Roses Distillers Co. |

See the girls on "TELEPOLL" WABC-TV CHANNEL 7 (6:30 P. M.) Contest JUDGED November 17th — Winner ANNOUNCED November 24th

*Service mark of NEW YORK SUBWAYS ADVERTISING CO. INC. 630 Fifth Avenue, New York 20

YOU CHOOSE the next two "MISS SUBWAYS" from these 6 Finalists

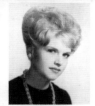 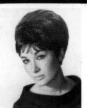 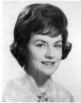 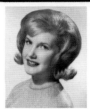 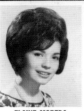 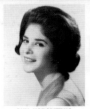

| MARY McCUE | SHARON FRIEDMAN | CAROLE NEALON | HEATHER DUNCAN | ELAINE MOREDA | ANN NAPOLITANO |
| First National City Bank | Clairol, Inc. | The Home Insurance Co. | United States Plywood Corp. | Revlon, Inc. | Doyle, Dane, Bernbach, Inc. |

VOTE via POSTCARD before JUNE 15, '63

Write the names of TWO of above finalists on a postcard — sign your name and address and mail to: N.Y. SUBWAYS ADVERTISING CO., INC. 630 FIFTH AVENUE, NEW YORK 20, N.Y.

Photographed By MICHAEL BARBERO 48 West 48th St., N.Y. CI 6-4773

* service mark of NEW YORK SUBWAYS ADVERTISING CO. INC.
An O'Ryan & Batchelder Operation

YOU CHOOSE the next two "MISS SUBWAYS" from these 6 Finalists

| ROSALIND CINCLINI | DIANA WALLACH | ELLEN RYAN | JUDY MARSHALL | CAROLE JOHNSTON | JUDITH HOROWITZ |
| American Broadcasting Co. | McGregor-Doniger, Inc. | American International Oil Co. | Kraft Foods Co. | National Broadcasting Co. | Brooklyn College |

VOTE via POSTCARD before JAN. 22, 1965

Write the names of TWO of above finalists on a postcard — sign your name and address and mail to: N.Y. SUBWAYS ADVERTISING CO., INC. 630 FIFTH AVENUE, NEW YORK 20, N.Y.

Photographed By MICHAEL BARBERO 48 West 48th St., N.Y. CI 6-4773

* "MISS SUBWAYS" is a service mark of NEW YORK SUBWAYS ADVERTISING CO. INC.
An O'Ryan & Batchelder Operation

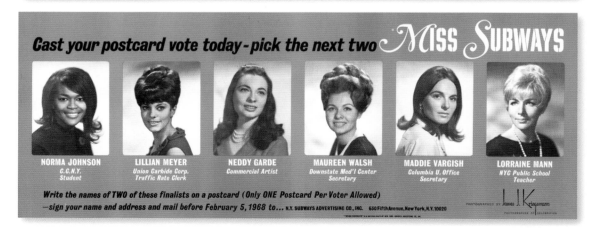

Cast your postcard vote today - pick the next two MISS SUBWAYS

| NORMA JOHNSON | LILLIAN MEYER | NEDDY GARDE | MAUREEN WALSH | MADDIE VARGISH | LORRAINE MANN |
| C.C.N.Y. Student | Union Carbide Corp. Traffic Rate Clerk | Commercial Artist | Downstate Med'l Center Secretary | Columbia U. Office Secretary | NYC Public School Teacher |

Write the names of TWO of these finalists on a postcard (Only ONE Postcard Per Voter Allowed)
—sign your name and address and mail before February 5, 1968 to... N.Y. SUBWAYS ADVERTISING CO., INC. 630 Fifth Avenue, New York, N.Y. 10020

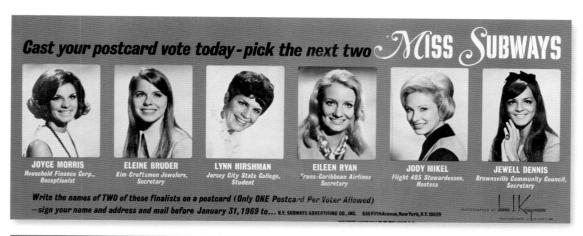

Cast your postcard vote today-pick the next two **MISS SUBWAYS**

JOYCE MORRIS
Household Finance Corp.,
Receptionist

ELEINE BRUDER
Kim Craftsmen Jewelers,
Secretary

LYNN HIRSHMAN
Jersey City State College,
Student

EILEEN RYAN
Trans-Caribbean Airlines
Secretary

JODY MIKEL
Flight 485 Stewardesses,
Hostess

JEWELL DENNIS
Brownsville Community Council,
Secretary

Write the names of TWO of these finalists on a postcard (Only ONE Postcard Per Voter Allowed)
—sign your name and address and mail before January 31, 1969 to... N.Y. SUBWAYS ADVERTISING CO., INC. 630 Fifth Avenue, New York, N.Y. 10020

Cast your postcard vote today-pick the next two **MISS SUBWAYS**

RUTH ZALDUONDO
Secretary,
Radio Station WHN

HARRIETTE SCHWARTZ
Reporter,
Radio Free Europe

LINDA LANNA
Student,
Finch College

CAROL BROWN
Administrative Assistant,
MacKay-Shields Financial Corp.

ALICE JONES
Secretary,
Select Magazines, Inc.

DIANE WEISGERBER
Secretary,
City Investing Company

Write the names of TWO of these finalists on a postcard (Only ONE postcard per voter allowed)
—sign your name and address and mail before May 7, 1973 to... N.Y. SUBWAYS ADVERTISING CO., INC. 750 Third Avenue, New York, N.Y. 10017

Cast your postcard vote today-pick the next two **MISS SUBWAYS**

 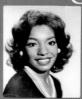

CAROL ANN NORMAN
Ass't Manager,
Tower Health Club

SONIA DOMINGUEZ
Data Processing,
Bache & Co.

STACEY-MARIE MAUPIN
Secretary,
Paragon Pictures

CHARLOTTE SEVERSON
Sec'y-Artist,
Womankind Unlimited

MARCIA KILPATRICK
Administrative Ass't,
Off Track Betting Corp.

CHIM YI
Ass't Art Director
Rothchild Printing Co.

Write the names of TWO of these finalists on a postcard (Only ONE postcard per voter allowed)
—sign your name and address and mail before May 10, 1974 to... N.Y. SUBWAYS ADVERTISING CO., INC. 750 Third Avenue, New York, N.Y. 10017

Cast your postcard vote today-pick the next two **MISS SUBWAYS**

JOSEPHINE LAZZARO
Secretary,
St. Vincent's Hospital

AYANA LAWSON
Head teller,
National Bank of No. America

SUSAN SCHWARTZ
Student,
Queens College

VIRGEN LOPEZ
Housewife

GUILLERMINA BERGA
Secretary,
Sperduto, Priskie & Vanacore

NELLY PIERRE
Bilingual teletypist,
Mobay Chemical Co.

Write the names of TWO of these finalists on a postcard (Only ONE Postcard Per Voter Allowed)
—sign your name and address and mail before April 30, 1975 to. N.Y. SUBWAYS ADVERTISING CO., INC. 750 Third Avenue, New York, N.Y. 10017

Credits

All Miss Subways portraits © 2007-2012 Fiona Gardner.
All still life photography © 2012 Hiroki Kobayashi.
Most of the personal photographs and ephemera in this book have been provided by Miss Subways and used with permission. The following list acknowledges photographs and ephemera from other sources.

End paper: Luncheon for the opening of the 57th street F line station June 26, 1968, courtesy of *New York Post*.

Page 3: *Hue* May 19, 1954, photo G. Marshall Wilson. *Jet* October 1954, photo G. Marshall Wilson.

Page 4: *New York Post* Monday June 5, 1995, photo by Charles Wenzelberg.

Page 5: Clawson Triplets Publicity shots courtesy of Lindsay Shropshire.

Page 8: Fiona Gardner photographing Sanora Selsey May 2012, photo Hiroki Kobayashi.

Page 9: Miss G train, November 20, 2009, photo Paul Quitoriano, courtesy of *Village Voice*.

Page 10: Phyllis Johnson (Jan/Feb 1955) on the New R-16 cars-rapid transit division, photo Peter Russo, courtesy of the New York Transit Museum.

Page 12: Margaret Gorman, "Miss Washington," September 13, 1921, courtesy of Library of Congress. Inter-city beauties, Atlantic City Pageant, 1927, courtesy of Library of Congress.

Page 13: Miss Chinatown USA 1962 Darrah Lau, courtesy of Connie Young Yu and the Chinese Historical Society of America. Miss Transit contestants, photo George Hopkins, courtesy of the New York Transit Museum.

Page 14: John Robert Powers 1955, courtesy of JRPowers Modeling agency.

Page 15: Miss Subways Luule Khula *Brief* January 1952.

Page 16: Thelma Porter March 20, 1952, photo Cecil Layne, courtesy of *Jet*.

Page 17: Vanessa Williams, Miss America, December 1983, courtesy of *Ebony*.

Page 18: Crandell, Bradshaw, artist Recruiting Publicity Bureau United States Army, 1943, courtesy of Library of Congress Prints and Photographs.

Page 19: Actress Sono Osato, acting in the play "On the Town", 1947, photo Eileen Darby/Time Life Pictures/Getty Images. "On the Town" PlayBill 1947 featuring (clockwise from top center) John Battle, Cris Alexander, Nancy Walker, Sono Asato, Adolph Green and Betty Comden. Gene Kelly hugging Miss Turnstiles poster, photo Alfred Eisenstaedt/Time Life Pictures/Getty Images.

Page 20: Exterior Of Subway Car Covered In Graffiti, January 1970, photo Leo Vals/Getty Images, *New York* March 29, 1976.

Page 21: Miss Subways Dorothy Calaghan poses in new subway car at Willis Point, photo Ed Clarity/*NY Daily News* Archive via Getty Images.

Page 22–23: "Miss Subways" spread, *Collier's*, September 25, 1943, courtesy of Knopf-Pix.

Page 40–41: "Miss Subways" spread, *Collier's*, September 25, 1943, courtesy of Knopf-Pix.

Page 62: Enid Berkowitz, "Young Girl," 1972, Rose Aurora marble, Height 18 1/2" including base x width 5 1/2", courtesy of the artist.

Page 63: Enid Berkowitz, "Raga Aegis," 1967, Pink alabaster, Height 14" including base x width 7 1/2", courtesy of the artist.

Page 78: Angela Vorsteg with her poster at a reunion at Ellen's Coffee Shop, photo by Joe Giardelli, courtesy of *North Bergen Record*.

Page 100: Actress Sono Osato acting in the play "On the Town", 1947, photo Eileen Darby/Time Life Pictures/Getty Images. Susan Steel as Madame Dilly With Sono Osato as Ivy in scene: Mme. Dilly's Studio from "On the Town", 1944 Vandam Studio, courtesy of the New York Public Library.

Page 102: Miss Subways Stella Deere with her Christmas tokens at Jay Street Station December 18, 1961, photo Paul Bernius/*NY Daily News* Archive via Getty Images.

Page 103: Miss Stella Deere, Miss Evelyn Tasch, Terry Fox, Miss Vernell Davis and Miss Kathy Dempsey, photo by Nick Sorrentino/*NY Daily News* Archive via Getty Images.

Page 103 and 106: Sally Pishney pictured with members of Japanese Traffic Survey, October 1962, courtesy of the New York Transit Museum.

Page 124: Marie Leonard and her father Frank Leonard at a ribbon cutting ceremony for a new tunnel, photo Dick De Marsico, courtesy of the New York Transit Museum.

Page 188: Sanora Selsey holding her poster, photo by Charles Frattini/*NY Daily News* Archive via Getty Images.

Page 190: Thelma Porter send-off "Underground Lovelies change Hands", *The New York Amsterdam News.* July 25, 1964.

Page 195: Exercise spreads, *Figure Beauty* 1965.

Page 211: (2) Luncheon for the opening of the 57th Street F line station June 26, 1968, photo courtesy of *New York Post*.

Page 232: Ayana Scott Lawson modeling portfolio head shot, photo Don Ramsay.

Page 237: *The Beeper* monthly newsletter for Employees of St. Vincent's Hospital and Medical Center, New York, May 1975.

Citations

Page 2: Re: Number of Miss Subways winners, see Johnston, Laurie and Susan Heller Anderson. "Calling All Miss Subways," *The New York Times.* August 22, 1983.

Re: Mona Freeman, see Geist, William E. "Subway Queens of Old To Gather for Reunion," *The New York Times.* October 15, 1983, Page 25 & 29.

Re: Number of posters, see Robertson, Nan. "Miss Subways Reigns: to 5 Million," *The New York Times.* February 18, 1957. Page 30.

Page 6: Walter Winchell quote from Winchell, Walter. "Keep Clean As Milk," San Antonio Light. May 31, 1954.

Page 24: Re: Origin of contest, see Bayer, Ann. "Token Women," *New York* magazine. March 29, 1976. Page 45.

Page 24 and 185: Re: Subway system history & ridership, see Hood, Clifton. 722 Miles: The Building of the Subways and How They Transformed New York. Baltimore: The John Hopkins University Press. 1993.

Page 24: Re: Popularity of contest, see Geist, William E. "Subway Queens of Old To Gather for Reunion," *The New York Times.* October 15, 1983, Page 25 & 29.

Re: "Miss Turnstiles" role in On The Town, see "Speaking of Pictures… New York City's 'Miss Subways' is 4 Years Old," *Life.* April 23, 1945. pp 14.

Page 25: Re: Early contest selection process, see Vandervoort, Jean. "Meet Miss Subways," Barnard Bulletin. Vol XLVI, No 37. April 10, 1942. "Speaking of Pictures… New York City's 'Miss Subways' is 4 Years Old," Life. April 23, 1945. pp 13.

Re: Photographer Menyhert Munkacsi, see Strum, Charles. "The Man Who Took Pictures of the Movies," *The New York Times.* May 8, 1994.

Page 24, 105, 185: Re: The role of women in the workforce and changes in family structure during 20th Century, see Skolnick, Arlene. Embattled Paradise. New York: BasicBooks. 1991.

Page 104, 184: Re: 1950 and 1962 changes in ownership of contest, see "Walter O'Malley: Biography." O'Malley Seidler Partners, LLC. http://walteromalley.com/biog_short_page3.php Accessed Aug 11, 2012.

Page 104, 184: Re: Suburbanization and change of population of New York region, see Suarez, Ray. The Old Neighborhood. New York: The Free Press. 1999 Hobbs, Frank and Nicole Stoops. "Demographic Trends in the 20th Century." U.S Census Bureau. November 2002.

Page 104: Re: Change in duration of poster reign, see Robertson, Nan. "Miss Subways Reigns: Persephone to 5 Million," *The New York Times.* February 18, 1957. Page 30.

Re: Photographer Michael Barbaro, see D'Aurizio, Elaine. "A Beautiful Baby's Modeling Career Was A Perfect Picture of Anonymity" The Record. April 3, 2003.

Re: Creation of "Miss Transit" contest by "Harlem Transit Committee" employee association, see Webb, Alvin Chick. "Winning Beauty Crown 'No Cinch' Queen Says," New York Amsterdam News. September 26, 1953. Page 26.

Page 105: Re: End to *New York Times* employment listings gender segregation, see Menand, Louis. "Books As Bombs: Why the women's movement needed 'The Feminine Mystique'," *The New Yorker.* January 24, 2011.

Re: Spaulding quote from Nemy, Enid. "Miss Subways of '41, Meet Miss Subways of '71," *The New York Times.* December 8, 1971. Page 62.

Re: Attendance at luncheon for new station at 57th Street, see Permutter, Emanuel. "Luncheon in Subway Opens Station," *The New York Times.* June 27, 1968. Page 45.

Page 185: Re: Change in women's labor force participation rate, see Smith, Kristin E. and Amara Bachu. "Women's Labor Force Attachment Patterns and Maternity Leave: A Review of the Literature" U.S. Census Bureau. Population Division Working Paper Number 32. January 1999. Accessed at http://www.census.gov/population/www/documentation/twps0032/twps0032.html August 11, 2012.

Page 185: Re: "Mr. Subways" guerilla art project, see "The Art Phantom Strikes Again" New York magazine. June 10, 1974. Page 71.

Crude pickup line at club fromBayer, Ann. "Token Women," *New York* magazine. March 29, 1976. Page 45. ess. 1996.

Index

Interviews:
Names, People, And Places

ACKNOWLEDGEMENTS

We would like to thank our wonderful publishers Spencer Smith and Jean Kerr of Seapoint Books for believing in *Miss Subways* from the start, as well as our invaluable managing editor Heather Peterson. Jody Churchfield brought the book alive with her playful and sensitive design. The brilliant and talented Kathy Peiss was so generous with her major contributions to the book. Thanks to Prem Krishnamurthy for bringing the *Miss Subways* team together.

Thanks to the staff of the New York Transit Museum—especially Rob Delbango, Gabrielle Shubert, Carey Stumm, Marcia Ely, and Renee Wasser—for putting on the Miss Subways exhibition. We also thank Derrick Adams and Dave Herman for early exhibitions of the Miss Subways portraits at Rush Arts and the City Reliquary in New York, and we appreciate the interest that Joe Richman and Samara Freemark of Radio Diaries took in the work.

We would like to thank Jeff Hersch and Photo Care for sponsoring Miss Subways with all the lighting equipment that we need to make this book possible. Ken Schneidermann's lighting design brought the women and their spaces to life. We had an army of photo assistants including Hiroki Kobayashi, Joe Wessely Gardner, James Holland, Katarina Kojic, Jaime Skolfield, Simao Ago, Rachel McLaughlin, Annie Shaw and others. Eddie Kunze's retouching helped to create our cover.

Scott Barbarino and Ellen Hart Sturm, of Ellen's Stardust Diner and The Iridium Jazz Club, made this project possible by sharing the largest collection of Miss Subways posters, connecting us with many of the Miss Subways and keeping the contest memory alive over the years. Private Eye Charles Gordon helped us track down some of the Miss Subways that were more difficult to find. It was a treat for us to be photographed for this book by James Kriegsmann Jr., the last Miss Subways photographer. Thanks also to the advice from Clifton Hood, Melissa Rachleff Burtt, Jan Ramirez, Bonnie Yochelson and Steve Zeitlan. We wish to thank the Crisis Publishing Co., Inc., the publisher of the magazine of the National Association for the Advancement of Colored People, for the use of the images first published in the May 1948 and July 1950 issues of *The Crisis* magazine.

The Miss Subways exhibition and book is a sponsored project of Artspire, a program of the New York Foundation for the Arts. Private funds were critical to seeing it through, and we are grateful to Kickstarter for giving individuals a fundraising tool, and to all those who contributed. Thanks to the Fountainhead Residency and the Atlantic Center for the Arts for making our travel to Florida possible.

A very special thanks to our family and friends for their incredible support and belief in *Miss Subways* over the last five years. We're especially grateful to Heron Gardner and Michael Freedman-Schnapp for being stalwart champions of the project throughout the countless hours we've dedicated to it.

Lastly, we are indebted to the many Miss Subways who let us into their lives, often picking us up at bus or train stations and graciously sharing their stories, photos and time with us. We're really lucky to have met such dynamic women.